THE INTERNATIONAL CARAVAGGESQUE MOVEMENT

BENEDICT NICOLSON

THE INTERNATIONAL CARAVAGGESQUE MOVEMENT

Lists of Pictures by Caravaggio and his Followers
throughout Europe from 1590 to 1650

PHAIDON · OXFORD

Phaidon Press Limited, Littlegate House, St Ebbe's Street, Oxford
Published in the United States of America by E. P. Dutton, New York

First published 1979
© 1979 by Phaidon Press Limited
All rights reserved

ISBN 0 7148 1916 6
Library of Congress Catalog Card Number: 78-20343

Printed in Great Britain
Text printed by Western Printing Services Ltd, Bristol
Plates printed by The Cavendish Press Ltd, Leicester

Contents

Foreword

Benedict Nicolson's sudden death from a heart attack on 22 May 1978 prevented him from seeing this book in its published form, but he had put the finishing touches to the typescript, except for a few notes of details which reached him after the text had been sent to the printers and which have been carefully inserted by Luisa Vertova, his former wife and literary executor, who has seen the book through the press. It can therefore in the literal as well as the general sense be regarded as his last will and testament.

It represents, in highly condensed form, the result of more than twenty-five years' work, going back to the time when he published his first articles on the Caravaggisti in the early 1950s.

In his earlier years Ben had written on a variety of painters of different schools—Cézanne and Vermeer in 1946, the Ferrarese in 1950—but in the last decades of his life he devoted all the time that he could spare from the onerous task of editing the *Burlington Magazine* to the Caravaggesque painters in Italy and in Northern Europe. Wisely perhaps—because Ben did not like controversy—he did not enter the dangerous field of attribution and dating in connection with Caravaggio himself, though he followed the discussion closely and expressed his own opinions in many references in his books and articles on the artist's followers, but he has, understandably, summed up his views in the List of Caravaggio's own paintings published here. His most important ideas were incorporated in two monographs: *Terbrugghen*, published in 1958, and *Georges de La Tour* (written in collaboration with Christopher Wright) in 1974, to which must be added—by extension—the two-volume *Wright of Derby* (1968), in which the night-pieces were clearly what particularly interested the author.

The most obvious characteristic of these books is their meticulous and modest scholarship. Ben himself was almost apologetic about this. In the first chapter of the La Tour book he wrote: 'from the word go we shall betray our irresolution with that indigestible, staple diet of the art historian, those words "probably", "perhaps", "presumably", which besmirch this book from end to end.' He should have written *caution* for *irresolution* and *decorate* for *besmirch*. In a field where so much was and remains uncertain—and where so much has been affirmed without evidence—such scruples are essential if a historian is to arrive at solid conclusions. An astonishingly high percentage of Ben's attributions have stood the test of criticism, but it is typical of his honesty that the section headed 'wrong attributions' in the present book includes corrections to his own earlier lists. He was never afraid to admit that he had changed his mind.

Another feature which jumps to the eye from the pages of these books is Ben's remarkable style of writing. Whether this gift was inherited from his parents, both of whom were distinguished writers, or whether it was due to absorbing the intellectual atmosphere in which he was brought up, the fact is that he had a quite exceptional ability to translate into vivid words the visual or dramatic qualities of a painting. A single passage from his *Terbrugghen* must suffice to show his talent:

> His habit of closing up a composition, of leaving in the centre an empty space or a resigned, suffering figure tormented by others encircling him, is part of the vocabulary he had inherited from early youth, and had saved up through years of basking in the hot sun. In the Copenhagen picture, even the groups in the background form their own separate closed circles, where no eye is permitted to stray into the distance, where eye meets eye, and two lost profiles converge on a third rigidly frontal, as can often be found in Lucas and Dürer. The eye of the spectator in consequence is only invited to move within strictly defined limits, at a measured pace, from one figure to the next, and is never led out of the picture altogether but always back to the point where it started its journey.

The evocative quality of this description of an artist's style is rare in English art-history since Hazlitt.

The present book—alas!—allows no opportunities for such writing. It is a work of austere scholarship, listing, the author tells us, thousands of pictures, first under artists, then under subjects and finally under places. The model was clearly Berenson's Lists of Italian Renaissance paintings, a work on which he was brought up and from whose author he learnt much during visits to I Tatti; but he applied Berenson's method to a subject covering the greater part of Europe, and his entries are fuller.

I said at the beginning of this foreword that this book is Ben's testament, and this is true in a special sense. A testament is something which deals with the future, and these lists will serve scholars in this particular field for generations. Ben ends his introduction with a sentence of characteristic modesty: 'With every month that passes, the lists grow more terrifyingly outmoded.' This is wrong. They will be kept up, amended, completed by students of the Caravaggisti in Europe and America; they will no doubt change—and grow—but they will not become 'outmoded'.

Even in the few months since Ben's death some new information has come to light, which, happily, can be incorporated in the form of a note, as the author would certainly have wished. In his section dealing with Trophime Bigot, Ben wrote: 'It is rumoured that the archive of S. Maria in Aquiro has revealed the name of "Maestro Jacopo" as the author of the three altarpieces in the church, listed as Bigot below. If this proves correct, then the author's name of all these pictures must be changed to "Maestro Jacopo".' It turns out that it is true, and the information is published by Ben's old friend, Jacques Thuillier, in the catalogue of a splendid exhibition, entitled 'La Peinture en Provence au XVIIe siècle', organized in the Palais de Longchamp at Marseilles. By a happy thought of the organizer, M. Henri Wytenhove, the exhibition is dedicated to Ben's memory, a very fitting tribute, since it contains a large group of Caravaggesque paintings, centred on the work of an artist whom Ben had 'rediscovered'—one could almost say 'invented'—first under the name of 'the Candlelight Master' and then under that of Trophime Bigot.

September 1978 ANTHONY BLUNT

Introduction

GENERAL

The lists which follow, arranged alphabetically as well as under subjects and locations, are of pictures (and a few drawings) by Caravaggio and his followers throughout Europe from about 1590 to about 1650, from Caravaggio's arrival in Rome to the death-throes of the movement in Sicily, Utrecht and Lorraine. Probably the latest pictures listed are a Nicolas van Galen at Hasselt (1657), and a Kuyl *Concert* of 1662. Some 123 artists are represented, including thirteen anonymous 'Masters' with a sizeable *œuvre*, but in fact many more artists are included, since under 'Caravaggesque unknown' further pictures are listed by unknown hands who cannot be made responsible for more than one or two works, and paintings are distributed throughout some lists (Baburen, Terbrugghen, Manfredi etc.) by unidentified hands from the circle of the artists to whom the list is dedicated. Thus thousands of pictures are listed, but I do not claim that the entries are anywhere near complete. Many sprats must have escaped my net. The entire work of an artist is listed if he remains more or less consistently Caravaggesque throughout his career; in other cases only that phase of an artist's work is listed where he can be shown to have come temporarily under Caravaggio's sway. A few artists are listed with a single work, or a mere handful, since they soon went on to develop different tastes. In some cases, only one or two pictures in all are known from an artist's hand. Many new attributions are proposed.

INFORMATION PROVIDED

The object has been to pack the maximum amount of information into the shortest space. For this a system of abbreviations has been devised. A: Atelier. BP: Badly preserved (not the same as 'R' below). C: Copy. D: Dated. F: Fragment. P: Later pastiche (sometimes worth recording because it may reflect a lost original). R: Ruined or drastically repainted. SA: Studio assistance. S: Signed. U: Uncertain attribution, but included in a given list because it finds no obvious place elsewhere. UU: an attribution in which I have no confidence, but included because its appearance in a list may stimulate others to find the correct place for it.

Besides the abbreviations, the following information is also provided: essential biography heading each entry; subject; location; date and number of fullest recent museum or private collection catalogue (in brackets after location); dimensions in centimetres (on canvas unless otherwise stated); date if known; standard book or article with catalogue number or other reference and plate number where catalogued and/or reproduced. Where there is no standard work or where the picture is omitted from it, references to other publications are given. This ensures that references to all illustrations of a picture are provided, wherever known. Where no such reference appears in an entry, it is believed that the picture has never been reproduced. Where 'A' or 'SA' or 'U' or 'UU' is not added, it is to be assumed that I regard the picture as entirely by the artist himself. References to the literature throughout the lists are abbreviated, and full references are given in the 'bibliography' (only listing publications which happen to be mentioned in the text, and therefore neither judiciously selective nor comprehensive). Question-marks after a subject mean there is uncertainy about the subject, not the author.

To take an example more or less at random:

> Baburen **Granida and Daifilo.** Musée Royal des Beaux-Arts,
> Brussels (1949/1047). 166 × 209. S A. S/A25 (Fig. 29).

Meaning: a painting by Baburen representing *Granida and Daifilo* in the Musée Royal des Beaux-Arts, Brussels, catalogue 1949, No. 1047, on canvas measuring 166 by 209 cm., with studio assistance, illustrated in the standard work by Slatkes on *Dirck van Baburen*, Utrecht, 1965, catalogue No. A25, illus. Fig. 29 (the bibliography, as in this case, being even further abbreviated, and noted as having been so treated in the biographical section heading the lists).

PAINTINGS WITH WRONG ATTRIBUTIONS

At the end of most lists there are lists of wrong attributions. The full listing of these will be found under their corrected attribution, except on occasions where a picture wrongly given to a Caravaggesque artist turns out not to be Caravaggesque, in which case it is marked by an asterisk and is not listed elsewhere. References to the literature are given for the asterisked pictures, which might otherwise be unidentifiable from a too brief description. Only a selection is included of wrong attributions, because it would obviously be absurd to attempt comprehensive lists of pictures wrongly called Caravaggio, for instance, in the past.

DATES

Dates are only given if works of art are actually dated or if the date of execution is known from documents. Thus, 'D 1624' means it is dated on the picture that year; '1624', that it is known to have been done in that year. No attempt is made to date on stylistic grounds, even though many such dates may be incontrovertible.

ORDER WITHIN EACH LIST

The entries are arranged by subject order approximately as they appear in the Iconographical Index (for notes on the latter, see p. 209), from 'Mythology' to 'Unidentified Subjects'. They generally appear alphabetically under categories, but for the Old and New Testaments and the Apocrypha the Bible chronology is adopted, and the proliferating genre scenes are broken down into numerous sub-categories. Musical themes are arranged in descending order of number of instrumentalists, and single musicians subdivided under instruments played. Feasting scenes are in descending order of number of eaters and drinkers, and these are further subdivided where musicians entertain the revellers or fortune-tellers are present. With the help of two Indices, this should enable the reader to find the reference to any picture in a matter of seconds.

CATALOGUE NUMBERS

By quoting catalogue numbers from museum and private collection publications, I do not make rigid distinctions between different categories of numbers (e.g. Inventory Nos. or Nos. specially adopted for a given catalogue) since it should be simple enough to find the reference straightaway in the catalogue concerned.

LOST PICTURES, DRAWINGS, ENGRAVINGS, COPIES

Pictures recorded in old lists or inventories but now untraced are included only if they are known from reproductions in standard works, or if they are authoritatively recorded in the twentieth century. The few surviving Caravaggesque drawings are listed, and so are early engravings after known or lost compositions. The inclusion or exclusion of copies may seem a little arbitrary. In general, copies of lost

works are included (except in such cases as Caravaggio's *Bari*, which exists in over fifty versions and it would be a waste of space to list them). Copies of known works are normally cited unless full details about them are given in easily accessible literature, in which case the reader is referred to these facts, and only copies not appearing in the literature are here added. Alfred Moir's book *Caravaggio and His Copyists* (1976) appeared after this manuscript was complete. It has only been possible to add a few notes here to Moir.

SALEROOM ENTRIES

Saleroom entries have been cut down to the minimum in order not to clutter up the lists with dates, by sometimes listing pictures under previous owners before sale. Pictures appearing in the international auction houses generally are listed only under sales where previous and subsequent owners are not known to me.

ARTISTS REPRESENTED

My most difficult task has been to decide whom to include and whom to exclude, or which pictures in an artist's work deserve record here. There has been a heated controversy, particularly in Italian periodicals over the last years, as to whether a given artist is Caravaggesque or not, and undoubtedly my lists will provoke further complaints. Whatever one does, there are bound to be borderline cases. Thus, among the artists I do include (even if only with a small section of their work), there will be disagreements about certain genre scenes by Preti, who is undoubtedly never more than marginally Caravaggesque; about Abraham Janssens, who traces his origins to late Antwerp Mannerism but in my view must have been deflected at one point by the latest revolutionary developments in Rome; about Borgianni, who is more in the Venetian tradition but again pays his respects to Caravaggio after his return from Spain; about Reni, who, I recognize, is too distinguished and individual an artist to be classified as truly Caravaggesque at any stage. And I also see eyebrows raised at the appearance of my Bernardi, Manetti, Rustici, Spada, Tanzio and Tornioli lists. I have perhaps unjustifiably listed the entire works of Orazio Gentileschi except for his beginning and end, but not the early Saraceni, although it must be admitted that a few Saracenis of the first decade are just as much (or as little) Caravaggesque as a few Gentileschis of the same years which do appear here. But I found it even more difficult than with Saraceni to know where to draw the line with Gentileschi between the inspiration of Elsheimer and that of Caravaggio. I have put in a handful of so-called Caravaggesque Rembrandts while remaining fully aware that this explosive young artist could never have rested content with merely imitating his predecessor. And the same goes for Ribera. These great artists refuse to be categorized. On the other hand, Velázquez is not listed, although it is undeniable that his early career would have taken a different course had Caravaggio never existed.

I am conscious that I have failed, by my silence about them, to do justice to the following who were aware of the Caravaggesque movement while remaining on its outskirts: Timon Arentsz. Cracht or Craft, whose *St Vincent Ferrer* at Bassano di Sutri might just have qualified; Pietro Paolo Bonzi, who is still inadequately defined; Agostino Tassi, the collaborator of Gentileschi and Saraceni, but as a *quadraturista* rather out of the running; the *Bamboccianti* who developed their own brand of Caravaggism in the 1630's '*a passo ridotto*'; Hendrick van Somer, the Ribera follower; the Veronese Bassetti, Turchi, Ottino, who were in Rome at the height of the Caravaggesque vogue late in the second decade and can hardly be said to have been indifferent to it; Arnout Mijtens, who would have been drawn into Caravaggio's orbit had he not died too early (1601); the young Jordaens; Fiasella; Zurbarán; some ill-defined, anonymous still life painters from the Crescenzi circle—and no doubt the list could be considerably expanded.

I do not regard these inclusions and exclusions as so desperately significant, so long as it is understood what we mean by 'strictly Caravaggesque', 'near Caravaggesque', 'distantly Caravaggesque', 'Caravag-

gesque at two removes' and so forth; and this should become clear from my comments on the status of an artist at the head of each list.

ILLUSTRATIONS

The plates in this volume have been generally selected among pictures which are either completely unpublished or are known only from publications difficult of access. I have however kept in mind when making my selection that in spite of the obscurity of the works reproduced, they should nevertheless be representative of the artist's *œuvre*, and should fulfil the same function in this respect as a choice of better known examples would have done. Some artists of importance for whom fully illustrated and easily accessible monographs exist, such as Caravaggio himself, Baburen, Terbrugghen, Finson, Serodine, Saraceni, La Tour are played down (though not Honthorst). Thereby I run the risk of giving a false impression of their status, but readers will appreciate that the paucity of illustrations of their work implies no criticism of their value. Occasionally in cases where I can take up no unpublished material, better known pictures are illustrated, or more often, striking details.

CHART

The chart on pp. 14–15 shows which Caravaggesque artists were in Rome and Naples when. The years 1593 to 1647 run from top to bottom, and the artists (divided into Italians (and subdivided), North and South Netherlandish, French, German, Spaniards and of uncertain origin in that order, alphabetically within categories) from left to right. Rome is to the left of the thick double vertical line, Naples to its right. Squares blocked out in black indicate that the artist is certainly or almost certainly known to be in Rome or Naples at that time. Areas shaded from top right to bottom left in the squares indicate that he is thought to be resident in these cities then. Areas shaded from top left to bottom right indicate that documents exist referring to an artist in these cities who may be the one in question. The date of an artist's death (if before 1648) is indicated by a horizontal double line. It must be emphasized that some artists represented in the chart were in Rome or Naples at other times, but they are not marked with black squares unless they are thought to be working in the Caravaggesque idiom. Arrows pointing upwards and downwards indicate that these artists were then also in Rome or Naples, but have not yet entered, or have passed out of, the Caravaggesque orbit. Some ill-documented artists who are believed to have worked in these cities during these years are omitted altogether from the chart where no precise information is available.

ACKNOWLEDGEMENTS

Far too many people in their official or private capacity have helped me during the course of this compilation, in answering sometimes quite complicated questions, in sending me photographs, and in so many other ways, for me to be able to acknowledge to them all individually. If I were to provide a comprehensive list, I would only be boasting of the extent of my correspondence. I have decided that the only way I can settle the problem is by singling out a few people and representatives of institutions who have gone out of their way to be helpful, sometimes by answering questions I never asked, by volunteering information I did not possess and was glad to have. The danger of doing this is that I may overlook someone who took no end of trouble. Among those who have helped me in their private capacity are: Dr John A. Cauchi of Rabat (Malta); Mr David Koetser of Zurich; Professor J. Richard Judson of Chapel Hill (N.C.), who went so far as to hand over to me the Honthorst photographs he had collected which were missing from my own files; Denis Mahon, to whom I am indebted for my single Schidone entry and for helping me to make up my mind about the original of Caravaggio's *Boy peeling a bitter Fruit* (and in indirect ways for so much besides); Professor Alfred Moir of Santa Barbara, who passed over to me some valuable scraps of information as we sat at adjoining tables in the Witt Library; Dr Anna Ottani Cavina for supplying precious photographs and back numbers of

unobtainable Bolognese periodicals; Dr Luigi Salerno, who helped me sort out the vicissitudes of pictures in Roman churches, and used to end his long letters to me with the phrase 'do not hesitate to ask me anything else you want to know' (and he is not alone in so writing); Brian Sewell; Olga Pujuanová; John Spike, with whom I discussed my Preti list; Enrique Valdivieso; Luisa Vertova and Ing. Alfredo Muratori for supplying me with photographs of Caravaggesque pictures in Italian Collections; Malcolm Waddingham, who ought to take part of the credit for my 'Moeyaert' list. (One of my troubles is that I have stolen ideas from friends and colleagues without acknowledgement because there is no place in the lists for what historians call in their stilted jargon 'oral communication').

In their official capacity, the following went beyond what was required of them in civility: Dr Raffaello Causa of the Museo di San Martino, Naples; M. Jacques Foucart and M. Arnauld Brejon of the Louvre, who provided information and photographs of inestimable value and rarity, not only of pictures in Paris but in the hermetic French provinces; Dr Erich Schleier of the Berlin Museums; Dr Nicola Spinosa of Capodimonte, who was particularly helpful in tracing lost, stolen or strayed Stomers; Vincenzo Pacelli and Riccardo Lattuada for driving me around Neapolitan churches and for being so kind in innumerable other ways; Dr van Thiel of the Rijksmuseum; and members of the staff of the museums of Brunswick, Dijon, Munich, the Chrysler Museum at Norfolk (Virginia), the Galleria Nazionale d'Arte Antica, Rome, and the Kunsthistorisches Museum, Vienna. I am indebted to all the collectors and dealers throughout Europe and the USA who have given permission for their paintings to be reproduced.

The great international art photographic libraries from which I have most profited are the National Gallery, London, the Witt Library, the Louvre, the Rijksbureau at The Hague and the German Institute in Florence: in all five places I found material unfamiliar to me, and a staff only too eager to do what they could to help. I must thank in particular Dr J. Nieuw Straten at the Rijksbureau for his unfailing helpfulness. My many Saturdays spent in the Victoria and Albert Museum Library have been richly rewarded. Lady Hulbert has been invaluable in saving me months of work by corresponding with museums all over Europe and the United States on my behalf, finding out among other things what happened to pictures passed over in silence in the latest catalogues. Joanie Spears has identified for me numerous seventeenth-century musical instruments, the fruits of which knowledge are reflected chiefly in the Iconographical Index. Anthea Brooke, as well as Miss Spears, and above all Sally Linehan, have been most helpful in secretarial work.

DEADLINES

The lists are by way of being up-to-date until the early months of 1978. Thereafter, very few changes are incorporated. With every month that passes, the lists grow more terrifyingly outmoded.

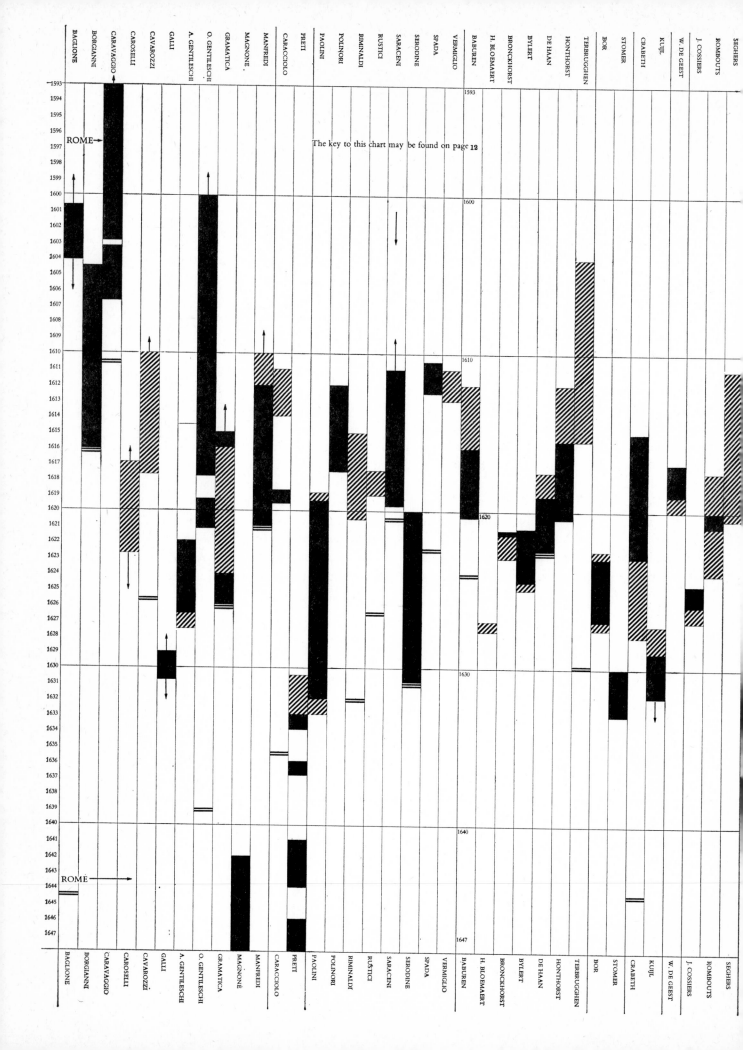

The key to this chart may be found on page 12

ROME→

ROME→

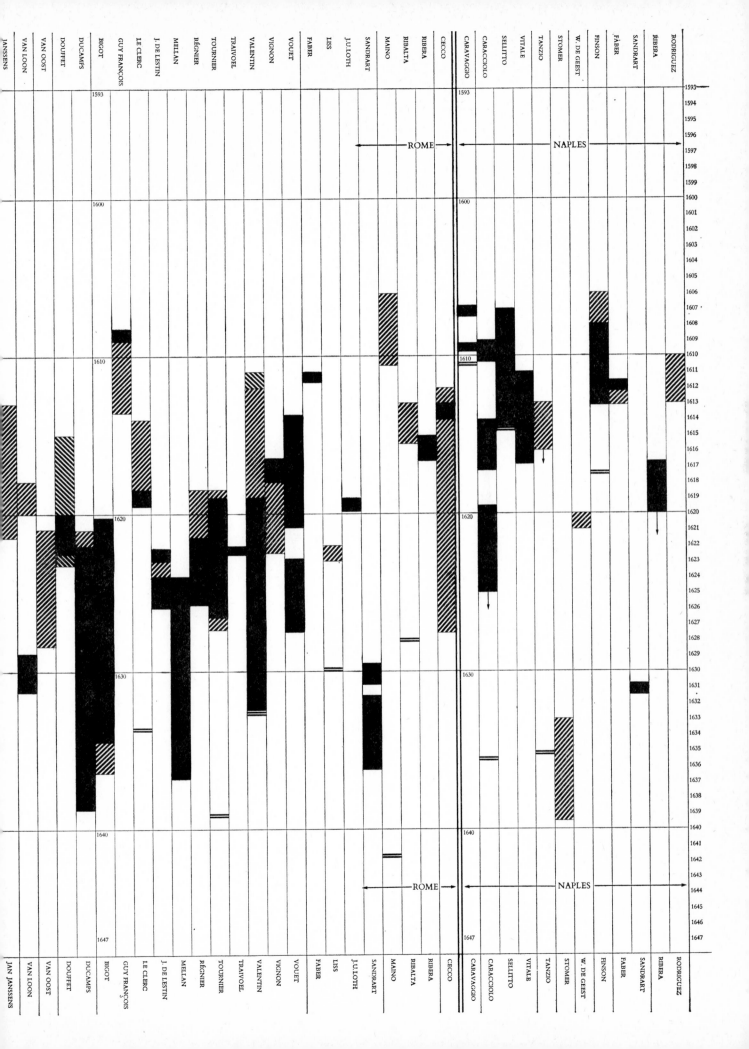

ABBREVIATIONS

see also Introduction p. 9

A: Atelier
BP: Badly Preserved (not the same as R)
C: Copy
D: Dated
F: Fragment
P: Later Pastiche

R: Ruined or drastically repainted
S: Signed
SA: Studio Assistance
U: Uncertain attribution
UU: Wrong attribution
★: not Caravaggesque

Lists of Caravaggesque Pictures

'ADELO, R. van' (active 1620's)

An unrecorded, Baburen-like artist who appears to have signed the picture formerly in Cologne 'R van Adelo fecit 1625' (?Adel, ?Adels). In the Lübeck picture, he reverts to the mannerism of A. Bloemaert.

Joseph before Pharaoh [Plate 124]. Formerly Wallraf-Richartz-Museum, Cologne (sold, 1944). 125 × 168. S & D 1625.

St John the Baptist preaching [Plate 123]. Private Collection, Lübeck (1959). 165 × 220. S & D 1628.

Four Evangelists. Musée des Beaux-Arts, Quimper, as Scorel. 90 × 96. U. '1626' exh., Leyden, 1976–7 (S 34), illus. as anon., c. 1625–30.

BABUREN, Dirck van (not later than 1595–Feb. 1624).

Pupil of Paulus Moreelse in Utrecht, 1611. Leaves for Rome c. 1612 or soon after. Influenced in Rome by Manfredi, and on his return north by Terbrugghen. Works (c. 1617–20), in Pietà Chapel, S. Pietro in Montorio, in company with David de Haan, with whom he is living in 1619–20. Returns c. 1620 to Utrecht where he dies prematurely. All works listed. S followed by stroke and number refers to Slatkes, 1965 catalogue numbers, pp. 101–72.

Apollo and Marsyas. Fürst Schaumburg-Lippe Collection, Schloss Bückeburg. 192 × 160. Schleier, 1972, p. 787, Fig. 67.

Chaining of Prometheus. Rijksmuseum, Amsterdam (1976.A1606, illus.). 202 × 184. S & D 1623. S.A21 (Fig. 21).

Roman Charity. City Art Gallery, York (1961 and 1974/788). 127 × 151.1. S.A22 (Fig. 20). Copy by Jan Janssens in Madrid (q.v.).

Emperor Titus. Jagdschloss Grunewald, Berlin. 69 × 52. S & D 162(2?). S/A16 (Fig. 34). Mezzotint by J. F. Leonart.

Granida and Daifilo [Plates 117, 118]. Three versions: 1. Private Collection, New York (1971). 165.7 × 211.4. S & D 1623. Slatkes, 1973, Fig. 2. 2. Musée Royal des Beaux-Arts, Brussels (1949/1047). 166 × 209. SA. S/A25 (Fig. 29). 3. Fragments of a third version or variant divided between (a) *Daifilo* alone. Christie's, 4 Feb. 1977 (79); with estate of T. P. Grange, London (1977). Canvas laid on board, 118.1 × 74.9. S/A24 (Fig. 28); (b) Head of shepherdess *Dorilia* alone. With E. V. Thaw & Co., New York. Canvas laid on board, 62.2 × 43.2.

Lot and his Daughters. Pierre Landry Collection, Paris. 100 × 146. S & D 1622. S/A15 (Fig. 19).

Judah and Tamar. 1. Rijksprentenkabinet, Amsterdam (No. A1469). Black chalk with traces of white chalk, 25.1 × 38.6. S/A27 (Fig. 36). **2.** Adaptation of this composition (?by Bramer after lost painting by Baburen): Rijksprentenkabinet, Amsterdam (No. A3119). Black chalk, 32.1 × 45.1. Slatkes, *Master Drawings*, 1968, plate 9.

Christ among the Doctors [Plates 114, 116]. Three autograph replicas known (No. 2 partly studio): **1.** Nasjonalgalleriet, Oslo (1973/606). 190 × 210 (with original strip of 24 cm along top). S & D 1622. S/A11 (Fig. 13). **2.** Sale, Locke & England, Leamington Spa, 25 March 1976 (279), illus. with Colnaghi's, London (1977), and Richard Feigen, New York.172.7 × 123.4. SA. **3.** Private Collection, near Turin (1978); formerly Mansi Collection, Lucca. ?S & D 1622. S/A11B. Three copies recorded by Slatkes: **1.** Palazzo Venezia, Rome. 220 × 250. SA. **2.** Bob Jones University, Greenville (SC) (1962/164, illus.). 173.7 × 233. Late copy. **3.** Formerly Rimpau Collection, Langenstein bei Halberstadt. 162 × 210.

Woman taken in Adultery. With Miethke Gallery, Vienna (1938), as Manfredi. Sold with copy of Borghese *Capture of Christ* (q.v.). ?C of lost Baburen. UU.

Christ washing the Disciples' Feet. Städtische Gemäldesammlungen, Wiesbaden (1937/BM 462). 200 × 296. S/A2 (Fig. 8). One copy known: formerly Busiri Vici Collection, Rome. 124.5 × 176. Exh. Palazzo delle Esposizioni, Rome, 1954 (8), illus.

Capture of Christ. Galleria Borghese, Rome. 139 × 202. S/A7 (Fig. 11). Three copies known: **1.** Private Collection, Rome. Hoogewerff, 1952, pl. 8. **2.** With Miethke Gallery, Vienna (1938), as Manfredi, sold with *Woman taken in Adultery* (q.v.). **3.** Gerd Rosen Auction Sale, No. XXXI, Berlin, 29 Nov. 1958 (273) as Rombouts. 139 × 197, illus., unsold.

Capture of Christ with Malchus Episode. Longhi Collection, Florence. 125.3 × 95. S/A1 (Fig. 9).

Capture of Christ with Malchus Episode [Plate 121]. With Colnaghi's, London (1977). 147 × 194.

Agony in the Garden. Pietà Chapel, S. Pietro in Montorio, Rome. Lunette, 155 × 330. S/A4 (Fig. 6).

The Way to Calvary. Pietà Chapel, S. Pietro in Montorio, Rome. 199.4 × 248.9. S/A5 (Fig. 7).

Crowning with Thorns. Two versions (with changes): **1.** Provincialaat der Minderbroeders, Weert. 106 × 136. S. S/A17 (Fig. 16). **2.** Captain Drury-Lowe Collection, Locko Park (Derbyshire). 127 × 168. S/A18 (Fig. 15).

Entombment. Pietà Chapel, S. Pietro in Montorio, Rome. 222 × 142. Said to have been S & D 1617. S/A3 (Fig. 1). Etching (anon. 17th century) in reverse, Rijksprentenkabinet, Amsterdam (Slatkes, Fig. 2). Slatkes lists under A3, 18 copies, the best known of which are: **1.** Centraal Museum, Utrecht (1952/6). 220 × 135. **2.** Musée Royal des Beaux-Arts, Brussels (1949/16). 220 × 149. Add to these: copy by Van Dyck (three figures only) in Italian sketchbook, British Museum, folio 22r. Black chalk. 1622–3. R. Slatkes, *Master Drawings*, 1968, pl. 8. An unrecorded C in church at Beauzac (Haute-Loire).

St Francis. Kunsthistorisches Museum, Vienna (1973, illus.). 114 × 82. S/A6 (Fig. 10 and detail, frontispiece). Copy Sotheby's, 12 Dec. 1973 (118), illus. as 'Matthias Stomer'. 84 × 77.

St Sebastian tended by Irene [Plates 119, 120]. Kunsthalle, Hamburg. 108.9 × 153.7. Slatkes, 1973, Fig. 1.

Incredulity of St Thomas. Roman art market (1966). U. Bodart, *Finson*, p. 91 note 4.

Four Evangelists (Four canvases). La Seo, Saragossa. Each 98 × 75. Seville 1973 (51–4), illus.

Concert. (Four figures) ('*Prodigal Son*'). Gemälde-galerie, Mainz. 110 × 154. S & D 1623. S/A20 (Fig. 22).

Concert. (Four figures). Hermitage, Leningrad. 99 × 130. S/A26 (Fig. 23). Linnik, 1975, illus. Colour pls. 113–16.

Concert. (Three figures). Lost. Stipple engraving by F. Frick, as Honthorst. S/B2 (Fig. 35).

Concert. (Two figures). Lost. Copy: formerly A. de Burlet, Berlin (in 1910's). S/B6 (Fig. 42).

Concert. (Two figures). Lost. Two copies: **1.** Schloss Weissenstein, Pommersfelden. 105 × 84. S/B4 (Fig. 41). **2.** Formerly Frezzati Collection, Venice, 97.5 × 83. See under S/B4.

Luteplayer. Centraal Museum, Utrecht (1961/5). 71.4 × 58.6. S & D 1622. S/A13 (Fig. 31).

Luteplayer. With Leger Galleries, London (1924). 82.5 × 66. ?S. S/A10 (Fig. 32). Two copies known: **1.** Private Collection, Washington D.C.; Juell Sale, Parke-Bernet, New York, 19 Feb. 1948 (58), illus. as Finson. 82.5 × 67.3. **2.** Col. R. K. Page Collection, County Wicklow (Eire). 84 × 69.

Luteplayer. Kupferstichkabinett, Berlin-Dahlem. Black chalk, 24 × 18.8. Reworked. S/A28 (Fig. 27). ? Study for right-hand figure in Mainz *Concert* (q.v.)

Violinist. Lost. One copy known: with J. Denijs, Amsterdam (1942), as Honthorst. 72.5 × 60.

Fluteplayer. Lost. Engraving (S & D 1625) by Cornelis Bloemaert (S/B1/Fig. 39). Six painted copies recorded by Slatkes.

Fluteplayer. Lost. Three copies recorded by Slatkes under No. B5, of which one was: Dordrecht Sale, 23 March 1915. 64 × 55 (Fig. 40). There is one copy in the National Gallery, Prague. Lost original ?pendant to Utrecht *Boy Musician* (q.v.).

Singer. Gleimhaus, Halberstadt. 71 × 59. S & D 1622. S/A14 (Fig. 33). Two studio replicas known: **1.** Mr and Mrs Stanley S. Wulc Sale, Christie's 29 June 1973 (48). 78.6 × 63. D 1623. A. **2.** Musée des Beaux-Arts, Nantes (1900/6679). 72 × 60. D 1623. A. Benoist, 1961, illus. colour.

Boy Musician. Centraal Museum, Utrecht (1961/4). 65 × 52.5. S & D 1621. S/A9 (Fig. 30). Copy in Dordrecht Sale, 23 March 1915, as pendant to copy of *Fluteplayer* (q.v.), both as school of Judith Leyster.

Backgammon Players (four figures). Three versions: **1.** Residenzgalerie, Bamberg. 100 × 121. S/A23. Nicolson, 1962, Fig. 34. **2.** Akron Art Institute, Akron, Ohio. 105.4 × 128.3. S/A23 (Fig. 24). **3.** Stichting Wagner-de Wit, The Hague. 100 × 123 (including six cm addition at top). S/A23. *Burl. Mag.*, Dec. 1957, Supplement, Pl. XI.

Backgammon Players (three figures). Variant composition of S/A23. No original known but engraved by Crispin van de Passe I (Slatkes Fig. 26).

Card Sharpers. Lost. Slatkes under B3 lists several copies of which two are here recorded: **1.** Prentenkabinet der Rijksuniversiteit, Leyden. Pen and brown ink, some blue-grey wash, 14 × 19.4. Inscribed with Baburen's name. **2.** Sale, Sotheby's, 16 May 1962 (25). 96.5 × 119.4. Slatkes, 1965 (Fig. 25).

Procuress. Museum of Fine Arts, Boston. 101 × 107.3. S & D 1622. S/A12 (Fig. 17). Two near-contemporary copies known: **1.** Rijksmuseum, Amsterdam (1976/C612, illus.). 100 × 96. **2.** Sale, Christie's, 29 Nov. 1968 (10) and 5 Dec. 1969 (7) with false signature and date 1621. 96.5 × 106.7. There are

also copies by Vermeer and Van Meegeren (Wright, 1976, Pls. 15, 35 and Fig. 12).

Procuress. Residenz, Würzburg. Original size, 109.2 × 132.1 (filled out with canvas to fit Rococo frame). S & D 1623. S/A19 (Fig. 18). One reduced copy known: on loan to Centraal Museum, Utrecht (1952/7), from C. W. A. Buma Collection, Marssum. Subsequently Collection N. V. Landbouwonderneming Oedtsma, Huizum; sale, Mak van Waay, Amsterdam, 26 Feb. 1969 (15), illus. 27 × 29. Spurious S & D 1623.

Pipe Smoker. Musée Marmottan, Paris. 80 × 64. S & D 1623. Paris, 1970 (5), illus. One copy known: formerly L. Baldass Collection, Vienna ?By Master B (q.v.). 79.5 × 64 (S/D6/Fig. 46).

Unidentified Subject (?Offering to Ceres). Vicomte de Vaulchier Collection, Savigny-lès-Beaune (Côte d'Or). 138.5 × 196.5. BP. Bouquet of flowers a later addition. S/A8 (Fig. 12).

The following are mostly by assistants of Baburen; the letter 'B' indicates that his intervention is strongly suspected, both as designer and executant:

Democritus. Estate of A. Wenner-Gren, Stockholm. 72 × 59. Inscribed 'T. B. fecit 1622'. S/D3 (Fig. 45). Studio version: G. W. Carruthers Collection, Gisborne, NZ. 72.4 × 58.4. Wenner-Gren picture ?pendant to:

Heraclitus. Formerly Baron Eric Langenskiöld Collection, Stockholm. 73 × 59. Signed or inscribed 'T.B. fecit Ano 1622'. B. S/D4 (Fig. 44). A copy was Lempertz Sale, Cologne, 26 April 1940 (60), as Jordaens. Panel, 62 × 51.

Christ among the Doctors. Sale, Christie's, 11 July 1975 (51), as Crabeth, illus.; Central Picture Galleries, New York (1978), as Crabeth. 159.9 × 195.5. *Burl. Mag.*, Supplement June 1978, Pl. xvi. By the same hand is: **Ecce Homo.** Earl of Plymouth Collection, Oakly Park, Shrops. 81.9 × 69.8.

Christ driving out the Money Changers. Private Collection, Westphalia (1968). 156 × 195.

Doctor of the Church. Sale, Finarte, Milan, 6 May 1971 (5), illus., as Caravaggesque, 17th century. 65 × 52.

Old Man Writing. With Wildenstein (1973). 86.4 × 68.6 S/D2 (Fig. 38).

Philosopher. With Schaeffer Galleries, New York (1965). 87.6 × 101.6. B. S/D1 (Fig. 37).

The following six are by imitators of Baburen (not the same hand):

Tobias healing his Father [Plate 127]. Kunsthistorisches Museum, Vienna (1973, p. 122, as Netherlandish Caravaggio follower). 122 × 163.5. S/E3.

Another version in a Private Collection in Switzerland. **St Sebastian tended by Irene** [Plate 126]. Formerly with F. Mont, New York. S/E18.

St Sebastian tended by a variety of helpers. Musée des Beaux-Arts, La Rochelle (1974, p. 43, as attr. to De Haan, illus.). 282 × 245.

Singer [Plate 175]. Rheinisches Landesmuseum, Bonn. 78 × 62. S/D9 (Fig. 49).

Man squeezing grapes into his mouth (?Bacchus). Roman art market (1973). 116 × 88.

Smoker [Plate 125]. Two versions: **1.** Musée des Beaux-Arts, Ghent (1937/5–74). 68 × 53. **2.** Château d'Aywiers, Couture-Saint Germain.

Possibly by the same hand as the last is: **Two Cardplayers.** Formerly James Murnaghan Collection, Dublin. 78.7 × 96.5. However, more in direction of R. van Zijl.

Some works by followers of Baburen and Terbrugghen where the same hand can be detected in more than one picture are listed under Caravaggesque Masters A to D (q.v.). Two further ones have often been associated with Baburen's Italian period. They were done in Rome by an artist of his and De Haan's entourage, who may turn out to be Crabeth (q.v.):

Christ among the Doctors [Plate 122]. Kunsthistorisches Museum, Vienna. 146 × 206. S/E6.

Beggar. Galleria Borghese, Rome. 110 × 78. S/E35. Della Pergola, 1959 (198), illus. associate these two with:

St Jerome. With Trafalgar Galleries, London (1975).

The following is a selection of wrong attributions to Baburen (apart from those listed above); for a more complete list, see S/F1–17. Some pictures listed under wrong attributions to Terbrugghen (q.v.) have also been known as Baburens.

Honthorst **Lais and Xenocrates** (fragment). Formerly Binder Collection, Berlin (1914). S/E27.

*Gaspare Traversi **Job.** Museum, Warsaw (1954, Fig. 31). S/E1.

?Manetti **St Roch.** Galleria Borghese, Rome. S/E16.

Caravaggesque (South Netherlandish) **Incredulity of St Thomas.** Pio Monte della Misericordia, Naples.

Master G **Drinker with Still Life.** Galleria Colonna, Rome. S/E32.

Couwenbergh **Smoker with Mug.** Museo Nazionale di San Martino, Naples. S/B7.

Couwenbergh **Man with tankard and glass.** Formerly Morris Kaplan Collection, Chicago.

Honthorst **Ham Eater.** Musée Calvet, Avignon. S/E29.

BAECK, Johannes (?–before 1655)

Thought to be trained in Utrecht. His signed picture listed below shows obvious dependence on Bijlert of the 1630's.

Musical Party. Kunsthistorisches Museum, Vienna (1973, illus.). 122.5 × 184. S & D 1637.

BAGLIONE, Giovanni (*c.* 1573–1644)

Born in Rome, with Florentine family connections. Develops in the tradition of Barocci and d'Arpino, but about 1600–1 turns in the direction of Caravaggio, though the earliest works in this style are more reminiscent of Gentileschi than Caravaggio himself. He is not appreciated by the Caravaggeschi, and in August 1603 Baglione brings an action against them for defamation. He has one ally, his pupil Salini. This near-Caravaggesque phase lasts a mere three years, until the winter of 1603–4. From then onwards he follows an individual style, sometimes Reniesque, with the isolated case of a reversal to the Caravaggesque idiom. Created Cavaliere dell'Abito di Cristo, 1606. Altar-pieces in Roman churches proliferate throughout three decades. Author of famous art-historical treatise (1642) followed by autobiography, where he plays down his own role in the Caravaggesque movement. Lists are confined to 1600–3, with the occasional addition of a later work where he reverts to his early manner. M followed by stroke and plate number refers to Martinelli, 1959; L followed by stroke and plate number, to Longhi, *Baglione*, 1963.

Sacred and Profane Love. Museum Dahlem, Berlin (1972/381, illus.). 179 × 118. *c.* 1601–2. M/Pl. 50b. Engraved in Landon (1812) as Caravaggio.
Sacred and Profane Love. Galleria Nazionale d'Arte Antica, Rome (1970/37). 240 × 143. M/Pl. 51c.
Judith and Holofernes. Galleria Borghese, Rome (1959/98, illus.). 220 × 150. 1608. Moir, 1967. Pl. 33.
Agony in the Garden. Dott. Paolo Candiani Collection, Busto Arsizio (1963). L/Pl. 36.
Ecce Homo. Galleria Borghese, Rome (1959/97, illus.). (On loan to Cappella del Crocifisso, Castel Sant' Angelo). 163 × 116. Mahon, 1956, Pl. 18.
St Andrew and the Angel. S. Cecilia in Trastevere, Rome. M/Pl. 48b.
Ecstasy of St Francis. Private Collection, Chicago. 154 × 112. D 1601. M/Pl. 49a. Engraved by P. F. Basan (1750) as Caravaggio, 29.1 × 39.6, illus. De Benedetti, 1949, Fig. 4. Two copies recorded (perhaps identical): **1.** Private Collection, Rome. **2.** Sale, Christie's, 29 May 1952 (46).
St John the Baptist. Two versions known: **1.** National Gallery, Athens (No. 2163). 135 × 95. Spear, 1971, Fig. 10. **2.** With June Fell, London (1967). *Apollo*, 1967, No. 63, p. LXXXII.
St John the Baptist. Hampton Court Palace (Levey, 1964/353, illus.). 119.7 × 142.2.
Saints Peter and Paul. S. Cecilia in Trastevere, Rome. Before Dec. 1600. M/Pl. 48a.
St Sebastian tended by an Angel. Paul Ganz Collection, New York. 104.1 × 77.5. L/Pl. 35.
St Sebastian and Angels. S. Maria dell'Orto, Rome. 1624. Longhi, Q.C., 1968 (1930), Pl. 213. Drawing in Cabinet des Dessins, Paris, Longhi, loc. cit. Pl. 214. ?C.
Self Portrait. Palozzi Collection, Rome. After 1606. L/Pl. 37.

The following are wrong attributions to Baglione:
Caravaggesque (Roman-based) **Love Triumphant.** Heim Gallery, London/Paris (1976); variant formerly Principe di Cuto Collection, Palermo.
Caravaggesque (Roman-based) **Love Triumphant.** Private Collection, Rome.
Caravaggesque (Roman-based) **St John the Baptist.** Galleria Nazionale d'Arte Antica, Rome.

BATTISTELLO see CARACCIOLO

BERNARDI, Pietro (?–before 1623)

Veronese. No journey to Rome is recorded, but Bernardi is the only member of the Veronese group (Turchi, Bassetti, Ottino) who shows definite echoes of the Caravaggesque movement, and even he has as close affinities with the Emilian as with the Roman world of the second decade.

Annunciation (two canvases). S. Fermo Maggiore, Verona. Each 158 × 159. Magagnato, 1974 (75), illus.
Holy Family with Saints Joachim and Elizabeth. S. Maria in Chiavica, Verona (in store at Castelvecchio). 230 × 165. S. Magagnato, 1974 (74), illus.
St Charles Borromeo distributing Bread to the Poor. S. Carlo, Verona. 240 × 271. Probably 1616. Magagnato, 1974 (73), illus.

St Charles Borromeo ministering to the Plague-stricken. S. Carlo, Verona. 240 × 271. S & D 161(?). Probably 1616. Magagnato, 1974 (72), illus.

The following appears to be a wrong attribution to Pietro Bernardi:
*?Francesco Bernardi **Agony in the Garden.** S. Anastasia, Verona. 438 × 227. Magagnato, 1974 (76), illus.

BIGOT, Trophime (?*c.* 1600–?after 1650) (or 'Maestro Jacopo'?)

From Arles. In Rome from 1620 until 1634, no doubt later. Plays active part in the affairs of the Accademia di San Luca continuously from 1621 to 1629 at earliest. Influenced by Manfredi, Saraceni, Honthorst, Stomer(1630–32), finally by La Tour (1640's). Has been confused with another Trophime Bigot (probably his father, b. 1579) who signed non-Caravaggesque altarpieces in Aix and Arles and surroundings in the 1630's. All works listed. BN followed by number refers to Nicolson 1965 catalogue numbers, pp. 97–105. It is rumoured that the archive of S. Maria in Aquiro has revealed the name of 'Maestro Jacopo' as the author of the three altarpieces in the Church, listed as Bigot below. If this proves correct, then the author's name of all these pictures must be changed to 'Maestro Jacopo'. [*Editorial note*: When this book was in proof stage, the facts about the Chapel in S. Maria in Aquiro were published by Jacques Thuillier in the catalogue of the exhibition held at the Musée des Beaux-Arts, Marseilles (July–October 1978), entitled 'La Peinture en Provence au XVII siècle' and dedicated to the memory of Benedict Nicolson. M. Olivier Michel has established (p. 3) that in 1634 a payment of thirty *scudi* was made to a 'Mr Jacomo pittore' for a painting in the Passion Chapel; and in 1653 Fioravante Martinelli specifies that the *Lamentation* over the altar is by 'Jaccobe'. The new documents do not refer to the other two paintings in the Passion Chapel and Bigot's name has not been found in the archives of the church.]

Cupid and Psyche. Denis Coekelberghs Collection, Brussels. 137 × 192. U.
Cupid and Psyche. Two versions known: 1. Museo Civico, Teramo (1960/42, illus.). 96 × 129. 2. With Di Castro, Rome (1977) BP.
Allegory of Death or **Vanitas.** Galleria Nazionale d'Arte Antica, Rome. 95 × 135. BN31 (Pl. 13).
Judith and Holofernes. Walters Art Gallery, Baltimore. 125.7 × 196.8. BN1. Nicolson, 1964, Pl. 29.
Judith and Holofernes. Galleria Nazionale, Parma. 127 × 158. *Acquisizioni e Restauri . . . Parma. . .*, 1972, Fig. 2.
Nativity: Holy Family with two Angels. Two versions: 1. Palazzo Marefoschi, Macerata. 2. Hôtel-Dieu, Quebec, as Jacques Stella. Nicolson, 1974, Fig. 62.
Christ in the Carpenter's Shop. Formerly Boyer d'Aguilles Collection, Aix-en-Provence (lost). BN4. Engraved by S. Barras (*c.* 1690) and Coelemans (1708), both as after Bigot. Nicolson, 1964, Pl. 23 (Coelemans copy).
Christ in the Carpenter's Shop. Hampton Court Palace (1929/383). 99 × 134.6. BN3 (Pl. 12).
Capture of Christ. Galleria Spada, Rome (1954/289), illus.). 108.5 × 147. BN6. Nicolson, 1964, Pl. 12.

Engraved by P. Ghigi. C. in Residenzgalerie, Bamberg, as Juriaen Ovens.
Capture of Christ. Palazzo Marefoschi, Macerata. BN7. Nicolson, 1964, Pl. 8.
Mocking of Christ. Musei Civici, Pesaro (1956/54). 97 × 134. BN8 (Pl. 4).
Mocking of Christ. Galleria Comunale, Prato (1958/39). 73 × 97. BN9 (Pl. 5).
Mocking and Crowning with Thorns [Plate 60]. M. Chappert Collection, Montpellier (1971).
Crowning with Thorns. Passion Chapel, S. Maria in Aquiro, Rome. *c.* 180 × 130. BN10 (Pl. 5).
Flagellation. Passion Chapel, S. Maria in Aquiro, Rome. *c.* 180 × 130. ?SA. BN11. Nicolson, 1964, Pl. 3.
Lamentation over the Body of Christ. Passion Chapel, S. Maria in Aquiro, Rome. *c.* 270 × 180. ?SA. BN12. Nicolson, 1964, Pl. 4.
Angel watching over the Dead Christ [Plate 59]. Two versions known: 1. Private Collection, Paris (*c.* 1950). 100 × 137. Contemporary C. BN13. Nicolson, 1964, Pl. 24. 2. La Salle College, Philadelphia. 95 × 124.5. Probable original.
Christ at Emmaus. Musée Condé, Chantilly (1899/124). 121 × 173. BN5 (Pl. 2). Copy in Collegiata di S. Maria a Mare, Maiori, as copy after Honthorst.

Ecstasy of St Francis. Museo Francescano, Rome. 97 × 135. BN15 (Pl. 14).

St Francis and St Clare [Plate 61]. Two versions: **1.** Private Collection, Valencia. **2.** Guglielmo Maccaferri Collection, Bologna. 115 × 154.

St Jerome listening to the Trumpet of the Last Judgement. Sale, Sotheby's, 19 March 1975 (30), illus. as Stomer. 121 × 213.

St Jerome reading. Three versions: **1.** Galleria Nazionale d'Arte Antica, Rome, 105 × 138. BN16. Gall. Naz. 1955 (17), illus. **2.** National Gallery of Canada, Ottawa. 97.2 × 121. Spear. 1971 (5), illus. BN17 (detail, Pl. 15). **3.** Private Collection, Rome (1970); sale, Christie's, Rome, 15 Oct. 1970 (72). 96.8 × 129.5. Spear, 1971, Fig. 11. Composition is conceived as pendant to *Conversion of the Magdalen* (q.v.).

St Jerome reading. Cassa Depositi e Prestiti, Rome (1956/127 as Volmarijn). 95 × 132. BN18. Nicolson, 1964, Pl. 35.

St Jerome praying. Parish Church, Saint-Antonin, near Aix-en-Province (described by Boyer, 1971, p. 60 as stolen a few years ago). ?Contemporary C. BN20. Nicolson, 1964, Pl. 32.

St Jerome praying. Saint-Jean-Baptiste, Arras. 107 × 137.

St Luke. Saint-Séverin, Paris (1963). 98 × 153. BN21. Nicolson, 1964, Pl. 34. Bertin-Mourot, 1963, illus. colour.

Conversion of the Magdalen. Miss E. Cawthorne Collection, Leeds. *Burl. Mag.*, Oct. 1974, Fig. 3.

Conversion of the Magdalen. Museo de Arte de Ponce (Puerto Rico) (1965/62.0335). 93 × 122. BN22 (Pl. 16). Conceived as pendant to *St Jerome reading* (q.v.).

St Paul visiting St Peter in Prison. Marquis of Exeter Collection, Burghley House, Stamford (No. 220). 122.5 × 104.5. BN23 (Pl. 1.)

Liberation of St Peter. With Victor Spark, New York. 99 × 132. BN27. Nicolson, 1964, Pl. 30.

Denial of St Peter (four figures). Formerly Mrs Olga Jitkow-Ploschek Collection, Montville (NJ); on USA market (1977). BN24. Nicolson, 1964, Pl. 31.

Denial of St Peter (four figures). Hôtel de Ville, Eguilles, near Aix-en Provence. BP. Boyer, 1964, Pl. 4.

Denial of St Peter (or **Dream of St Joseph?**). (Two figures). Musée Granet, Aix-en-Provence. BN25.

Denial of St Peter (two figures). Private Collection, Paris (early 1950's). *c.* 80 × 100. BN26. Nicolson, 1964, Pl. 33.

St Sebastian tended by Irene. Three versions: **1.** Pinacoteca Comunale, Collezioni Comunali d'Arte, Bologna (1938/25). 124 × 174. BN30 (Pl. 18). **2.** Bob Jones University, Greenville (S.C.). 124.5 × 160. BN 29. Florida 1970 (11), illus. **3.** Pinacoteca Vaticana, Rome. 98 × 137. Rome/Paris, 1973–4 (5), illus.

St Sebastian tended by Irene. Musée des Beaux-Arts, Bordeaux. 125.7 × 167.6. BN 28 (Pl. 17).

Franciscan(?) Saint. Longhi Collection, Florence. 70 × 83.5. BP. ?F.U. Exh. 'French Painting', Florence, 1977/102. illus.

Hermit trimming a Wick. Formerly Turnbull Collection (until 1924). 123 × 140. BN 34. Nicolson, 1964, Pl. 22. Presumably fragment (or cropped photograph) of the same picture on Amsterdam art market, 1929, and not a truncated replica.

Portrait of a Man (?Self Portrait). Formerly James Murnaghan Collection, Dublin. 104 × 90. BN32 (Pl. 6).

Drinking Scene. (Three figures). Two versions: **1.** Cav. Uff. Comm. Domenico Fraccaroli Collection, Verona. BN42. Nicolson, 1964, Pl. 11. **2.** Leib Herman Collection, Jerusalem (1965).

Man masking a Flame with a Paper Shade [Plate 63]. Two versions known: **1.** Dr Alfred Bader Collection, Milwaukee. 65.4 × 50.8. **2.** Museo Cerralbo, Madrid (1969/4611, as Honthorst). 50 × 40.5. Spear, *Storia dell'Arte*, 1972, Fig. 16.

Doctor examining a Sample of Urine. Two versions: **1.** Ashmolean Museum, Oxford (1962/24). 72 × 99. BN33 (Pl. 8). **2.** With Galleria Vangelli, Rome (1972). 71.2 × 90. Spear, *Storia dell'Arte*, 1972, Fig. 17.

Girl catching Fleas. Galleria Doria-Pamphilj, Rome (1942/354). 100 × 75. BN35 (Pl. 10). Nicolson, 1964, colour plate.

Boy singeing a Bat. Galleria Doria-Pamphilj, Rome (1942/352). 47 × 39. BN36. Nicolson, 1964, Pl. 19.

Boy pouring Oil into a Lamp. Galleria Doria-Pamphilj, Rome (1942/351). 46 × 38. BN37 (Pl. 11).

Girl singing crowned with Laurel. Galleria Doria-Pamphilj, Rome (1942/364). 46 × 39. BN38. Nicolson, 1964, Pl. 18.

Boy singing by Candlelight. Galleria Doria-Pamphilj, Rome (1942/365). 45 × 39. BN39. Nicolson, 1964, Pl. 17.

Boy singing by Candlelight. Fine Arts Museums, San Francisco (California Palace, 1946–7, p. 49). 67 × 49.5. BN 40 (Pl. 19).

Smoker. Pinacoteca, Montefortino (Ascoli Piceno). BN41 (Pl. 9).

Smoker [Plate 64]. Private Collection, Auvergne (1970). 49 × 38. Exh. Riom 1970 (49), illus.

Coal Heaver. Marchese Ricci Collection, Palazzo Ricci, Montepulciano. 96 × 130. BN43. *Cahier Poussin*, 1950, Pl. 17.

Tavern Scene. Five versions: **1.** Formerly Miss Grete Ring Collection, London (late 1940's), later in USA BN44 (Pl. 7). **2.** Florentine Galleries. Panel, 25.3 × 36.4. Exh. Florence, 1970 (31), illus. **3.** Galleria Nazionale delle Marche, Urbino. *c.* 98 × 133. C. **4.** Major Edward Scicluna Collection, Valletta (Malta). **5.** Art market in Devonshire (1975). ?C.

A. The following are possible Bigots:
St Jerome with Skull and Crucifix. Whereabouts unknown. Nicolson, NKJ, 1960, Pl. 13.

St Joseph reading. Galleria Colonna, Rome. Thuillier, 1972, Pl. 14.

B. The following is by an associate of Bigot in Rome who might have collaborated on the S. Maria in Aquiro altarpieces:

Liberation of St Peter. Galleria Comunale, Prato (1958/92, illus.). 74 × 99.

C. The following are by artists in Rome apparently in contact with Bigot:

Christ in the Carpenter's Shop. Private Collection, Sweden. 96 × 132.

St Francis in Meditation. Galleria Estense, Modena (1945/435, illus.). 138.5 × 93.2 Two replicas recorded: **1.** Accademia dei Concordi, Rovigo (1972/30, illus. as Pietro della Vecchia). Panel, 27 × 35. **2.** Private Collection, Mantua (1945). Variants in Munich and Musée Magnin, Dijon. C in Szépművészeti Múzeum, Budapest (1967/839). Panel, 44.7 × 34.5.

St Francis in Meditation. Guest Collection, Birmingham.

St Luke [Plate 62]. Musée d'Art et d'Histoire, Chambéry (Inv. No. 985). 97.9. × 134.6.

St Jerome writing. Cassa Depositi e Prestiti, Rome (1956/74 as school of Honthorst). 90 × 65.

St Jerome writing. With A. F. Mondschein, New York (1946), as Georges de La Tour? 66 × 52.1.

St Jerome reading. Comte de Salverte Collection, Château de Ray (Haute-Saône).

St Jerome contemplating a Skull. Bob Jones University, Greenville (SC), as Serodine. 82.5 × 104.1.

St Jerome with Skull and Crucifix. Kuderna Collection, Vienna (1920). 96 × 132. Nicolson, NKJ, 1960, No. 12. Frimmel, 1929, Pl. xx.

Incredulity of St Thomas. Palazzo Donà dalle Rose, Venice. Ivanoff, 1961, Fig. 2.

Card Players. Arniston Estate Trustees, Gorebridge (Midlothian). 79 × 99. Nicolson, NKJ, 1960, Pl. 14.

D. The following are wrong attributions to Bigot: Honthorst circle **St Jerome.** Two versions: **1.** Abbey of Grinbergen, Belgium. F. **2.** Private Collection on loan to Utrecht Museum (1954).

?G. Seghers **St Jerome.** Saint-Leu-Saint-Gilles, Paris; copy at Honfleur.

?Honthorst **Penitent Magdalen.** Museo de Bellas Artes, Saragossa, deposited in Prado.

BLOEMAERT, Abraham (Dec. 1564–Jan. 1651)

With Paulus Moreelse and Wtewael, the leading Utrecht artist of the last Mannerist generation. For brief periods in early 1620's, influenced by Honthorst on his return to the North, but his 'Caravaggism' is quite superficial and he soon reverts to an individual mannerist style which he retains till the end of his long life. He visits Paris in the 1580's but never Italy. Only a handful of pseudo-Caravaggesque pictures listed.

Avaritia. Gemäldegalerie, Dresden (1930/1252). Panel, 92 × 70. Hoogewerff, 1924, Pl. xv. Engraved by Cornelis Bloemaert (19.2 × 13.6), S & D 1625, Pariset, 1948, Pl. 8(2); by Charles David after Cornelis, for Pierre 1 Mariette (Weigert, 1953, Fig. 7); and by Hendrik Bary (Gouda 1640–1707) (Hollstein, 1949ff. 1, p. 112, illus. [in reverse]). Pendant to this is:

Liberalitas. Lost. Engraved by Cornelis Bloemaert (1625, Pariset, 1948, Pl. 8/1).

Temperantia. With W. J. Abrahams, London (1922). 25 × 32.

Allegory of Winter. Musée du Louvre, Paris. 70 × 57. S. Von Schneider, 1933, Pl. 28b. Engraved in reverse by Hendrik Bary (Gouda 1640–1707) (Hollstein, 1949ff., 1, p. 112, illus.).

Nativity. Herzog Anton Ulrich-Museum, Brunswick (1976/171, illus.). 97 × 125. S. Von Schneider, 1933, Pl. 27b. Engraved by Cornelis Bloemaert (1625).

Christ at Emmaus. Musée des Beaux-Arts, Brussels (1949/695). Panel, 145 × 215. S & D 1622. Von Schneider, 1933, Pl. 27a.

St Jerome [Plate 108]. Alfred Bader Collection, Milwaukee. 64.4 × 53. S. Engraved in reverse by Cornelis Bloemaert (19 × 13.5, Von Schneider, 1933, Pl. 29a).

St Jerome. Kunsthistorisches Museum, Vienna (1972, p. 11). 101 × 69. U. Hoogewerff, 1924, Pl. XXIII, as Honthorst.

Magdalen reading. Lost. Engraved by Cornelis Bloemaert (Pariset, 1948, Pl. 11/1).

Penitent Magdalen 'Melancholia'. Lost. Engraved by Cornelis Bloemaert (Pariset, 1948, Pl. 11/2).

Fluteplayer. Centraal Museum, Utrecht (1952/17, illus.). 69 × 57.5 S & D 1621. Von Schneider, 1933, Pl. 28a.

Bagpipe Player. Czernin Collection, Vienna (exh. Residenzgalerie, Salzburg, 1970/16, illus.). Panel, 86.5 × 68. Engraved in reverse by Cornelis Bloemaert (Von Schneider, 1933, Pl. 29b). Another version recorded in Museum at Toulouse.

Rommelpot Player. Formerly Maurice Kaplan Collection, Chicago; Sale, Sotheby's, 12 June 1968 (14), illus. 87.6 × 52.1. Engraved in reverse by Cornelis Bloemaert, and by Charles David in same direction (Pariset, 1948, Pl. 8/7). The same boy engraved in France, but with tall glass in right hand (Pariset, 1948,

Pl. 8/8). A similar boy in Vignon's *Bagpipe Player* (q.v.).
Man with Chicken. Lost. Engraved by Cornelis
Bloemaert (Pariset, 1948, Pl. 8/6).
Old Woman praying with Rosary. Lost. Engraved

by Cornelis Bloemaert (Hollstein, 1949ff., II, p. 80,
illus.).
Head of Old Woman. Sale, Lempertz, Cologne,
14 Nov. 1963 (14). Panel, 37.5 × 28. S.

BLOEMAERT, Hendrick (1601–Dec. 1672)

Son of Abraham Bloemaert. Trained in Italy. Documented there in Feb. 1627. Guild of St Luke at
Utrecht, 1630–2. Sometimes almost indistinguishable from his father. Only a small selection of works
listed.

Allegory of Winter [Plate 115]. Major the Hon.
Robert Bruce Collection, Dunphail (Morayshire).
103.5 × 83.3. S & D 1631.
Allegory of Winter. Formerly Rijksmuseum,
Amsterdam (1976/A674, illus.) (destroyed, 1940).
81 × 98. S & D 1631. Von Schneider, 1933, Pl. 30b.
Plato and Diogenes. Bayerische Staatsgemäldesammlungen, Munich (Inv. No. 411). 104 × 133. Von
Schneider, 1933, Pl. 30a.
King David in Prayer [Plate 109]. Národní Galerie,
Prague. 82 × 71. S & D 1633.
Samson and Delilah. Akademie der Bildenden
Künste, Vienna (1973/9, illus.). 142 × 202. S. R.
Christ at Emmaus. With W. A. Hofer, Berlin
(1939). 97 × 132. S & D 1630.
St Jerome [Plate 113]. Bayerische Staatsgemäldesammlungen, Munich (No. 173, as Balen). S & D 1624.
64 × 81.5.
St Jerome. Formerly Harrach Gallery, Vienna (1926
/425), now Schloss Rohrau. 100 × 137. S & D 1630.
Strümpell, 1925–6, Pl. LIID.
St Jerome [Plate 112]. Nasjonalgalleriet, Oslo (1973/
612). 103.5 × 82.5.

St John the Baptist. Glasgow Art Gallery (1961/32,
illus.). 81.2 × 66.3 (arched top cut). S & D 1624.
Man with Tankard and Dried Fish. Museum der
Bildenden Künste, Leipzig. 74 × 60. S & D 16 . . . Engraved in reverse by P. Viel.
Man with Chicken [Plate 111]. Nationalmuseum,
Stockholm (1958/331). 76 × 60. S.
Boy with Owl. Lost. Engraved by Cornelis after
Hendrick Bloemaert (16.9 × 12.1). Hollstein, 1949ff.,
II, p. 81, illus.
**Man eating Eggs, being robbed by Woman
behind.** Sale, Berlin, 4 June 1929 (9); sale, Christie's,
26 Nov. 1976 (52), illus. and 2 Dec. 1977(6), illus.
127 × 103. S & D 1632.
Old Woman selling Eggs. Rijksmuseum, Amsterdam (1976/C106, illus.). 76 × 58. S & D 1632.

The following is a wrong attribution to Hendrick
Bloemaert:
*Utrecht School **Penitent St Peter.** Centraal
Museum, Utrecht (1952/35, as attributed to H.
Bloemaert). 79 × 66.

BOR, Paulus (*c.* 1600–Aug. 1659)

From Amersfoort. Goes to Italy in early 1620's. Documented there 1623–6. One of the founders of the
Schildersbent as 'Orlando'. Back home by 1628, the year of a group portrait at Amersfoort. Settles in
Utrecht. Influenced by Gentileschi and the Utrecht Caravaggesques, but also has affinities with the young
Lievens and with Salomon de Bray. Falls under the spell of Rembrandt from the late 1620's till mid- or
late 1630's, but then reverts to an Utrecht-inspired style. A few, the least Rembrandtesque, pictures listed.

Bacchus; Ariadne (two canvases) [Plates 198, 199].
Museum Narodowe, Poznán (1972/6.7, illus.). Each,
149 × 106.
Mythological Figure (?**Pomona**) [Plates 201, 202:
details]. Rijksmuseum, Amsterdam (1976/A4666,
illus.). 151 × 114. (?cut at top). Calvesi, 1971, Fig. 33.
?Pendant to:
Sorceress (?**Circe**). Metropolitan Museum of Art,
New York. 155 × 111.8. Walsh, 1974, p. 346, illus.
Logic. Sale, Sotheby's, 9 July 1975 (108), illus.; Musée
des Beaux-Arts, Rouen (Baderou Collection); Baderou

Cat. 1977, illus. colour on cover. 77.5 × 65.5. S. *Burl.
Mag.*, May 1977, Fig. 80.
Magdalen. Walker Art Gallery, Liverpool (1977/958;
illus.). Panel, 65.7 × 60.8 (probably cut at bottom).
Nicolson, 1952, Fig. 6.
Flower-Seller (from play by Jacob Cats) [Plates 200,
203, 204]. Nationalmuseum, Stockholm (1958/5041).
Panel, 143 × 175.
Gipsy Fortune-Teller (from play by Jacob Cats).
Centraal Museum, Utrecht (1952/42, illus.). 120 ×
144. S & D 1641. Bloch, 1928, illus., p. 24.

The Fruit Gatherers [Plate 206]. Courtauld Institute Galleries, London (on loan to London Graduate School of Business Studies, 1976). 139.7 × 92.7. Bore illegible monogram (optimistically 'PB'). Cat. of Lee of Fareham Collection, 1923, No. 36, illus. as Dutch Master *c.* 1650–5.

Head of a Woman. H. E. Benn Collection, Ilkley. Panel, 42 × 37. Bissell, 1971, Fig. 15. Uncertain between Bor and O. Gentileschi (q.v.).

The following is from the circle of Bor but does not quite qualify as his work:

Flea Catcher. Bredius Museum, The Hague (1978/29), illus., as after Van Campen). 92 × 67.

The following are wrong attributions to Bor:

★Haarlem School **Bathsheba.** City Art Gallery, York (1961/851, illus.). 104.7 × 71.7. F.

★Cesar van Everdingen **Shepherdess.** Yale University Art Gallery.

BORGIANNI, Orazio (*c.* 1578–Jan. 1616)

Tuscan by origin, but Roman by upbringing, with family connections in Sicily. Earliest dated work 1593. Documented in Spain 1604–5 but perhaps also visits Spain at the turn of the century. Works at Valladolid. In Rome early in 1604 and again from 1605 onwards. Described by Baglione as '*aderente al Caravaggio*' in Sept. 1606. Dies in Rome. Early Spanish works show influence of Tintoretto, Bassano and perhaps El Greco. His production once he settles in Rome is alone listed because the juvenile and Spanish paintings show no Caravaggesque influence. W followed by stroke and Fig. number refers to Wethey, 1964, pp. 146ff.

David and Goliath. Academia de San Fernando, Madrid. 119 × 143. Voss, 1924, Pl. 125.

Christ among the Doctors. J. P. Almagià Collection, Rome. 78.1 × 108. W/Fig. 17.

Christ on the Mount of Olives. Herzog Anton Ulrich-Museum, Brunswick (1976/475, illus.). Panel, 100 × 123.

Way to Calvary. Chapel of Palazzo Reale, Portici, near Naples. 100 × 120. Nicolson, 1963, Fig. 26.

Lamentation over the Body of Christ (two mourning figures). Sacristy, San Salvatore in Lauro, Rome. Fresco, 57 × 67.5. R. W/Fig. 18. Three copies known: **1.** Galleria Spada, Rome (1954/286, illus.). 55 × 77. Voss, 1924, Pl. 124. **2.** Sacristy, S. Domenico Maggiore, Naples. 62 × 74. **3.** Palace of Epila, near Saragossa. 62 × 74.

Lamentation over the Body of Christ (with addition of third mourner). Etching. S & D 1612 and (later state), 1615. Longhi, S.G., 1961 (1912–22), Pl. 65. Two painted versions: **1.** Palazzo Venezia, Rome. 71 × 86. C. W/Fig. 14. **2.** Longhi Collection, Florence. ?C. 73.8 × 90.3. Longhi, S.G., 1961 (1912–22), Pl. 111.

Birth of the Virgin. Santuario della Misericordia, near Savona. 250 × 150. S. Longhi, S.G., 1961 (1912–22), Pls. 58–60.

Madonna. Earl Spencer Collection, Althorp (Garlick, 1976/586 as attributed to Schedoni). 62.2 × 45.7. U. Waddingham, 1961, Pl. 139a.

Holy Family with St Anne. Three versions known: **1.** Isabelle Renaud-Klinkosch Collection, Switzerland (in London, 1975). 95.2 × 78.1. Spear, 1971 (7), illus. **2.** With Hazlitt Gallery, London (1973). 103 × 81. S. Nicolson, *Borgianni*, 1973, Fig. 1. **3.** Longhi Collection, Florence (1971, Pl. 55 in colour). 97.5 × 79.5. S. Spear, 1971, Fig. 12.

Holy Family with St Anne, St John and an Angel. Galleria Nazionale d'Arte Antica, Rome. 226 × 174. Voss, 1924, Pl. 121.

300 Christian Martyrs in Calchis. Ambrosiana, Milan (1969, p. 271, illus.). 177 × 132.

St Charles Borromeo during the Plague in Milan (1576). SS. Annunziata a Piazza Buenos Aires, Convento dei Mercedari, Rome (formerly S. Adriano). 300 × 141. Voss, 1924, Pl. 123. Engraved by Henri van Schoel (d. 1622).

St Charles Borromeo adoring the Trinity. Sacristy, S. Carlo alle Quattro Fontane, Rome. 217 × 151. S. 1611–12. Voss, 1924, Pl. 122.

St Charles Borromeo. Hermitage, Leningrad (Inv. No. 2357). 152.2 × 123. Linnik, 1975, illus., colour Pls. 13–15.

St Christopher [Plate 7]. Etching. S. Longhi, S.G., 1961 (1912–22), Pl. 57. One certain original painting: Private Collection, England (1978). 110 × 77. Two painted versions of good quality: **1.** National Gallery of Scotland, Edinburgh (1970/48). Panel transferred to canvas, 104.1 × 78.1. Possible original. W/Fig. 13. **2.** Voss Collection, Wiesbaden (in 1930's). 96 × 71. ?C *Berliner Museen*, 1929, Heft 2, p. 26, Pl. 6. Three copies: **1.** National Gallery of Scotland, Edinburgh (1970/20). 99.4 × 74. **2.** Martin von Wagner Museum der Universität, Würzburg (without landscape). 74.5 × 54. **3.** San Vicente, Seville. A similar design in an extensive moonlit landscape is at Windsor.

Vision of St Francis. Municipio, Sezze Romano (stolen, 1977; a fragment of left central area recovered). 380 × 250. D 1608. W/Fig. 15.

Death of St John the Evangelist. Gemäldegalerie, Dresden. 146 × 118. S. W/Fig. 1.

Self Portrait. Berlin art market (c. 1960). U. Voss, 1962, Figs. 1, 2.

Portrait of a Cardinal (?St Bonaventura) [Plate 6]. Formerly Morris Kaplan Collection, Chicago; sale, Sotheby's 12 June 1968 (16), illus. 87.6 × 74.9.

The following is a selection of wrong attributions to Borgianni:

★ ?French **Lamentation over the Body of Christ.** Two versions: **1.** Hermitage, Leningrad. 90 × 135. Linnik, 1975, illus. Pl. 16 in colour and detail in black and white, Pl. 17. **2.** S. Maria in Trivio, Rome. Linnik, 1975, illus.

Caravaggesque (probably Spanish) so-called **Self Portrait.** Museo del Prado, Madrid.

Caravaggesque (Roman-based) **Portrait of Borgianni** (1617). Accademia di San Luca, Rome.

Caravaggesque (Neapolitan) **Calling of St Sylvester; Martyrdom of Pope Stephen I.** S. Silvestro in Capite, Rome.

Vouet **Bravo.** Herzog Anton Ulrich-Museum, Brunswick.

BRONCKHORST, Jan Gerritsz van (c. 1600–1661)

Born Utrecht. Trained as glass-painter. In Rome March 1621 with Bijlert and Poelenburgh. Not inscribed in Schildersbent, so perhaps back home by 1623. In Utrecht Nov. 1626; in Paris in 1628, where he inspects Rubenses and Gentileschis. Well known as a designer of stained glass in late 1620's and 1630's, and as engraver. Moves to Amsterdam 1650, where he dies. Occasionally shows affinity with Bor and his pupil Cesar van Everdingen. His son Jan Jansz (1626–?) also a painter. Only small selection listed, chiefly *Concerts* in manner of Bijlert.

Laban and Rachel. Museum Boymans-van Beuningen, Rotterdam (1972/1104, illus. as ?Bijlert). 202 × 192. U. Hoogewerff, 1965, No. 3, Fig. 7, as Bijlert.

Susanna and Attendants(?). Sale, Christie's, 12 March 1976 (31), illus. 141 × 170.

St Bartholomew. Liechtenstein Collection, Vaduz (1931/119). 137 × 94. S & D 1652 (?by the son). Von Schneider, 1933, Pl. 32a.

Concert (six figures behind parapet). Dr H. Cohen Collection, London (1950). S & D 1630.

Concert (six figures behind parapet). Two versions recorded: **1.** Hermitage, Leningrad. 120 × 148. S. Exh. Leningrad, 1973 (7). One figure missing right. Linnik, 1975, illus. colour Pls. 118–20 (one black and white detail). **2.** Centraal Museum, Utrecht (1952/50, illus.). 115 × 154. Von Schneider, 1933, Pl. 31a.

Concert (five figures). Khanenko Collection, Kiev (1933). 88 × 136.

Concert (four figures behind parapet) [Plate 229]. With Heim Gallery, Paris (1957). 134 × 146. S & D 1653. Ad. *Burl. Mag.*, July 1957, illus.

Concert (one figure behind parapet) [Plate 219]. Formerly Baron A. Reedtz-Thott Collection, Gaunø

(Denmark) (1914/69 as Honthorst); Reedtz-Thott sale, Sotheby's, 10 July 1968 (76). 99.1 × 77.5. F of large composition.

Female Theorbo Player. With J. Reder, New York (1954). Panel, 84 × 62. S.

Female Guitar Player. Private Collection, Munich (1933). Von Schneider, 1933, Pl. 32b.

Concert with Drinker (eight figures, some behind parapet). Herzog Anton Ulrich-Museum, Brunswick (1976/191). 141 × 205.7. Von Schneider, 1933, Pl. 31b.

Concert with Feasting Scene (eight figures). Herzog Anton Ulrich-Museum, Brunswick (1976/190, illus.). 142 × 219, S & D 1644.

Concert with Drinker (eight figures behind parapet). Centraal Museum, Utrecht (1961/15, illus.). 148.4 × 191.4. S & D 1646.

Party behind Parapet (four figures, one fluteplayer, one drinker) [Plate 230]. With Francesco Pospisil, Venice (1950's) as Honthorst, 121 × 133.

Harvest Festival. Muzeum Narodowe, Wrocław (1973/8, illus.). 100 × 176. BP. Steinborn, 1974, pp. 137–42, illus.

BYLERT or BIJLERT, Jan van (1598–Nov. 1671)

Born Utrecht, the pupil of his father, a glass-painter, and of A. Bloemaert. To Rome *via* France. Documented in Rome, 1621. Probably member of Bent c. 1623. Back in Utrecht by May 1625 and perhaps before the end of 1624. Guild of St Luke, Utrecht, 1630; Dean, 1633–35. Influenced by his fellow Utrecht Caravaggists, especially Honthorst. Works from 1624 to about 1640 listed except for those mentioned in literature which are unknown to me. Later genre scenes omitted. No portraits listed. H followed by stroke and number refers to catalogue numbers in Hoogewerff, 1965.

Bacchanal. De Malander Sale, Le Roy, Brussels, 7–8 Oct. 1930.

Mars overpowered by Cupid. Chrysler Museum, Norfolk (Virginia). 136 × 141. S. H/31. Exh. Birmingham (Al.), Chattanooga (Tenn.), 1957–8, p. 12, illus.

Mercury [Plate 208]. Formerly Kaiser-Friedrich Museum, Berlin (destroyed 1945) (No. 1772). 86 × 67. S. H/32.

Nymph, Cupid and Satyr. Armando Sabatello Collection, Rome (1948). 95 × 122. H/43, Fig. 11.

Venus chastising Blind Cupid [Plate 209]. Mario Lanfranchi—Anna Moffo Collection, Rome (1972). 127 × 146. Bears Honthorst's 'signature' and date 1628, but earlier a Bijlert signature is recorded. H/36. Spear, *Storia dell'Arte*, 1972, Fig. 11 as Honthorst.

Venus, Cupid and Old Woman. With Hazlitt Gallery, London (1973). 109.2. × 119.3. S. H/35. Christie's, 1 June 1973 (144), illus.

Caritas. Sale, Dorotheum, Vienna, 15–18 June 1971, as Wallerant Vaillant, illus. Panel, 114 × 87.5. H/24.

Five Senses. Two versions known: **1.** Niedersächsische Landesgalerie, Hanover (1954/48). 154.3 × 185.8. S. H/29, Fig. 13. **2.** Jewett Art Center, Wellesley (Mass.) (1958, p. 40, illus.). 148.6 × 187.3. H/29a. H records third version.

Allegory of the Senses [Plate 211]. Museo de Arte de Ponce (Puerto Rico). (1965, p. 27). 113 × 91.4. S. H/77.

Heraclitus and Democritus. Centraal Museum, Utrecht (1952/58). 72 × 84.5. S. H/45. Von Schneider, 1933, Pl. 24a.

Adam and Eve [Plate 205]. Wawel Castle, Cracow. 110.5 × 85.5 H/1.

Christ washing St Peter's Feet [Plate 215]. With Messrs Appleby Bros., London (1965). Panel, 53.3 × 81.3. S. H/13a.

Christ washing St Peter's Feet. James Belden Collection, New York (1960). 114 × 165. S. H/13, Fig. 18.

Pilate washing his Hands. Two versions known: **1.** National Museum of Wales, Cardiff. Panel, 106.7 × 82.5. S. H/14, Fig. 1. **2.** With Trafalgar Galleries, London (1974); sale, Christie's, 25 March 1977 (102), illus. 108 × 83. Ad. *Burl. Mag.*, Oct. 1974, illus.

Madonna [Plate 214]. Herzog Anton Ulrich-Museum, Brunswick (1976/510). 113 × 92. H/6. Von Schneider, 1933, Pl. 25a. C. in Glasgow Art Gallery (1961/273). 117.7 × 94.

Madonna. Baroness Sigrid Rålamb Collection, Stockholm (1912), as Flemish. Panel, 104 × 78. H/7. Granberg, 1912, II, (312), illus. Exh. Leger Galleries, London, April 1976 (16), illus.

Madonna with Girl offering a Bowl of Fruit. J. Cremer Sale, Berlin (Wertheim), 24 May 1929 (38), illus. 98 × 83. S. H/9, Fig. 15.

Madonna with Girl offering a Bowl of Fruit. Muzeul Brukenthal, Sibiu. 104 × 83. S. H/10. Quite different composition from Cremer's.

Madonna with Infant St John. With Frederick Mond, New York (1971); Sale, Dorotheum, Vienna, 6–9 June 1972 (17), illus. 100 × 85. S. Presumably H/11.

Holy Family. Galleria Sabauda, Turin. 115 × 93. S. H/4, Fig. 8. H lists (No. 5) a variant on the Belgian market before 1961, presumably: Brussels sale, 17–18 Feb. 1956 (552), illus. as Terbrugghen. Panel, 120 × 91.

St Joseph and the Christ Child. With Messrs Appleby Bros., London (1962). 109 × 85. S. H/8. Ad. *Burl. Mag.* Supplement, June 1962, Pl. v.

St John the Evangelist. Centraal Museum, Utrecht (1971–2/20, illus.). 94.6 × 77.5. S. H/20. Spear, 1971 (9), illus. Pendant to other three *Evangelists* (q.v.).

St Luke. Schwagermann Collection, Schiedam (before 1939). 95 × 79. S. H/19. Pendant to other three *Evangelists* (q.v.).

Magdalen turning from the World to Christ [Plate 210]. Bob Jones University Collection of Sacred Art, Greenville (SC). 114.3 × 111.1. S.

St Mark. Sale, Bukowski, Stockholm, 22–4 Oct. 1952 (111), illus. 94 × 78. S. H/18, Fig. 6. Pendant to other three *Evangelists* (q.v.).

St Matthew and the Angel. Ulster Museum, Belfast. 95 × 79. S. H/17. Ad. *Burl. Mag.* Supplement, Dec. 1968, Pl. xxvIII. Pendant to other three *Evangelists* (q.v.).

Calling of St Matthew. Oud-Katholieke Parochie van St Maria, Utrecht. Canvas on panel, 144 × 199. S. H/12, Fig. 4. Two copies known: **1.** Szépművészeti Múzeum, Budapest (1967/359). 128.3 × 200. H/12a. Von Schneider, 1933, Pl. 23b. **2.** Private Collection, Rome (1974). 151 × 206. H lists what could be a fourth version.

St Sebastian tended by Irene. Harrach Gallery, Vienna (1929/68). 113 × 113. S & D 1624. H/21, Fig. 2.

Concert (seven figures). With Robert Noortman Gallery, London (1978). Panel, 38 × 58. S & D 1629. H/15, Fig. 19. Noortman cat. 1978 (5), illus. colour. H lists version in Baltimore.

Concert (five figures) [Plate 218]. With Paul Botte, Paris (1959); sale, Versailles, 25 Oct. 1964 (65) 115 × 198. S. ?H/87.

Concert (three figures) [Plate 212]. Ault Collection, Brooklyn (NY). (1956). S. BP. H/88.

Luteplayer by oil lamp. Rijksmuseum, Amsterdam (1976/A1338, illus.). Panel, 18 × 18. S. H/72.

Luteplayer (man). Two versions known: **1.** Pushkin Museum, Moscow. 100 × 95. Pendant to Moscow *Fluteplaying Shepherdess* (q.v.). Nicolson, Russia, 1965, Fig. 52. **2.** Private Collection, Zurich (1944). 106 × 85. S. Pendant to Sydney *Fluteplaying Shepherdess* (q.v.). Bodmer, 1944, p. 528. illus.

Luteplayer (girl). Herzog Anton Ulrich-Museum, Brunswick (1976/189). 75 × 57. S. H/49, Fig. 9.

Cello Player (man) [Plate 217]. With H. Shickman Gallery, New York (1975). 98.1 × 83.8. S.

Flute-playing Shepherd (with crook). Sale, Christie's, 14 Feb. 1975 (141). 77.4 × 62.8.

Flute-playing Shepherd (three-quarters to left, with cap) [Plate 228]. Centraal Museum, Utrecht (1952/65). 77 × 63. Inscribed with Bijlert's name and dated 1639. H/68. H lists three other versions, one of which is: Sale, Helbing, Munich, 24–5 May 1928 (348) along with pendant *Shepherdess* (q.v.), as Terbrugghen, 99 × 77. H/68a. Variant in Bowes Museum, Barnard Castle. Panel, 26 × 21. S. H/67.

Flute-playing Shepherd (pipe to mouth) [Plate 213]. Lord Lothian Collection.

Flute-playing Shepherd (full face). Vassar College Art Gallery, Poughkeepsie (New York) (1967, p. 13). Copper, 18.8 × 16.

Flute-playing Shepherd (three-quarters to right, with cap and feather) [Plate 227]. With Julius Weitzner, New York (1956). 76.2 × 62.2. BP.

Flute-playing Shepherd (three-quarters to right, with cap and feather). Private Collection, Newport (Mon.). C or A.

Flute-playing Shepherd (near-profile to right, with cap and feather). Sale, Düsseldorf, 11 June 1932 (131). 104 × 79. H/70. Sluijter, 1977, Plate 16.

Shepherd trimming his Flute. John Herron Art Institute, Indianapolis (Indiana) (1970/58.57, illus.) 73 × 60.5. S. H/71. *Art Quarterly*, Spring 1959, p. 85, illus.

Flute-playing Shepherdess. Two versions known: **1.** Pushkin Museum, Moscow. 100 × 95. Pendant to Moscow *Luteplayer* (q.v.). Nicolson, Russia, 1965, Fig. 53. **2.** Art Gallery of New South Wales, Sydney (NSW) (Museum Picture Book, 1972, illus. colour). 109.2 × 86.4. S. Pendant to Zurich *Luteplayer* (q.v.). *Burl. Mag.*, May 1967, Fig. 67.

Bagpipe Player [Plate 216]. Private Collection, Ireland. *c.* 102 × 87.

Shepherd and Shepherdess singing. Städtisches Museum, Wuppertal-Elberfeld. 75 × 103. H/74. Exh. Utrecht/Antwerp, 1952 (32), illus.

Eating and Drinking Scene, with female Luteplayer (three figures). With Galerie Müllenmeister, Solingen (1968). Panel, 38 × 53. S. Ad. *Burl. Mag.*, June 1968, illus.

Eating and Drinking Scene (five figures). Herzog Anton Ulrich-Museum, Brunswick (1976/187). 91 × 121. S. H/81, Fig. 14. Von Schneider, 1933, Pl. 23a.

Eating and Drinking Scene (four figures). Centraal Museum, Utrecht (1971–2/21, illus.). 90.5 × 119. S. Exh. Rijksmuseum, Amsterdam, 1976 (11), illus.

Backgammon Players. Nasjonalgalleriet, Oslo (1973/621). Panel, 26 × 35.5. S. H/80.

Fortune-Teller. Musée Mandet, Riom. S. Cuzin, 1977 (67), illus.

Brothel Scene. Two versions known: **1.** Musée des Beaux-Arts, Lyon. 105 × 152. S. BP. H/79, Fig. 12.

2. Muzeum Narodowe, Wrocław (Poland) (1973/5, illus.). 115.5 × 159. A.

Mercenary Love. Herzog Anton Ulrich-Museum, Brunswick (1976/188). 77.7 × 110.2. S & D 1626. H/78, Fig. 3.

Old Man paying for Love with Pearls. Stichting Nederlands Kunstbezit, The Hague (1950). 100 × 122. S. H/76.

Old Woman tempting a young one with a Necklace (Allegory of Vanity). Schloss Wilhelmshöhe, Cassel (1958/184, illus.). 112 × 88. S. H/75. Von Schneider, 1933, Pl. 25b.

Shepherd with Crook. Schloss Weissenstein, Pommersfelden. 77.5 × 63.5. Pair to Pommersfelden *Shepherdess* below. H/65.

Shepherdess with Crook. Schloss Weissenstein, Pommersfelden. 80. 5 × 58. Pair to Pommersfelden *Shepherd* above. H/54.

Shepherdess. Sale, Helbing, Munich, 24–5 May 1928 (348) along with pendant *Flute-playing Shepherd* (q.v.), as Terbrugghen. 100 × 77. H/52. Variant is: Bowes Museum, Barnard Castle. Panel, 26 × 21. S. H/55.

Sutler. Centraal Museum, Utrecht (1952/61, illus.). 84.5 × 68. S. H/51, Fig. 10.

Soldier drilling with Spear [Plate 207]. With Robert Noortman Gallery, London (1978).83.8 × 64.8. S. Ad. *Weltkunst*, Jan. 1978, illus. Noortman cat. 1978 (6), illus. Colour.

Boy lighting Pipe from Brazier. Formerly with Victor Spark, New York; Sale, Sotheby's, 12 July 1972 (119). 75 × 62.

Old Man gazing at Hour Glass. With Alan Jacobs Gallery, London (1972). 67 × 57. S. *Burl. Mag.*, Nov. 1972, Fig. 82.

Woman holding up Paper. Sale, Christie's, 2 March 1934 (28); sale, Weinmüller, Munich, 26–7 April 1978. Panel, 52.3 × 44.4 S. H/59. Ad. *Weltkunst*, 1978, p. 927, illus.

The following is a selection of wrong attributions to Bijlert:

?Moeyaert **Orpheus, Pluto and Proserpine.** Pinacoteca Vaticana, Rome.

Honthorst **Orpheus.** Palazzo Reale, Naples.

★Dutch School 17th century **Abraham and the three Angels.** Leo Brom Collection, Utrecht (1952). 140 × 210. Bears false Bijlert signature and date 1631. H/2, Fig. 16.

★Dutch School 17th century **Isaac and Esau** (Museum, Nancy) and **Benediction of Jacob** (Mainz), companions, as J. C. Loth.

?Bronckhorst **Laban and Rachel.** Museum Boymans-van Beuningen, Rotterdam.

Tournier **Denial of St Peter.** Dresden No. 413.

Honthorst **St Sebastian.** Munich, and C at Aix.

★Utrecht School **Concert** (four figures). Muzeum Narodowe, Warsaw. 103 × 144. Exh. Bordeaux,

1961 (95), illus. as Bijlert, Michałkowa, 1961, Fig. 1, as ?Bijlert.

?Flemish imitator of Manfredi **Three Musicians.** Munich.

Rombouts **Musical Pair.** Munich.

A. Janssens **Fluteplayer and Girl.** Formerly Matzwansky Collection, Vienna.

Master G **Singer and Drinker,** Galleria Spada, Rome; **Drinker with Still Life.** Galleria Colonna, Rome.

?Kuyl **Card Players.** Copenhagen.

Imitator of Manfredi **Card Players.** Dresden No. 414.

Régnier **Fortune Teller.** Formerly Kaiser-Friedrich Museum, Berlin.

CAMPEN, Jacob van (1595/98–Sept. 1657)

Can only be described as Caravaggesque at various removes, and two pictures only can be listed which are at all relevant, one lost. Visits Italy. Chiefly noted as an architect in the wake of Palladio and Scamozzi. Working as painter in Haarlem in late 1620's, and at Amersfoort in early 1630's: hence reflection of Honthorst and Baburen. Works in Oranjezaal at Huis ten Bosch in mid-1640's.

Diogenes. Centraal Museum, Utrecht (1961/20, illus.). 92.6 × 156.6. S & D 1628. Waddingham, 1961, Pl. 142b.

Old Woman with Book. Lost. Engraving by Jan Matham, 1643. Van Gelder, 1948–9, Pl. 19.

The following is a wrong attribution to Van Campen: ★?Cesar van Everdingen **Bacchus.** Wadsworth Atheneum, Hartford (Conn.).

CARACCIOLO, Giovanni Battista (called Battistello) (Dec. 1578–Dec. 1635)

From Naples. Nothing of his activity is known before a Caravaggesque phase late in the first decade, and nothing after 1630 is more than remotely Caravaggesque (and is therefore not listed), since during these final years he adopts a classicizing style in the manner of the Bolognese and the Florentines. Already by 1620 he moves away from Caravaggio in a Carraccesque direction and some pictures of the 1620's are not given here. Seems to have contact with Lanfranco in the second decade. Influenced by Gentileschi. In Florence throughout most of 1618, and in Rome late 1618 and early 1619; though he is surely in Rome earlier, to judge by his works in the first part of the second decade which can hardly be explained solely on the grounds of his knowledge of Caravaggio's Neapolitan pictures. A number of drawings given (occasionally with good reason) to Caracciolo are not listed. L followed by stroke and fig. number refers to Longhi, S.G. 1961 (1912–22).

Daedalus and Icarus. Residenzgalerie, Salzburg, Czernin Collection (1970/28 as Caravaggio follower). 75.5 × 100.5. U U.

Sleeping Cupid. Museo Nazionale, Palermo. L/Fig. 89.

Sleeping Cupid. Private Collection, Los Angeles (c. 1965). Moir, 1975, Fig. 106, as Riminaldi?

Sleeping Cupid. Hampton Court Palace (Levey, 1964/422, illus). 92.1. × 126.4. B P. Partly repainted by Largillierre. Levey (1964) cites two copies. One copy is: Duke of Grafton Collection, Euston Hall. 94 × 134.5. Moir, 1976, Fig. 104.

Sleeping Cupid. With Galerie Heim, Paris-London (1974). 90.3 × 127.6. Surrounded by symbols of the arts and sciences by different hand. U U. Moir, 1976, Fig. 107.

Bacchus with Putto. Arch. Luigi Moretti Collection, Rome (1951). Panel, 57 × 67.5. Exh. Milan, 1951 (79), illus.

Adam and Eve. With Gilberto Algranti, Milan

(1970). 103 × 77. Exh. 'Seicento-Arte "Moderna", Arte di Domani', Milan, 1970, illus. colour.

Adam and Eve in mourning over the Body of Abel. Formerly with Galleria San Marco, Rome. 145 × 180.

Lot and his Daughters. Columbia University, New York. 130.1 × 149.9. Hibbard/Lewine, 1965, Fig. 37.

Lot and his Daughters. P. Volpini Collection, Milan, Volpe, 1972, Figs. 11, 12.

Sacrifice of Isaac. City Art Gallery, Dundee (1973/45/12, illus.). 243.8 × 182.9. *Burl. Mag.*, Oct. 1974, Fig. 5.

Rest on the Flight. Museo di Capodimonte, Naples. 111 × 151. Exh. Louvre, 1965 (16), illus.

Rest on the Flight. Florentine Galleries. 205 × 186. Exh. Florence, 1970 (5), illus.

Return from Egypt. Pietà dei Turchini, Naples. 340 × 230. L/Fig. 92.

Christ among the Doctors. Two rather poor pictures may conceivably reflect a lost Caracciolo composition: **1.** Private Collection, Madrid. 80 × 120.

Exh. Seville, 1973 (17), as Caracciolo, illus. **2.** Bowes Museum, Barnard Castle (1970/37, illus.). 99.1 × 142.2. Moir, 1976, Fig. 95. Traditional attribution to Spada.

Baptism. Quadreria dei Girolamini, Naples. 116 × 145. L/Fig. 87.

Christ and the Samaritan Woman. Brera, Milan (1935/359). 200 × 155. S. Moir, 1967, Fig. 190 (L/Fig. 91 is detail).

Christ and the Samaritan Woman. Metropolitan Museum of Art, New York. 203 × 152. *Art News*, 1937, XXXV, 18, 30 Jan., illus.

Christ washing the Disciples' Feet. Certosa di San Martino, Naples. 393 × 393. 1622. L/Fig. 95.

Agony in the Garden. Parish Church, Rho (Lombardy). 212 × 137. Gregori, 1957, Figs. 23, 24.

Agony in the Garden. Kunsthistorisches Museum, Vienna (1973, illus. Plate 44). 147 × 121. S. Heinz, 1962, Pls. 144–6.

Christ and Caiaphas. Hermitage, Leningrad. 73 × 103. Exh. Leningrad, 1973 (21), illus. Linnik, 1975, illus. colour and black and white, Pls. 20–2.

Ecce Homo. Museo Filangieri, Naples.

Christ at the Column. Museo di Capodimonte, Naples. 200 × 150. Marini, 1974, p. 326 (C47), illus.

Christ at the Column. Buonocore Collection, Naples. Causa, 1972, Pl. 270.

Christ carrying the Cross. Quadreria dei Girolamini, Naples. L/Fig. 94.

Way to Calvary. Museo Nazionale di San Martino (from S. Maria del Popolo agli Incurabili), Naples. 128 × 180. L/Fig. 93.

Christ and Simon the Cyrenean. University, Turin. 158 × 193. S. Carità, 1951, Figs. 26–8.

Crucifixion. Real Casa Santa dell'Annunciata, Naples. 150 × 100. La Rota, No. 6, Nov.–Dec. 1971, illus. colour as Preti.

Lamentation over the Body of Christ. San Michele Arcangelo, Baranello (Molise). 151 × 214.

Entombment. Longhi Collection, Florence (1971, Pl. 57). 128 × 164.5.

Noli me tangere. Museo Civico, Prato (Galleria Comunale) (1958/29, illus.). 109 × 130.5 S. BP. Exh. Florence, 1970 (3), illus.

Annunciation. Wadsworth Atheneum, Hartford (Conn.). (1934, p. 26, illus.). 56.1 × 44.4. S. Volpe, 1972, Fig. 10. *Studio*, Oct. 1931, illus. colour.

Immaculate Conception. S. Maria della Stella, Naples. 334 × 209. S. L/Fig. 90.

Madonna. Los Angeles County Museum. 106 × 78. S. Spear, 1971 (12), illus.

Madonna with Infant St John. Casa Borghese, Naples (1950). Causa, 1950, Fig. 23.

Madonna with St Anne. Kunsthistorisches Museum, Vienna (1973, illus. Pl. 44). 120 × 152. L/Fig. 108, and colour Pl. x. One copy known: Seville Cathedral. 134 × 178. Exh. Madrid, 1970 (27), illus.

Madonna, St Anne and Infant St John. St Mary's, Newmarket. 194.5 × 135. U U. *Burl. Mag.*, June 1967, Fig. 56.

Madonna with Saints Francis and Clare and a Soul in Purgatory. S. Chiara, Nola. 290 × 205. Moir, 1967, Fig. 182.

Madonna in Glory. Museo Provinciale, Catanzaro.

St Joseph and the Christ Child. Musée Cantonal des Beaux-Arts, Lausanne. Longhi, *Battistello*, 1957, Fig. 21.

Miracle of St Anthony of Padua. S. Giorgio dei Genovesi, Naples. 290 × 218. L/Fig. 88. Causa, 1950 lists *bozzetto*, now Pisani Collection, Naples. Sketch illus. by D'Argaville, 1972, Fig. 97 looks like partial C.

St Bartholomew. Quadreria dei Girolamini, Naples.

St Catherine of Siena. With Gilberto Algranti, Milan (1974). Gregori, 1959, Fig. 41.

St Charles Borromeo. S. Maria dell'Incoronata a Capodimonte (from S. Nicola alla Dogana), Naples. 221 × 141. Sellitto Exh., 1977 (18).

Saints Cosmas and Damian. Museum Dahlem, Berlin (1975/1981, illus.). 98 × 125. S. Moir, 1967, Fig. 189. One copy known: Museo del Prado, Madrid (1972/2759). 96 × 121. Exh. Madrid, 1970 (28), illus.

Saints Cosmas and Damian. With Mrs Drey, London (c. 1960). 94 × 127. S. Bologna, 1960, Fig. 37.

Head of St Januarius. Brera, Milan. 61 × 73.9. S. Marini, 1973, Fig. 40.

Infant St John the Baptist. Ing. Giuseppe de Vito Collection, Milan. 65.5 × 50.5. Longhi, *Battistello*, 1957, Fig. 22.

Adolescent St John the Baptist. ?Lost. ?C. Bowes Museum, Barnard Castle (1960/23, illus.). 128.3 × 94. R.

Adolescent St John the Baptist. Château de Versailles (formerly on loan to Musée des Beaux-Arts, Dijon (1918/484, as Valentin). 76 × 59. Hoog, 1960, Fig. 5.

Adolescent St John the Baptist. Art Museum, University of California, Berkeley (Calif.). 95.8 × 127.3. Spear, 1971 (10), illus.

Mature St John the Baptist. V. Baratti Collection, Naples (1959), S. R. L., 1959, Fig. 35.

Salome with the Head of St John the Baptist. Florentine Galleries. 132 × 156. Spear, 1971 (11), illus.

Salome with the Head of St John the Baptist. Peltzer Collection, Cologne (1927). Moir, 1976, Fig. 118.

Salome with the Head of St John the Baptist. Museo de Bellas Artes, Seville. 110 × 150. BP. Exh. Seville, 1973 (15), illus.

St John the Baptist; St Martin (a pair). Certosa di S. Martino, Naples. Each 208 × 75. L/Figs. 101 a, b.

St Lawrence. Museo Nazionale di San Martino, Naples. 82 × 63. BP.

Magdalen. Busiri Vici Collection, Rome. 158 × 97. S. Moir, 1967, Fig. 191.

Magdalen at the Foot of the Cross. Museo de Arte de Ponce (Puerto Rico). 99.1 × 76.2. S. Exh. Finch College, New York, 1962 (1), illus.

St Onuphrius. Galleria Nazionale d'Arte Antica, Rome. 180 × 117. L/Fig. 102.

Liberation of St Peter. Pio Monte della Misericordia, Naples. 310 × 207. 1614–15. S. L/Fig. 86.

St Sebastian. Fogg Museum of Art, Cambridge (Mass.). 203.2 × 114.3. Spear, 1971 (13), illus.

St Sebastian tended by Irene. Musée des Beaux-Arts, Caen, as Neapolitan School.

Stories of the Carmelites. S. Teresa agli Studi, Naples. Frescoes. Largely R.

The following is a selection of wrong attributions to Caracciolo:

Sellitto (?) **Bacchus.** National Museum, Valletta (Malta) and Städelsches Kunstinstitut, Frankfurt-am-Main.

Sellitto **David with the Head of Goliath.** National Gallery, Salisbury (Rhodesia).

Caravaggesque (Neapolitan or Sicilian) **Christ Healing the Sick.** Private Collection, Florence (1969).

★Anon. **Christ saving St Peter from the Waters** (?). Musée Calvet, Avignon. 185 × 196. R. Pepper, 1972, Fig. 7.

Sellitto **Adoration of the Shepherds.** S. Maria del Popolo agli Incurabili, Naples.

Manfredi **Crowning with Thorns.** Alte Pinakothek, Munich No. 1234.

Sellitto **St Cecilia and Angels.** Museo di Capodimonte, Naples.

★?Lanfranco **St Charles Borromeo.** Rheinisches Landesmuseum, Bonn.

Sellitto **St Charles Borromeo.** S. Maria delle Grazie a Caponapoli, Naples (deposited in Museo di Capodimonte.)

★Remote follower of Manfredi **St John the Evangelist.** City Art Gallery, York (1961/811, illus. as Caracciolo). 101.6 × 92.7 (octagonal). Exh. Barnard Castle, 1962 (5), illus.

Vitale **Liberation of St Peter.** Musée des Beaux-Arts, Nantes.

Paolini **Boy with Butterfly.** Fine Arts Museums of San Francisco (Calif.).

CARAVAGGIO, Michelangelo Merisi (Autumn 1571–July 1610)

From Caravaggio (Lombardy). Serves apprenticeship with Peterzano in Milan, 1584 (contract 6 April) for four years. Travels in North Italy, studying the Cinquecento masters, especially the Brescians and Venetians. Reaches Rome about autumn 1592. Finds employment in workshop of Cavaliere d'Arpino for a few months (c. 1593), but most of the time is nearly destitute. Taken into the house of Cardinal del Monte (c. 1594) for whom he paints some well-known pictures. Already famous or notorious in Rome before the turn of the century when he receives the commission for paintings in S. Luigi dei Francesi and S. Maria del Popolo (1599–1602). Patronized at this period by Vincenzo Giustiniani. 1600 onwards, involved in a series of brawls and libel actions, the most dramatic being the action for slander brought by Baglione (Aug.–Sept. 1603). Winter of 1603–4 in the Marches. Jailed on a number of occasions (1603–5), on others a fugitive from justice. May 1606, commits murder and is forced to flee Rome. Succeeds in reaching Naples (before 6 Oct. 1606) where he remains till about autumn 1607. To Malta, about winter 1607–8. Received into Order of Knights (July 1608). Imprisoned and escapes (Oct. 1608). Expelled from the Order (Dec. 1608). Flees to Sicily before his expulsion. In Syracuse, Messina, Palermo probably in that order (early 1609). Thinks he is not safe and sails back to Naples, where he is wounded (Oct. 1609). Still a fugitive, dies at Port' Ercole (July 1610). All pictures listed but none of the many copies after known originals, unless there is a special reason for listing them. M. followed by number refers to Marini, 1974.

Head of Medusa. Florentine Galleries. Canvas on wooden shield, diameter, 55.5. M/21, illus. with detail.

Narcissus. Galleria Nazionale d'Arte Antica, Rome, 133.3 × 95. BP. U. M/39, illus. with details. Longhi, QC 1968 (1929), Pl. 169, illus. colour.

Jupiter, Neptune and Pluto. Villa Ludovisi, Rome. Oil on ceiling, 300 × 180. After Nov. 1596. UU. M/R1, illus. with details. Zandri, 1969, pp. 338ff. with colour plate and details.

Sleeping Cupid. Florentine Galleries. 72 × 105. 1608. M/77, illus. with detail and C. Engraved by T. ver Cruÿs (1778), in reverse, Isarlo, 1951, illus.

'Amore Vincitore'. Museum Dahlem, Berlin (1975/ 369, illus.). 156 × 113. Before 1603. M/46, illus. with details. Engraved as from Giustiniani Collection in Landon, 1812, p. 33.

Sacrifice of Isaac. Florentine Galleries, 104 × 135. M/49, illus. with details.

Sacrifice of Isaac. Lost. Three copies illus. under M/24.

David with the Head of Goliath. Galleria Borghese, Rome (1959/114, illus.). 125.5 × 99. M/92, illus. with detail and C.

David with the Head of Goliath. Kunsthistorisches Museum, Vienna (1973, illus. Plate 34). Panel, 95 × 165. M/70, illus.

David and Goliath. Museo del Prado, Madrid (1972/65). 110 × 91. M/34, illus.

Judith and Holofernes [Plate 5: detail]. Galleria Nazionale d'Arte Antica, Palazzo Barberini, Rome (1970–2/5, illus. with colour detail). 145 × 195. M/32, illus. with details.

Nativity with Saints Lawrence and Francis. Formerly Oratorio di S. Lorenzo, Palermo (stolen Oct. 1969). 271 × 198. Before Oct. 1609. M/88, illus. with details.

Adoration of the Shepherds. Museo Nazionale, Messina. 314 × 211. 1609. M/83, illus. with details.

Flight into Egypt. Galleria Doria-Pamphilj, Rome (1942/241). 135.5 × 166.5. M/14, illus. with details. Longhi QC 1968 (1929), detail of landscape in colour.

Calling of Saints Peter and Andrew. Hampton Court Palace (Levey, 1964/424, illus.). 132 × 163. ?C. BP. M/27. illus. as C. Several copies recorded, at Weston Park; Ponce (1965/57.0016); formerly Chatsworth (sale, Christie's, 21 May 1976/43). Engraved by Murphy (1782), Longhi, 1943, Pl. 15. See similar picture in Ansoldi Collection under ?Galli (q.v.).

Raising of Lazarus. Museo Nazionale, Messina. 380 × 275. 1609. BP. M/82, illus. with details.

Agony in the Garden. Formerly Kaiser-Friedrich Museum, Berlin (1931/359) (destroyed 1945). 154 × 222. M/54, illus. Engraved as from Giustiniani Collection in Landon, 1812, p. 31.

Capture of Christ. ?Lost. Best version in Museum of Eastern and Western Art, Odessa. 134 × 172.5. Linnik, 1975, illus. colour Pls. 5, 6. M/28, illus. with details and copies.

Crowning with Thorns. ?Lost. Original or excellent C (?by Caracciolo) in Kunsthistorisches Museum, Vienna (1973, illus. Pl. 34). 127 × 165.5. M/26, illus. with details.

Crowning with Thorns. Cassa di Risparmi e Depositi, Prato (ex-Cecconi). 178 × 125, M/44, illus. Gregori, 1976, Figs. 1–3 in colour, 6–9 in black and white.

Ecce Homo. Palazzo Rosso, Genoa. 128 × 103. BP. ?C. M/58, illus, with details and C.

Flagellation. Musée des Beaux-Arts, Rouen (1966/194, illus.). 134.5 × 175.4. M/65, illus. with detail and copies.

Flagellation. San Domenico Maggiore, Naples (on deposit at Capodimonte). 286 × 213. 1607. M/91, illus. with details and C.

Christ at the Column. ?Lost. Good version in Collection of heirs of Baronessa Emma Camuccini, Cantalupo Sabino (Rieti). 140 × 106. M/25, illus. with detail and copies.

Entombment. Pinacoteca Vaticana, Rome. 300 × 203. 1602–4. M/48, illus. with details. Anon. 17th century engraving, illus. Moir, 1976, fig. 74 as Baburen. Engraved in outline by Guattani (1784), Friedlaender, 1955, Fig. 102. C or rather adaptation by Rubens (q.v.).

Christ at Emmaus. National Gallery, London (1971/172). 141 × 196.2. M/30, illus. with details. Engraved by Pierre Fatoure (d. 1629), Friedlaender, 1955, Fig. 94.

Christ at Emmaus. Brera, Milan. 141 × 175. M/61, illus. with details.

Annunciation. Musée des Beaux-Arts, Nancy. 285 × 205. R. M/86, illus. with detail.

Death of the Virgin [Plate 3: detail]. Musée du Louvre, Paris (1965/26). 369 × 245. 1606. M/60, illus. with details. Engraved in Landon, IV, p. 71.

Madonna. Galleria Nazionale d'Arte Antica, Rome. 113 × 91. M/R10, illus.

Madonna di Loreto, or **dei Pellegrini.** S. Agostino, Rome. 260 × 150. 1603–6. M/52, illus. with details and C. Copy by Andrea Polinori (q.v.). Engraved by L. Vorsterman in reverse. Moir, 1976, Fig. 84.

Madonna dei Palafrenieri or **del Serpe.** Galleria Borghese, Rome (1959/116, illus.). 292 × 211. 1605 to before April 1606. M/56, illus. with details.

Madonna del Rosario. Kunsthistorisches Museum, Vienna (1973, illus. Pl. 34). 364 × 249. 1607. ?Finished by Finson. M/64, illus. with details. Engraved by Vorsterman in reverse; first state, Stechow, 1959, Fig. 1: second state, Friedlaender, 1955, Fig. 111.

Holy Family. ?Lost. Good version formerly with Acquavella Galleries, New York. 116 × 94. M/71, illus., with copies. Engraved by Pierre(?) Daret in same direction (mid-17th century).

Seven Acts of Mercy. Pio Monte della Misericordia, Naples. 390 × 260. 1606–7. M/63, illus. with details and (pp. 320–1) X-rays.

Crucifixion of St Andrew [Plate 4: detail]. Cleveland Museum of Art. 202 × 152. Nicolson, 1974, Figs. 55 and 54 (detail). M/72, illus. Two copies. Lurie/Mahon, 1977, illus. colour and black-and-white with details after restoration, plus three copies, one of which is by Finson (q.v.).

St Catherine of Alexandria. Schloss Rohoncz Foundation, Lugano-Castagnola (1977/55). 173 × 133. M/22, illus. with detail and C. Spear, 1971 (16), illus. colour.

St Francis in Meditation. S. Pietro, Carpineto Romano (Rome) (in store in Palazzo Venezia). 123.8 × 93. M/89, illus. with detail and C. Brugnoli, 1968, colour plate.

St Francis in Meditation. Pinacoteca Civica, Cremona. 130 × 90. M/50, illus. with details.

St Francis in Ecstasy. Wadsworth Atheneum, Hartford (Conn.). 92.5 × 128.4. M/9, illus. with detail and two copies.

St Isidore Agricola. Lost. 1603–4. One C. known: Palazzo Comunale, Ascoli Piceno. 220 × 150. M/51, illus.

St Jerome writing. Galleria Borghese, Rome (1959/115, illus.). 112 × 157. M/59, illus. with details.

St Jerome writing. Co-Cathedral of St John,

Valletta (Malta). 117 × 157. 1607–8. M/76, illus. with details.

St Jerome in Meditation. Monastery, Monserrat (Barcelona). 110 × 81. M/55, illus.

St John the Baptist drinking at the Well. Heirs of Vincenzo Bonello, Valletta (Malta). 100 × 73. ?C. R. M/78, illus. with two copies, one full-length with Lamb.

St John the Baptist. Eglise Paroissiale, Marly-le-Roy. UU. Three copies known, two of which are: **1.** Musée des Beaux-Arts, Rouen (1966/196, illus.). 81 × 65. **2.** Musée du Louvre, Paris (1926/1206, as 'Canlassi'). 148 × 114.

St John the Baptist. Cathedral, Toledo. 169 × 112. M/R11, illus.

St John the Baptist. Galleria Borghese, Rome (1959/113, illus.). 152 × 124.5. BP. M/93, illus. with details.

St John the Baptist. Galleria Nazionale d'Arte Antica, Rome. 97 × 131.9. M/57, illus. with details.

St John the Baptist. Pinacoteca Capitolina, Rome. 130.4 × 97.6. M/36, illus. with details. Another version in Galleria Doria-Pamphilj, Rome. 132 × 98. ?C. M/under 36, illus.

St John the Baptist. Nelson Gallery-Atkins Museum of Art, Kansas City (Missouri). 172.5 × 134.5. M/38, illus. with detail and C.

Beheading of St John the Baptist. Co-Cathedral of St John, Valletta (Malta). 361 × 520. 1608. S. M/75, illus. with details.

Salome with the Head of St John the Baptist. National Gallery, London (1971/6389, as ascribed to Caravaggio). 91.5 × 106.7. M/67, illus. with details and C.

Salome with the Head of St John the Baptist. Palacio Real, Madrid (formerly Escorial). 116 × 140. BP. M/84. illus.

Burial of St Lucy. S. Lucia, Syracuse. 408 × 300. 1608. BP. M/80, illus. with details and copies.

Penitent Magdalen. Galleria Doria-Pamphilj, Rome. 123 × 98.3. M/13, illus. with details.

Magdalen in Ecstasy. ?Lost. Many versions known. Copies by Finson and W. de Geest (q.v.). Best uninscribed version: formerly Avv. Giuseppe Klain Collection, Naples; 1976 in Roman Collection. 106.5 × 91. BP. M/62, illus. and in colour, Plate II. Another good example is: Hermitage, Leningrad. 99 × 84. Linnik, 1975, illus. colour, Pl. 7. M/62, illus. six copies.

Conversion of the Magdalen. Detroit Institute of Arts, Detroit (Michigan). 100 × 134.5. M/23, illus. as copy, erroneously as in Private Collection, Great Britain, and entitled *Martha reproving the Magdalen*, with details and copies. Cummings, 1974, as original, colour plate detail Fig. 1. and Figs. 6–13 in black-and-white.

St Matthew and the Angel. Formerly Kaiser-Friedrich Museum, Berlin (1931/365) (destroyed 1945).

223 × 183. Said to be after Feb. 1602, but probably *c.* two years earlier. M/45, illus. with detail. Engraved as from Giustiniani Collection in Landon, 1812, p. 29.

St Matthew and the Angel. S. Luigi dei Francesi, Rome. 296.5 × 195. Before Sept. 1602. M/47, illus. with details.

Calling of St Matthew. S. Luigi dei Francesi, Rome. 322 × 340. 1599–1600. M/35, illus. with details and X-ray.

Martyrdom of St Matthew. S. Luigi dei Francesi, Rome. 323 × 343. 1599–1600. M/33 (first version, illus. with X-rays) and M/40, illus. with details.

Conversion of St Paul. Principe Guido Odescalchi Collection, Rome. Cypress panel, 237 × 189. 1600. M/37, illus. with details, and Plate 1 in colour.

Conversion of St Paul. S. Maria del Popolo, Rome. 230 × 275. 1600–1. M/42, illus. with details.

Denial of St Peter. Private Collection, Switzerland (1978). 94 × 125.5. M/66 illus. with detail and in colour Plate III.

Crucifixion of St Peter. ?Lost first version of painting for S. Maria del Popolo may be reflected in: Hermitage, Leningrad. 232 × 201. Wrongly attributed to Luca Santarello. Linnik, 1975, illus. colour Pls. 11, 12, as ?Spada. M/R2, illus. with C.

Crucifixion of St Peter. S. Maria del Popolo, Rome. 230 × 175. 1600–1. M/41, illus. with details and C. Copies by Ribalta (q.v.), and Honthorst (q.v.).

Martyrdom of St Sebastian. Lost. Three copies known. **1.** Private Collection, Rome. 170 × 120. M/69, illus. **2.** Private Collection in the Vosges, illus. Pariset, 1958, as Le Clerc; 162 × 110 D 1628. **3.** Sacristy, Cathedral, Como. Large.

Incredulity of St Thomas. Sanssouci, Potsdam (1964/24). 107 × 146. M/31, illus. with C. Engraved by Robillart. Moir, 1976, Fig. 57.

Portrait of Maffeo Barberini. Private Collection, Florence. 124 × 90. ?BP. M/29, illus. with details. Longhi, 1963, Pls. 1–3 and in colour.

Portrait of Sigismond Laire. Kunstmuseum, Düsseldorf (1931 Berlin Catalogue/354). 75 × 62. U. Salerno, Jan. 1960, Fig. 30. Engraved as from Giustiniani Collection in Landon, 1812, p. 123 as 'Tête de caractère'.

Portrait of Paul V. Principe Flavio Borghese Collection, Palazzo Borghese, Rome. 203 × 119. After May 1605. M/53, illus. with details.

Portrait of Alof de Wignacourt. Florentine Galleries. 118.5 × 95.5. 1607–8. M/79, illus. with details and Plate IV in colour. Engraved as Niccolò Cassana by G. Silvani in *La Galleria Imperiale di Palazzo Pitti* (1838).

Portrait of Alof de Wignacourt with Page. Musée du Louvre, Paris (1926/1124). 195 × 134. 1607–8. M/74, illus. with details and a poor variant without page. Engraved by Baudoin, Paris (1643) and in Landon, IV, p. 37.

Portrait of Alof de Wignacourt. Lost. 1607–8. C. S by Giandomenico Corso and D 1617, in Collegio dei Canonici della Grotta di San Paolo, Rabat (Malta). 136 × 113. M/73, illus. with second C full length. Two engravings based on original of the Rabat portrait by Philippe Thomassin (1609; Gregori, 1974, Fig. 42) and Boyssat (1612; Maindron, 1908, illus. p. 245).

Portrait of a Woman, 'Cortegiana Fillide'. Formerly Kaiser-Friedrich Museum, Berlin (1931/356) (destroyed 1945). 66 × 53. M/20, illus. Engraved as from Giustiniani Collection in Landon, 1812, p. 135.

Concert Party of Youths. Metropolitan Museum of Art, New York. 92 × 118.5. BP. M/8, illus. with details and C.

Luteplayer. Hermitage, Leningrad. 94 × 119. Linnik, 1975, illus. colour, Pls. 1–4. M/17, illus. with C by Carlo Magnone (ex-Barberini) (q.v.).

Card Sharpers. Formerly Sciarra Collection, Rome, but at present untraced. 99 × 137. M/11, illus. with two copies. More than fifty other copies survive. Engraved in late 18th century by Giovanni Volpato (*Novità*, Cinotti, 1975 illus. p. 219) and by Michetti when in Palazzo Sciarra (1889).

Fortune-Teller. Musée du Louvre, Paris (1965/18). 99 × 131. M/15, illus. with details. Engraved by Benoist II Audran before 1729, and by Levillain in *Galerie du Musée Napoléon*, 1812 as Manfredi.

Fortune-Teller. Pinacoteca Capitolina, Rome. 116 × 151.2 C. M/12, illus. with details.

Tooth Extractor. Florentine Galleries. 139.5 × 194.5. R. U. *Novità*, Gregori, 1975, Figs. 23, 24.

Youth as Bacchus. Florentine Galleries. 95 × 85. R. M/16, illus. with details and X-ray.

Self Portrait as Young Bacchus ('Bacchino malato'). Galleria Borghese, Rome (1959/112), illus.). 67 × 53. M/4, illus. with details. Longhi, SR 1967 (1927), colour Pl.

Boy with Basket of Fruit. Galleria Borghese, Rome (1959/111, illus.). 70 × 67. M/5. illus. with details.

Boy with Vase of Flowers. ?Lost. Best version is: formerly Mrs Borenius Collection, Coombe Bissett (Wilts). 66 × 50.8 M/under 6, illus. as C. C is: The High Museum of Art, Atlanta (Georgia). 67.3 × 51.8. M/6, illus. with detail. Illus. colour in *L'Oeil*. 15 Feb. 1955, p. 23. Original possibly pendant to:

Boy bitten by Lizard (Plate 2). Probably the original is: Vincent Korda Collection, London. 68 × 51.5. M/under 7, illus. two copies known: **1.** Longhi Collection, Florence (1971, Pl. 52 in colour and detail). 65.8 × 53.5. M/7, illus. with detail **2.** Formerly with Katz, Dieren. 70 × 50. Moir, 1976, Fig. 3.

Boy peeling a bitter Fruit (Plate 1). Private Collection, England (1978). 65 × 52. Hinks, 1953, Pl. 1. [Editorial Note: After this painting had been fully cleaned, Benedict Nicolson examined it early in 1978, when Denis Mahon drew his attention to the fact that the fruit which the boy is peeling (the identification of which is unclear in the many copies) seems to be a small citrous fruit such as the *bergamotto*, which is bitter in taste. This gives an extra piquancy to the subject-matter, in that the boy has selected a fruit which could unexpectedly turn out to be disagreeable: it would thus amount to an ironic commentary by Caravaggio, whose earliest surviving work this can claim to be, on the disillusioning surprises which life has in store for inexperienced youth.] Numerous copies survive, including: Longhi Collection, Florence (1971, Pl. 54 in colour). R. 67.2 × 57.6. M/2, illus. with five other copies.

Basket of Fruit. Ambrosiana, Milan. 31 × 47. M/19, illus. with X-ray.

The following Marini Nos. are not listed through lack of evidence of their association with the Caravaggesque movement: 1, 3, 10, 18, 81, 87, 90.

No. 85 is listed under Caravaggesque unknown (?Sicilian).

The following Marini Nos. are listed under wrong attributions to the artists here given in brackets, but are not listed elsewhere by me because of their non-Caravaggesque character: 43 (Cecco); 68 (Finson and Sellitto); R14 ('Pensionante del Saraceni').

The following selection of Marini 'R' numbers represents wrong attributions to Caravaggio by other writers (not himself) and will be found in the following lists:

R3. Caravaggesque unknown (Roman-based) **Boy bitten by Crayfish.** Strasbourg.

R4, R5. Rodriguez **Incredulity of St Thomas** and **Christ at Emmaus.** Messina.

R8. Caravaggesque unknown (Spanish; ?Maino) **St John the Baptist.** Basle.

R9. Gentileschi **Way to Calvary.** Vienna.

R12. Caravaggesque unknown (Roman-based) **Luteplayer.** Munich.

R13. 'Pensionante del Saraceni' **Still Life.** Washington.

R15. Caravaggesque unknown (?South Spanish) **Card Players.** Fogg Art Museum, Cambridge (Mass.).

Innumerable other pictures have been wrongly given to Caravaggio and need not be repeated here, except for the following, for which see under: Caravaggesque (South Netherlandish, near Finson) **Luteplayer.** Dresden.

CARAVAGGESQUES, Anon. non-Italian 'Masters' (Masters A–L)

The following are lists of twelve anonymous non-Italian artists working in the Caravaggesque idiom to whom more than one painting can be ascribed. Two further unnamed Terbrugghen-like and Baburen-like artists with two pictures each are listed under Terbrugghen and Baburen respectively. The 'Master of the Judgement of Solomon' and 'Pensionante del Saraceni' are listed separately under their invented names.

I. UTRECHT

MASTER A. Close follower of Terbrugghen in Utrecht in mid-1620's.

Luteplayer. Schloss Wilhelmshöhe, Cassel (1958/178, illus.). 75 × 60.5. S. (?) & D 1625. Slatkes, 1965, Fig. 51. Pendant to:
Violinist with Glass. Schloss Wilhelmshöhe, Cassel (1958/177). 75 × 59. Slatkes, 1965, Fig. 50.

The following is a wrong attribution to Master A but is of his circle:
Baburen imitator **Singer** [Plate 175]. Rheinisches Landesmuseum, Bonn.

MASTER B. Imitator of Terbrugghen and Baburen in Utrecht, with traces of Honthorst influence.

Boy Violinist. Formerly Direktör P. W. Widengren Collection, Stockholm. 83 × 65. Nicolson, 1958, Pl. 106b.
Fluteplayer. Formerly with P. de Boer, Amsterdam. 78 × 62. Slatkes, 1965, Fig. 47.
Boy Fluteplayer by Oil Lamp. With P. de Boer, Amsterdam (1970), as Finson. 67 × 51. BP.
Boy with Flute and Mug. Formerly Sven Boström Collection, Stockholm. 73.5 × 60.5. Slatkes, 1965, Fig. 48.
Boy with empty Glass [Plate 173]. Národní Galerie, Prague (Nostitz catalogue, 1905/215) as manner of Terbrugghen). 71 × 63.5.
Pipe Smoker. Fomerly L. Baldass Collection, Vienna. 79.5 × 64. U. Slatkes, 1965, Fig. 46. Copy of Baburen in Musée Marmottan, Paris (q.v.).

MASTER C. Close follower of the Utrecht Baburen, with affinities with Master E below.

Denial of St Peter. Two versions known: **1.** National Museum, Cracow (1957/183, illus. as ?Honthorst). Canvas on panel, 87 × 106. Rostworowsky, 1960, Pl. 1 as Baburen. **2.** Old Master Galleries, London (1971). 67.3 × 81.3. Sale, Drouot, Paris, 22 Jan. 1969 (6), illus.
The following, though not by Master C (being more in direction of Stomer) can be associated with these two:
St Peter [Plate 176]. With Poletti, Milan, as Stomer. 71 × 58.

MASTER D. Follower of Baburen and Terbrugghen in Utrecht probably in 1630's. (Uncertain grouping).

Violinist. Formerly A. Wenner Gren Collection, Stockholm. 71 × 59. Fischer Sale, Lucerne, 18–20 August 1931 (227), illus. as Baburen.
Fluteplayer. With Alfred Brod, London (1955), as Rombouts. 64.3 × 49.5. Sale, Palais des Beaux-Arts, Brussels, 19–21 Feb. 1957 (425), illus. Bauch, 1956, Fig. 6, as Rombouts.

II. ?UTRECHT

MASTER E. Working in tradition of Honthorst and G. Seghers.

Denial of St Peter [Plate 179]. Abbé Jean Jacquart Collection, Catholic University, Argens (1942), as La Tour.
Denial of St Peter [Plate 180]. H. W. Streit Collection, Hamburg (1935) as Gerard Seghers. 96.5 × 119.

III. BRUGES

MASTER F. Bruges master working in tradition of Abraham Janssens in direction of Van Loon and elder Van Oost.

Allegorical Figure pointing to open Book labelled 'Cognitione' [Plate 105]. Assistance Publique, Bruges.
Feasting Scene. Columbus Gallery of Fine Arts, Columbus (Ohio). 132.1 × 190.5. Exh. Agnew's, London, 1960 (15), illus., as Gerard Seghers.

IV. ?UTRECHT

MASTER G. North Netherlandish artist in Rome, perhaps associated about 1620 with Rombouts and Ducamps during their Roman periods. Influenced by the Roman Baburen. N followed by stroke and Fig. number refers to Nicolson, 1975.

Singers (four figures). Musée d'Art et d'Histoire, Geneva (No. 1826–10) as Caravaggio. 75.5 × 111.5. N/Fig. 11.
Singer and Drinker (two figures). Galleria Spada, Rome (1954/109, illus. as Bylert). 74.3 × 97.2. Unfinished sketch. Fokker, 1932, illus. Pl. XVI as Baburen.
Singer (one figure) [Plate 178]. Two versions known: **1.** Hatton Gallery, University, Newcastle upon Tyne. *Burl. Mag.*, Oct. 1974, Fig. 2. N/Fig. 10. **2.** Filiberto Catinari Collection, Fermo. 46 × 59. Pendant to *Man laughing* below.
Drinker with Still Life. Galleria Colonna, Rome

(1937/74, as 'Barburen' [*sic*]). 116 × 163. Exh. 'La Natura Morta Italiana', Naples—Zurich—Rotterdam, 1964–5 (34), illus., as Bylert. N/Fig. 8.

Young Man with Flask. National Trust, Stourhead, as Caravaggio follower. Tondo, diameter, 70.4. N/Fig. 6. Pendant to:

Woman with Pestle and Mortar. National Trust, Stourhead, as Caravaggio follower. Tondo, diameter, 70.4. N/Fig. 7.

Man with Flask. Kunsthalle, Karlsruhe (Flemish catalogue, 1961/11 illus. as Flemish Master, *c.* 1620–5). 72.5 × 57.5. Bodart, 1970, Fig. 19. N/Fig. 9. One copy known: Musée, Bayeux (98) as Spanish 18th century.

Man laughing [Plate 177]. Filiberto Catinari Collection, Fermo. 46 × 59. Pendant to *Singer* above.

The following, probably Italian, has affinities with Master G:

Second-hand Goods Seller. Formerly Mario Lanfranchi—Anna Moffo Collection, Rome. 100 × 75. Affinities with Siena *Morra Players*, see below under Caravaggesque, South Netherlandish.

The following, Netherlandish but done in Italy, has affinities with Master G:

Drinker. Florentine Galleries. 60 × 45. Rubens exh., Pitti, Florence, 1977 (CIIa), illus. as after Rombouts.

MASTER H.?Central European, with possible connections with Tilmann. The picture in Prague has a signature beginning 'J.BR.'

Concert (four figures) [Plate 96]. Two versions known (or the same picture?): **1.** Národní Galerie, Prague, Museum of Czech Music, as Italian 17th century. 120 × 185. S. **2.** With Galerie van Diemen, Berlin (1922), as South Italian School. 122 × 198.

Gamblers with Luteplayer (six figures). Three versions known: **1.** State Collections of Art, Wawel (Cracow). 104 × 135.5. Mirimonde, 1965, Fig. 39, as attributed to the Elder Van Oost. **2.** Schidlof Sale, Vienna, 12–15 April 1920 (173), illus. as Dutch 17th century. 125 × 197. **3.** (?identical with **2**). Residenzgalerie, Bamberg, as Honthorst.

V. FRANCO-FLEMISH

MASTER J. Associated with Régnier, Valentin and Tournier in Rome, *c.* 1620–5.

?Still Life of Fruit in Régnier's *Allegory of Summer* (q.v.).

Denial of St Peter. Kunsthistorisches Museum, Vienna (1931/487A). 157 × 232. Architecture by Codazzi. Waddingham, 1961, Pl. 140a.

Concert (four figures). Private Collection, Rome. 111.8 × 147.9. Spear, 1971 (78), illus.

Pomegranate Seller. Private Collection, Italy. 116 × 90. Bauch, 1956, Fig. 5.

Soldier resting his Arm on Sword Hilt [Plate 65]. Sale, Finarte, Milan, 6 May 1971 (8), as Régnier. 67 × 55.5 A replica is said to exist (see Fantelli, 1974, Cat. No. 55).

VI. FRENCH

MASTER K. Eastern France, possibly in contact with Saraceni. Has been confused with Francesco del Cairo.

Esau selling his Birthright [Plate 67]. With Hazlitt Gallery, London (1967). Tondo. Pendant to *David with the Head of Goliath* (q.v.).

David with the Head of Goliath [Plate 68]. Two versions known: **1.** With Hazlitt Gallery, London (1967). Tondo. Pendant to *Esau selling his Birthright* (q.v.). **2.** Adonero Collection, Madrid (1950). 70 × 52. Pérez Sánchez, 1965, Pl. 100.

Head of Boy [Plate 66]. Wadsworth Atheneum, Hartford (Conn.). 38.1 × 28.5.

Head of Boy. Stanford Museum, Stanford University (Calif.), as Italian 17th century. 41.2 × 34.3. BP. Nicolson, 1974, Fig. 60.

Similar in style to Master K is:

Boy frightening a Girl with a Crab. Formerly Joseph Kaplan Collection, Chicago. Moir, 1976, Fig. 5.

MASTER L. ?Burgundian *c.* 1625–35. Possible relationship with early Tassel and Bigot. Close to Quantin.

Adoration of the Shepherds. Three versions known: **1.** Drossaert Collection, Brussels. 145 × 190. Nicolson, 1974, Fig. 65 (detail). **2.** Musée des Beaux-Arts, Dijon (1933/137), now as A. van den Heuvel. 196 × 246. Nicolson, 1974, Fig. 63. **3.** Private Collection, Bassano del Grappa. 175 × 215. Variant.

Adoration of the Shepherds. Parke-Bernet Sale, New York, 4 April 1947 (166), illus., as attributed to Quantin. 204.5 × 184.

St Joseph and the Christ Child. Central Picture Galleries, New York (1961). 101.6 × 86.4. Nicolson, 1974, Fig. 64.

CARAVAGGESQUE UNKNOWN

An alarming number of pictures refuse to fit into any other category but 'Caravaggesque unknown'. In order that these lists should not become unmanageable, many that might have appeared here are listed under imitators of, or circle of, Manfredi, Caracciolo, Valentin, Baburen, Terbrugghen etc., and 12 anonymous non-Italian artists to whom more than one picture can be attached are listed separately under

'Caravaggesques, Anon. non-Italian "Masters".' This helps to dispose of a sizable group of unattributable works. With what remains, an attempt is made here for the sake of clarity to subdivide the pictures into schools, although this system has its drawbacks, since Flemings and Frenchmen often worked side by side in Roman studios and are hard to differentiate. Notes are appended at the end of each entry in brackets in an attempt to bring a little more precision into these ambiguous classifications. Some supposedly Caravaggesque works cited in the literature and unknown to me are omitted. I have also passed over in silence a few which might qualify but are too disagreeable to contemplate.

I. ROMAN-BASED

Bacchus. Galleria Nazionale d'Arte Antica, Rome. 95 × 74. Exh. Gall. Naz., 1955 (6), illus. (Apparently painted in Rome, but possibly non-Italian as late as *c.* 1630).

Love Triumphant. Two versions differing from one another are recorded: **1.** Heim Gallery, London/Paris (1976). 152 × 111. Moir, 1967, Fig. 31 as Baglione. **2.** Formerly Principe di Cutò Collection, Palermo. 130 × 94. BP. ?C. Martinelli, 1959, Pl. 51b as after Baglione. (These two, which seem not to be by the same hand, are more Vouet-like than Baglione-like and could conceivably be French *c.* 1620–5 in the direction of Mellan).

Love Triumphant. Private Collection, Rome. 130.5 × 97.5. Spear, 1971 (4), illus. as Baglione. (In tradition of Roncalli).

Death of Cato. Akademie der Bildenden Künste, Vienna (1973/2, illus. as follower of Manfredi). 134 × 176. (Compare with A. Gentileschi).

Sacrifice of Isaac. Only one original of this subject by Caravaggio is known, in the Uffizi (q.v.). Copies after the only other composition of this subject which can reasonably be assumed to go back to a lost original by him are listed under Caravaggio. Caravaggesque compositions of this subject, the origins of which are unsettled (and therefore not necessarily 'Roman-based'), are as follows. **1.** (Isaac's head on block, held down by Abraham). Lost. Engraved by Le Vasseur in Orléans catalogue (1786) as Caravaggio. Formerly Queen Christina; sale, London 1800. Moir, 1976, Fig. 23. (Cannot possibly reflect Caravaggio original). **2.** (Isaac, almost nude, lying on block but half raised on elbow). Giancarlo Pelloso Collection, Verona, as Saraceni. 102 × 132. (Only remotely Caravaggesque). **3.** (Isaac, half draped, lying on block but half raised on elbow). Formerly Nils Rapp Collection, Stockholm. 105 × 149. Moir, 1976, Fig. 21. (Possibly Flemish, from Elsheimer circle). **4.** (Angel pointing, with left arm above Abraham's head). Dr Leo Loeweohnns Collection, Glasgow (1951–2). 103.5 × 135.9. **5.** (Bundle of sticks by block). Sale, Dorotheum, Vienna, 21–4 Sept. 1971 (24), illus. 123 × 145. (very poor). **6.** (Isaac nude, with arms crossed over chest). Private Collection, Naples. 135 × 203. Marini, 1974, No. C11, illus. p. 316. (?Neapolitan).

David with the Head of Goliath. Galleria Borghese, Rome (1959/118, illus.). 202 × 112. (In direction of Borgianni, *c.* 1610).

Return of the Prodigal Son. Museo de Bellas Artes, Saragossa, on loan from Prado (1970/64). 112 × 147. Figure of youth in plumed cap on left exists in a version: Galleria Spada, Rome (1954/51, illus.). 67.4 × 50. (Schleier, *Kunstchronik*, 1970, p.348 thinks the former is by Giacinto Brandi, the latter by Lanfranco).

Kiss of Judas. Mrs Harry Jackson Collection, Glaslyn (Hereford) (before 1930); ?later in a collection in Washington, DC, as Manfredi. (Conceivably non-Italian).

Crowning with Thorns. Private Collection, Milan (*c.* 1950). 150 × 200. Bottari, 1965, plate 23a as Manfredi. (Unidentifiable Manfredian).

Madonna in Clouds with Saints John the Baptist and John the Evangelist [Plate 19]. Parish Church, Torri in Sabina. (Unconvincingly associated by Salerno, Bagnaia, 1960, with Mao Salini).

St John the Baptist drinking at the Well. Two versions known: **1.** Cecchi Collection, Florence. Borea, 1974, Fig. 1. **2.** Cathedral, Plasencia. 177 × 121. ?C. Exh. Seville, 1973 (39), illus. as anon. Italian. (In direction of Galli.)

St John the Baptist drinking at the Well. Palazzo Giustiniani, Bassano di Sutri. 135 × 105. Salerno, April 1960, Fig. 5. (Possibly listed in Giustiniani Inventory of 1638, II, No. 130).

St John the Baptist drinking at the Well. Formerly Joan Evans Collection, Wotton-under-Edge. 78.2 × 62.2. Exh. Burlington Fine Arts Club, London, 1925 (33), illus. (Inscrutable).

St John the Baptist [Plate 8]. Galleria Nazionale d'Arte Antica, Rome, as Baglione. 95 × 79. (More Caravaggesque than Baglione ever is, in direction of Borgianni).

St John the Baptist. Whereabouts unknown, formerly Galleria Nazionale d'Arte Antica, Rome, as anon. Caravaggesque. 78 × 113. Exh. Gall. Naz., 1955 (4), illus. (Close Caravaggio imitator).

St John the Baptist [Plate 9]. With David Peel, London (1977). (Probably not Italian-born).

St John the Baptist. St Albert's Convent, Hinckley (Leicestershire), as ?Caravaggio. (Imitator).

St Mark; St John the Evangelist (two canvases). Sale, Sotheby's—Parke Bernet Italia, Palazzo Serristori, Florence 16 May 1977 (29), illus. 113 × 98. (Non-Italian, *c.* 1630–5, near Bigot and Stomer).

St Matthew and the Angel. Edoardo Almagià Collection, Rome. 100 × 126.5. Spear, 1972 (13), illus. as anon. *c.* 1620. (?Roman).

Portrait of Borgianni. Accademia di San Luca, Rome. 66 × 50. D 1617. (Vouet circle, but not necessarily French).

Portrait of a Scholar [Plate 11]. Norton Simon Foundation, Los Angeles. 128.3 × 95.8. Kaplan sale, Sotheby's, 12 June 1968 (20), illus. as school of Caravaggio. (Affinities with Munich *Luteplayer*, see below).

Self-Portrait of Youth of about 17 [Plate 10]. Private Collection, London. (Circle of adolescent Bernini, *c.* 1615).

Two Musicians (Girl with Flute-playing Boy) [Plate 12]. Perolari Collection, Bergamo. 88 × 113. Exh. 'Natura Morta', Naples etc. 1964–5 (40), illus. One (superior) variant known: Franco Piedimonte Collection, Naples. 76.2 × 99.1. C. in Musée du Louvre (1926/1123). 121 × 172. (?From Crescenzi circle).

Luteplayer. Bayerische Staatsgemäldesammlung, Munich (Inv. No. 4868). 110 × 81. Longhi, 1943, Pl. 11. (Affinities with Norton Simon *Portrait of a Scholar*, see above).

Still Life with Violinist. Private Collection, Lecce. Volpe, 1973, Fig. 5 and in colour. (Violinist apparently by different hand from still life).

Fluteplayer. Institute of Fine Arts, New York University (?formerly on loan). Held, 1972, illus. detail, as ?Cecco. (Probably French *c.* 1620–5 between Régnier, Bigot and Tournier).

Fortune-Teller. Roman art market (1968). 96 × 136. Moir, 1976, Fig. 7. (Based on Capitoline Caravaggio).

Boy bitten by Crayfish. Two versions: 1. Musée des Beaux-Arts, Strasbourg. 96 × 73. Posner, 1971, Fig. 10. 2. Roman Art Market (1955). 97 × 73.7. Jullian, 1961, plate v, Fig. 3. What appears to be damaged copy is: Musée des Beaux-Arts, Lyon. 117 × 78. *Gazette des Beaux-Arts*, Dec. 1975, Fig. 3, p. 201. (Hard to say whether Italian or Netherlandish; perhaps the former).

Boy bitten by Mouse. V. Mameli Collection, Rome (1954). Moir, 1976, Fig. 6.

II. NEAPOLITAN, SOUTH ITALIAN, SICILIAN, SPANISH

David with Sling and Sword. Fine Arts Gallery, San Diego (Calif.), as Ribera. 128.3 × 95.8. (Towards Stanzione).

Job. Art Institute of Chicago. Nicolson/Wright, 1974, Fig. 61 as '?Spanish School'.

Judith and Holofernes. Real Casa Santa dell'Annunciata, Naples. (?Sicilian).

Christ healing the Sick. Private Collection, Florence (1969). 194.4 × 145. Marini, 1974, No. 81, illus. with details. (Neapolitan or Sicilian).

Adulteress before Christ. Museo di Castelvecchio, Verona. 121 × 142. Longhi, 1959, Fig. 8 as Spadarino? (Puzzling, half-Cavallino, half-Van Dyck). The following by a different hand is comparable:

Raising of Lazarus [Plate 79]. John Herron Art Museum, Indianapolis (Indiana) (1970/57.209), as Roman 1615–25). (?Neapolitan).

Christ at Emmaus [Plate 76: detail]. J. Paul Getty Museum, Malibu (Calif.). 139.6 × 194.3. Spear, 1971 (25), illus. colour, as attributed to Falcone. (Neapolitan).

Christ at Emmaus. John and Mable Ringling Museum of Art, Sarasota (Florida) (1949/116, illus. as Caravaggesque *c.* 1620). 119.4 × 167.6. Exh. Sarasota, 1960 (24), illus. as Van Somer. (Cf. supposed Gramatica *Card Players* at Apsley House, but the Sarasota picture could be Neapolitan).

Vision of St Jerome. Worcester Art Museum, Worcester (Mass.). 72.8 × 97.5 (originally larger, cut on all sides). Spear, 1971 (76), as anon., illus. Marini, 1971, colour plate and many black and white details, as Caravaggio. (Seems to be Sicilian, influenced by late Caravaggio).

St Jerome [Plate 78]. Sale, Sotheby's, 27 March 1963 (79), as Caravaggio. 97.8 × 121.8. (?Neapolitan).

St John the Baptist. Öffentliche Kunstsammlung, Basle (1946, p. 82). 102.5 × 83. Milan, 1951 (45), illus. (?Spanish, perhaps Maino).

Executioner, and Salome with the Head of the Baptist. Private Collection, Milan (1959), as Caracciolo. 90 × 110. Moir, 1976, Fig. 115, as? Bijlert. (?Netherlandish artist working in Naples).

Saints Peter and Paul. University of Nebraska Art Galleries, Lincoln (Nebraska), Kress Collection (1973/ K1535, illus. as attr. to Pietro Novelli). 72.4 × 89.6. (?Neapolitan or South Italian).

Penitent St Peter. Museum, Chieti. Moir, 1976, Fig. 99. (?Sicilian or Sicilian–based Caravaggesque, *c.* 1640–50).

St Sebastian tended by Irene. Sale, Christie's, 16 Oct. 1973 (11) as Neapolitan Caravaggesque. 155 × 116. (?Neapolitan: delicate tints between Cavallino and early Preti).

St Sebastian (alone) [Plate 81]. Galleria dell'Arcivescovado, Milan (?Neapolitan).

St Sebastian with four other figures. Museum Narodowe, Warsaw (1957/170, illus. as Manfredi). 124 × 162. (Between Cecco and Finoglia, probably Neapolitan).

Calling of St Sylvester; Martyrdom of Pope Stephen I. S. Silvestro in Capite, Rome. Each, 270 × 160. Before Dec. 1609. *Stephen:* BP. Toesca, 1960, Figs. 1, 3, 5, (*Sylvester*); Figs. 2, 4 (*Stephen*). (?Neapolitan, in circle of young Caracciolo).

Self Portrait of an Artist (so-called Borgianni). Museo del Prado, Madrid (1972/877). 95 × 71. Spear, 1971 (8), illus. (?Spanish around Tristan).

Fluteplayer. Ashmolean Museum, Oxford (1962/160 as ?Finson). 103 × 138. Bodart, *Finson*, Fig. 54. (?Spanish).

Card Players. Fogg Art Museum, Cambridge (Mass.). 97.1 × 121.9. Berenson, 1953, Pl. 16. Marini, 1974

under No. R15 publishes replica in private collection. (Probably South Spanish, *c.* 1620; affinities with young Velázquez).

Card Sharpers. With Julius Weitzner, New York (1960). 101.6 × 147.3. Exh. Sarasota, 1960 (4), illus. (Possibly Neapolitan).

III. NORTH ITALIAN

Rest on the Flight into Egypt. Brera, Milan. 120 × 170. Castelfranchi Vegas, 1977, Figs. 3–5. (?Emilian or Lombard, or Frenchman working in these districts under Correggio influence). By the same hand is:

Rest on the Flight into Egypt. Formerly Vitale Bloch Collection, The Hague. Castelfranchi Vegas, 1977, Fig. 6.

Christ at Emmaus. Kunsthistorisches Museum, Vienna (1973, illus. Pl. 35). 156 × 199. Nicolson, 1958, Pls. 22, 11, 14, 82. Copies listed under Nicolson No. A73. (Close to Serodine and Terbrugghen but the problem is unsettled).

Fortune-Teller. Galleria Estense, Modena (1948/482), 89 × 76. (?Francesco del Cairo).

IV. FRENCH

Death of Lucretia. Witten Harris Collection, San José (Calif.). 137.2 × 94. (Painted in Rome *c.* 1625–30 in circles of Vouet and Valentin. Cf. L'Homme brothers).

Erythrean Sibyl. Musée des Beaux-Arts, Caen. 91 × 75. *Burl. Mag.*, Feb. 1972, Fig. 40. (French artist of the 1630's who seems to be aware of both Gentileschi and Le Nain).

Christ handing over the Keys to St Peter [Plate 75]. With Galerie Pardo, Paris (1977). 131 × 192. (French or possibly Netherlandish, *c.* 1630).

Crowning with Thorns. Prefettura, Parma, as Valentin. Brejon/Cuzin, 1974, Fig. 26 as ?French. (Could equally well be Netherlandish Manfredian).

Christ at Emmaus [Plate 70]. Musée des Beaux-Arts, Nantes (1913/724, as Valentin). 204 × 154. *Réalité*, 1934 (111), illus. (Probably painted in Rome in the 1630's by a Frenchman in contact with Tournier).

St Francis in Ecstasy, with a Franciscan. Regional Museum, Zhitomir (USSR). 111.5 × 153. Linnik, 1975, illus. colour, Pls. 43–5. (Possibly Lorraine, *c.* 1640).

St Francis in Ecstasy. Private Collection, Paris. 110.5 × 136. Voss, 1965, pp. 402–4, illus. as La Tour. (French or less likely Netherlandish).

St Francis and the Angel [Plate 73]. Two versions known: **1.** With J. Dumont, Paris (1973). **2.** Hermitage, Leningrad, as ?Preti. 119 × 149. Linnik, 1975, illus. colour and black and white, Pls. 92, 93. (?French).

St Jerome. S. Gaudenzio, Novara. 97 × 130. Exh. Rome/Paris, 1973/74 (74), illus. as anon. (Connections with Valentin). A similar picture, also deriving from

Valentin but not necessarily by the same hand, is a **St Jerome** in Galleria Corsini, Florence [Plate 71].

St Jerome. With Heim Gallery, Paris/London (1974). 77 × 92. Exh. Heim Gallery, London, 1974 (3), illus. as anon. (French Master *c.* 1630–40, only remotely Caravaggesque).

St John the Baptist. Durazzo-Pallavicini Collection, Genoa. 135 × 115. Brejon/Cuzin, 1974, Fig. 27. (?French).

Liberation of St Peter. Parish Church, Rosay-en-Brie. (Wrongly associated by Ivanoff, 1962, p. 66 with engraving of this subject by Jan Pynas and Claes Pietersz. Lastman (1609), Hollstein, 1949ff., IX, p. 34; painted copy in Bredius Museum, The Hague (1978/131, illus.).

Denial of St Peter [Plate 74]. Musée des Beaux-Arts, Rouen (1966/248, as Italian 17th century). 113 × 145. (Looks more French, echoing Vouet and Valentin).

Denial of St Peter. Musée du Louvre, Paris (1972/M.I. 1450 as ?French; 1974 catalogue of illustrations, No. 1022). 94 × 152. (Possibly Netherlandish and not French).

Luteplayer [Plate 72]. With Edward Speelman, London (1973). 88.7 × 107.8. (Similar to Group 'Master K').

Concert and Drinking Party. Formerly Paul Jamot Collection, Paris (1934). 115 × 103. *Réalité*, 1934 (138), illus. (?French).

Eating and Drinking Party. With Marshall Spink, London (1958). 113 × 154.9. *Burl. Mag.*, supplement June 1958, Pl. v. (Poor near-Caravaggesque, probably French).

Bust of Man. Florentine Galleries. 'French Painting', Florence, 1977 (LXXVI), illus. (Near Tournier).

Head of Youth (?David). Musée Crozatier, Le Puy, as Caracciolo. 65 × 55. Brejon/Cuzin, 1976, Fig. 6 as ?Régnier. (Possibly French from the Vouet circle, but reverting to Giorgionesque 'Bravo' type).

V. NORTH NETHERLANDISH

Lot and his Daughters [Plate 184]. With Rothmann, London (1958). 127 × 111.8. Nicolson, 1958, No. E105. (Perhaps Utrecht, in direction of Terbrugghen).

Esau selling his Birthright [Plate 181]. National Westminster Bank, London. 74.9 × 94.6. (?Utrecht).

Esau selling his Birthright [Plate 182]. Two versions: **1.** Mrs C. A. W. Beaumont Collection, London. 99.1 × 111.8. **2.** (without dog). Sale, Galleria d'Arte Bernini, Rome, 21 March 1977 (117), as Antonio Maria Vassallo. 98 × 120. (Hard to pinpoint; cf. Michel Corneille at Orléans [1630]).

Man of Sorrows. Church of Chancelade (Dordogne). 136 × 94. Pariset, 1948, Pl. 22 as La Tour. (Comparable to Roman-period Honthorst, 1615–20). One copy known: Rijksmuseum, Amsterdam (1976/A3569, illus.). 134 × 99. Frabetti, 1959, Fig. 6.

Christ at Emmaus. Prefettura, Rome. 122 ×

167. Exh. Gall. Naz. (1955/7, illus.), as anon. (?Utrecht).

St Cecilia. Pastorie Oud-Katholieke Kerk, Oudewater. 111 × 130. Hoogewerff, 1965, No. 22. (Near Bijlert).

Concert in the Open Air. Jacques Dupont Collection, Paris. (?Haarlem around Blommendael, with Utrecht affiliations).

Concert with Drinker. (Six figures). Dr Henri Barbier Collection, Geneva (*c.* 1950). 143 × 178. Van de Watering, 1967, Pl. 9, as Tilmann. (Elements of Honthorst, Tilmann and L. Portengen).

Boy pointing to Tumbler. F. Strecker Collection, Vienna (1963); sale, Dorotheum, Vienna, 3–6 Dec. 1963 (118), illus., as Utrecht, *c.* 1630. Panel, 93 × 72.5. (Terbrugghen influence).

Man frightened. Dr and Mrs James Lasry Collection, La Jolla (Calif.). Moir 1976, Fig. 4. (In direction of Crabeth).

Painter in his Studio. Galleria Nazionale d'Arte Antica, Rome. 97 × 135. Hoogewerff, 1952, Pl. 2, as Terbrugghen. Nicolson, 1958, No. E110. (?Utrecht, *c.* 1630).

Boy with Candle [Plate 183]. Commander J. B. Laing Collection, London. (Utrecht associations).

Unidentified Subject. (?Scene of Suicide from a contemporary Dutch play). [Plate 107]. With Heim Gallery, London (1977). 105.6 × 96.5 (Total mystery).

VI. SOUTH NETHERLANDISH

Allegory of the five Senses. Formerly Mme L. H. Roblot Collection, Paris; sale, Galerie Georges Petit, Paris, 13 March 1914 (39); sale, Galliéra, Paris, 7 March 1970 (70), illus. 192 × 250. Roblot Delondre, 1930, Fig. 3, p. 187 as Seghers. Pendant to *Backgammon Players*, see below. (Direction of Rombouts).

Crowning with Thorns. Musée du Louvre, Paris, as Jan Janssens. 134 × 99. (Probably South Netherlandish influenced by Terbrugghen).

Christ at Emmaus [Plate 110]. City Art Gallery, York, as Van Herp. 105.4 × 134.6 (No suggestions).

St John the Evangelist [Plate 104]. Musée de Tessé, Le Mans (No. 224), as Valentin. (Antwerp Caravaggist in direction of Rubens).

Calling of St Matthew. Jocelyn T. Duesberry Collection, New York (1972); sale, Sotheby's Parke Bernet, New York, 6 March 1975 (72), illus. as Neapolitan 17th century. 120.6 × 195.6. (Barely Caravaggesque).

St Matthew and the Angel. John and Mable Ringling Museum of Art, Sarasota (Florida) (1949/109, illus. as attributed to Gentileschi). 105.4 × 119.4. Spear, 1971 (80), illus., as anon. *c.* 1620–30. One reduced copy (?) known: Princeton University Art Museum, Princeton (NJ). 81.9 × 101.6. (?Bruges School, near Van Oost).

Liberation of St Peter. Two versions known: **1.** St Peter's, Ghent. Spear, 1971, Fig. 45, as anon. **2.** North Carolina Museum of Art, Raleigh (NC) (1956/152), as Le Clerc). 120.6 × 96.5. Spear, 1971 (81), illus., as anon. (?Antwerp artist in Rome, influenced by Saraceni, working in direction of the young Rombouts).

Denial of St Peter. University of Wisconsin, Elvehjem Art Center, Madison (Wisconsin) as G. Seghers. 116.8 × 165.1. Roggen/Pauwels, 1955–6, Pl. 9, as Seghers. (Dependent on Seghers but more Baroque).

Incredulity of St Thomas. Pio Monte della Misericordia, Naples. 122 × 167. Causa, 1970, Pl. XIV in colour, as Baburen. (By a Flemish Caravaggesque, slightly Van Dyckian).

Concert (six figures). Staatliches Museum, Schloss Mosigkau (1976/17, as Rombouts, illus.). 169 × 204. Mirimonde, 1965, Fig. 30. (Antwerp or Bruges?).

Concert (five figures). Cummer Gallery of Art, Jacksonville (Florida) (1971 Yearbook, illus. colour). 113 × 175.3. (Circle of Rombouts).

Concert in the Open Air. Dr G. Deuche Sale, Berlin, 7 Dec. 1932, as Rombouts. Mirimonde, 1965, Fig. 31. (Late Antwerp Caravaggist).

Luteplayer. Gemäldegalerie, Dresden (1930/1841, as Liss). 105 × 77.5. Bodart, *Finson*, Fig. 50. (Near Finson, but better).

Card Players. Private Collection, London (1977). 112 × 185. (?Bruges School in direction of Van Oost, but could equally be East France).

Backgammon Players. Formerly Mme L. H. Roblot Collection, Paris; sale, Galerie Georges Petit, Paris 13 March 1914 (39); sale, Galliéra, Paris, 7 March 1970 (70), illus. 192 × 250. Roblot Delondre, 1930, Fig. 3, p. 187 as Seghers. Pendant to *Allegory of five Senses*, see above. (Direction of Rombouts).

Morra Players. Pinacoteca, Siena. 116 × 173. Bodart, 1970, Fig. 28. (Self portrait top left. Affinities with Lanfranchi—Moffo *Second-hand Goods Seller*, see under Master G.) By the same hand is: **Soldiers playing Cards on a Drum.** G. Grisaldi del Taia Collection, Siena (1932). Brandi, 1932, Pl. xii. (Near Manetti, with Cecco-like elements).

VII. CENTRAL EUROPEAN

Concert; Fortune-Teller (two panels, pairs). Galleria Pallavicini Collection, Rome (1959/108, 107), both illus.). Panels, 45.7 × 33.8 and 45.5 × 32.8 respectively. **Fortune-Teller** derived from etching in same direction inscribed with initials MAAIF, illus. Zahn, 1928, Fig. 5 as Caravaggio. Related drawing in Uffizi (1353E), an interpretation of the etching, illus. *Mostra di Disegni Veneziani del Sei e Settecento* 1953 (50), as Liss; pen and ink, water-colour and bistre, 19.5 × 22.

Another related drawing: Museo de San Carlos, Instituto Nacional de Bellas Artes, Mexico City, as Guercino. Pen, wash and gouache, 18 × 17. (?German showing affinities with Vignon, Lallemand and Tilmann).

Boy with Candle and Book [Plate 241]. Bayerische Staatsgemäldesammlung, Munich (Inv. No. 7058). 63 × 51. (German, *c.* 1630).

CAROSELLI, Angelo (Feb. 1585–April 1652)

Born and bred in Rome. Well known as copyist of the Carracci, Raphael, Poussin etc. In Florence, 1605; in Naples, 1613; back in Rome not later than 1615, the date of his first marriage. Listed among Accademici di S. Luca, 1608–36. His chronology has to be reconstructed from internal evidence since one picture only is datable (1631) and that largely the work of his brother-in-law. But a short near-Caravaggesque phase (which is alone listed) seems to occur in the late 1610's and 1620's. Later, he develops an eclectic style, reverting to Renaissance models, occasionally approaching the Baroque and neo-Venetian manner of Mola and Testa. His necromantic pictures (if they are in fact by his hand, which is uncertain) are unfortunate. O followed by stroke and plate refers to Ottani, 1965.

Spring; Autumn. Musée Fesch, Ajaccio. Two octagonal panels. O/Plate 115a (*Spring*). From series of *Four Seasons*, to which also belongs:
Summer. With Sestieri, Rome (1965). Octagonal panel. O/Plate 114b.
Vanitas. Longhi Collection, Florence (1971, Pl. 64 in colour). Panel, 66 × 61. Bore false initials R.M. O/Plate 114a.
Christ and the Adulteress. Sale, Finarte, Milan, 18 April 1972 (12), illus. 126 × 150.
Penitent Magdalen. Musée Calvet, Avignon (No. 529). O/Plate 113b.
Male Portrait with a Tacitus in his Hand. Private Collection, Berlin. O/Plate 113a.
Man Singing. Kunsthistorisches Museum, Vienna (1973, illus., Pl. 35). Panel, 53 × 43. S. O/Plate 119a.
Girl Singing. Whereabouts unknown. Exh. Baroque exh. Berlin, 1927 (29). 48 × 37.
Procuress. Sale, Dorotheum, Vienna, 13–15 March 1958 (21), illus.; sale, Sotheby's, 15 July 1970 (104), illus. 62 × 76. Engraved in outline in same direction in Rosini, 1852, VI, as in Gerini Collection.
The Dupe of Love. Major W. M. P. Kincaid-Lennox Collection, Downton Castle (Herefordshire). Panel, 54.6 × 77.5. Moir, 1976, Fig. 29.

The following is a selection of wrong attributions to Caroselli:

*Attributed to Guerrieri **Allegorical Scene.** Galleria Pallavicini, Rome (1959/110, illus.). 73.7 × 123.7.
?A. Gentileschi **St Cecilia.** Galleria Spada, Rome.
Paolini **Conversion of the Magdalen.** Galleria Pallavicini, Rome.
Honthorst imitator **Girl Singing, with Old Woman.** Mario Modestini Collection, New York (1924).
Paolini **Boy Violinist.** University of Wisconsin, Madison (Wisconsin).

CASSARINO or CASSAVINO

Nothing is known of this artist who signed the Caravaggesque picture listed below:

St Sebastian tended by Irene. Co-Cathedral of St John, Valletta (Malta). 204 × 154. S. before 1624. Moir, 1967, Fig. 232, as Minniti.

CAVAROZZI, Bartolomeo (after 1585–Sept. 1625)

From Viterbo. Comes to Rome as youth. Nothing datable before the quite non-Caravaggesque Viterbo *Visitation* (1622), except a Pomarancio-like *St Ursula* (1608). Patronized by the Crescenzi family, with whom he lives in the second decade more or less as an adopted son, earning the name of 'Bartolomeo dei Crescenzi'. It is through them, no doubt, that he moves away from Pomarancio towards Caravaggio *c.* 1610, for a decade or so. Evidently associated with Fiasella (who is in Rome, 1615) and may himself make the trip to Genoa. Taken to Spain by Giovan Battista Crescenzi, a once famous still life painter, probably towards the end of 1617. Back in Rome *c.* 1620, where he dies five years later. Only a few

works listed, where in Baglione's phrase, '*diedesi a ritrarre dal naturale*'. P S followed by stroke and plate number refers to Pérez Sánchez, 1964.

Holy Family. Several variants recorded, of which the best known are: **1.** Galleria Spada, Rome (1954/153, illus.). 168.3 × 111. Perhaps a Genoese variant of Cavarozzi's pattern (?Fiasella). **2.** Private Collection, Madrid. P S/Pl. 22, who cites two further versions in Madrid and New York Collections, both once known as Zurbarán. **3.** Dr Jan Billiter Collection, Vienna (1928). Zahn, 1928, Fig. 7 (shown as half length, but strikingly similar to whole length illus. Borea, 1972, Fig. 8 as ?Cecco). Longhi, 1943, note 69, cites other replicas and copies.

Holy Family. Sale, Finarte, Rome, 12–13 Dec. 1973 (65), illus. colour. 156 × 118.

Holy Family. Hermitage, Leningrad. 143.5 × 121. Linnik, 1975, illus. colour Pl. 64 (half length). Flemish copy of this composition whole length, *Madonna and Child* alone, is: Earl of Haddington Collection, Tyninghame (East Lothian). Panel, 61.3 × 44.8. Set in Van Balen-like landscape with peacocks etc. Of the same pattern is a Flemish *Holy Family* in a garland of flowers: Dr Miklos Rosza, Hollywood, as Jan Breughel and Seghers. Panel (oval), 104 × 73.5.

Holy Family. Accademia Albertina, Turin. 174 × 130. Longhi, 1943, Pl. 73.

Mystic Marriage of St Catherine, including Holy Family with Virgin crowned by Angels. Several versions recorded, of which some are: **1.** Museo del Prado, Madrid (1972/146). 256 × 170. Certainly original. P S/Plate 18. **2.** Staatsgalerie, Stuttgart (1962, p. 119 as ?Maino). 252 × 171. Probably C. P S/Plate 19a. **3.** With Gilberto Algranti, Milan (1973). 240 × 152. Probable original. Faldi, 1970, Fig. 225. **4.** Duque del Infantado Collection, Madrid. Probably C. P S/Plate 19b. **5.** With Central Picture Galleries, New York (1971). 157.5 × 124.5. Top half of composition only. ?C. Sale, Christie's, 17 July 1964 (108), illus. P S cites further replicas under Nos. 19a and b, p. 47.

St Jerome. Florentine Galleries, 116 × 173. Exh. Florence, 1970 (18) illus.

The following is a wrong attribution to Cavarozzi:

Caravaggio **St John the Baptist.** Cathedral, Toledo.

CECCO DEL CARAVAGGIO

Described by Mancini (*c.* 1620) as 'Francesco detto Cecco del Caravaggio'. His stylistic affinity with Maino indicates a Spaniard by origin, but he is in Rome early in the second decade at work with Tassi at Bagnaia in the service of Cardinal Montalto, accompanied by Frenchmen (1613). Influenced by Finson as well as Caravaggio, and apparently in contact with Ducamps (?late 1620's). All works listed.

Cupid at the Fountain (*trompe l'oeil*). Viti Collection, Rome. 119 × 170. Longhi, 1943, Pl. 58.

Christ driving the Money Changers from the Temple. Staatliche Museen, Berlin (East). 128 × 173. Longhi, 1943, Pl. 57. Engraved as from Giustiniani Collection in Landon (1812) as Ducamps.

Resurrection [Plate 27: detail]. Art Institute of Chicago. 339 × 199.5. Longhi, 1943, Pl. 60.

Guardian Angel with St Ursula and St Thomas. Nelson Gallery—Atkins Museum, Kansas City (Missouri). 212.7 × 106.7. B P. F. Spear, 1971 (22), illus.

Martyrdom of St Cecilia. Musée Granet, Aix-en-Provence, as Venetian School.

St Lawrence. Two versions known: **1.** Oratorio di San Filippo Neri alla Chiesa Nuova, Rome. 143 × 95. Spear, 1971, Fig. 17. **2.** Private Collection, Rome. Salerno, 1971, Pl. 2.

Penitent Magdalen [Plate 29]. Städtische Kunstsammlungen, Augsburg. 144 × 102.

Penitent Magdalen [Plate 30]. With Silvano Lodi, Munich (1969). 96 × 74. Bodart, *Finson*, Fig. 61.

St Margaret. Convento de las Descalzas Reales, Madrid. 101 × 83. Exh., Seville, 1973 (21), illus.

Male Portrait with Rabbit. Palacio Real, Madrid.

66 × 47. Pendant to Prado *Female Portrait* (q.v.). Exh. Madrid, 1970 (53), illus.

Female Portrait with Dove. Museo del Prado, Madrid (1972/148 as A. Gentileschi). 66 × 47. Pendant to Palacio Real *Male Portrait* (q.v.), probably marriage portraits. Exh. Madrid, 1970 (52), illus.

Musical Instrument Maker. National Gallery, Athens. *c.* 117 × 98. Variant of picture in Wellington Museum (q.v.). Bodart, *Finson*, Fig. 55.

Musical Instrument Maker. Wellington Museum, Apsley House, London. 123.8 × 98.4. Variant of picture in Athens (q.v.). Spear, 1971 (23), illus.

Still Life, two paintings. Private Collection, Bergamo. Oil on parchment, each 48 × 62. Exh. 'La Natura Morta Italiana', Naples—Zurich—Rotterdam, 1964–5 (35–6), illus.

The following is a selection of wrong attributions to Cecco:

*Fra Paolo Novelli series of frescoes from the story of Moses, and one other. Palazzina Montalto, Villa Lante, Bagnaia (Viterbo). Salerno, *Bagnaia*, 1960, Figs. 9, 10, 12–14, as ?Cecco.

*Circle of Lanfranco **Susanna and the Elders.** 180.4

× 208.2. Exh. Helikon, London, 1974 as attributed to Lanfranco, illus.

Cavarozzi imitator **Holy Family.** Galleria Spada, Rome.

Gentileschi imitator **St Peter Nolasco upheld by Angels.** SS. Annunziata a Piazza Buenos Aires, Convento dei Mercedari, Rome.

Caravaggesque unknown (Neapolitan) **St Sebastian.** Muzeum Narodowe, Warsaw.

Caravaggesque unknown (Roman-based) **Luteplayer.** Bayerische Staatsgemäldesammlung, Munich.

Caravaggesque unknown (?Spanish) **Fluteplayer.** Ashmolean Museum, Oxford.

CESAR VAN EVERDINGEN (*c.* 1616/17–Oct. 1678)

Born Alkmaar. Enters Alkmaar Guild, 1632. According to Houbraken, a pupil of Bronckhorst. In Alkmaar, 1643–45, 1647. Living in Haarlem, 1648 and enters Guild there, 1651; Dean, 1655–56. Works at Huis ten Bosch, *c.* 1648–50. Returns to Alkmaar, where he dies. Shows affinities with Haarlem Classicists, and Bor. Born too late to be classified as true Caravaggist and only very few marginally Utrecht-like pictures listed.

Venus and Cupid. Frans Halsmuseum, Haarlem. 115 × 96. Von Schneider, 1933, Pl. 33a.

Girl as Flora (Sense of Smell). With Malcolm Waddingham and Old Master Galleries, London (1971). 61.4 × 50.1. S. Sale, Sotheby's, 24 Nov. 1971 (10), illus.

Allegory of Winter. Southampton Art Gallery. 91.4 × 71.1. Bloch, 1936, Fig.3.

St Sebastian tended by Irene. Formerly Cathedral, Ghent. Lost. Engraving after C. van Everdingen.

Female Cittern Player. Musée des Beaux-Arts, Rouen (1967, p. 47, illus). 75 × 60. S. Exh. Paris, 1970 (74), illus. Paris catalogue notes C. in Vienna sale, 1958.

Young Woman with Flower and Hand Mirror [Plate 225]. Schloss Weissenstein, Pommersfelden. Panel, 78.5 × 64.5. S.

Young Woman combing her Hair. Formerly Baron Steengracht Collection, The Hague; sale, Paris, 9 June 1913 (22), illus. Panel, 70.5 × 61.5. S. Von Schneider, 1933, Pl. 33b.

***Shepherdess.** Yale University Art Gallery, New Haven, as Bor. *Burl. Mag.*, Jan. 1971, Fig. 79.

COSSIERS, Jan (July 1600–July 1671)

Born Antwerp. Pupil of his father Antoon, later perhaps of Cornelis de Vos. In Aix-en-Provence, 1623–4 on his way to Italy; with Adriaen de Vries there June–Sept. 1623; again Aug. 1624. Works there for the Pénitents Noirs (lost) with Hugues Martin. In Rome by Oct. 1624. ?Visits Spain. Passes through Aix again on his way home, 1626. Master of the Antwerp Guild of St Luke, 1628–9. In later years is caught up in the Flemish Baroque current, but is responsible for a small group (inadequately studied) of early, near-Caravaggesque genre scenes, some of which are listed below.

Concert Party. Hospice, Cachan (near Paris). 150 × 195. S. Boyer, 1956, Fig. 1.

Concert Party (four figures plus boy serving drink) [Plate 95]. ?Lost. One (?) copy known: Residenz, Würzburg. 137 × 156 (enlarged to fit Rococo frame). Three of the five figures reappear in two copies: **1.** Private Collection, Munich. 103 × 76. **2.** Berlin Art Market (1933). Mirimonde, 1965, Fig. 32.

Luteplayer and Singer with Death as Violinist. Lost. Engraved by J. Meyssens after Cossiers.

Backgammon Players, with Woman pouring out Glass of Wine. With Julius Weitzner, New York (1956). C. With Alan Jacobs, London (1974). 100 × 150. The same subject represented in a Cossiers in museum at St.-Omer, Exh. Lille/Calais/Arras, 1977/10, illus. 154 × 219.

Fortune-Teller (boy turned to right). Two versions known with marked changes: **1.** Hermitage, Leningrad (No. 4717). 132 × 155. S. Exh. Leningrad 1973 (25). Linnik, 1975, illus. colour Pls. 173–6 (also black and white). **2.** Losser-Zollheim Collection, Baden (1924); Grimsburg sale, Dorotheum, Vienna, 14–19 March 1921 (93), illus. 110 × 156.

Fortune-Teller (boy turned to left). Two versions known: **1.** Staatliche Kunsthalle, Karlsruhe (1961/25, illus.). Panel, 83.5 × 120. **2.** Nationalmuseum, Stockholm. 117 × 183. S. Granberg, 1912 (165), Pl. 91.

Fortune-Teller (similar composition to Karlsruhe/Stockholm above) [Plate 100]. Two versions known: **1.** Bayerische Staatsgemäldesammlung, Munich (No. 231). 135 × 200. **2.** Museum, Valenciennes. 112 × 169. S. Linnik, 1975, illus. opp. Pl. 173.

Man lighting Pipe from Candle and Youth with Tankard. Koninklijk Museum voor Schone Kunsten, Antwerp (1958/38). 123 × 101. F. Mirimonde, 1965, Fig. 33. Whole composition known from copy (with

two figures, a man and a woman, seated left): The Hague Art Market (1961). 68 × 82.

Boy pouring Liquid from Tankard into Glass. Akademie der Bildenden Künste, Vienna (1973/8, illus.). Panel, 74.5 × 57.

The following is a wrong attribution to Jan Cossiers: Simon Cossiers **Two Youths with Wineglass and a third smoking.** Musée du Louvre.

COSSIERS, Simon (active in 1620's)

Nothing is known of this excellent artist who signs the picture listed below, but he must surely be related to Jan Cossiers.

Two Youths with Wineglass and a third smoking. Musée du Louvre, Paris (1922/1952E). 62 × 93. S & D 1626. Von Schneider, 1933, Pl. 45a, as Jan Cossiers.

COSTER, Adam de (*c.* 1586–May 1643)

Born at Malines, where there was a sixteenth-century tradition of candle-light painting. Master of the Guild at Antwerp, 1607–8. Documented at Hamburg, 1635. No Italian journey recorded, but affinities with Antonio Campi seem to indicate a visit to Lombardy. Described as '*Pictor noctium*' in Van Dyck's *Iconography*. Contact with Gerard Seghers and perhaps the Elder Van Oost in Flanders. All pictures listed. All attributions based on Vorsterman engraving after lost *Backgammon Players*. N followed by stroke and Fig. number refers to Nicolson, 1966.

Judith and Holofernes. Museo del Prado, Madrid (1975 Flemish cat./1466, as anon. Flemish) (on loan to Seville Museum). 144 × 155. UU.

Concert, with Youth lighting Pipe from Candle (ten figures). Lost. One copy known: Arcade Gallery, London (1957) as Heimbach. 63.5 × 99. Nicolson, 1961, Fig. 36.

Concert (four figures). Hampton Court Palace (1929/ store No. 537 as Honthorst). 118 × 158. Nicolson, 1961, Fig. 37.

Concert (four figures). Formerly Preuss. Schlösser und Gärten, Berlin (No. I 5450), as Honthorst.

Concert (three figures). Liechtenstein Collection, Vaduz. 117 × 92. Von Schneider, 1933, Pl. 39a.

Concert (three figures) [Plate 92]. Niall Meagher Collection, Naas, County Kildare (Eire). 106.7 × 86.4. One copy known: with O. Poggi, Rome (1976).

Luteplayer and Singer. Musée de Peinture et de Sculpture, Grenoble, as Honthorst. N/Fig. 48.

Singer and Smoker. Galerie St Luc, Paris (1948). 110 × 85. Probably C. F. Pariset, 1948, Pl. 9 (5).

Singer by Candlelight. National Gallery of Ireland, Dublin (1971/1005). 123 × 93. U. N/Fig. 50.

Boy Singer [Plate 93]. Four versions known: **1.** Mrs Judith Leycester Collection, Godmanchester (1966). *c.* 65 × 50. N/Fig. 53. **2.** With Ira Spanierman, New York (1970), as Le Clerc. 72.7 × 55.9. **3.** H. Wetzlar Collection, Amsterdam, as Adam de Coster. 67 × 51. N/Fig. 54. **4.** R. Underwood Collection, Amarillo (Texas) (1960's), as Schalken.

Boy Singer. Formerly Bellanger Collection, Paris, as Honthorst. N/Fig. 55.

Card Sharpers with Luteplayer (five figures). Two versions known: **1.** Dr Theodor Bauer Sale, Berlin, 12 May 1928 (60), illus., as Honthorst. 117 × 156. **2.** Rectorado de la Universidad, Santiago de Compostela, as follower of Honthorst. Valdivieso, 1973, p. 285, illus.

Card Players with Man lighting Pipe from Candle (five figures). Two versions known: **1.** Left hand group only. Musée Municipal, Guéret. 110 × 92. F. Thuillier, 1973, Pl. D14. **2.** Whole composition. Caloyannis Collection, Athens. 108 × 143. N/Fig. 45.

Backgammon Players with Luteplayer. Lost. Engraved by Vorsterman (in reverse) after De Coster. 26.6 × 35. Von Schneider, 1933, Pl. 39b.

Scene of Mercenary Love. Sale, Dorotheum, Vienna, 17–20 March 1964 (25), illus. as De Coster. 123 × 100. N/Fig. 52.

Two Men with Statuettes. Statens Museum for Kunst, Copenhagen (1951/880). 114 × 95. Nicolson, 1961, Fig. 38.

Drinker by Candlelight. Nationalmuseum, Stockholm (1958/469, as Honthorst). 85 × 64. U. N/Fig. 49.

Boy blowing on Firebrand. Two versions known: **1.** Formerly A. Busiri Vici Collection, Rome, as Volmarijn. 68.5 × 15.5. N/Fig. 56. **2.** Museum, Dunkirk (1974/p. 72 as Volmarijn, illus.). 72 × 60.

The following is a selection of wrong attributions to De Coster:

Paolini **Concert** (three figures plus Angel). J. Paul Getty Museum, Malibu (that is, if this is the picture referred to by Longhi, 1958, p. 63 as not by Valentin in the Czernin Collection).
Rombouts **Concert.** Galleria Nazionale d'Arte Antica, Rome.

*Jens Juel **Boy reading by Candlelight.** Lord Clark Collection, Saltwood Castle. N/Fig. 46, where it is described, erroneously, as by the anonymous master now identified by me with De Coster.

COUWENBERGH, Christiaan van (Sept. 1604–July 1667)

Born Delft. In Italy before 1625. On his return, works in Delft (inscribed in guild records, 1627), until 1647; then at The Hague. One of the team under Van Campen at the Oranjezaal, early 1650's. Settles in Cologne in 1654 as portrait painter, where he dies. Signs with monogram 'CB' (Couwen Bergh). Sets out under influence of Baburen, Terbrugghen and Moeyaert, but loses his Caravaggesque affiliations in the 1630's. Only works down to mid-1630's listed and not all of these. G followed by stroke and number refers to catalogue numbers in Van Gelder, 1948–9, and B-M followed by stroke and Fig. number refers to Brière-Misme, 1955.

Bacchus and Ceres. Arcade Gallery, London (1953). 158 × 210. S & D 1626. G/11. Pl. 31.
Roman Charity. Hermitage, Leningrad. 122 × 142. S & D 1634. Exh. Leningrad, 1973 (22), illus. Linnik, 1975, illus. colour Plate 132.
Joseph and Potiphar's Wife. Lilienfeld Sale, Berlin, 6 Dec. 1933 (75), illus. as C. Bloemaert. 120 × 137. S & D 1626. G/2.
Samson and Delilah. Town Hall, Dordrecht. 156 × 196. Before 1632. B-M/Fig. 3.
Christ in the House of Mary and Martha. Musée des Beaux-Arts, Nantes (1913/482 as ?Cornelis Bloemaert). 122 × 147. S & D 1629. B-M/Fig. 4.
Quarrel over Cards. Wegg Sale, Giroux, Brussels, 11 May 1925 (76), illus. 117.5 × 141. S & D 1627.
Backgammon Players. Los Angeles County Museum; sale, Sotheby's Parke Bernet, Los Angeles, 7 Nov. 1977 (178), illus. 105.4 × 130.8. S & D 1630. G/78. B-M/Fig. 1.

Woman holding up Glass, with luteplaying and pipe-smoking Man behind. Whereabouts unknown. Bore false Hals signature and date 1650. Formerly as J. M. Molenaer. Panel, 90 × 74.
Two Men and a Girl at a Table. Formerly Van Gelder Collection, Uccle. Panel, 78 × 110. S & D 1626. G/70, Pl. 27.
Man with Tankard and Glass. Formerly Morris Kaplan Collection, Chicago; sale, Sotheby's, 12 June 1968 (5), illus. as Baburen. 67.3 × 60.3.
Man holding up two Glasses, inscribed 'ic. hebse. beij'. Whereabouts unknown.
Man with Glass and Pipe. F. Stuyck Collection, Antwerp (1952); with S. Nijstad, The Hague (1960). Panel, 89 × 73. S & D 1627. G/56.
Smoker with Mug [Plate 226]. Museo Nazionale di S. Martino, Naples. 65 × 55. G/63.
Rape of a Negress. Musée des Beaux-Arts, Strasbourg. 104 × 127. S & D 1632. Ad. *Burl. Mag.* supplement, June 1970, Pl. XXIII.

CRABETH, Wouter Pietersz. II (c. 1593–1644)

From Gouda. Pupil of Cornelis Ketel. Travels to Italy *via* France; from 1615 onwards working in Rome (where he is documented 1619, 1621–2 with Bramer), but back in Gouda by summer 1628, where he is active for the remainder of his life. One of the founders of the Schildersbent, known there as 'Almanack'. Evidently associated in Rome with Baburen, Rombouts and De Haan, and on his return influenced by Terbrugghen. Only a few works listed.

Christ among the Doctors. Kunsthistorisches Museum, Vienna. U. (See under circle of Baburen).
St Jerome. With Trafalgar Galleries, London (1975). U. (See under circle of Baburen).
Incredulity of St Thomas. Rijksmuseum, Amsterdam (1976/A1965, illus.). 240 × 308. Von Schneider, 1933, Pl. 26a. Engraved by Cornelis van Dalem as after Crabeth (42 × 51.8).
Concert (four figures). Laszló Sale, Ernst-Museum,

Budapest, 9 Dec. 1929 (221), illus. as Honthorst. 134 × 170.
Concert (three figures) [Plate 138]. With Guy Darrieutort, Paris. 132 × 170.
Flute-playing Shepherd, and Shepherdess. Koninklijk Museum voor Schone Kunsten, Antwerp (1958/600). 87 × 70. S. Hoogewerff, 1952, Pl. 12.
Card Sharpers. Sale, Dorotheum, Vienna, 19–22 Sept. 1961 (29), illus. Panel, 78 × 110.

Card Sharpers. Muzeum Narodowe, Warsaw (1957/188, illus.). 134 × 169. S. Pendant to:
Card Sharpers. Formerly Pflaum Collection, Fahnenburg (near Düsseldorf). S. Voss, 1924, Pl. 135.
Gipsy or **Magus.** Saibene Collection, Rome (1955). 66 × 52. U. Zeri, 1955, Pl. 43.

Beggar. Galleria Borghese, Rome. U. (See under circle of Baburen).

The following is a wrong attribution to Crabeth:
David de Haan **Entombment.** Formerly Kaiser-Friedrich Museum, Berlin.

DOBSON, William (March 1611–Oct. 1646)

Chiefly remembered as a fine portrait painter of the Royalist Court in the early and mid-1640's. His copy after Stomer listed below is the only English Caravaggesque picture known.

Executioner with Head of St John the Baptist.
Walker Art Gallery, Liverpool. 110 × 130.1. *Burl. Mag.*, Jan. 1957, Fig. 37. C of Stomer's picture in Denis Mahon's Collection (q.v.).

DOUFFET, Gérard (1594–1661/5)

Born Liège. Is said to work in Rubens's studio 1612–14, but a painting in Liège dated 1615 is quite un-Rubensian as well as un-Caravaggesque. A 'Gerardo Fiammingo' who cannot be Honthorst or Seghers because they are both back in the North earlier, and may be Douffet, is recorded in Rome between 1615 and 1623. Certainly in Rome, 1620–2 living with Valentin. May visit Naples, but is documented in Venice winter 1622–3, penniless. Back in Liège by Spring 1623. From Sept. 1634 onwards, official painter to Prince-Bishop of Liège, Ferdinand of Bavaria. Close affinities with the 'Master of the Judgement of Solomon', with whom he is sometimes sensibly identified. Influenced by Baburen, Valentin, Vouet and Cecco. Active on return home as portrait painter. Only a handful of near-Caravaggesque pictures listed, none of which are certainly Roman period.

Roman Charity. Schloss Weissenstein, Pommersfelden. 146 × 190. U.
Pope Nicholas V at the Tomb of St Francis. Bayerische Staatsgemäldesammlung, Munich. 404 × 347. 1627. Bodart, 1970, Fig. 22.
Christ appearing to St James the Great. Bayerische Staatsgemäldesammlung, Munich. 227 × 169. S. Bodart, 1970, Fig. 23.
Entombment. Obere Pfarrkirche zu Unserer Lieben Frau, Bamberg. 240 × 130. U.
Holy Cross appearing to St Helena. Bayerische Staatsgemäldesammlung, Munich. 309 × 367. S & D 1624. Von Schneider, 1933, Pl. 35b.
St Roch; St Sebastian (two canvases) [Plate 77: detail]. With Gilberto Algranti, Milan (1973). Each 116 × 84.5. UU. Algranti Exh., Milan, 1973, both illus. colour, plus details.

The following is from the circle of Douffet, in the direction of Valentin:

Prophet with a Book [Plate 80]. Kunsthalle, Karlsruhe. 105 × 85.5.

The following is a wrong attribution to Douffet:

*Neapolitan School **Saints Peter and Paul.** Three versions known: **1.** Musée des Beaux-Arts, Strasbourg (1938/103 as Douffet). 126 × 112. Bore false Ribera signature. Trapier, 1952, Fig. 170. **2.** Ruffo Scaletta Collection, Rome. **3.** Dr Hans Wetzlar Sale, Sotheby's Mak van Waay, Amsterdam, 9 June 1977 (172), illus., as Pietro Novelli. 124.6 × 101.6. Several copies recorded in Spain.

DUCAMPS, Jean (*c.* 1600–after 1638)

From Cambrai. Pupil of Abraham Janssens in Antwerp. In Rome at latest by 1622, until 1638, living part of the time with Kuyl (1629–31), later with Pieter van Laer. Known in Rome as 'Giovanni del Campo' and nicknamed 'de Brave' in Bentvueghels, of which he is founder member. Associated with Accademia di San Luca, 1635–6, 1638. Thereafter moves to Spain in service of Philip IV, where he dies. Influenced by Cecco del Caravaggio, probably by Manetti and contemporary Florentines. All works listed.

Memento Mori (Death comes to the Table) (six figures plus Death). Isaac Delgado Museum of Art, New Orleans (Louisiana). 120.6 × 174. Spear, 1971 (24), illus. C reduced to five figures: Musée de St Denis, La Réunion. 100.9 × 142.8. Spear, 1971, Fig. 18.

Memento Mori (Death comes to the Table) (six figures plus Death). Formerly Forteguerri Collection, Pistoia (1942), now in Florentine Collection. 117 × 172. Borea, 1972, Fig. 10. Similar picture formerly in a collection at Modena.

Memento Mori (Death comes to the Table) (four figures plus Death). Sale, Sotheby's, 29 Nov. 1961 (100) as Paolini. 75.5 × 97.8. Spear, 1971, Fig. 19.

Memento Mori (Death comes to the Usurer) (more than six figures plus Death). Amsterdam art market (1943) as Vouet. UU. Brejon/Cuzin, 1974, Fig. 24.

Gamblers (eight figures). Two versions recorded, with changes: **1.** Destroyed. Formerly Longhi Collection, Florence (before second war). S. Volpe, 1972, Pl. 16. **2.** Exh. 'Dipinti di due secoli', Relarte, Milan, 1963 as Ducamps, illus. 121 × 153. Bodart, 1970, Fig. 29.

The following is a selection of wrong attributions to Ducamps:

Honthorst imitator **Democritus.** Mincuzzi Collection, Bari.

Caravaggesque unknown (South Netherlandish) **Morra Players.** Pinacoteca, Siena.

EVERDINGEN see CESAR VAN EVERDINGEN

FABER, Martin Hermansz. (?1587–1648)

From Emden. In Rome, 1611, in Naples May 1611 and Jan. 1612. Follows Finson from Italy to Aix, 1613; thence to Toulouse, Bordeaux, Paris. Thought to be responsible for some landscapes in Finson's pictures. Known for landscapes and historical compositions on return to Emden in 1616. Only a handful of Finson-like paintings listed.

Liberation of St Peter. With Galerie Marcus, Paris (1974). 105 × 166. S & D 1622. Ad. *Burl. Mag.*, July 1974, illus.

Liberation of St Peter. Rathaus, Emden. After 1616. Siebern, 1927, Pl. via.

Self Portrait. Musée des Beaux-Arts, Marseille. 81 × 62. S & D 1613. Bodart, *Finson*, Fig. 33. Pendant to Finson *Self Portrait* (q.v.).

FETI or FETTI, Domenico (c. 1589–April 1623)

Born Rome. Pupil of Cigoli. In Mantua, 1613 as Court painter. 1621, and again in 1622, in Venice, where he dies. Although brought up in the Caravaggesque climate of the first decade, he cannot ever be described as a Caravaggio follower, except in the one picture listed below, doubtfully attributed to him when a young man.

Healing of Tobit. Museum Dahlem, Berlin, as School of Caravaggio (1975/1/72, illus.). 117 × 148. U. Schleier, Berlin, 1972, illus. colour and detail black-and-white.

FINSON, Louis (before 1580–Autumn 1617)

From Bruges. Earliest works show impact of Netherlandish Mannerists (e.g. Cornelis van Haarlem). In Naples certainly by 1608 (*Burl. Mag.*, December 1977, p. 829, note 35), probably as early as 1606–7. Provence, 1613–14, working in Marseille, Aix, Arles. Then proceeds to Montpellier, Toulouse, Bordeaux (1614), ?Poitiers, Paris (1615), Amsterdam 1617 and probably earlier, where he dies that autumn. From at latest 1610 onwards (the first dated work known), strongly influenced by Caravaggio, whom he could have known in Naples. Also active as dealer and entrepreneur, and as copyist of Caravaggio's works. All works listed except portraits of others beside himself (his self-portraiture alone being strictly

Caravaggesque). A dubious drawing in Montpellier is omitted. B followed by number refers to Bodart, *Finson*, 1970, catalogue numbers.

Samson with Delilah, overwhelming the Philistines. Private Collection, Paris (1955). 158 × 149. B22 (Fig. 45).

David and Goliath. With Brian Sewell, London. Panel, 106.7 × 82.6. S. B P. B14 (Fig. 29).

Adoration of the Magi. Saint-Trophime, Arles. 403 × 318. S & D 1614. Landscape by Faber? B9 (Figs. 21, g). Engraved by E. van Paenderen (1617) (B, Fig. 22) and by J. Isaac (B, Fig. 23).

Circumcision. Two versions: **1.** Chapelle du Lycée, Poitiers. 342 × 201. S & D 1615. B10 (Fig. 24 [inscrutable], Fig. h). Engraved by E. van Paenderen (B, Fig. 25). **2.** Saint-Nicolas-des-Champs, Paris. 399 × 282. Probably A. B under 10.

Massacre of the Innocents. Sainte-Begge, Andenne. 250 × 370. S & D (date missing: ?1615). B13 (Fig. 28).

Christ and the Adulteress. Neues Palais, Sanssouci, Potsdam (until 1945). 159 × 201. ?S. B20 (Fig. 43).

Raising of Lazarus. Two versions: **1.** Parish Church of Château-Gombert, Marseille. *c.* 320 × 231. S & D 1613. B4 (Figs. 6, e). **2.** Town Hall, Bergen-op-Zoom. 262 × 212. C by nephew David Finson (S & D 1638). B under 4 (Fig. 7).

Christ bound. Sainte-Catherine, Lille. 185 × 120. Exh. 'Trésors d'art sacré, Diocèse de Lille', Lille, 1964 (77), illus.

Crucifixion. Château, La Calade (Bouches-du-Rhône). 137 × 106. S & D 1613. B5 (Fig. 8).

Resurrection. Saint-Jean de Malte, Aix-en-Provence. 218 × 168. S & D 1610. B1 (Fig. 1, a).

Annunciation (upright). Two versions: **1.** Museo di Capodimonte, Naples (store). 310 × 205. S & D 1612. B3 (Fig. 3). **2.** Museo Nazionale Abruzzese, L'Aquila (Inv. 384). 285 × 170. B, p. 214. Posthumous C, with S & D added.

Annunciation (horizontal). Three versions known: **1.** Aubanel Collection, Avignon. 119 × 150. S & D 1612. B3 (Figs. 4, c). **2.** Museo del Prado, Madrid (1975 Flemish Cat. /3075, illus.). 173 × 218. S. B3 (Figs. 5, d). **3.** Saint-Trophime, Arles. 145 × 200. S & D 1614. B3.

Madonna del Rosario, see Caravaggio.

Holy Family. Lost. Engraved by E. van Paenderen (B16, Fig. 30) Landscape by Faber?

Crucifixion of St Andrew. Formerly Back-Vega Collection, Vienna; now in private collection, Switzerland. 200 × 150. C after the Cleveland Caravaggio (q.v.). Lurie/Mahon, 1977, Fig. 2.

Beheading of St John the Baptist. Musée, Hazebrouck, as Honthorst. 220 × 305. Flemish Exhibition, Lille/Calais/Arras, 1977, not shown but illus. U U.

Beheading of St John the Baptist. Herzog Anton Ulrich-Museum, Brunswick (1976/504). 201 × 152. B21 (Fig. 44).

Magdalen in Ecstasy. Two versions: **1.** Musée des Beaux-Arts, Marseille. 126 × 100. S & ?D (now effaced; ?1613). B7 (Fig. 10). **2.** Private Collection, Saint-Rémy (Bouches-du-Rhône). 112 × 86.5. S & D 1613. B under 7 (Fig. 11). Both copy a Caravaggio (q.v.), where other copies are recorded.

Charity of St Martin. Parish Church, Ermenonville (Oise). 181 × 157. S & D 1615. B11 (Fig. 27).

Martyrdom of St Sebastian. Parish Church, Rougiers (Var). 220 × 162. S & D 1615. B12 (Fig. 26).

Martyrdom of St Stephen. Saint-Trophime, Arles. 440 × 330. S & D 1614. B8 (Fig. 18).

Incredulity of St Thomas. Cathédrale Saint-Sauveur, Aix-en-Provence. 260 × 201. S & D 1513 (for 1613). B6 (Figs. 9, f).

Self Portrait. Musée des Beaux-Arts, Marseille (879). 81 × 62. S & D 1613. B46 (figs. 32, i). Pendant to Faber *Self Portrait* (q.v.).

Self Portrait. Musée Magnin, Dijon. Panel 41.5 × 28. U. B under 46 (Fig. 34).

Self Portrait. Riechiers Collection, Neuilly-sur-Seine (Hauts-de-Seine). 57 × 46. U. B under 46 (Fig. 35).

Concert. Herzog Anton Ulrich-Museum, Brunswick (1976/37). 141 × 189. B41 (Fig. 49).

The following are from the circle of Finson:

Madonna del Rosario. Sale, Christie's, 29 March 1974 (49), illus. as Cavarozzi, 113 × 96.5. B25.

Salome with the Head of St John the Baptist. With A. F. Mondschein, New York (1946). 113 × 95. B under No. 21. R. L., 1952, Fig. 24.

The following is a selection of wrong attributions to Finson:

*Italian School, ?after 1650 **Guardian Angel.** Gesù, Valletta, Malta.

*Anon. **Adoration of the Shepherds.** Saint-Pierre-aux-Chartreux, Toulouse (also attributed to Tournier, q.v.).

*?Neapolitan School **St Januarius.** Mr and Mrs Morton B. Harris Collection, New York. 126.3 × 92.4. Exh. Cleveland 1971–2 (26), illus. Prohaska, 1975, p. 10, attrib. to Sellitto.

Copy after Honthorst **St Sebastian.** Chapelle des Pénitents 'Bourras', Aix-en-Provence.

Caravaggesque unknown (South Netherlandish) **Luteplayer.** Gemäldegalerie, Dresden.

Caravaggesque unknown (?Spanish) **Fluteplayer.** Ashmolean Museum, Oxford.

Adam de Coster (?C) **Singer and Smoker.** Galerie St Luc, Paris (1948).

Master J **Pomegranate Seller.** Private Collection, Italy.

FRANÇOIS, Guy (?1578–after Oct. 1650)

From Le Puy-en-Velay. In Rome 1608, back in Le Puy, 1613. The first painter to introduce post-Mannerist Italian fashions into France. Follower, perhaps pupil, of Saraceni. Working for Charterhouse at Toulouse at an uncertain date. Consul at Le Puy in 1640's. Well established locally with flourishing studio. Influenced by Guido Reni, by sixteenth-century North Italian painting, with contacts with contemporary Spanish art. Only the most Saraceni-like, not necessarily the earliest, pictures listed. P followed by number refers to Pérez, 1974.

Adoration of the Shepherds. Parish Church, Saint-Bonnet, near Riom. 308 × 229. S & D 1643. P17, illus.
Presentation of Christ in the Temple. Musée des Augustins, Toulouse. 198 × 159. P7, illus. One copy known: Cathedral, Cahors.
Crucifixion with Two Maries and St John. Eglise du Collège, Le Puy. 400 × 265. S & D 1619. P4, illus.
Virgin appearing to St Francis of Assisi. Eglise des Carmes, Le Puy. 250 × 165. S & D 1620. Pérez, *Musée du Louvre*, 1974, Fig. 5.
Madonna del Rosario. Saint-Laurent, Le Puy. 207 × 212. S & D 1619. R. P1, illus.

Holy Family with Infant St John. Musée des Beaux-Arts, Brest. 126.5 × 88. BP. U. *Revue de l'Art*, 1971, No. 11, p. 107, Fig. 2, as Saraceni.
Holy Family with St Bruno and St Elizabeth of Thuringia. Musée, Bourg-en-Bresse. 210 × 153. S & D 1626. BP. P9, illus.
St Cecilia and the Angel. Galleria Nazionale d'Arte Antica, Palazzo Barberini, Rome. 173 × 136. U. P24, illus.
Incredulity of St Thomas. Saint-Laurent, Le Puy. 160 × 190. S. P2, illus.

GALEN, Nicolas van (c. 1620–after 1683)

Active at Hasselt and for short period, c. 1652, at Kampen. Still influenced by Terbrugghen long after the demise of Caravaggism. Two works known and listed.

Justice of Count William the Good. Town Hall, Hasselt. 190 × 213. S & D 1657. Exh. Utrecht/Antwerp 1952 (35), illus.

The Trapped Thief [Plate 240]. With David Koetser, Zurich (1955); sale, Christie's, 26 June 1959 (48) as 'Honthorst'; again, 25 Nov. 1960 (105).

GALLI, Giacomo (?c. 1580–after 1649)

Known as 'Lo Spadarino'. First appears in a lawsuit, 1597. Works at the Quirinal in the second decade with Saraceni, Lanfranco and Tassi. Only one published work is documented, the *Saints Valeria and Martial* (there are also some non-Caravaggesque frescoes by him in Palazzo Doria a Piazza Navona). All other attributions are based on this picture, and the most doubtful listed separately. Appears to travel to Naples around 1630. Influenced by Gentileschi and Saraceni. Some non-Caravaggesque works (including Zeri's *St Sebastian*) are not listed. BV 1974, 1975 and 1977 refers to Busiri Vici, 1974, 1975, 1977.

Assembly on Olympus. Florentine Galleries (until recently in the Pistoia Museum). 124.5 × 193.5. Schleier, *Kunstchronik*, 1971, Fig. 2a. BV1974, Fig. 1.
Tobias and the Angel. S. Ruffo, Rieti, 200 × 150 (arched top an addition). Before 1619. Longhi, 1943, Pl. 64.
Tobias and the Angel healing Tobit. Antonio Jandolo Collection, Rome. 120 × 172. BV1975, Fig. 7.
Christ Child with Infant St John the Baptist and two Cherubim. Whereabouts unknown. 78 × 98. BV1977, Fig. 3.
Christ among the Doctors. Palazzo Reale, Naples.

116.8 × 195.6. Spear, 1971 (79), illus. as anon. c. 1620?
Calling of Saints Peter and Andrew. Ansoldi Collection, Naples (1963). 88 × 103. C after Caravaggio (q.v.). U. Exh. Naples, 1963 (5a).
Cherubim (seven heads). Private Collection, Rome. 63.5 × 76. BV1974, Fig. 10.
Cherubim (three heads). Palazzo di Propaganda Fide, Rome. 34 × 43.5. BV1974, Fig. 9. A variant is:
Cherubim (three heads). Galleria Pallavicini, Rome (1959(323), illus. as Neapolitan 17th century). 49.6 × 65.9.
Cherubim (two heads). Marques de Bencevent Collection, Barcelona. BV1974, Fig. 11. A variant is:

Cherubim (two heads). Galleria Spada, Rome (1954(278), illus. as Neapolitan 17th century). 52.2 × 67.1.

Cherubim (three heads). Sforza Cesarini Collection, Rome. BV1974, Fig. 5. The right-hand cherub reappears in:

Cherub. With Poletti, Milan (1959). Longhi, 1959, Pl. 10.

St Anthony and the Christ Child. SS Cosma e Damiano, Rome. Longhi, 1943, Pl. 61.

S. Francesca Romana with Angel. Dr Edoardo Almagià Collection, Rome. 42 (reduced) × 69. After May 1608. Spear, 1972 (12), illus. Three copies known: **1.** Palazzo Rosso, Genoa (1961, Room 4). 49 × 67. Spear, 1971, Fig. 21. **2.** S. Pietro, Perugia (sacristy). 43 × 66. Exh. Milan, 1951 (93). **3.** Formerly Christopher Norris and Edward Hutton Collections; sale, Sotheby's, 13 July 1977 (26), illus. 46.3 × 68.6. Spear, 1971, Fig. 22.

Penitent Magdalen. Walters Art Gallery, Baltimore (1976/316, illus.). 133 × 99. BP. U. BV1975, Fig. 8.

Denial of St Peter. Pinacoteca Nazionale, Bologna. 97.8 × 132.1. Moir, 1967, Fig. 122 (Surely the same picture as Moir, 1976, Fig. 52?).

Saints Valeria and Martial. Museo Petriano, Rome.

1629–30. Longhi, 1943, Pls. 67, 68. C by Camuccini in S. Caterina della Ruota, Rome.

The following seem to be connected with Galli but not to be by his hand:

St Anne and the Virgin. A lost original may conceivably go back to Galli. ?four copies known: **1.** Galleria Spada, Rome (1954/154, illus. as anon.). 101 × 131. Berne Joffroy, 1959, Pl. XLVIII. **2.** ?Formerly Schloss Rohoncz Foundation, Lugano-Castagnola (no records kept of this picture at Lugano). **3.** Rutger Moll Collection, Stockholm. **4.** With Seligmann, Rey, New York (1936) as Zurbarán. F of right hand side. *Art Digest*, June 1936, illus.

St Homobonus and the Beggar. Vicariato, Rome. 260 × 221. Longhi, 1943, Pl. 63.

St Thomas of Villanova. Pinacoteca Comunale, Ancona (1960/32). 192 × 111. Spear, 1972, Fig. 8.

The following is a selection of wrong attributions to Galli:

★Fra Paolo Novelli **Story of Moses.** Palazzo del Quirinale, Rome. Frescoes. Longhi, 1959, Pls. 6, 7, as ?Lo Spadarino.

Caravaggesque (?Neapolitan) **Adulteress before Christ.** Castelvecchio, Verona.

GEEST, Wybrand de (1592–1659)

In Provence, 1616; in Rome, Dec. of that year, and remains till at least 1618. Perhaps travels to Naples in 1620, the date on his copy of Caravaggio's *Magdalen*, which was presumably still there. Back in his native town Leeuwarden by 1621. Only one Caravaggesque picture known and listed.

Magdalen in Ecstasy. Don Santiago Alorda Collection, Barcelona. 110 × 87. S & D 1620. C after Caravaggio (q.v.). Bodart, *Finson*, Figs. 12–13.

GENTILESCHI, Artemisia (July 1593–c. 1652)

Born in Rome. Daughter of Orazio, from whom she learns the elements of her art in Rome. She is very precocious: the Pommersfelden *Susanna* seems to be dated 1610 when she is only 17. Marries Nov. 1612 but is later (understandably) separated from her husband. Already in Florence by autumn 1614 where she remains until 1620, patronized by the Medici (1618–20). Possibly accompanies her father to Genoa, 1621. Back in Rome by 1622, where she remains until at earliest 1626. Also travels to Venice (?1627). In Naples by Aug. 1630, and almost continuously until her death. Pays a short visit in 1638–40, at about the time of her father's death there, to London. A remarkable and formidable lady. Only a few (not all) early Roman and Florentine works listed where she is inspired by the styles of her father, of Honthorst and Vouet; and two later works, the large Capodimonte *Judith* and the Hampton Court *Self Portrait*, where she reverts to her earlier styles.

Cleopatra. Formerly Palazzo Cattaneo-Adorno, Genoa. 145 × 180. ?1621. Bissell, 1968, Fig. 5.

Lucretia. Formerly Palazzo Cattaneo-Adorno, Genoa. 137 × 130. ?1621. Gregori, 1968, Fig. 6. (detail). Bissell, 1968, Fig. 6.

Sibyl. With Acquavella Galleries, New York (1957). 64.1 × 69.8. U.

The Murder of Holofernes. Two versions known: **1.** Florentine Galleries. 199 × 162.5. S. Exh. Florence, 1970 (49), illus. Engraved in *Etruria Pittrice*, late 18th

century. **2.** Museo di Capodimonte, Naples. 163 × 126. Bissell, 1968, Fig. 10. At least two copies known: **1.** Galleria dell'Archivescovado, Milan, as Guercino; slate, small. **2.** Pinacoteca Nazionale, Bologna. 161 × 138.

Judith with the Head of Holofernes (three-quarter length, daylight)**.** Three versions known: **1.** Florentine Galleries. 114 × 93.5. Exh. Florence, 1970 (48), illus. **2.** Galleria Corsini, Florence (?untraced). ?C. Longhi, S.G. 1961 (1916), Fig. 129 **3.** (With considerable variations) Nasjonalgalleriet, Oslo (1973 (767), illus.). 136 × 159. De Witt, 1939, illus. Florence, 1970 under No. 48 lists three copies.

Judith with the Head of Holofernes (full length, candlelight)**.** Two versions known (with considerable differences): **1.** Museo di Capodimonte, Naples. 272 × 221. Moir, 1967, Fig. 160. **2.** Detroit Institute of Arts, Detroit (Michigan) (1960, p. 93, illus.). 184.1 × 141.6. Spear, 1971 (28), illus. Exh. 'Women Artists: 1550–1950', Los Angeles County Museum, 1976 (13), illus. colour.

Susanna and the Elders. Schloss Weissenstein, Pommersfelden. 170 × 119. S & D 1610. Longhi, S.G. 1961, Fig. 192.

Susanna and the Elders. Marquess of Exeter Collection, Burghley House, Stamford (No. 218). 150.5 × 103.5. Gregori, 1968, Fig. 2.

St Cecilia. With Edward Speelman, London (1953); sale, Christie's, 18 March 1960 (66). 90.2 × 68.6

Burl. Mag., Supplement, Dec. 1953, Plate IX, as Orazio.

St Cecilia. Galleria Spada, Rome (1954/293, illus.) 108 × 78.5. U.

Salome with the Head of St John the Baptist. Guidi Sale, Sangiorgi Galleries, Rome, April 1902 (144). ?Now in Budapest Museum. 85 × 90. U. Moir, 1976, Fig. 116.

Penitent Magdalen. With Old Master Galleries, London (1975). U.

Penitent Magdalen. Florentine Galleries. 146.5 × 108. S. Exh. Florence, 1970 (47), illus.

Self Portrait (The Personification of Painting). Hampton Court Palace (Levey, 1964/499, illus.). 96.5 × 73.7. S. Levey, 1962, Fig. 37.

Portrait of a Condottiere. Pinacoteca Comunale, Collezioni Comunali d'Arte, Bologna. 208 × 128. S & D 1622 (in Rome). Bissell, 1968, Fig. 8.

The following is a selection of wrong attributions to Artemisia Gentileschi:

?Riminaldi **Juno placing Argus's eyes on her peacock's tail.** Galleria Doria-Pamphilj, Rome.

Cecco del Caravaggio **Female Portrait.** Museo del Prado, Madrid.

★Anon. **King Charles VIII of France.** Casa di S. Luigi dei Francesi, Rome.

Vouet **Lovers.** Galleria Pallavicini, Rome.

GENTILESCHI, Orazio (July 1563–Feb. 1639)

From Pisa. Trained by Aurelio Lomi, his elder half-brother. To Rome by 1576. Plays prominent part in famous lawsuit of 1603 brought by Baglione against him, Caravaggio and others. Working with Tassi in Casino delle Muse, Palazzo Rospigliosi-Pallavicini, 1611–12, but their association is abruptly terminated by Tassi's alleged rape of Gentileschi's teenage daughter Artemisia. Works at the Quirinal early in second decade, and later in the Marches, but back in Rome by Feb. 1619. In Genoa after Feb. 1621 working for Sauli and Doria. Leaves for Paris 1624, where he remains two years in service of Marie de Médicis. Travels (largely on the recommendation of Buckingham) to England, Sept. or Oct. 1626, where he remains over twelve years till his death, working for Charles I, the Duke of Buckingham and patrons in Holland and Brabant. All works listed except Tuscan Mannerist beginnings before *c.* 1600, and last English works for the Queen's House, Greenwich, although it has to be admitted that some Roman and Marchigian paintings of the second decade, and the Genoese, French and English works of the third and fourth, can only be described as very loosely Caravaggesque; but with him it is more difficult to know where to draw the line than it is with Saraceni.

Decorative Scheme with Nine Muses and Mussicians [Plates 18, 20]**.** Casino delle Muse, Palazzo Rospigliosi-Pallavicini, Rome. Frescoes above cornices with fictive architecture by Tassi. 1611–12. S A. One scene, Zeri, Pallavicini, 1955, Fig. 3; another Freedberg, 1976, Fig. 6.

Apollo and the Nine Muses. Lost. Original or C was: Lily Lawlor Collection, New York (before Oct. 1937). 1626–9. Isarlo, 1951, illus. C by Rubens of part of composition, Museum Boymans-van Beuningen, Rotterdam; black chalk with brown wash, 30.2 × 22.2; 1629–30. Müller Hofstede, 1965, Fig. 1.

Diana the Huntress. Musée des Beaux-Arts, Nantes (1967/23, illus.). 215 × 135. S. Sterling, 1964, Figs. 2, 3. C of part by Jean Monier, formerly Kurt Stern Collection, New York; Sterling, 1964, Fig. 4.

Danaë [Plate 13: detail]**.** Two versions known: **1.** Switzerland, Private Collection (1978) 151 × 127.

1621–2. [Nicolson, 1979.] **2.** Cleveland Museum of Art, Cleveland, Ohio. 163.4. × 228.6. Spear, 1971 (32), illus.

Cupid asleep. Viscount Scarsdale Collection, Kedleston Hall. UU. Pepper, 1972, Fig. 9.

Public Felicity triumphant over Dangers. Musée du Louvre, Paris. 270 × 170. 1624–6. Sterling, 1958, Fig. 1.

Sibyl. Museum of Fine Arts, Houston (Texas) (Kress Cat. 1973/K1949, illus.). 79.7 × 71.7. Spear, 1971 (31), illus.

Sibyl (?). Hampton Court Palace (Levey, 1964/500 illus.). 58.4 × 66. Sterling, 1958, Fig. 5.

Lot and his Daughters. Three versions known (with minor differences): **1.** Thyssen-Bornemisza Collection (whereabouts unknown). 120 × 168.5. 1621–2. Bissell, 1969, Fig. 5 (from an old photograph made when in the Theophilatos Collection, Genoa). **2.** Museum Dahlem, Berlin (1975/2/70, illus.). 169 × 193. Bissell, 1969, Fig. 9. **3.** National Gallery of Canada, Ottawa. 157.5. × 195.6. Bissell, 1969, Fig. 13. Engraved in reverse in Orléans Collection by Philippe Trière after a drawing by Borel, late 18th century. A fourth is a copy: Marquess of Exeter Collection, Burghley House, Stamford. 59.7 × 99.5. Bissell, 1969, Fig. 10. [All versions are referred to in Nicolson 1979.]

Lot and his Daughters. Museo de Bellas Artes, Bilbao. 225 × 281. S. *c.* 1626. Bissell, 1969, Fig. 11. Engraved in reverse by Lucas Vorsterman; Bissell, 1969, Fig. 12.

Sacrifice of Isaac. Palazzo Cattaneo-Adorno, Genoa. 245 × 152. ?1621. R. Torriti, 1970, Fig. 214.

Joseph and Potiphar's Wife. Hampton Court Palace (Levey, 1964/501, illus.). 201.9 × 261.9. Before 1634. Hess, 1952, Fig. 2. Reduced replica with Mrs Drey, New York (1976).

Finding of Moses. Museo del Prado, Madrid (1972/147). 242 × 281. S (detail of signature, Harris, 1967, Fig. 52). Before May 1633. Bissell, 1971, Fig. 13.

Finding of Moses. George Howard Collection, Castle Howard (Yorks.). 257.8 × 302.3. 1633. Longhi, S.G. 1961, Fig. 125. Engraved in Orléans Catalogue as Velazquez.

David with the Head of Goliath. National Gallery of Ireland, Dublin (1971/980; 1963, illus.). 186 × 135. Bissell, 1971, Fig. 8.

David with the Head of Goliath. Museum Dahlem, Berlin (1975/1723, illus.). Copper, 36 × 28. Bissell, 1971, Fig. 5. Two copies known: **1.** Herzog Anton Ulrich-Museum, Brunswick (1976/364). Canvas on panel, 39.5 × 28.5. **2.** Galleria dell'Arcivescovado, Milan, as Guercino. Slate, small.

David with the Head of Goliath. S. Paolo fuori le mura, Rome.

David with the Head of Goliath. Galleria Spada, Rome (1954/175, illus.). 173 × 142. Similar to pattern of Berlin picture above but landscape by different

hand, and ?also head of Goliath. Longhi, S.G. 1961, Fig. 121. One copy (without landscape) known: with Di Castro, Rome (1977).

Judith and Holofernes. Wadsworth Atheneum, Hartford (Conn.). 133.3 × 156.8. Spear, 1971 (30), illus. Drawing of this composition by van Dyck in Chatsworth sketchbook. Two further copies known: **1.** Pinacoteca Vaticana, Rome. 127 × 147. Redig de Campos, 1939, Figs. 1, 2, as Orazio. **2.** Formerly with Ugo Jandolo, Rome; sale, Buenos Aires, mid-1920's. 110 × 137.

Circumcision. Gesù, Ancona. 370 × 220. After 1605. Emiliani, 1958, Pls. 30–31.

Rest on the Flight. Marquess of Exeter Collection, Burghley House, Stamford. Copper, 28.5 × 22.2 *Burl. Mag.*, Feb. 1960, Fig. 44.

Rest on the Flight. Four versions known: **1.** with donkey behind wall. City Art Gallery, Birmingham. 172.5 × 215. Voss, 1959, Fig. 1. **2.** with dark background. J. Paul Getty Museum, Malibu. 139.7 × 170.2. Voss, 1959, Fig. 2. **3.** with dark background. Kunsthistorisches Museum, Vienna (1973, Plate 34). 138.5 × 216. S. 1626 or earlier. Voss, 1959, Fig. 3. **4.** with landscape behind wall. Musée du Louvre, Paris. 158 × 225. Voss, 1959, Fig. 4. Engraved in Landon, VII, p. 93. Variant of this composition showing Virgin and Child alone, 92.7 × 113; sale, Fernando Vallerini, Pisa, 4 Oct. 1959 (63).

Baptism. S. Maria della Pace, Rome. Before March 1605. BP. Griseri, *Paragone* 1961, Pls. 40–1.

Christ and the Samaritan Woman. Palacio Real, Madrid. 193 × 145. Previtali, 1973, Fig. 1. One copy known: with Herbert Bier, London (1973). 191.8 × 149. Nicolson, 1972, Fig. 58.

Christ and St Francis. Incisa della Rocchetta Collection, Rome. Copper, 45 × 34. Longhi, 1943, Pls. 35, 36.

Crowning with Thorns. Two versions known: **1.** Herzog Anton Ulrich-Museum, Brunswick. 119.5 × 148.5. ad. *Apollo*, June 1977, p. 133, illus. colour. **2.** Lizza-Bassi Collection, Varese (1951). 135 × 152. A. Longhi, 1943, Pl. 42.

Way to Calvary. Kunsthistorisches Museum, Vienna (1973, illus Pl. 34 as Caravaggio circle). 138.5 × 173. Marini, 1974, R.9, illus. with details.

Crucifixion (canvas), 368 × 210, with frescoes: *Capture of Christ* and *Agony in the Garden*; in ceiling, medallions with *God the Father* and frescoes of *Crowning with Thorns* and *Scourging*. Cathedral of San Venanzo, Fabriano. 1613–17. Voss, *Orazio*, 1960–1, illus. *Capture*, *Agony* and *Crucifixion* in colour, Pls. 1–6, 8. Emiliani, 1958, adds *Crowning*, and *Scourging* on ceiling, Fig. 38.

Annunciation [Plate 15: detail]. Two versions known: **1.** S. Siro, Genoa. 225 × 157 (enlarged to 281 high). Probably C. **2.** Galleria Sabauda, Turin. 286 × 196. 1622–3. Bissell, 1971, Fig. 12. Engraved in Landon,

VI. Bissell, 1971, note 23, records two copies, both R.

Assumption of the Virgin. S. Maria al Monte dei Cappuccini, Turin (1976, in storerooms of Museo Civico). 366 × 226. Griseri, *Paragone* 1961, Pls. 24–6.

Madonna. Fogg Museum of Art, Cambridge (Mass.). 99.5 × 85. Bissell, 1967, Fig. 7. Freedberg, 1976, Fig. 1 in colour.

Madonna. Schloss Weissenstein, Pommerfelden. 116 × 100. Longhi, S. R., 1967, Fig. 142a, C made into *Holy Family* at Museo Borgogna, Vercelli (1969/130, illus.), by Elisabetta Sirani. 112 × 102. S & D 1663. *Emporium*, March 1961, Fig. 8.

Madonna. Galeria de Artă, Bucharest (formerly Schloss Pelesch). 116 × 100. Longhi, S. R., 1967, Fig. 142b. Variant (?C) was: with Heinemann, New York (1937).

Madonna adoring the Child. With Silvano Lodi, Campione d'Italia (Lake of Lugano) (1976). 138.4×97.1. Adapted from Turin *Annunciation*. Marini, 1974, Fig. C46, p. 326.

(For *Madonna in Landscape* at Burghley, see *Rest on the Flight*).

Madonna presenting the Child to S. Francesca Romana. Galleria Nazionale delle Marche, Urbino. 270 × 157. Longhi, S. G., 1961, Fig. 118. Partial replica is *Head of S. Francesca Romana*. Arch. Luigi Bonomi Collection, Milan (1933). ?C. F. Wittgens, 1933, Fig. 2.

Madonna del Rosario. S. Lucia, Fabriano. BP. Schleier, 1969, Fig. 4.

Dream of St Joseph. Formerly S. Stefano, Genoa. 450 × 300 (with 19th century additions); originally 120 × 80. BP. UU. Strinati, 1976, Figs. 1–2.

Infant Christ asleep on the Cross. Museo del Prado, Madrid (1972/1240). 75 × 100. Voss, 1924, p. 115, illus.

St Cecilia and the Angel. National Gallery of Art, Washington (DC) (Kress Cat. 1973/K1920, illus.). Where C is noted. 88 × 108. Moir, 1967, Fig. 71.

Saints Cecilia, Valerian and Tiburtius. Brera, Milan (1935/588). 350 × 218. S. Bissell, 1971, Fig. 7. ?Preparatory drawing, *Head of Youth;* Janos Scholz Collection, New York; black and white chalk on grey paper, 37 × 27; Exh. Detroit, 1965 (7).

(For *St Cecilia*, see also *Female Violinist*).

St Charles Borromeo in Prayer before the Angel with the Cross. S. Benedetto, Fabriano. 398 × 169. Emiliani, 1958, Pls. 42–3.

St Christopher. Museum Dahlem, Berlin (1975/1707, illus.). Copper, 21 × 28. Longhi, S. R., 1967, colour pl. and Fig. 141.

St Francis supported by an Angel. Galleria Nazionale d'Arte Antica, Rome (1955/15, illus.). 133 × 98. Bissell, 1971, Fig. 18.

St Francis supported by an Angel. Whereabouts unknown.

St Francis supported by an Angel. Museo del Prado, Madrid (1972/3122). 126 × 98. Exh. Seville, 1973 (24), illus. C in Museum, Gerona.

Stigmatization of St Francis. S. Silvestro in Capite, Rome. After 1605. Longhi, S. G., 1961, Fig. 117. Small variant: Formerly Galleria Colonna, Rome. 77 × 60. Moir, 1967, Fig. 42 (as on copper).

St Jerome. Museo Civico, Turin (1970, p. 11). 153 × 128. Probably 1611. Bissell, 1971, Fig. 23.

Executioner with Head of St John the Baptist [Plate 16]. Museo del Prado, Madrid (1972/3188). Panel transferred to canvas, 82 × 61. S.

Penitent Magdalen. Three versions, with changes, known: **1.** Switzerland, Private Collection (1978). 149.5 × 183. 1621–2. [Nicolson, 1979.] **2.** Kunsthistorisches Museum, Vienna (1973, illus. Pl. 34). 163 × 208. S. Voss, 1924, p. 116, illus. **3.** with Richard Feigen, New York (1975) (ex-Elgin). 131 × 206. Nicolson, R. A., 1960, Fig. 42 (before removal of draperies over breasts); Christie's, 28 June 1974 (115), illus. after removal of draperies. Two copies known of No. 1 above: **1.** Pinacoteca, Lucca, as Giacinto Gemignani. **2.** Musée des Beaux-Arts, Dijon (1968/129). 105 × 174. Attributed to Jean Tassel. Sterling, 1958, Fig. 2.

Penitent Magdalen. S. Maria Maddalena, Fabriano. 218 × 158. Bissell, 1971, Fig. 9.

Penitent Magdalen. With Enzo Costantini, Rome (1978).

Conversion of the Magdalen. Alte Pinakothek, Munich (1975/12726, illus.). 133.9 × 154.6. Voss, 1924, p. 117, illus.

St Michael the Archangel overcoming the Devil [Plate 17: detail]. S. Salvatore, Farnese. 278 × 192 (excluding later additions). Schleier, 1962, Figs. 28, 31.

Conversion of St Paul. Lost. Formerly S. Paolo fuori le mura, Rome. Finished by 1603. Burnt 1823. Twice engraved: **1.** by Giovanni Maggi (*c.* 1620). Hess, 1952, Fig. 25; **2.** by Callot; Celio/Zocca, 1968, p. 99. illus.

Female Luteplayer [Plate 14: detail]. National Gallery of Art, Washington (DC) (1975/1661). 149 × 130. Bissell, 1971, Fig. 1. Claimed as a related composition (erroneously) is: Pen and bistre wash drawing. 23 × 18. National Gallery of Art, Washington (DC). U. Sterling, 1958, note 41, records replica in Paris Collection (?the copy recorded by Moir, 1967, p. 75, note 22, as at New Orleans).

Female Violinist (?St Cecilia). Detroit Institute of Arts, Detroit (Michigan) (1971, p. 96, illus.). 83.5 × 97.8. Bissell, 1971, Fig. 2.

Head of a Woman. H. E. Benn Collection, Ilkely. Panel, 42 × 37. Bissell, 1971, Fig. 15. Uncertain between Gentileschi and Bor (q.v.).

The following is a selection of works by followers and imitators of Gentileschi:

Orpheus. B. Edgar Collection, Broadway (Worcs.)

(1967). 134 × 99. Bears or bore a false Caravaggio signature and date 1593. Gregori, *Riminaldi*, 1972, Plate 62, as Manetti 'Allegory of Music' in Florentine Collection. By the same hand is:

Love Triumphant. Prague Castle (1967/30, illus.). 170 × 107 (cut down from 122.4 wide). R. *Burl. Mag.* Supplement, June 1967, Fig. A.

Cupid and Psyche. Hermitage, Leningrad. 137 × 160. Exh. Leningrad. 1973 (14), illus. Linnik, 1975, illus. colour Pls. 18, 19.

Sacrifice of Isaac. Two versions known: **1.** Lothar Busch Collection, Berlin (1974). 161 × 123. Zahn, 1928, Fig. 6. **2.** Sale, Bonham's London, 27 June 1974 (107), illus. as Caravaggio (unsold). 162.5 × 122.5. Affinities with Rosenberg *Christ at the Column* and Béziers *St Sebastian* (see below).

Crowning with Thorns. Pushkin Museum, Moscow (No. 229). Canvas transferred from panel, 125 × 90. Linnik, 1975, illus. colour Pl. 8, and black and white details, Pls. 9–10.

Mocking of Christ and Flagellation. Sale, Galerie Fischer, Lucerne, 21–4 June 1960 (1759), illus. as Gentileschi. 126 × 161.

Christ at the Column Two versions known: **1.** Pierre Rosenberg Collection, Paris. 91 × 78. Rome/Paris, 1974 (76), illus. **2.** Formerly Dr Ganal Collection, Innsbruck, as Caracciolo. ?By same hand (?French) as Béziers *St Sebastian* (see below). See also under *Sacrifice of Isaac* above.

Madonna with Saints Gregory and Mary Magdalen. Cathedral, Ripatransone. 267 × 173. BP. ?By Giulio Lazzarelli.

St Charles Borromeo in Prayer. Museo Nazionale, Messina. Marini, 1974, p. 327, illus. No. C52 as Rodriguez.

St Peter Nolasco upheld by Angels. SS. Annunziata, Piazza Buenos Aires, Convento dei Mercedari, Rome (formerly S. Adriano). Borea, 1972, Fig. 7. ?By Emilio Savonanzi. Copper engraving by Claude Mellan (1629).

Liberation of St Peter. Two versions known: **1.** Florentine Galleries. 147 × 190.5. Engraved in reverse by Fr. A. Lorenzini as Guercino in 1778. Rome/Paris, 1974, p. 238, Fig. 26 (where the statement that the picture belonged to an Archduke of Austria is misleading: the Grand-Duke of Tuscany was at that date also a Habsburg Archduke). Volpe, 1970, Pl. 54 as ?Cavallino. Cuzin, *Florence*, 1977, Fig. 1. **2.** Formerly Cook Collection, Richmond (No. 127); sale, Sotheby's, 25 June 1958(7), as Carlo Bononi, 139.7 × 188.6. One copy is recorded: Medina Collection, Madrid (1927), as Zurbarán. The design is conceivably Neapolitan.

St Sebastian. Two versions known: **1.** Musée Fabregat, Béziers No. 287, as copy of Ribera). 129 × 91. BP. Mesuret, 1957, Fig. 4 as Tournier. C in Musée des Beaux-Arts, Strasbourg, wrongly as Tassel. **2.** Pushkin Museum, Moscow (with two additional figures). Longhi, 1926, Fig. 5 as Guercino. ?By same hand (?French) as Rosenberg *Christ at the Column* (see above). Gentileschi-like in direction of Riminaldi. See also under *Sacrifice of Isaac* above.

The following is a selection of wrong attributions to Gentileschi which could be very considerably extended:

Caracciolo **Cupid.** Hampton Court Palace.
Honthorst **Orpheus.** Palazzo Reale, Naples.
A. Gentileschi **Judith.** Nasjonalgalleriet, Oslo.
Caravaggio **Madonna.** Galleria Nazionale d'Arte Antica, Rome.
Cavarozzi **Mystic Marriage of St Catherine, including Holy Family with Virgin crowned by Angels.** Museo del Prado, Madrid.
★Tuscan unknown **Angel Annunciate.** Accademia Albertina, Turin.
Galli **Tobias and the Angel.** S. Ruffo, Rieti.
?Guy François. **St Cecilia.** Galleria Nazionale d'Arte Antica, Rome.
Cavarozzi **St Jerome.** Florentine Galleries.
Caravaggesque unknown (?Neapolitan) **St Sebastian.** Galleria dell'Arcivescovado, Milan.
★Savonanzi **St Stephen disputing.** Historical Society, New York.
★'Il Genovesino' **Luteplayer.** Palazzo Rosso, Genoa.

'GIUSTO FIAMMINGO'

Probably French artist working in Rome *c*. 1615–25 in the circle of Vouet, but influenced by Guido. Patronized by Giustiniani, whose inventory of 1638 listed two pictures under this designation, one of them the *Socrates* below. Has been confused with Sustermans. All works listed.

Cephalus and Procris. Herzog Anton Ulrich-Museum, Brunswick (1976/480, illus. as Cagnacci). 119 × 166.

Historical or Mythological Scene. Private Collection, Rome.

Five Senses. Galleria Pallavicini, Rome (1959/106, illus.). 123.3 × 171.5.

Death of Socrates [Plate 233]. Formerly Kaiser-Friedrich Museum, Berlin (1931/449; illus. 1930, p. 114 as School of Caravaggio) (destroyed 1945). 174 × 243. Engraved as Sustermans by Mme Soyer in Landon (1812, Giustiniani Collection).

David. Abbazia, Cava dei Tirreni. Brejon/Cuzin, 1974, Fig. 19 as copy of lost Vouet.

Angels with the Symbols of the Passion (six canvases). Galleria Pallavicini, Rome (1959/100–5, illus.). Each, c. 99 × 74.
Penitent Magdalen. With Heim Gallery, London (1968), as Aubin Vouet. 147 × 118. Exh. Heim, London, 1968 (7), illus. U.

The following is a wrong attribution to 'Giusto Fiammingo':

Caravaggesque (Roman-based) **Love Triumphant.** Heim Gallery, London/Paris (1976); variant formerly Principe di Cutò Collection, Palermo.

GRAMATICA, Antiveduto (c. 1570–Jan. 1626)

Born in Rome of Sienese origin. Early work a mixture of Vanni, Salimbeni and Barocci. Working for Ferdinando Gonzaga, 1610, 1619. Well patronized by Cardinal del Monte. Some early works go to Spain. Caravaggio is believed to be working in his shop, 1594. Recorded in Rome 1615, when he is witness to Borgianni's will; in Turin, 1621. *Principe* of Accademia di S. Luca (Jan. 1624), but as a result of disputes with Salini, is ousted by Vouet in the following autumn. Has son Liberale (d. aged 34), a painter responsible for a *Liberation of St Peter* in S. Salvatore in Lauro (S & D 1624). Only a small number of near-Caravaggesque works known, listed below, among a large, Bolognese-orientated *œuvre*. L followed by stroke and Fig. number refers to Longhi, Q.C., 1968.

Judith with the Head of Holofernes. Nationalmuseum, Stockholm (1958/11). 120 × 93. Spear. 1971 (34), illus. L/Fig. 197 in colour.
Adoration of the Shepherds. Galleria Doria-Pamphilj, Rome (1942/191). 135 × 175. L/Fig. 202.
Christ among the Doctors. Private Collection, Cowdenbeath (Fife). Longhi, 1969, Pl. 58.
St Cecilia and two Angels. Two versions (with considerable changes) known: **1.** Museu Nacional de Arte Antiga, Lisbon. 100 × 126. S. L/Fig. 195. **2.** Kunsthistorisches Museum, Vienna (1973, Pl. 37). 91 × 120. Mirimonde, 1965, Fig. 26 as Tibaldi.
Salome with the Head of St John the Baptist. Museum, Aschaffenburg. L/Fig. 198.
Vision of St Romuald. Sacro Eremo dei Camaldoli, Frascati. 300 × 200. Longhi, S.G. 1961, Fig. 119, and detail in colour.
Death of St Romuald. Certosa dei Camaldoli, Naples. 275 × 212. 1619–21. Exh. Naples, 1963 (29), illus. (Others in this series not listed).
Saints. Certosa dei Camaldoli, Naples. 1619–21. Mostly A. Exh. Naples, 1963 (33–4, full length, 180 × 130, illus.); (35–7, half length, 130 × 110, two illus.; four others recorded). See also for better illus., Marino, 1968, Figs. 1, 10.

Self Portrait. Florentine Galleries. 65 × 52.5 (increased to 71 × 57). U. Exh. 'Pittori Bolognesi . . .', 1975(74), illus. as unknown Caravaggesque *Presumed Self Portrait of Lionello Spada.*
Concert (three figures). Galleria Sabauda, Turin. 119 × 85. F of theorbo player only. L/Fig. 196 in colour. One C of whole compositions recorded: Michelsen Sale, Bangel, Frankfurt, 2 April 1922 (127) as Simone Cantarini. 120 × 141. Spear, 1971 (under 33), Fig 25.
Card Players (two figures). Wellington Museum, Apsley House, London (1965/5, illus.). 85.1 × 113. U U

The following is a selection of wrong attributions to Gramatica:

★?Finoglio **Adoration of the Shepherds.** S. Maria della Salute, Naples (1943).
Caravaggesque unknown (South Netherlandish) **Morra Players.** Pinacoteca, Siena.
Manfredi **Fortune-Teller.** Florentine Galleries, and other versions.
★?Dutch School **Poultry Dealer.** Landesgalerie, Hanover (1954/111). 96.5 × 73. Remains of (illegible) signature.

GUERRIERI, Giovan Francesco (1589–between July 1655 and Dec. 1659)

A provincial painter, born and bred in Fossombrone, who as a result of various visits to Rome, and of contact with Gentileschi in his Marchigian travels, is spasmodically caught up in the Caravaggesque movement, although rooted in Roman and Marchigian Mannerism. The evidence of the documents does not permit us to reconstruct any consistent development, and so the very few pictures listed below (selected out of a primarily Bolognese-orientated *œuvre*) seem to belong to quite different periods. He is in Pesaro, 1605; in Rome, 1606 and 1612. Probably back in the Marches, 1613–14. Works for Marcantonio Borghese in his palazzo in Campo Marzio, Rome, Nov. 1615–Sept. 1618, where he employs several assistants. Thereafter he settles in Fossombrone. His few genre scenes seem to indicate association

in the Marches in the 1630's with Bigot, but this is speculative. He may have been in touch with Tanzio da Varallo during the latter's journeys to the South. At times he approximates to the Lombard realism of Ceresa. E followed by stroke, catalogue and plate number refers to Emiliani, 1956.

Madonna with St Anne. Sacristy, Cathedral, Fossombrone. 120 × 55. S & D 1627. E/No. 22.
St Charles Borromeo in Prayer. San Pietro in Valle, Fano. 240 × 155. E/No. 18, Pl. XXXVIII.
Miracles of St Nicholas of Tolentino, and other scenes. S. Maria del Piano, Sassoferrato (Ancona). The two main scenes, each 220 × 210: *Miracle of the Roses: S. Miracle of the Cane:* S & D 1614. E/No. 5. Whole complex, 1613–14. *Cane,* E/Pls. IV–VII.
St Sebastian tended by Irene. Galleria dell'Arcivescovado, Milan. U. E/No. 13 notes two copies in Fossombrone itself.

Flea Catcher. Museo Civico Passionei, Fossombrone. 50 × 60. E/No. 26, Pl. XXXV.
Girl playing with a Mouse. Museo Civico Passionei, Fossombrone. 48 × 45. E/No. 27, Pl. XXXVI.

The following is a selection of wrong attributions to Guerrieri:

?Manetti **Lot and his Daughters.** Galleria Borghese, Rome; Galleria Doria, Rome.
?Claude Mellan **Joseph interpreting Dreams.** Galleria Borghese, Rome.
?Manetti **St Roch.** Galleria Borghese, Rome.

HAAN, David de (?c. 1585–Aug. 1622)

Works with Baburen (with whom he is living, 1619–20) on decoration of Pietà Chapel, S. Pietro in Montorio, Rome, *c.* 1617–20. Probably in contact in Rome with Rombouts and Crabeth in late 1610's. On Baburen's return to Utrecht, enters the service of Vincenzo Giustiniani, in whose palazzo he remains until his death about two years later. Only two known works listed.

Mocking of Christ. Pietà Chapel, S. Pietro in Montorio, Rome. Lunette, 155 × 330. Slatkes, 1965, Fig. 5.
Entombment. Formerly Kaiser-Friedrich Museum, Berlin (destroyed 1945) (1931/353, as Crabeth). 280 × 211. 1620–2. Slatkes, 1965, Fig. 4. Engraved as from Giustiniani Collection in Landon (1812).

The following is a selection of wrong attributions to David de Haan:

★'David Han da Amsterdam' **Apollo flaying**

Marsyas (*recto* and *verso*). Drawing. Gabinetto dei disegni, Galleria degli Uffizi, Florence. S. Slatkes, 1966, Figs. 2–3.
Imitator of Baburen **Tobias healing his Father.** Kunsthistorisches Museum, Vienna.
Imitator of Baburen (?Crabeth) **Christ among the Doctors.** Kunsthistorisches Museum, Vienna.
Manfredi **Crowning with Thorns.** Munich No. 1234.
?Manetti **St Roch.** Galleria Borghese, Rome.

HEIMBACH, Wolfgang (active 1636–78)

Born probably in region of Oldenburg, a deaf-mute. First dated picture (Bremen) 1636–7. While not Caravaggesque, it presupposes training in circles of Duyster, Codde etc., as do other works. Indeed a contemporary historian describes him as studying under a painter in Holland and as spending twelve years in Italy. A letter from Grand Prince Ferdinand of Tuscany speaks of him in Italy in 1646. In Prague, 1651. Near Oldenburg early the following year. In Copenhagen 1653 when he becomes one of the Court painters of Frederick III. He himself says that he remains in the Danish Royal service eight and a half years. Still in Copenhagen, 1662. Through his Italian experience, he is Caravaggesque, but at several removes and intermittently. Rather few pictures listed below, and even these are only marginally relevant. G followed by stroke and number refers to Göttsche, 1935.

Adoration of the Shepherds. Longhi Collection, Florence. 35 × 43. S & D 1645. Milan, 1951 (121), illus. as Honthorst.
Flight into Egypt. Szépművészeti Múzeum, Budapest (1967/858). 76.5 × 60. S & D 1649. Pigler, 1948, illus.
Boy Luteplayer. Lost. One copy known: Musée des Beaux-Arts, Dijon (1968/67, as after La Tour). 61 ×

53. Thuillier, 1973, No. D17, illus. Pendant to Dijon copy of *Boy masking a Candle* (q.v.).
Supper by Night. Kunsthalle, Kiel. Panel, 46 × 55. S & D 1647. G/15, illus.
Supper by Night. National Gallery of Ireland, Dublin (1971/610). Panel, 37 × 29. S. G/1, illus.
Supper by Night. Amalienborg Castle, Copenhagen

(deposited in Statens Museum for Kunst). 99.5 × 68. S & D 1655. G/29, illus.

Card Players [Plate 243]. With Pardo, Paris (1955) as Honthorst. 91.1 × 108.

Interior of a Kitchen. Germanisches National-museum, Nuremberg. 59 × 78. S & D 1648.

Figures in an Interior reading. Statens Museum for Kunst, Copenhagen (1951/301). 93.5 × 108. S & D 1651. G/18, illus.

Two Men in an Interior, one reading. Galleria Borghese, Rome (1959/237, illus.). 44 × 35. S. G/16, illus.

Man keeping Accounts. Rosenborg Castle, Copenhagen. 43.5 × 31.3 S & D 165(?3). G/21, illus.

Youth shading a Candle with his Hat. With Brian Koetser Gallery, London (1966). Copper, 17.8 × 14.6 (oval). Exh. Koetser Gallery, 1966 (48), illus.

Porter masking a Candle. Galleria Borghese, Rome (1959/236, illus.). 45 × 35. G/9, illus. Exh. Bordeaux, 1959 (77), illus.

Porter masking a Candle. Rosenborg Castle, Copenhagen. 63.6 × 41.5. S & D 1654. G/27, illus.

Boy masking a Candle. Vicomte de Vauchier Collection, Savigny-lès-Beaune (Côte d'Or). Various copies cited by Nicolson/Wright, 1974, p. 205 under Nos. 16–23, one at Musée des Beaux-Arts, Dijon (1968/68, as after La Tour), 61 × 53 (Gudlaugsson, 1948, illus.), which has a pendant of a Boy *Lute-player* (q.v.).

Woman taking a Bath. Rosenborg Castle, Copenhagen. 43.1 × 30.6. G/19, illus.

Man with Oil Lamp. Galleria Doria-Pamphilj, Rome (1942/421, as Dou). 43 × 35 .G/10, illus. Pendant to:
Woman with Oil Lamp. Galleria Doria-Pamphilj, Rome (1942/422, as Dou). 43 × 35. G/11, illus.

HEUVEL, Anton van den (?–Aug. 1677.)

From Ghent. Master of the Guild there, 1629. Earlier for about 10 years in Antwerp and Rome. In the 1640's, painting in the manner of Casper de Crayer. One near-Caravaggesque work listed.

Liberation of St Peter. Sint Peterskerk, Zulte. S. Roggen, 1950, Fig. 8.

The following have points in common with the Zulte *Liberation* but are probably by different hands:

Liberation of St Peter. Museum, Chartres. 270 × 255. Exh. Réalité, 1934 (125), illus. as *'inconnu'*.
Liberation of St Peter [Plate 106]. Private Collection, Scotland (1972).

HONTHORST, Gerrit van (Nov. 1590–April 1656)

Born in Utrecht. Pupil of Abraham Bloemaert, *c.* 1606. Leaves for Italy ?*c.* 1612. Settles in Rome before 1616. Patronized by Marchese Giustiniani, the Grand Duke of Tuscany and Cardinal Scipione Borghese. Back in Utrecht by July 1620. Master of the Guild of St Luke, Utrecht, 1622; Dean, 1625–6, 1628–9. Works for Charles I in London, 1628. Lives in The Hague, 1637–52. Dies in Utrecht. Influenced when in Italy by Cambiaso, the Bassano, the Carraccesques, and Manfredi. More or less abandons Caravaggism before 1630. Almost nothing listed after 1628/29 except Delft and Armentières *Crowning with Thorns*, and Lvov *Guitar Player*, and a few non-Caravaggesque pictures and drawings before 1629 excluded. (Some mythological works of 1620–8 are included though only marginally Caravaggesque.) J followed by number refers to Judson, 1959 catalogue numbers, pp. 145–272.

Apollo and Diana. Hampton Court Palace. 357 × 640. S & D 1628. J73 (Fig. 41). Study for this picture: Museum Boymans-Van Beuningen, Rotterdam. Pen, grey ink, grey wash, white highlights, on sketch in black chalk, 38.2 × 58.3. J220 (Fig. 51).

Sine Baccho et Caerere friget Venus. Schloss Weissenstein, Pommersfelden. 163 × 208.5. S. J79. Longhi, S.G., 1961, Fig. 189. Judson under No. 79 cites copy in Ghent.

Nymph and Satyr. Schloss Weissenstein, Pommersfelden. 104 × 131. S & D 1623. J89 (Fig. 30). Judson under No. 89 cites copies.

Nymphs and Satyrs. Formerly (?) Kupferstich-kabinett, Berlin. Pen, brown ink, wash, white high-lights, 20.1 × 30.2. S & D 1622. J224 (Fig. 49).

Orpheus. Palazzo Reale, Naples. 320 × 240. Voss, 1924, Pl. 129.

Triumph of Silenus. Musée des Beaux-Arts, Lille (1893/405). 209 × 272. J93 (Fig. 33).

Mars [Plate 159]. Milwaukee Art Center. 35 × 29. F. S. *Annual Report*, 1976, illus.

Mars and Venus. Staatliche Graphische Sammlung, Munich (1973/636 illus.). Pen, brown wash, white highlights, 20.8 × 31. J223. Von Schneider, 1933, Pl. 9b.

Allegory. Bayerische Staatsgemäldesammlung, (1908/308); at Schleissheim 1960. 125 × 157. S & D 1623. J120 (Fig. 27). Engraved 1625.

Allegory of Winter. Formerly Stroganoff Col-

lection, Leningrad; Stroganoff Sale, Lepke, Berlin, 12–13 May 1931 (38), illus. 110 × 140. J127a.

Roman Charity. Lost. 102.6 × 132.3. Engraved. ?Copy of this: Bayerische Staatsgemäldesammlung, Munich (1908/312). 120 × 149. J99. Hoogewerff, 1924, Pl. XXVIII.

Lais and Xenocrates. Five versions: **1.** A. L. Hertz Collection, The Hague (1959). 150 × 202. S & D 1623. J103 (Fig. 31). **2.** Jacob Heyman Collection, Gothenburg (1958). 97 × 132. S A or C. **3.** Dr M. J. Binder Collection, Berlin (1914). 104 × 102. F of Xenocrates alone. C. F. *Archiv für Kunstgeschichte*, 1914, Pl. 58. **4.** Chelsea Arts Club, London. C. **5.** With Finarte, Rome (1977). C.

Death of Seneca. Three versions: **1.** Centraal Museum, Utrecht (1952/153). 205 × 265.5. ?S A. J106a (Fig. 45). **2.** Chrysler Museum, Norfolk (Virginia) (Exh. Portland Art Museum etc., 1956/10). 194.9 × 204.7. S A. J106b. **3.** Freiherr von Graes Collection, Haus Diependrock, Germany. 182 × 226. J106c. Rave, 1954, illus. Study for this composition: Centraal Museum, Utrecht (1952/422). Pen and sepia wash, 24.3 × 33.5. J228 (Fig. 50). A drawing (?early 19th century) after this composition (Private Collection, Auckland (NZ)) bears inscription stating that this painting belonged to a Mr Taylor, 1763.

Solon before Croesus. Kunsthalle, Hamburg. 165 × 210. S & D 1624. J107 (Fig. 34). Two copies cited by Judson under No. 107.

Granida and Daifilo. Centraal Museum, Utrecht (1952/151). 145 × 178.5. S & D 1625. J132 (Fig. 38).

Lot and his Daughters. Lost. Engraved by J. G. Müller after Honthorst of 1623. J2 (Fig. 29). Judson under No. 2 cites painted copies, and a possible original on panel, 36 × 26, Frankfurt Sale, 27 June 1934 (59), illus.

Samson and Delilah [Plate 155: detail]. Two versions: **1.** Cleveland Museum of Art. 129.2 × 94. Spear, 1971 (35), illus. **2.** Dutch art market (1967). ?A. *Connaissance des Arts*, Oct. 1967, p. 125, illus.

King David harping. Centraal Museum, Utrecht (1952/149). 83 × 67. S & D 1622. J9 (Fig. 22).

Nativity. Galleria degli Uffizi, Florence. 96 × 130.5. 1620. J17 (Fig. 11). Judson under No. 17 cites copies.

Adoration of the Shepherds. Florentine Galleries. 338.5 × 198.5. 1617. J19 (Fig. 12.) Judson under No. 19 cites copies.

Adoration of the Shepherds. Wallraf-Richartz Museum, Cologne (1967/2122). 150 × 191. S & D 1622. J20 (Fig. 20).

Christ in the Carpenter's Shop. Convent of S. Silvestro, Montecompatri (stolen and not recovered by 1977). 142 × 118. J27 (Fig. 5).

Christ in the Carpenter's Shop. Hermitage, Leningrad. 137.5 × 185. J27a (Fig. 13). Linnik, 1975, illus. colour Pls. 98–100.

Christ in the Carpenter's Shop. Bob Jones University, Collection of Sacred Art, Greenville (SC) (1962/166, illus.). 111.1 × 130.8.

Christ and Nicodemus [Plate 152]. Seattle Art Museum. Ink and wash, 19 × 29.6.

Agony in the Garden. Hermitage, Leningrad. 113 × 110. J39 (Fig. 4). Linnik, 1975, illus. colour Pls. 95–7.

Agony in the Garden [Plate 162]. A. B. Waterfield Collection, London. 114.3 × 147.3.

Christ before Caiaphas. National Gallery, London (1960/3679). 272 × 183. J44 (frontispiece). Engravings and copies listed by Judson under No. 44 and MacLaren, 1960, p. 181. Add to known copies: **1.** Church, Yssingeaux-en-Velay. **2.** Collegio Cicognini, Prato, as Volmarijn.

Crowning with Thorns. Pastorie Sint Dominicuskerk, Amsterdam. 189 × 219. J47 (Fig. 18).

Crowning with Thorns. Oud-Katholieke Kerk, Delft. 200 × 170. S & D 1638. Delft, 1959, illus.

Crowning with Thorns. Composition from school of Honthorst, see Jan Janssens.

Mocking of Christ. S. Maria della Concezione (Cappuccini), Rome. 179 × 210. C. Hoogewerff, 1917, Fig. 5.

Christ at Emmaus. Wadsworth Atheneum, Hartford (Conn.) (1958/75; illus. as 'circle', wrongly as on panel). 124 × 191. A. Gudlaugsson, 1952, Fig. 4.

Madonna with Saints Francis and Bonaventura, with Princess Colonna-Gonzaga. Chiesa dei Cappuccini, Albano. 233 × 370. S & D 1618. J61 (Fig. 7).

Madonna with Saints Sebastian and Roch. S. Pietro, Albano. U.

St Cecilia playing the Organ [Plate 153]. Schloss Wilhelmshöhe, Cassel (1958/182). 86 × 111. J65a, as copy. One copy known: Baron A. Reedtz-Thott Collection, Gaunø. 93 × 121.5. J65b.

Beheading of St John the Baptist. S. Maria della Scala, Rome. 345 × 215, 1618. J30 (Fig. 6). Engraved by Giuseppe Longhi (1806). Judson under No. 30 cites copy.

Head of St John the Baptist on a Charger [Plate 141]. With Colnaghi's, London (1965). 69.2 × 53.9. U.

Penitent Magdalen. Hermitage, Leningrad. 87.5 × 77.5. Hermitage *Bulletin*, XX, 1961, illus. as Seghers. Studio replica with Old Master Galleries, London (1974); Sale, Christie's 17 Feb. 1978 (81). 85.1 × 76.8.

Penitent Magdalen [Plate 154]. Kunstmuseum, Düsseldorf. Pen, grey wash, white highlights, 14.1 × 17.9. S. J217.

Penitent Magdalen. Museo de Bellas Artes, Saragossa (deposited in Prado). 58 × 86. U. Seville, 1973 (41), illus. Similar to picture in Capodimonte, Naples, as Vaccaro (see under Sellitto).

St Paul caught up in the third Heaven. S. Maria della Vittoria, Rome. 400 × 250. J57 (Fig. 8).

Penitent St Peter. With Galerie Rappe, Stockholm (1959). 110 × 98. S. J43. Granberg, I, 1911, No. 465, illus.

Liberation of St Peter. Staatliche Museen, Berlin-East (Kaiser-Friedrich Museum 1931/431). 129 × 179. J59 (Fig. 10). Engraved as from Giustiniani Collection in Landon (1812). Copies (among others) known: **1.** Ilardi Collection, Rome. 144 × 194. **2.** Shugborough (Staffs) (National Trust) as Reni (part original; the angel added later by Reni imitator). 149.9 × 185.4. Nicolson, 1975, Fig. 12. **3.** Collegio Cicognini, Prato. **4.** Finarte Sale, Rome, 12–13 Dec. 1973 (84) as ?Gerard Seghers. 99 × 120.5. The Bigot with Victor Spark (q.v.) listed by Judson is not a copy.

Liberation of St Peter [Plate 160]. Formerly Sir Ilay Campbell Bt. Collection, Glasgow; with Richard Feigen, New York (1975); Sale, Sotheby's, 12 April 1978 (58), illus. 142.8 × 117. F. J60C. RA1938 (157), illus. Four copies known: **1.** Roman art market (1959). 153 × 188. J60a. **2.** Bayerische Staatsgemäldesammlung, Munich (1908/Inv. 310), on loan to Schleissheim (1959). 152 × 196. J60b. **3.** French art market (1978). 130 × 190. **4.** Museum Schloss Anholt. 160 × 196. A. Vliegenthart, 1973, Fig. 10.

Denial of St Peter. Minneapolis Institute of Arts. 118.4 × 144.8. Nicolson, Minneapolis, 1974, Fig. 1.

Denial of St Peter. Musée des Beaux-Arts, Rennes. 150 × 197. Paris, 1970 (110), illus. Engraved by Landon (1807).

Denial of St Peter [Plates 135, 156]. Formerly Glenstall Abbey, Murroe (Co. Limerick); London art market (1975). Withdrawn from sale Sotheby's, 11 Dec. 1974 (106), illus. 137 × 244.

Martyrdom of St Peter. Nasjonalgalleriet, Oslo. Pen, brown ink, wash, 38 × 26.5. S & D 1616. Copy of the Caravaggio in S. Maria del Popolo (q.v.). J218 (Fig. 47).

St Sebastian. Many versions cited under J68, the best known being: **1.** National Gallery, London (No. 4503). 101 × 117. S. J68 (Fig. 28), **2.** Bayerische Staatsgemäldesammlung, Munich (Schleissheim 1914/ 1236) as Bylert. 108 × 140 including later additions; originally 103.7 × 117. **3.** Chapelle des Pénitents 'Bourras', Aix-en-Provence, as Bylert and Finson. 110 × 135. C. **4.** With Galerie St Anna, Zurich (1959). ?S A. *Pro Arte.* 1944, illus.

Ceiling Painting: Musicians behind a balustrade [Plates 157, 158]. J. Paul Getty Museum, Malibu. Panel, 285 × 212. S & D 1622. BP in parts. J198 (Fig. 24). illus. since recent restoration in Utrecht, Reznicek, 1972, Fig. 4.

Concert (five figures plus two angels). Musée du Louvre, Paris (1922/2409). 168 × 178. S & D 1624. J189 (Fig. 32). Judson under No. 189 cites copies. Part of same scheme of decoration as Fontainebleau *Luteplayer* and Ministère des Finances *Guitar Player* (see below).

Concert (five figures). Toledo Museum of Art, Toledo (Ohio) (1976, p. 80, as Honthorst follower, illus.). 113.6 × 158.1. ?P.

Concert (four figures). Galleria Borghese, Rome. 168 × 202. J190. Von Schneider, 1933, Pl. 2a. Judson under No. 190 cites replica in private collection in South America as a probable original.

Concert (four figures). Statens Museum for Kunst, Copenhagen (1951/321); on loan to Kronborg Castle, Elsinore, Denmark. 117 × 146.5. S & D 1623. J197 (Fig. 25).

Concert (four figures). Formerly Kupferstichkabinett, Berlin. Pen and wash with white highlights, 20.2 × 27.9. S. (?not by Honthorst). J251. Slatkes, 1970, Fig. 2.

Concert (three figures) [Plate 161]. Musée des Beaux-Arts, Lyons. 104 × 134. J196.

Concert (three figures). Museum der Bildenden Künste, Leipzig (1973, p. 64, illus.). Panel, 113 × 95. S & D 1629.

Concert (two figures). Montreal Museum of Fine Arts. 78 × 94.5. S & D 1624. Judson, 1970, Fig. 1. J176. Judson under No. 176 cites copy or copies.

Elderly Man playing Drum and Flute, with Woman masking Candle. Dens Collection, Brussels (1959). J184 (Fig. 15).

Girl with Flute, being seduced by young Man. With H. Shickman Gallery, New York (1970). 104 × 132. C. Exh. Shickman Gallery, 1967 (20), illus.

Boy Shepherd playing Flute, with Girl Shepherdess. Pushkin Museum, Moscow. 71 × 98. S & D 16 . . . Linnik, 1975, illus. colour Pls. 104–6.

Luteplayer (girl, facing spectator, smiling, looking to right). Two versions: **1.** Musée du Château, Fontainebleau (on loan from Louvre). 82 × 68. S & D 1624. Paris 1970 (112), illus. See under Louvre *Concert* above. **2.** Formerly with J. Néger, Paris. 76 × 63. Probably C. J153. Utrecht/Antwerp, 1952 (50), illus. Copies were: **1.** Finarte Sale, Rome, 12–13 Dec. 1973 (102). 81.5 × 67.5. **2.** Formerly with Böhler, Munich, as Baburen. 79 × 63.

Luteplayer (girl, to left). Hermitage, Leningrad. 84 × 66.5. S & D 1624. J154 (Fig. 35). Linnik, 1975, illus. colour Pl. 108. Pair to Leningrad *Violinist with Glass* (q.v.).

Luteplayer (girl, facing spectator, head towards right) [Plate 149]. Museum der Bildenden Künste, Leipzig. 87 × 72.5. This is a pair to:

Violinist (male, with candle) [Plate 150]. Museum der Bildenden Künste, Leipzig. 87.5 × 72.

Violinist (male, to right, head to spectator) [Plate 147]. Musée des Beaux-Arts, Angers. Panel, 72 × 60. S & D 1625. J175a.

Violinist (male, violin under arm, making sexual gesture with fist) [Plates 139, 140]. Three versions: **1.** Formerly F. Brandeis Collection, Qualicum Beach (British Columbia); sale Christie's, 10 April 1970 (112). 81.3 × 63. S & D 1624. J169. **2.** Schloss Weissenstein,

Pommersfelden. 83 × 68. Pair to Pommersfelden *Girl counting Money* (q.v.). **3.** Sale, Sotheby's, 25 June 1969 (22). 79.5 × 63. Probably C.

Violinist with Glass (male, at window). Rijksmuseum, Amsterdam (1976/A180, illus.). 108 × 89. S & D 1623. J168 (Fig. 26).

Violinist with Glass (male, holding up glass to light). Two versions: **1.** Earl C. Townsend Jnr Collection, Indianapolis. 82.5 × 67.3. S. J170 (Fig. opp. Fig. 87). **2.** E. B. Crocker Art Gallery, Sacramento (Calif.). 94 × 74.9. C. Trivas, 1940, illus.

Violinist with Glass (variant of Townsend canvas). Franz Mayer Collection, Museo di San Carlos, Mexico City. 77.5 × 66.3. BP. J170a. Spear, 1971 (under No. 36), illus. Near-replica in Dorotheum Sale, Vienna, 28 Nov.–1 Dec. 1967, as Baburen. 81 × 66.

Violinist with Glass (violin tucked under arm, pointing to long glass). Hermitage, Leningrad (1957 vol. of illus. Pl. 427). 84 × 66.5. S & D 1624. J162. Linnik, 1975, illus. colour Pl. 107. Engraved by Matham (1627). Pair to Leningrad *Girl Luteplayer* (q.v.). Copy in museum at Gouda (Van Gelder, 1948–9, No. 62 of Couwenbergh lists).

Violinist (girl). Sale, Sotheby's, 23 June 1937 (53a). 81.2 × 63.5. S & D 162 (?6). J152a.

Violinist (girl). Lost. Engraved early 17th century after Honthorst (*Gazette des Beaux-Arts*, Oct.–Dec. 1950, p. 208, Fig. 57). Similar to above.

Guitar Player (girl, facing spectator, head to left). Ministère des Finances, Paris (on loan from Louvre). 82 × 68. Paris, 1970 (113), illus. See under Louvre *Concert* above.

Guitar Player (girl, facing spectator, head to right, with mask). Picture Gallery, Lvov (USSR). 84 × 67.5. S & D 1631. Album of illustrations of Netherlandish pictures in Russian Museums, Moscow, 1959, Fig. 8. Copy with Acquavella Galleries, New York (1966); sale, Christie's, 30 July 1976 (156), as 'D. van Baburen', 78.7 × 67.3 (presumably the same). 81.3 × 68.6. Lvov picture a pair to:

Viola da Gamba Player (man). Picture Gallery, Lvov. 84 × 67.5. S & D 1631. Both pictures illus. Linnik, 1975, Pls. 101–3 in colour.

Viola da Gamba Player (girl). Heyl Collection, Worms (1928). 77 × 64. J152.

Fluteplayer singing. Staatliches Museum, Schwerin (1962/148). 107.5 × 85.5. S. J173. Von Schneider, 1933, Pl. 7a. Two copies: **1.** Kunsthaus Malmédé, Cologne (1932). 106 × 87. *Burl. Mag.* June 1932, illus. **2.** Heirs of R. Dooyes, The Hague; sale, Sotheby's, 9 Dec. 1959 (116). Panel, 103.5 × 85.7 [the same as listed under J173 as Arnheim (1933)].

Old Woman singing Street Songs. Frans Halsmuseum, Haarlem (1955/173). 65 × 50. J158 (Fig. 19). Engraved by Cornelis Bloemaert, Cornelis van Dalen, and Charles David (illus. Weigert, 1953, Fig. 8). Judson cites copy on panel under No. 158.

Feasting Scene with Luteplayer. Florentine Galleries. 142 × 212. 1619–20. J194 (Fig. 9). Judson under No. 194 cites copies, but one described in Leicester Museum is not known there.

Feasting Scene with Luteplayer and betrothed Couple. National Gallery of Ireland, Dublin (1971/1379). S(?) & D 1628. 146 × 205. Exh. Bordeaux, 1969 (40), illus.

Feasting Scene with betrothed Couple. Florentine Galleries. 138 × 203. Florence, 1970 (27), illus.

Feasting Scene with Love-making. Alte Pinakothek, Munich (1967/1312). 130 × 196.5. S & D 1622. J195 (Fig. 17).

Feasting Scene. Albertina, Vienna. Pen with white highlights on preliminary sketch in black chalk, 18.3 × 27.1. J253. Judson under No. 253 cites copy. Associated with Munich picture above.

Drinking and smoking Scene [Plate 142]. Beningbrough Hall (North Yorkshire), National Trust. 97.8 × 78.7. F. U.

Backgammon Players. Staatliche Museen, Berlin-East (Kaiser-Friedrich Museum 1931/444). Panel, 46 × 65. 'S & D 1624'. C. J186 (Fig. 36). That lost original was larger is indicated by C in a Weinmüller, Munich, sale, 19 June 1974 (854), illus. and on other occasions in 1974–5, as Utrecht School, 71 × 91.

Backgammon Players. Prenten Kabinet der Rijksuniversiteit, Leiden. Pen and brown ink, brown wash, 16 × 25. S. J248. Similar composition to East Berlin picture above.

Chess Players. Pushkin Museum, Moscow. Pen and pencil, heightened with white, 20.2 × 29. Exh. of Drawings from Leningrad and Moscow, Brussels/Rotterdam/Paris, 1972–3 (51), illus.

Gamblers and cheating Cardplayers (five figures). Two versions (not identical): **1.** Städtische Gemäldesammlungen, Wiesbaden. 125 × 190. Gudlaugsson, 1952, Fig. 5. **2.** Residenzgalerie, Bamberg. A.

Gamblers and cheating Cardplayers (five figures). With Paul Botte, Paris (late 1960's), as Valentin. Drawing. C.

Gipsy Fortune-Teller. Florentine Galleries. 137 × 204. Florence, 1970 (26), illus. Replica formerly in Viennese Imperial Collections, engraved in *Prodromus* (1735).

Procuress. Centraal Museum, Utrecht (1952/152). Panel, 71 × 104. S & D 1625. J199 (Fig. 37).

Brothel Scene [Plate 151]. Ashmolean Museum, Oxford. Pen and brush in Indian ink over black chalk, 16 × 24.2. J249.

Tooth Extractor. Gemäldegalerie, Dresden (1960/1251). 147 × 219. S & D 1622. J191 (Fig. 21). Judson under No. 191 cites copies.

Tooth Extractor. Musée du Louvre, Paris. 137 × 200. S & D 1627. J192 (Fig. 39). Engraved (1728).

Flea-Catcher. Two versions: **1.** With H. Shickman Gallery, New York (1971). 132 × 188. S & D 162

(?1). J178b. Nicolson/Wright, 1974, Fig. 55. **2.** Öffentliche Kunstsammlung, Bachofenmuseum, Basle (1946, p. 83). 105 × 136. With omission of two figures left. A. J178a. Von Schneider, 1933, Pl. 5a.

Flea-Catcher. Formerly C. H. van Bohemen Collection, The Hague (1929). Panel, 101 × 87. J178c.

Old Woman throwing Candle Beam on a Girl. Museum der Bildenden Künste, Leipzig. Pen, grey wash, white highlights, 18.2 × 16.2. S. J246 (Fig. 48).

Girl blowing on Coal, with Cavalier. Herzog Anton Ulrich-Museum, Brunswick (1976/178, illus.). 82 × 66. J179. Exh. Rijksmuseum, Amsterdam, 1976 (28), illus. colour.

Boy blowing on Firebrand. Private Collection, Brussels (1959). 76.8 × 63.5. J161 (Fig. 16).

Young Man crushing Grapes into a Cup. Worcester Art Museum, Worcester (Mass.) (1974/1968.15, illus.). 83 × 66.6. S & D 1622. J75. Judson, 1969, illus.

Young Man with Tankard and Glass. Czernin Collection, Vienna (exh. Residenzgalerie, Salzburg, 1970/86, illus.). Panel, 62 × 54. J166.

Young Man holding up Glass. Sale (Weinmüller) Munich, 15–16 March 1961 (870) as Terbrugghen. 81 × 65. C. A poorer copy was: Sale, Sotheby's, 21 Dec. 1960 (112) as Honthorst. 81.7 × 63.5.

Young Man holding tilted Glass. Kunsthandel Basch, Rotterdam (1926). 76 × 60. ?C.

Shepherdess holding up (?) Plums [Plate 144]. Anson Collection, Catton Hall, near Burton-on-Trent. 77.8 × 63.5. J133.

Shepherdess with a Nest of Doves. Centraal Museum, Utrecht (1952/150). 80 × 65. S & D 16(?2)2. J134 (Fig. 23). Copies at Sotheby's, 26 June 1957 (145), 84.4 × 64.1, and Eduard Hünerberg Sale, Brunswick, 14–15 Sept. 1961, as Claude Audran, 83 × 65.

Girl with obscene Picture [Plate 146]. City Art Museum, St Louis (Missouri). 82 × 64. S & D 1625. J149. Judson under No. 149 cites copies.

Girl counting Money [Plate 145]. Schloss Weissenstein, Pommersfelden. 83 × 66. Pair to Pommersfelden *Violinist* (q.v.). J147. Judson under No. 147 cites copy.

Girl lighting Candle from Lantern. Lost. Engraved by Cornelis Bloemaert after Honthorst. Pariset, 1948, Pl. 24 (4).

Old Woman with Purse. ?Lost. Engraved by Cornelis Bloemaert. J156. Pariset, 1948, Pl. 8 (3) shows C. David engraving after C. Bloemaert. Add to the painted copies(?) listed by Judson: **1.** formerly James Murnaghan Collection, Dublin. 63.5 × 48.3 (to left). **2.** Dr Jacques Depaulis Collection, Bordeaux (1971). Panel, 73 × 59.

Old Woman examining Coin. Turnbull Sale, Christie's, 26 May 1924 (129). 75 × 60. ?S & D. J157 (Fig. 14).

Old Woman masking Candle [Plate 148]. Marquess of Waterford Collection, Portlaw (Eire). 98.4 × 78.7.

Ham Eater. Musée Calvet, Avignon (1924, p. 212, as Zurbarán). 83 × 69. J164. Bruyn, 1949, Fig. 1. Engraved by Cornelis Bloemaert after Honthorst (1625) (Hollstein, 1949ff., II, p. 80, illus.), by Cornelis van Dalen and Charles David. Judson under No. 164 cites copies, one of which may be: Dorotheum Sale, Vienna, 18–21 Sept. 1973 (122), illus. colour and black and white, as Stomer. 86 × 66.3. Others are: with Trafalgar Galleries, London (1974), 81.3 × 66 (? the one at Christie's, 18 July 1974 (262) and again 16 May 1975 (100)); and Museum, Syracuse (after the engraving).

Male Nude. Kupferstichkabinett, Dresden. Black chalk, 42.3 × 26. S & D 1619. J254. Reznicek, 1972, Fig. 2.

Unidentified Subject (single head) [Plate 143]. Julius S. Held Collection, New York. 41.8 × 34.2. F. J200. Exh. Arcade Gallery, London, 1953 (7), illus.

The following are by imitators of Honthorst who need not necessarily have been in his workshop:

Vanitas. Ashmolean Museum, Oxford (1962/204, illus.). 101 × 82. Voss, 1924, Pl. 130.

Democritus. Comm. Mincuzzi Collection, Bari. 92 × 71. Hoogewerff, 1952, Pl. 1.

Christ in the Carpenter's Shop. Billedgalleri, Bergen.

St Jerome. Two versions: **1.** Private Collection, Holland, on loan to Centraal Museum, Utrecht (1954). 101.5 × 130. Nicolson, NKJ, 1960, Fig. 6. **2.** Abbey of Grinbergen, Belgium. F.

St Jerome. Two versions **1.** Kunsthistorisches Museum Vienna. **2.** Muzeul Brukenthal, Sibiu, as G. M. Tamburini. 99 × 127. (Reversed from Vienna composition).

Denial of St Peter. Musée des Beaux-Arts, Dijon. Pencil, black chalk, brown wash with white highlights, 14.9 × 20.3.

Girl singing, with Old Woman. Mario Modestini Collection, New York (1924). Voss, 1924, Pl. 107.

Youth reading Manuscript by Candlelight. Musée des Beaux-Arts, Valence. 99 × 74. *Gazette des Beaux-Arts*, Feb. 1973, Fig. 49.

The following is a selection of wrong attributions to Honthorst:

Galli **Assembly on Olympus.** Florentine Galleries.

Heimbach **Adoration of the Shepherds.** Longhi Collection, Florence.

Bigot **Capture of Christ.** Galleria Spada, Rome.

Bigot three altar-pieces in Passion Chapel, S. Maria in Aquiro, Rome.

?Finson **Beheading of St John.** Musée, Hazebrouck.

*Sweerts Circle **Boy Fluteplayer.** Herzog Anton Ulrich-Museum, Brunswick (1969/175). Panel, 41 × 31. J163.

Sandrart **Allegory of Vanity: Young Lady at her Dressing Table.** Hermitage, Leningrad.

HOUBRACKEN, Jan van (?–1665)

Native of Antwerp. Susinno (1724, ed. 1960) tells us most improbably that he reaches Italy with his 'master' Rubens and is with him in Rome, Florence and Venice. Active in Eastern Sicily from 1630's onwards where he is influenced by Stomer's Sicilian phase, and also apparently in touch with Rodriguez, but most of his Sicilian works in Messina and Randazzo are quite un-Caravaggesque and are not listed below. Dies in Messina. Two surviving pictures are or were dated 1636 (?) and 1657.

Five Senses (five canbases) [Plate 193]. Chiesa Madre, Caccamo. Each, 131 × 102. Negri Arnoldi, 1968, Figs. 101–5. Replica of *Smell*: Ryolo Collection, Palermo; BP; Negri Arnoldi, 1968, Fig. 106.

Miracle of St Roch. Museo Nazionale, Messina. Canvas on panel, 278 × 185. R. U. Negri Arnoldi, 1968, Fig. 110.

JANSSENS, Abraham (*c.* 1576–1632)

Antwerp School. No trace of Caravaggio influence in first Roman period (1598–1601), which has led scholars to imagine he paid a second visit there towards end of first decade. Even on this supposed second journey, traces in his work of Caravaggio's influence are minimal (represented by a tiny group listed below). He is much more deeply affected by Rubens.

Pietà. Three versions recorded: **1.** Museum, Valenciennes. 150 × 122. A. Exh. Utrecht/Antwerp, 1952 (97). **2.** Church, Vilvoorde. **3.** Bob Jones University, Collection of Sacred Art, Greenville (SC). 180 × 153. Longhi, 1965, Pl. 45. Composition engraved by Egbert van Panderen (*c.* 1628).
Angels watching over the Dead Christ. Two

versions recorded: **1.** Church of St John the Baptist, Lage Zwaluwe (N. Brabant). 108 × 159. Müller Hofstede, 1971, Pl. 22. **2.** Metropolitan Museum of Art, New York. 116.8 × 144.1. Spear, 1971, Fig. 28.
Fluteplayer and Girl [Plate 84]. Matzwansky Collection, Vienna (1943). 105 × 75. Widerhofen Sale, Vienna, 18–20 Feb. 1902 (20), illus.

JANSSENS, Jan (Aug. 1590–*c.* 1650)

Born Ghent. In Rome after 1612 to 1620–1. Master of the Guild of St Luke, Ghent, 1621. Appears to be active in Ghent for the remainder of his life. Strongly influenced by Baburen and Honthorst. Some altar-pieces in Flemish churches not listed. R followed by stroke and Fig. or page number refers to Roggen, 1950.

Roman Charity. Academia de San Fernando, Madrid. 172 × 215. C after Baburen in York (q.v.). S. After 1620. Exh. Seville, 1973 (43), illus.
Crowning with Thorns (five figures) [Plate 102: detail]. Musée des Beaux-Arts, Ghent (1937/1929-BB). 375 × 300. Von Schneider, 1933, Pl. 47a. Replicas cited by R/p. 280, to which add: **1.** with Néger, Paris (1959). ?75 × 60. **2.** Musée des Beaux-Arts, Ghent (1937/1919-BA). 210 × 178.
Crowning with Thorns (five figures). Replicas cited by R/p. 273, among which are: **1.** St Michael's, Roeselare. *c.* 225 × 200. S. **2.** Church at Laarne. 1647. **3.** Musée des Augustins, Toulouse. 185 × 244. R/Figs. 9–10. **4.** Koninklijk Atheneum, Ghent. Another is: Saint-Vaast, Armentières (near Lille). 275 × 208. The composition derives from the school of Honthorst, to which some versions may belong.
Crowning with Thorns (three figures). Replicas cited by R/p. 278, among which are: **1.** St Peter's, Ghent. 185 × 145. 1627. R/Figs. 6–7. **2.** St James's, Ghent.

Resurrection. Saint-Sauveur, Bruges. S. 1640. R/Fig. 8.
Annunciation [Plate 103]. Musée des Beaux-Arts, Ghent (1937/S–91). 258 × 222. ?C after lost Baburen. S. R/Fig. 11; exh. Museum, Ghent, 1975 (58), illus. colour. Two replicas known of top half: **1.** With Mrs Frank, London (1952), sale, Christie's, 30 June 1961 (96). 105.4 × 170.2. **2.** Byloke Hospital, Ghent.
Martyrdom of St Adrian. St Martin's, Akkergem (Ghent). ?S. R/Fig. 13.
Martyrdom of St Barbara. St Michael's, Ghent. R/Figs. 15–16.
St Jerome listening to the Trumpet of the Last Judgement. Three versions known: **1.** St Nicholas, Ghent. 1621. R/Fig. 4. **2.** Historical and Art Museum, Serpukhov (USSR). 160 × 82. Linnik, 1975, illus. colour Pl. 183. **3.** Sainte-Gudule, Brussels.

The following is a wrong attribution to Jan Janssens:
Caravaggesque unknown (South Netherlandish)
Crowning with Thorns. Musée du Louvre.

KUIJL or KUYL, Gerard van (Jan. 1604–March 1673)

From Gorinchem (Gorkum). The pictures listed below (a selection from a more extensive *œuvre*) were thought until 1977 (Sluijter) to be by a Gysbert van der Kuyl of Gouda, who is mentioned in Gouda archives of 1656 and 1669, though it is not clear whether he is even a painter. Gerard van Kuijl or Kuyl, to whom they have now been transferred, is mentioned as 'Gerardo fiamingo' or 'Gherardo pittore' in Roman documents, living for three years (1629–31) with Jean Ducamps in the via Margutta, and is mentioned by Sandrart (1925 ed., p. 86) as Gerhardt von Krick. He reaches Rome 1627–8, but is back in Gorinchem by 1632, where he spends much of the rest of his life. None of his Italian works are known, but on his return he is influenced by Bijlert and Honthorst. W followed by stroke and plate number refers to Waddingham, 1960; S followed by stroke, catalogue and plate number to Sluijter, 1977.

Narcissus [Plate 221]. John and Mable Ringling Museum, Sarasota (Florida). 142.2 by 190.5. U.

Philoctetes on Lemnos. Formerly with Di Castro, Rome. 136 × 109. S & D 1647. W/Pl. 25. S/A4, Pl. 6.

Scene from the Life of the Roman Emperor Sertorius ('Cunning often gets the better of Force'). Town Hall, Gorinchem (Gorkum). (Rijksmuseum, Amsterdam, loan until 1925, No. 1398). 167 × 238. S & D 1638. W/Pl. 27. S/A1, Pl. 1.

The Magnanimity of Scipio (?). Sale, Koller, Zurich, 9 Nov. 1973, illus. 148 × 212. S. S/A2, Pl. 3.

Joseph interpreting Dreams. Loewi-Robertson Gallery, Los Angeles (1976). 134.6 × 172.7. S. W/Pl. 24. S/A3, Pl. 5.

Christ shown to the People. Statens Museum for Kunst, Copenhagen (1951/851, illus. as ?Italian). 191 × 141.1. W/Pl. 26. S/B1, Pl. 22.

St Sebastian [Plate 223]. Bayerische Staatsgemäldesammlung, Munich (Inv. No. 2056). 109.5 × 85. UU.

Concert (five figures) [Plate 224]. Chrysler Museum, Norfolk (Virginia). 124.5 × 180.5. S. 'Vermeer' exhibition, Rotterdam, 1935 (3), illus. S/A7, Pl. 10.

Concert (five figures). Rijksmuseum, Amsterdam (1976/A835, illus.). 99 × 131. S & D 1651. S/A8, Pl. 12.

Concert (three figures). Stichting Nederlands Kunstbezit, The Hague (on loan to Catharina Gasthuis, Gouda). 118 × 150. S & D 1662. BP. Hoogewerff, 1952, Pl. 7. S/A10, 14.

Violinist and female Singer. Sale, Berlin, 28 June 1956 (111, illus.). 104 × 98. S & D 1659. ?F. S/A9, Pl. 13.

Flute-playing Shepherd. Rolf Schmoll Collection, Hamburg (1975). 88.5 × 73. S. S/A11, Pl. 15.

Flute-playing Shepherd. A. Fleischner Sale, Vienna, 12 Dec. 1927 (30), illus., as attr. to Bronckhorst. 121 × 98. S/A12, Pl. 17.

Card Players. Statens Museum for Kunst, Copenhagen (1951/729, as Valentin). 163 × 229. U. W/Pl. 28.

The following are thoroughly dubious attributions to Kuijl:

Luteplayer. Národní Galerie, Prague (1969/17). 97 × 74. UU. S/B2, Pl. 23.

Dice Players. Regional Museum of Fine Arts, Rostov-on-Don. 110 × 147. UU. Linnik, 1975, illus. colour Pl. 88, as Preti.

LANA, Ludovico (1597–1646)

Born Codigoro (Ferrara), but spends most of his adult life in Modena, where he dies. A few works known by him, including an engraved *Death of Seneca*, but only one, listed below, remotely Caravaggesque.

Concert (three figures). Formerly Duchess of Wellington Collection, Penns-in-the-Rocks, Withyham (Sussex); Wellington Sale, Penns, 30 Jan. 1957 (186), bt in; Sotheby's, 29 Nov. 1961 (118); with John Hewitt, London (1964). *Burl. Mag.*, Aug. 1957, Fig. 33.

The following is a wrong attribution to Lana:
Vouet imitator **Portrait of a Young Man.** Galleria Estense, Modena.

LA TOUR, Georges de (March 1593–Jan. 1652)

Born at Vic-sur-Seille (Lorraine). Moves after his marriage (1617) to Lunéville (1620), where he settles for the remainder of his life. First described as a painter in 1617, but nothing is known of his apprenticeship or of any journeys outside Lorraine except probably to Paris in the late 1630's. He may visit Rome

about 1640. Only three pictures are dated (one illegibly, and two 1645 and 1650), but it is generally believed that the early works, except for the picture at Lvov, are daylight scenes, and the later ones night scenes. Influenced by Netherlandish and Lorraine Mannerism, by Terbrugghen and perhaps Le Clerc. Probably in contact in middle age with Bigot. All works listed. N/W followed by number refers to Nicolson/Wright, 1974 Catalogue numbers, pp. 156–203, many plates in colour.

Job mocked by his Wife. Musée Départemental des Vosges, Epinal. 144 × 95. S. BP. N/W 1 (Pl. 47).

Adoration of the Shepherds. Musée du Louvre, Paris. 106.5 × 131. ?1643. BP. N/W5 (Pl. 69). One copy known: Musée Toulouse-Lautrec, Albi. 123 × 152. N/W, Fig. 99.

Christ in the Carpenter's Shop. Musée du Louvre, Paris. 137 × 101. N/W 24 (Pl. 52). One copy known: Musée des Beaux-Arts, Besançon. 126 × 106. N/W, Fig. 119.

Sewing Lesson. Detroit Institute of Arts. 57 × 45. F. R. N/W. 2, Fig 101. Copy of whole composition: Rolandi del Carretto Collection, Cisano sul Neva, Savona. 82 × 95. N/W, Fig. 102.

Education of the Virgin. Lost. Four copies known: **1.** Musée des Beaux-Arts, Dijon (1968/66). 75 × 85. N/W, Fig. 104. **2.** Private Collection, Switzerland. 128 × 91 (full-length). N/W, Fig. 106. **3.** Frick Collection, New York. 83.3 × 100. Bears signature. N/W, Fig. 103. **4.** Musée du Louvre, Paris. 88 × 103. N/W, Fig. 105.

Newborn Child. Musée des Beaux-Arts, Rennes. 76 × 91. N/W 4 (Pl. 72). Besides the three copies listed under N/W 4, see also one by Maurice Denis, Thuillier, 1973, No. 57a, illus.

Madonna and Child with St Anne. Private Collection, Montreal. 66 × 55. F. R. N/W 6, Fig. 85. Whole composition of this or another version engraved by ?La Tour (as after Callot). 26.7 × 33.2. N/W, Fig. 86.

Dream of St Joseph. Musée des Beaux-Arts, Nantes. 93 × 81. S. N/W 23 (Pl. 62).

Salvator Mundi. Lost. One copy known: Musée Toulouse-Lautrec, Albi. 67 × 53.5. N/W, Fig. 20; see N/W 8.

St Alexis. Lost. 1648. Two copies known: **1.** National Gallery of Ireland, Dublin. 143 × 117. N/W, Fig. 111; see N/W 9. **2.** Musée Historique Lorrain, Nancy. 158 × 115. F. (also with later additions). N/W, Fig. 110.

St Bartholomew (?). Lost. One copy known: Musée Toulouse-Lautrec, Albi. 62 × 51. N/W, Fig. 27; see N/W 12.

St Francis in Ecstasy. Musée de Tessé, Le Mans. 154 × 163. S A. N/W 13 (Pl. 67). One copy known: ?Thiebeau Collection, Lyon. N/W, Fig. 91.

St Francis in Ecstasy. Lost. One copy known: Wadsworth Atheneum, Hartford (Conn.). 66 × 78.7. F. N/W, Fig. 92; see N/W 14.

St Francis in Ecstasy. Lost. Engraving by ?La Tour (as after Callot). 24 × 31. N/W, Fig. 81.

St James the Great. Lost. One copy known: Musée Toulouse-Lautrec, Albi. 63 × 51. N/W, Fig. 23; see N/W 16.

St James the Less. Musée Toulouse-Lautrec, Albi. 66 × 54. N/W 17 (Pl. 29).

St Jerome reading. Royal Collection, Hampton Court Palace. 62.2. × 47.1. N/W 18 (Pl. 31).

St Jerome reading. Lost. Two copies known: **1.** Musée du Louvre, Paris. 122 × 93. N/W, Fig. 37; see N/W 19. **2.** With Pardo, Paris (1972). 66 × 51. F. N/W, Fig. 36.

St Jerome reading. ?Reflects lost original. Copy or adaptation: with Wildenstein, New York (1971). 90.8 × 73.7. N/W, Fig. 38; see N/W 20.

St Jerome. Musée de Peinture et de Sculpture, Grenoble. 157 × 100. N/W 21 (Pl. 32).

St Jerome. Nationalmuseum, Stockholm. 152 × 109. N/W 22 (Pl. 33).

St Judas Thaddeus (?). Musée Toulouse-Lautrec, Albi. 62 × 51. N/W 25 (Pl. 28).

Repentant Magdalen with the Night-Light. Musée du Louvre, Paris. 128 × 94. S. N/W 26 (Pl. 48).

Repentant Magdalen with the Night-Light. Los Angeles County Museum of Art. 118 × 90. N/W 27 (Pl. 49).

Repentant Magdalen with the Mirror. Wrightsman Collection, New York. 92 × 134. N/W 28 (Pl. 56).

Repentant Magdalen (full length). National Gallery of Art, Washington, DC (1975/2672, illus.). 113 × 93. N/W 29 (Pl. 57). Several copies of upper part known, of which three are: **1.** Musée des Beaux-Arts, Besançon. 66 × 80. Thuillier, 1973, No. 40, illus. **2.** Dulac Collection, Le Cannet. **3.** Whereabouts unknown. 77 × 88. Isarlo, 1947, illus.

Repentant Magdalen (half length). Lost. Engraving by ?La Tour (as after Callot). 20.4 × 27.5. N/W, Fig. 82; see N/W 30. Two copies known: **1.** With Wildenstein, New York (1971). 67.9 × 73.7. N/W, Fig. 79. **2.** Formerly Terff Collection, Paris. 72 × 89. Thuillier, 1973, No. 34, illus.

Repentant Magdalen with the Document. Lost. One copy known: Roussel Collection, Nancy. Panel, 44 × 62. N/W, Fig. 75; see N/W 31.

Magdalen. Lost. One copy known: Private Collection, France. 72.5 × 58. Rosenberg, 1976, Fig. 1.

St Matthew. Lost. One copy known: Musée Toulouse-Lautrec, Albi. 65 × 53.5. N/W, Fig. 31; see N/W 32.

St Paul reading. Lost. One copy known: Musée Toulouse-Lautrec, Albi. 67 × 53.5. N/W, Fig. 29; see N/W 33.

Penitent St Peter. Cleveland Museum of Art, Cleveland (Ohio). 114.6 × 94.9. S & D 1645. N/W 85 (Pl. 70).

Penitent St Peter. Formerly Archduke Leopold Wilhelm Collection; lost. 55.2 × 73.6. Grossmann, 1958, Fig. 17. Mezzotint by Prenner. N/W, Fig. 41; see N/W 34.

Penitent St Peter. Lost. One copy known: Private Collection, France. 107 × 85. N/W, Fig. 100; see N/W 36.

St Peter. Lost. One copy known: Musée Toulouse-Lautrec, Albi. 67 × 53.5. N/W, Fig. 26; see N/W 37.

Denial of St Peter. Musée des Beaux-Arts, Nantes. 120 × 160. S & D 1650. N/W 39 (Pl. 80).

St Philip. Chrysler Museum, Norfolk (Virginia). 63 × 52. BP. N/W 40 (Pl. 30). One copy known: Musée Toulouse-Lautrec, Albi. 65 × 53. N/W, Fig. 28; see N/W 40.

St Sebastian tended by Irene (upright). Church of Broglie (Eure), lent from Church of Bois-Anzeray (Eure). 167 × 130. ?1649. BP. N/W 41 (Pl. 76). One copy known: Museum Dahlem, Berlin (1975/2046, illus.). 162 × 129. N/W, Fig. 116; see N/W 41.

St Sebastian tended by Irene (horizontal). Lost. More than ten copies known. Ten listed N/W Nos. 43 A–J, the best of which are: **1.** Formerly with Wildenstein, New York. N/W, Fig. 62; see N/W 43 F. **2.** Musée des Beaux-Arts, Orléans. 105 × 139. Thuillier, 1973, No. 41, illus. **3.** Art Market, Rome (1971). 102 × 136. N/W, Fig. 63a, detail: Wright, 1977, illus. colour Pl. 34; see N/W 43 I.

St Simon. Lost. One copy known: Musée Toulouse-Lautrec, Albi. 63 × 53. N/W, Fig. 30; see N/W 44.

St Thomas. Lost One copy known: Musée Toulouse-Lautrec, Albi. 65 × 53. N/W, Fig. 32; see N/W 45.

St Thomas. Collection Comtesse de Ruillé, Château Gallerande, La Flèche, Luché–Pringet (Sarthe). S. N/W 46 (Pl. 27).

Unidentified Saint. Lost. One copy known: Private Collection, Switzerland. 102 × 85. N/W, Fig. 40; see N/W 47.

A Monk reading. M. Pierre Fabius Collection, Paris. Drawing, 19.5 × 13.8. U. N/W under No. 15, Fig. 83.

Concert. Engraving after Le Clerc by ?La Tour (as after Callot). N/W, Fig. 87.

Hurdy-Gurdy Player. Musée des Beaux-Arts, Nantes. 162 × 105. N/W 57 (Pl. 42). Copies listed under N/W 57.

Hurdy-Gurdy Player with his Dog. Musée Municipal, Mont-de-Piété, Bergues. 186 × 120. R. N/W 58 (Pl. 8).

Hurdy-Gurdy Player in Profile. Musée Diocésain Charles Friry, Remiremont (Vosges). 159 × 94. N/W 9, Fig. 47. Etched by Charles Friry (1877). One copy known: Musée Historique Lorrain, Nancy. 100 × 62. Thuillier, 1973, No. 24b, illus. (See also under 'Unidentified Subject').

Cornet Player. Lost. Engraving, Private Collection, Turin. Ottani Cavina, 1972 (Pl. 4).

Dice Players. Teesside Museums, Middlesbrough (Cleveland). 92.5 × 130.5. S. N/W 55 (Pl. 85). One poor variant known: Proctor Collection, Morecambe (Lancashire). Thuillier, 1973, No. 70, illus.

Cheat with the Ace of Diamonds. Musée du Louvre, Paris. 100 × 146. S. N/W 49 (Pl. 10).

Cheat with the Ace of Clubs. Marier Collection, Geneva. Canvas on panel, 104 × 154. N/W 50 (Pl. 11).

Soldiers playing Cards and smoking. Lost. Two copies known: **1.** Landry Collection, Paris. 93 × 123. N/W 53, Fig. 123. **2.** Regional Gallery, Koursk (USSR). 89 × 110 (added to at bottom). Zolotov, 1974, Fig. 5.

Fortune Teller. Metropolitan Museum of Art, New York. 102 × 123.5. S after August 1620. N/W 48 (Pl. 21).

Beggars' Brawl. J. Paul Getty Museum, Malibu (Calif.). 94.4 × 142. N/W 56 (Pl. 36). Two copies known: **1.** Musée des Beaux-Arts, Chambéry. 83 × 136. Thuillier, 1973, No. 22a, illus. **2.** Musée Antoine-Lécuyer, Saint-Quentin. Pastel on paper, 24.4 × 39. F of head of right-hand figure.

Payment of Dues. Museum, Lvov (USSR). 99 × 152.5. S & D 16. N/W 51 (Pl. 1).

Peasant, Peasant's Wife (two canvases). The Fine Arts Museum of San Francisco. Each 90.5 × 59.5. N/W 61, 62 (Pls. 4, 5).

Peasant and his Wife eating split Peas. Museum Dahlem, Berlin. 74 × 87. Bologna, 1975, Fig. 2. One copy known: Musée Historique Lorrain, Nancy.

Flea Catcher. Musée Historique Lorrain, Nancy. 120 × 90. N/W 60 (Pl. 43).

Boy blowing on Charcoal Stick. Musée des Beaux-Arts, Dijon. 61 × 51. S. N/W 64 (Pl. 54).

Smoker. Lost. At least seven copies known (six listed N/W 65A–F), the best of which are: **1.** Musée des Beaux-Arts, Besançon. 77 × 59. R. N/W, Fig. 114; see N/W 65 A. **2.** Private Collection, France. 71 × 62. S. N/W, Fig. 112; see N/W 65 F.

Girl blowing on a Brazier. Executors of Estate of Fletcher Jones, Los Angeles (Calif.); sale, Christie's, 28 Nov. 1975 (81). 65 × 55. S. N/W 66, Fig. 113. Three copies known (listed N/W 66 A–C).

Head of a Woman. Landry Collection, Paris. 37.7 × 28.8. F. R. N/W 67, Fig. 107.

Head of a Woman [Plate 237]. Schloss Fasanerie, Adolphseck bei Fulda, as Caravaggio. F. U.

Unidentified Subject. Musée Royal des Beaux-Arts, Brussels. 85 × 58.5. F. R. N/W 68, Fig. 49.

Thirty-nine wrong attributions to La Tour or his circle are listed by N/W pp. 204–6, to which add: ★Attr. to Circle of Ribera **St Ambrose.** Pijoan Collection, Paudex (Switzerland).

The most important of the thirty-nine are:

No. 2 Gerard Seghers (?) **St Jerome.** St-Leu-St-Gilles, Paris.

No. 25. Caravaggesque (North Netherlandish) **Man of Sorrows.** Church of Chancelade (Dordogne).

No. 27 Caravaggesque (?French). **St Francis in Ecstasy.** Private Collection, Paris.

No. 29. By or after Gerard Seghers **Penitent Magdalen.** Sale Galerie Fischer, Lucerne, June 1960.

LE CLERC, Jean (*c.* 1587/8–Oct. 1633)

From Nancy. In Rome working with Saraceni from unknown date to 1619 when he moves with Saraceni to Venice. Engraves Saraceni compositions (q.v.) and completes some of Saraceni's Venetian paintings on the latter's death (1620). *Cavaliere di S. Marco* (1621). Encounters Liss in Venice, 1621. Returns to Nancy between Spring 1621 and April 1622. Employed continuously by Dukes of Lorraine and Church authorities in Nancy from 1622 onwards. All works listed.

Doge Enrico Dandolo inciting to the Crusade. Doges' Palace, Venice. Initiated by Saraceni (q.v.), but terminated and signed by Le Clerc.

Adoration of the Shepherds. Musée Saint-Didier, Langres. 215 × 117. Longhi, 1935, illus. (See *Paragone*, July 1972, Pl. 2). Reduced variant attributed to Tassel: Cathedral, Langres. 110 × 100. Dijon, 1955 (41), illus.

Adoration of the Shepherds. Saint-Nicolas, Nancy. *c.* 300 × 250. Pariset, 1948, Pl. 5 (2).

Annunciation. Church, Santa Giustina (Feltre). In small part only by Le Clerc, who added inscription with date 1621; see under Saraceni.

Death of the Virgin engraving. See Saraceni.

Bénédicité [Plate 235]. The composition of Callot's famous etching exists in various paintings and drawings which can be associated with Le Clerc. The closest to him are: **1.** Wadsworth Atheneum, Hartford (Conn.). Copper. U. *Parnassus*, May 1940, p. 46, illus. **2.** Biblioteca Reale, Turin (Inv. No. 16269), as attributed to Le Clerc. Pen and grey wash; diameter, 19. Sciolla, 1974 (274), illus., as Le Clerc. Se also *Le Brelan*.

St Benno restores the Keys to the City of Meissen. Engraving. U. See Saraceni.

St Francis in Ecstasy. Parish Church, Bouxières-aux-Dames (Meurthe-et-Moselle). 160 × 100. Nicolson/Wright, 1974, Fig. 90. One copy known: Saint-Nicolas, Nancy.

Feast of Herod. Saint-Jean-Baptiste, Chaumont (Haute-Marne). 180 × 225. Nicolson/Wright, 1974. Fig. 19. One copy known: Art Market, Nice (1961).

Denial of St Peter. Galleria Corsini, Florence. 118 × 153. Ottani Cavina, 1968, No. 15, Fig. 68. One version known which could also be autograph: Staatsgalerie, Stuttgart. 68 × 50. F. Ottani Cavina, 1968, No. 79, Fig. 69. One copy known: Accademia, Venice. Panel, 25 × 17. F. Ottani Cavina, 1968, Fig. 134.

Martyrdom of St Sebastian. Saint-Sébastien, Nancy. *c.* 240 × 200. Said to bear monogram SHIP (?SQPR). Pariset, 1948, Pl. 6 (1). One copy known: Eglise Abbatiale, Etival (Vosges). 163 × 122. ?Bears date MC....

Saints Jerome, Mary Magdalen, Anthony, and Francis. Alte Pinakothek, Munich. By Saraceni (q.v.), but terminated by Le Clerc.

Blessed Joseph of Leonessa. Redentore, Venice. UU. Ivanof, *Arte Veneta*, 1964, Pl. 216.

Concert. Bayerische Staatsgemäldesammlung, Munich. 136 × 170. Nicolson/Wright, 1974, Fig. 88. Two versions, probably copies, known: **1.** Heirs of Rizzoli, Venice (1954). Ivanof. 1959, Fig. 109 as Le Clerc. **2.** Private Collection, Paris. 122 × 166. Said to bear artist's initials. Pariset, 1958, Pl. 3. Etching after Munich *Concert* by Le Clerc, 33.8 × 42.9. S. Nicolson/Wright, 1974, Fig. 89. Engraving of same composition by ?La Tour, Nicolson/Wright, 1974, Fig. 87.

Le Brelan. The composition of Callot's famous etching (or figures from it) exists in numerous paintings and drawings which can be associated with Le Clerc. The closest to him are the following: **1.** Formerly City Art Museum, St Louis (sold New York 1945), subsequently Aram Gallery, New York (1946). Exh. Wildenstein, New York, 1946 (23), illus. 78.7 × 104.7. ?A. **2.** Aulteribe (Puy-de-Dôme), Château. Arched top, large. *Merveilles des Châteaux d'Auvergne et du Limousin.* 1971, p. 88, illus. (inadequate) **3.** B. Lenz Collection, Prague (1939), as Honthorst. Black chalk, wash and pencil, 16.5 × 22. Three figures. Nicolson/Wright, 1974, Fig. 127. See also *Bénédicité*.

Three Figures at a Table [Plate 236]. Musée des Beaux-Arts, Rennes. Bistre wash, Indian ink on traces of red chalk, 21 × 19. Exh. *Musée de Rennes . . .*, Paris, 1939, (7), illus.

The following is a selection of wrong attributions to Le Clerc:

★Venetian imitator of Saraceni (?Andrea Piazza) **Return of Moses to Mount Sinai** (wrongly described as '*Adoration of the Golden Calf*'). Musée des Beaux-Arts, Nancy. 207 × 499. R. Pariset, 1958, Pl. 2 as Le Clerc.

★Callot imitator **Christ carrying the Cross.** Musée des Beaux-Arts, Nancy. 72 × 132. Pariset, 1958, Pl. 4 (detail), as Le Clerc.

★ ?Jean Tassel **Visitation.** Cathedral, Langres.

★ ?Lorraine School **St Ambrose** (?) and **St Helen**(?). Saint-Martin, Pont-à-Mousson. Marble, each 84 × 57

(hexagonal). **St Helen**(?) illus. in Pont-à-Mousson guide (n.d., after 1967), shown before restoration.
★Anonymous **St Francis Xavier.** Saint-Nicolas, Nancy. 360 × 300. BP. F. Pariset, 1958, Pl. 1 as Le Clerc. One wretched late copy known: Eglise de la Outre, Mirecourt (Vosges). 193 × 130.
Caravaggesque (South Netherlandish) **Liberation of**

St Peter. North Carolina Museum of Art, Raleigh (NC).
Copy after Caravaggio **St Sebastian.** Private Collection in the Vosges. 1628.
Jean Ducamps **Memento Mori.** Isaac Delgado Museum of Art, New Orleans.
Saraceni **Shipwreck Scene.** Villa Camerini, Piazzola sul Brenta.

LESTIN or L'ESTAIN or LETIN, Jacques de (Sept. 1597–Nov. 1661)

From Troyes. Lives with Vouet (whose pupil he is according to Félibien) in Rome in 1624. Also documented in Rome, 1622, 1625. Back in Troyes by 1626, where he works in the Cathedral and other churches. Only one picture somewhat in manner of Vouet's early period is known, listed below, although another, with Colnaghi's (1956) (see under Vouet imitators) may turn out to be his.

Self Portrait. Musée des Beaux-Arts, Troyes. 65 × 52. Exh. Troyes, 1976 (8), illus. colour.

LIEVENS, Jan (Oct. 1607–June 1674)

From Leiden. Studies with Lastman, 1619–21. Works closely with Rembrandt in late 1620's. Only his very first works concern us, and then only a selection of these, where he is affected, as Rembrandt himself is, by the Utrecht Caravaggists *retour de Rome*. S followed by stroke and catalogue and plate number refers to Schneider, 1932 (reprint 1973).

Vanitas. Musée des Beaux-Arts, Besançon. Panel, 100 × 72. S. S/113, Pl. 6.
Young Man drinking. Staatliche Museen, Berlin East (Kaiser-Friedrich Museum 1921/1808). Panel, 94 × 76. S/124, Pl. 3.
Backgammon Players. Formerly J. Boelen Collection, The Hague. 98 × 106. S/146, Pl. 2.
Boy blowing on Coals; Boy lighting Torch from

Coal (pendants, two panels) [Plates 189, 190]. Museum Narodowe, Warsaw (1969/671, 670). Both panels, 82 × 64. Both S. Rembrandt exh. Warsaw, 1956 (48, 49), both illus.

For works disputed between Lievens and Rembrandt, see under Rembrandt.

LISS, Johann (1597–Dec. 1631)

From Holstein. Travels in Netherlands *c.* 1615–19, to Haarlem, Amsterdam and Antwerp. Contacts there with Goltzius, Cornelis van Haarlem and Jordaens especially are presumed. Reaches Venice via Paris at latest by 1621. Probably in Rome, 1622. In Venice again by 1629, but probably arrived there several years earlier. Dies in Verona at end of 1631. Only one composition (listed below) can even remotely be described as Caravaggesque, where he shows affinities with Valentin and the young Régnier. One senses echoes of Fetti and Régnier's more mature style in his later work.

Scene of revelling and carousing. Two versions known: **1.** Schloss Wilhelmshöhe, Cassel (1969/90, illus.). 164.2 × 242. Probably C. Liss exh. Augsburg-Cleveland, 1975–6 (A15), illus. **2.** Germanisches

National Museum, Nuremberg. 161 × 240. Liss exh. Augsburg-Cleveland, 1975–6 (A16), illus. Copies listed in Augsburg catalogue, p. 86. Composition engraved by Jeremias Falck (Hollstein, 1949ff. VI, p. 214).

LOON, Theodoor van (1581/82–1667)

Probably born in Brussels. A pupil of Jacob de Hase in Rome (1602). A Flemish painter described as 'Theodoro Vallonio' is in parish of S. Lorenzo in Lucina, 1607–8. Back in Flanders from the South by

1612, perhaps soon after 1608. Collaborates with architect Wenceslas Coeberger (1560–1631). Returns to Italy at end of 1628, working for S. Maria dell'Anima (1628–9). Remains there two to three years, but recorded back in Brussels and Montaigu early 1632. Spends some time in Louvain, 1639–46. The strong influence of Bassetti and Borgianni apparent in the Montaigu series indicates a third Roman visit in late 1610's. Seems to have contact with Stomer in Rome *c.* 1630. Except at Montaigu, only marginally Caravaggesque, and Domenichino-like and Bassanesque pictures are generally excluded from following lists.

Daniel and the Priests of Bel [Plate 101]. Koninklijk Museum voor Schone Kunsten, Antwerp (1958/792). 153 × 214. Bears false signature 'von de havondt F.'.

Adoration of the Magi. Several versions listed by Cornil, 1936, of which two are: **1.** Béguinage, Brussels. 148 × 235. Boschetto, 1970, Pl. 38b. **2.** Liechtenstein Collection, Vaduz (1931/81 as G. Seghers). 185 × 227 (upper part an addition). Reduced, 18th century, copy in Fitzwilliam Museum, Cambridge (1960/277).

'Sinite Parvulos'. Saint-Jean, Malines. Panel, 29 × 41.3.

'Sinite Parvulos'. J. R. Critchley Collection (in 1950's?).

Christ at Emmaus. Maagdenhuis, Antwerp (as Rombouts). 152 × 219.5. Held, 1955, Fig. 8.

Seven altar-pieces from the **Life of the Virgin** [Plates 98, 99]: **1.** *Presentation of Jesus in the Temple.* Replica in St Catherine's, Diest (horizontal format). Copy in Collège Beau Séjour, Narbonne. **2.** *Nativity of the Virgin.* Replica in horizontal format, Musée des Beaux-Arts, Rouen (1966, p. 235), 165 × 206, Cornil, 1936, Pl. v. **3.** *Annunciation.* **4.** *Visitation.* Replica in horizontal format, Béguinage, Malines. **5.** *Presentation of the Virgin in the Temple.* **6.** *Meeting at the Golden Gate.* S & D 1626. **7.** *Assumption.* Probably after 1632. All Church of Montaigu (Scherpenheuvel), Belgium. 1623 to after 1632. All except *Assumption* illus. with details Boschetto, 1970, Pls. 39–51.

Toilet of the Virgin. Formerly Alfred Weiss Collection, Schloss Laudon, Purkersdorf (Austria); sale, Dorotheum, Vienna, 19–22 Sept. 1972 (76), illus. 197 × 156. ?1628–9. Boschetto, 1970, Pl. 55.

Holy Family. Demunter Collection, Louvain (1936). 124 × 187. Cornil, 1936, Pl. II.

Mystic Marriage of St Catherine. Art Gallery, Perm (USSR). 93 × 115. Linnik, 1975, illus. colour Pls. 180–2.

Mystic Marriage of St Catherine. Galleria Doria Pamphilj, Rome. 150 × 120. Boschetto, 1970, Pl. 56.

Salome. Béguinage, Brussels. 96 × 84. Cornil, 1936, Pl. III.

Liberation of St Peter. Béguinage, Brussels. 175 × 222. Boschetto, 1970, Pl. 38a.

LOTH, Johann Ulrich (?–after 1662)

Pupil of Candid in Munich, 1615. In Rome, 1619, in service of Maximilian of Bavaria, whose official painter he becomes. Acquainted with Saraceni in Venice, Nov. 1619. Returns from Italy to Bavaria, 1623. Copies Rubens, Jordaens, Carracci and others. Father of the painter Johann Carl Loth (1632–98). Only one Caravaggesque, or Saraceni-like, picture known.

Magdalen. Bayerische Staatsgemäldesammlung, Munich. 88.8 × 120.2. S & D 1630. Ottani Cavina, 1968, Fig. 35.

The following is a wrong attribution to J. U. Loth: Caravaggesque unknown (Sicilian) **Vision of St Jerome.** Worcester Art Museum, Worcester (Mass.).

MAGNONE, Carlo

Recorded as a professional copyist for the Barberini in the 1640's. He is known to have copied Caravaggio's *Bari*, but so far his only known work in the Caravaggesque mode—documented in the Barberini archives from 1642 onwards—is the copy listed below.

Luteplayer. With Wildenstein (1959), ex-Barberini. 101.5 × 129.5. C of Leningrad Caravaggio. Before 20 June 1642. Marini, 1974, illus. under No. 17 (copy E1).

MAINO, Fray Juan Bautista (1578–1641)

Born at Pastrana (Guadalajara), of a Milanese father and Spanish mother. Early pictures prove he must be in Rome in first decade, working in the circles of Gentileschi and Saraceni. Influenced by Cinquecento

Brescians. In Toledo before 1611. Joins Dominican Order in the Convent of St Peter Martyr, Toledo, July 1613. Settles in Madrid, *c.* 1620. Shows affinities with Cecco. Only the earliest Spanish pictures listed.

Adoration of the Shepherds. Museo del Prado, Madrid (No. 3227). 315 × 174. 1612–13. Spear, 1971 (42), illus. colour. Part of complex painted for Toledo with *Adoration of the Magi, Resurrection, Pentecost, Saints John the Evangelist* and *John the Baptist* (q.v.).
Adoration of the Shepherds. Hermitage, Leningrad. 143.5 × 100.5. S. Exh. Leningrad, 1973 (29), illus. Linnik, 1975, illus. colour and black and white, Pls. 23–9.
Adoration of the Magi. Museo del Prado, Madrid (1972/886). 315 × 174. S. After July 1613. Longhi S. G., 1961 (1916), Fig. 141 and colour Pl. detail XIX. See under Prado *Adoration of the Shepherds* above.
Resurrection. Museo Balaguer, Villanueva y Geltrú (Barcelona). 294.9 × 174. 1612–13. Spear, 1971, Fig. 30. See under Prado *Adoration of the Shepherds* above.
Pentecost. Museo del Prado, Madrid (1972/3018), on loan to Museo Balaguer, Villanueva y Geltrú (Barcelona). 285 × 163. 1612–13. See under Prado *Adoration of the Shepherds* above.
Landscape with St Anthony Abbot. Museo del Prado, Madrid. 61 × 155. Exh. Seville, 1973 (74), illus.

(For Basle *St John the Baptist*, see Caravaggesque (Spanish)).
St John the Baptist. Private Collection, Madrid. Colloquio, Pérez Sánchez, 1974, Fig. 2.
Landscape with St John the Baptist. Museo del Prado, Madrid. 74 × 163. 1612–13. Borea, 1974, Fig. 10. See under Prado *Adoration of the Shepherds* above. Enlarged C of Saint: St Peter Martyr, Toledo.
Landscape with St John the Evangelist. Museo del Prado, Madrid. 74 × 163. 1612–13. Borea, 1974, Fig. 9. Spanish exh. R. A. 1976 (20), illus. colour. See under Prado *Adoration of the Shepherds* above. Enlarged C of Saint: St Peter Martyr, Toledo.

The following is a wrong attribution to Maino:

?Tanzio **St Charles Borromeo giving Communion to the Plague-stricken.** Parish Church, Domodossola.

MANETTI, Rutilio (Jan. 1571–July 1639)

Sienese, a pupil of Francesco Vanni. His early works are Vanni-like and Salimbeni-like, with echoes of Barocci. More Guercinesque (by early 1620's) than Caravaggesque; in fact it would be rash to list more than a handful of works which reveal a marginal interest in such artists as Valentin and Honthorst. These must date from around the middle of the third decade onwards, but a few late genre scenes (also listed) continue the Caravaggesque tradition. [*Editorial note:* When this book was in proof stage, the catalogue by Alessandro Bagnoli of the exhibition at Siena from 15 June to 15 October 1978 devoted to Rutilio Manetti was published. In that catalogue Nos. 45, 47, 51, 52, 53, 56, 61, 67, 81 and 95 among the exhibited items, and also Figs. VIII and XV of unexhibited items, illustrate works which are mentioned below. It may be noted that no illustrations were cited in the list below for Manetti's *St Jerome* (No. 51), *Dante and Virgil* (No. 53), and the drawing after Valentin (No. 95); an unaccepted attribution, *Musicians and Drinker* after Valentin, is reproduced as Fig. XV. Benedict Nicolson was a member of the organizing committee of the Rutilio Manetti exhibition.]

Three Ages of Man. Sale, Finarte, Milan, 6 May 1971 (26), illus. 170 × 233. Longhi, S.R. 1967, Fig. 134.
Dante and Virgil. Pinacoteca, Siena.
Lot and his Daughters. Museo Provincial, Valencia. 156 × 154. Exh. Madrid, 1970 (114), illus. Chiaroscuro drawing by Manetti (formerly Giorgio Morandi Collection, Bologna) after this composition, Gregori, 1968, Fig. 5, for the etching by Capitelli after Manetti (B. XX, 153, 1).
Lot and his Daughters. Galleria Borghese, Rome (1959/134, illus., as Guerrieri). 143 × 165. U. Della Pergola, 1956, Fig. 16. One version known, probably C: Galleria Doria-Pamphilj, Rome (1942/250, as School of Honthorst). 140 × 177. Della Pergola, 1956, Fig. 19. P after similar composition to this one upright: Pinacoteca Provinciale, Bari (from Galleria Corsini, Rome). Della Pergola, 1956, Fig. 20.
Samson and Delilah. Museo de San Carlos, Instituto Nacional de Bellas Artes, Mexico City. 175.9 × 112.1. Spear, 1971(43), illus.
Triumph of David. Musée des Beaux-Arts, Tours, attr. to Manfredi. 120 × 168.
St Jerome upheld by two Angels. Monte dei Paschi, Siena.
St Roch. Galleria Borghese, Rome (1959/135, illus. as Guerrieri). 106 × 180. R. UU. Della Pergola, 1956, Fig. 21.
Two Prophets. Galleria Nazionale d'Arte Antica, Rome. 135 × 170. Exh. Gall. Naz. 1955 (22), illus.

Concert (five figures). Principessa Carafa di Roccella Collection, Montalto (near Siena) (1932).

Concert (four figures). With Gilberto Algranti, Milan (1973); Colnaghi's, London (1978). 153.7 × 200.7. Sale, Finarte, Milan, 14–17 May 1973 (532), illus.

Musicians and Drinker (six figures). Chigi Saracini Collection, Siena, 205 × 240. Salmi, 1967, Pl. XX in colour.

Draughts Players (four figures). Chigi Saracini Collection, Siena. 102 × 180. Salmi, 1967, Fig. 114.

Musicians and Card Players (five figures). Chigi Saracini Collection, Siena. 123 × 181. Salmi, 1967, Fig. 111.

Study of a Figure in Armour. Biblioteca Comunale, Siena (S.iii. 9/91 *recto*). Drawing after Valentin's *Soldiers gamblings for Chrit's Garments* (q.v.).

The following is a selection of wrong attributions to Manetti:

Caroselli **Vanitas.** Longhi Collection, Florence.

O. Gentileschi imitator **Allegory of Music.** Edgar Collection, Broadway (Worcs.) (1967).

Bigot circle **St Luke.** Musée des Beaux-Arts, Chambéry.

Valentin (copy) **Magdalen.** Musée des Beaux-Arts, Chambéry.

Serodine **St Margaret raising a Child from the Dead.** Museo del Prado, Madrid.

Valentin (copy) **Musicians and Drinker** (three figures). Chigi Saracini Collection, Siena.

Caravaggesque unknown (South Netherlandish) **Soldiers playing Cards on Drum.** G. Grisaldi Del Taia Collection, Siena (1932).

MANFREDI, Bartolommeo (*c.* 1587–Winter 1620–1)

Born at Ostiano, near Mantua. Spends his working life in Rome from well before 1615 to his death. Believed to have worked as a youth under Roncalli. Strongly influenced by Caravaggio, whom he 'brings down to earth'; he passes on the style of Caravaggio's genre scenes, or religious subjects disguised as genre, to Valentin, Régnier, Tournier and others active in the 1620's. Working primarily for private patrons, such as Giustiniani and the Medici. All works listed, except three or four mentioned in the literature which are unknown to me.

Bacchus and Drinker. Galleria Nazionale d'Arte Antica, Rome (No. 480). 129 × 94. Spear, 1971 (45), illus.

Mars punishing Cupid. Art Institute of Chicago. 170.2 × 122.5. Spear, 1971 (44), illus. colour.

Allegory of the Seasons. At least three versions recorded: 1. Heirs of Feodor Schaliapin, Paris (1943). Longhi, 1943, Pls. 51–2. 2. Dayton Art Institute. Dayton (Ohio) (1969/26, illus. colour). 134.6 × 91.4. ?C. R. Moir, 1967, Fig. 44. Spear and others, 1975, Pl. l and X-rays. 3. Rebora Collection, Rome (before 1939). C. Spear and others, 1975, Pl. ll.

Roman Charity. Sale, Finarte, Milan, 12–13 March 1963 (149). Probably C. Brejon, 1978, illus.

Roman Charity [Plate 33]. Private Collection, Milan (1968). BP.

Judith and Holofernes. Two versions known: 1. Bayerische Staatsgemäldesammlung, Munich (No. 2221). 117 × 169. U. Ivanoff, 1965, Fig. 5a. 2. Galleria Corsini, Florence. Status unknown.

Christ disputing with the Doctors. Florentine Galleries. 130 × 191. Pendant to *Tribute Money* (q.v.). Exh. Florence, 1970 (13), illus. Engraving by Dennel (late 18th century) as Caravaggio, and T. ver Cruys (1778).

Christ and the Adulteress [Plate 43]. Musée des Beaux-Arts, Brussels (1949/285). 120 × 184. U.

Christ driving the Money Changers out of the Temple. Two versions known: 1. Saint-Jean, Libourne. *c.* 168 × 244. Brejon, 1978, illus. 2. Formerly Musée des Beaux-Arts, Strasbourg (burnt 1870). *c.* 168 × 244. Engraving by Jean Haussart in *Recueil d'Estampes . . . Cabinet du Roy* (1742 or earlier), see Nicolson, 1967, Fig. 1. C in Bayerische Staatsgemäldesammlung (No. 5284) of one figure. Paper on panel, 51 × 39. Brejon, 1978, illus.

Tribute Money. Florentine Galleries. 130 × 191. Pendant to *Christ disputing with the Doctors* (q.v.). Exh. Florence, 1970 (12), illus. Engraving by L. J. Masquelier (late 18th century).

Capture of Christ. Formerly Archduke Leopold Wilhelm Collection, Antwerp (late 1650's). Lost. Engraving in Teniers's *Theatrum Pictorium*, Antwerp, 1658, No. 234. One copy known: detail from Teniers's *Gallery of the Archduke Leopold Wilhelm* (Munich), see Nicolson, 1967, Fig. 2.

Crowning with Thorns (nine figures). Formerly Baronesse Rengers-Van Pallandt Collection, Heino (1952). 161 × 229. Nicolson, 1967, Fig. 9. One copy known: Musée de Tessé, Le Mans (1932/756, illus.). Inscribed with Manfredi's name. Moir. 1976, Fig. 78.

Crowning with Thorns (four figures). Florentine Galleries. 122 × 146. Exh. Florence, 1970 (7), illus., where other versions are noted. C by Régnier (q.v.), with Silvano Lodi, Munich (1972).

Crowning with Thorns (three figures). Private Collection, Italy. 148.5 × 95 5. Brejon, 1978, illus.

Crowning with Thorns (five and three figures). Lost. What appears to be a Dutch fragmentary copy is: Baverische Staatsgemäldesammlung, Munich (1908

/1234). 118 × 135. Slatkes, 1965, Fig. 53 as David de Haan. F. Poor C with two extra figures right is: Musée des Beaux-Arts, Nantes (1913/32, as school of Caravaggio). 124 × 187.

Crowning with Thorns (two figures). Private Collection, near New York. 82.5 × 110. Brejon, 1978, illus. Three copies known: Christ Church, Oxford. 88.5 × 108.1. Christ Church Catalogue, 1967 (138), illus., as copy of Caravaggio (?). **2.** Formerly F. Pearsons Collection, New York (c. 1920), as Caravaggio. 80 × 115.5. BP. **3.** Museum, Bennington (Vermont). 79 × 114. Moir, 1976, Fig. 83.

Crowning with Thorns (two figures). A lost Manfredi may be reflected in: London art market (1965) as Terbrugghen.

Christ appearing to the Madonna after the Resurrection. Mina Gregori Collection, Florence. 258 × 178. Salerno, *Manfredi*, 1974, Figs. 79–80.

Martyrdom of St Bartholomew. Private Collection, Milan (1943). Longhi, 1943, Pl. 55.

Head of St John the Baptist. Reverdin Collection, Milan (1943). Longhi, 1943, Pl. 56.

St Jerome. Sale, Finarte, Milan, 1963 (42), illus. 133 × 95. Brejon, 1974, Pl. 25. The same figure with changed head appears in the next two entries:

St John the Evangelist. Galleria Pallavicini, Rome (1959/292, illus.). 136.2 × 98.6. BP. ?C.

St John the Evangelist. Pinacoteca Capitolina, Rome. 135 × 97.

St John the Evangelist. Private Collection, Paris. 87.5 × 64. UU. Brejon/Cuzin, 1976, Fig. 4, as Régnier. Apparently by same hand as Moscow *Head of Youth* (q.v.).

Denial of St Peter (nine figures). Herzog Anton Ulrich-Museum, Brunswick (1976/495, illus.). 166 × 232. Spear, 1971, Fig. 32.

Denial of St Peter (seven figures). Lost. One copy known: formerly Salafranca Collection, Madrid (1947) (in 1973 on London art market). Ainaud, 1947, illus. between pp. 388 and 389.

Concert (six figures). Florentine Galleries. 130 × 189.5. Pendant to *Card Players* (q.v.). Exh. Florence, 1970 (9), illus. Engraving after different version (?No. 3 below) by G. Battista Cecchi (1784), exh. Florence, 1970 (11a), illus. Many copies known, in Aix, Caen etc., sometimes accompanied by its pendant. The following may be recorded: **1.** Florentine Galleries, from Poggio Imperiale. 137 × 194.5. Exh. Florence, 1970 (11), illus. **2.** Sale, Weinmüller, Munich, 27–8 June 1962 (1004), illus. as manner of Terbrugghen (reappeared 5–6 Dec. that year in same rooms). 90 × 127. **3.** Ufficio Recuperi, Palazzo Venezia, Rome. 136 × 193. Siviero, 1950, Pl. CXLII. **4.** David Rust Collection, Washington, DC.

Concert (three figures). Malcolm Waddingham Collection, London. F. Waddingham, 1961, Pl. 139b.

Female Tambourine Player [Plate 31]. Two versions

known: **1.** Marchese de Mari Collection, Florence (1960). 65 × 49. Exh. *Tesori Segreti* . . . Florence, 1960 (63). **2.** Accademia Tadini, Lovere.

Concert, Eating and Drinking Party (seven figures) [Plate 34]. With Trafalgar Galleries, London (1976). 130 × 190. Nicolson, 1974, Fig. 56. Exh. Trafalgar Galleries, 1976 (1), illus. colour. Copy by Tournier at Le Mans (q.v.).

Drinkers. Two canvases in Modena, thought to be copies by Tournier (q.v.).

Card Players (six figures). Florentine Galleries. 130 × 191.5. BP. Pendant to *Concert* (q.v.). Exh. Florence, 1970 (8), illus. Engraving after another version in Archduke Leopold Wilhelm Collection, Antwerp, in Teniers's *Theatrum Pictorium* (1658), No. 235; in the *Prodromus* (1735), exh. Florence, 1970 (10a), illus.; and by Ver Cruys (1778). Many copies known in Aix, Caen (140 × 177) etc., sometimes accompanied by its pendant. One copy is: Florentine Galleries, from Poggio Imperiale. 137 × 195.5. Exh. Florence, 1970 (10), illus.

Card Players (three figures). Formerly Baron Grundherr Collection, Rome (later with Dr Rothmann, Berlin). Longhi, 1943, Pl. 54. One copy known: Vassar College Art Gallery, Poughkeepsie (New York) (1967/34.2, illus. as school of Caravaggio). 68.6 × 95.2. Exh. Pittsburgh, 1954 (16), illus.

Fortune-Teller with Draughts Players (seven figures). Formerly Gemäldegalerie, Dresden (destroyed 1945) (1930/412). 137.5 × 201. Cuzin, 1977 (36) illus. One copy recorded: Trower Sale, Christie's, 18 July 1947 (173) as Valentin. 129.5 × 198.1. C of two right-hand figures seated: on long loan to Vassar College Art Gallery, Poughkeepsie (NY), from Mrs Al Paul Lefton, Philadelphia. 92 × 80.

Fortune-Teller (four figures). David Rust Collection, Washington (DC). 105.4 × 135.2. ?C or adaptation by Tournier (q.v.) of part of Dresden No. 412 (see above) or of another, lost, version. Brejon/Cuzin, 1976, Fig. 7 as Régnier.

Fortune-Teller (three figures). Three versions known: **1.** Florentine Galleries. 97 × 134. Exh. Florence, 1970 (25), illus. as Gramatica. **2.** Galleria Nazionale d'Arte Antica, Rome. 133 × 195. Exh. Gall. Naz., 1955 (24), illus. as Manfredi. **3.** Art market, Milan (1973), as Antonio Cifrondi. 95 × 134. ?C. C recorded in Musée d'Art et d'Archéologie, Clermond-Ferrand; another on London art market (1975).

Head of Youth. Pushkin Museum, Moscow. Panel, tondo, diameter, 39. UU. Linnik, 1975, illus. colour, Pl. 33. Apparently by same hand as *St John the Evangelist* in a Paris collection (q.v.).

The following is a selection of pictures of unidentified imitators of Manfredi [see also under Caravaggesque unknown (Roman-based)].

Allegory of the Five Senses: fragment of right hand figure only. Pinacoteca Capitolina, Rome. 76 × 61. Bodart, 1970, Fig. 11. Whole composition recorded in C in Alarico Mazzanti Collection, Reppublica di San Marino. 114 × 160. Another version (also original) of Capitoline fragment engraved in Orléans catalogue (1786), as Valentin, C of F was: Comm. Paolo Merenghi Collection, Rome (1943). Hoogewerff, 1943, Pl. vii as Baburen.

Capture of Christ. Private Collection, Melbourne on deposit at National Gallery of Victoria. 98 by 140.5. (Probably non-Italian Manfredian, c. 1625).

Crowning with Thorns. Formerly Palazzo Altieri, Rome. Moir, 1976, Fig. 77.

Crowning with Thorns. Galleria Sabauda, Turin (as Giovanni Antonio Molinari). 115 × 175. Moir, 1967, Fig. 356.

Flagellation. Rhode Island School of Design, Providence (RI). 118.1 × 136.5. *Bulletin*, March 1957, illus. as Manfredi. ?Northern imitator, who seems to have been responsible for the De Vito *Liberation of St Peter* listed below.

Executioner with the Head of St John the Baptist. [Plate 36]. Museo del Prado, Madrid (1972/247 as Manfredi). 133 × 95. Close follower.

Liberation of St Peter [Plate 44: detail]. Ing. Giuseppe De Vito Collection, Milan. 170 × 238. *Rivista di Venezia*, 1928, vii, 9, p. 397, illus. as Valentin. Moir, 1976, Fig. 82 as Régnier. Seems to be same hand as Providence *Flagellation* listed above.

Denial of St Peter. Private Collection, Rome. 169 × 242. Bodart, 1970, Fig. 25, as Régnier. Manfredi-like in the direction of Régnier.

Denial of St Peter [Plate 45]. Marquis of Exeter Collection, Burghley House, Stamford (No. 324). 77.5 × 100.3.

Denial of St Peter [Plate 42]. Musée des Beaux-Arts, Nantes (1913/34 as School of Caravaggio). 127 × 150. 1953 (34) where Longhi is cited as ascribing to Camillo Gavasetti (b. Modena, d. Parma 1628).

Denial of St Peter. Pio Monte della Misericordia, Naples. 123 × 163. Causa, 1970, Pl. xv in colour.

Denial of St Peter. Stourhead (Wilts.), National Trust. 97.8 × 104.1. F. R. Nicolson, 1975, Fig. 5. Pendant to:

Fortune-Teller. Stourhead (Wilts.), National Trust. 95.2 × 130.8. Nicolson, 1975, Fig. 4. The two pictures are by the same hand, Manfredi-like in the direction of Valentin.

Concert (five figures) [Plate 40]. Hessisches Landesmuseum, Darmstadt. 124 × 175.

Concert (three figures) [Plate 41]. Two versions known: **1.** Fürstlich Fürstenbergische Gemäldegalerie, Donaueschingen (No. 744, as Finson). 112.2 × 136. **2.** Bayerische Staatsgemäldesammlung, Munich (No. 4835, as Manfredi). 114 × 139. Possibly Flemish.

Singers (two figures) [Plate 39]. Formerly Modiano Collection, Bologna. By same hand as Galleria Nazionale *Card Player* below.

Guitar Player with Dice and Cards. Florentine Galleries. 97 × 73. Exh. Florence, 1970 (22), illus. In direction of Tournier.

Card Players [Plate 38]. Gemäldegalerie, Dresden (1930/414 as School of Manfredi). 123 × 173.

Card Players. Private Collection, Bologna (1965) (sale, Christie's, 26 June 1964 (29) as Manfredi). 115.6 × 154.9. Bottari, 1965, Pl. 26a, as ?Régnier. Similar to Stourhead *Denial* and *Fourtune-Teller* above, though more in direction of Stomer.

Card Player. Galleria Nazionale d'Arte Antica, Rome. 66 × 51. Exh. Gall. Naz., 1955 (5), illus. In direction of Tournier, perhaps by same hand as Florentine *Guitar Player* above, and certainly by same hand as Modiano *Singers* above.

Chess Players. Accademia, Venice (1970/306, illus.). 95 × 132. B P.

Dice Player. Accademia, Venice (1970/305, illus.). 128 × 94. F.

Backgammon Players. Sale, Finarte, Milan, 14–17 May 1973 (518), illus. 95.5 × 132.

Scene of Prostitution. Van Veen Collection, Scheveningen. 98 × 134. Cuzin, 1977 (34), illus.

Man eating a Meal. Museum of Fine Arts, Kharkov (USSR). 91 × 70. Linnik, 1975, illus. colour and black and white, Pls. 31, 32.

Soldier in Armour. Hampton Court Palace (Levey, 1964/590, illus. as ascribed to Régnier). Canvas mounted on wood, 86.4 × 69.9; (original picture area), 78.1 × 56.5.

The following is a selection of wrong attributions to Manfredi:

Riminaldi **Cain and Abel.** Florence and (?) Malta.

Tournier **Joseph and Potiphar's Wife.** Cologne Sale, 1963.

Riminaldi **David.** Galleria Sabauda, Turin.

Caravaggesque unknown (Roman-based) **Crowning with Thorns.** Private Collection, Milan (c. 1950).

Régnier **Christ at Emmaus.** Potsdam.

Rombouts **Musical Pair.** Munich No. 4836.

★Orazio Fidani **Fluteplayer.** Five versions (not all associated with Manfredi). **1.** Florentine Galleries. 84.5 × 76. Florence, 1970 (62), illus. as Coccapani. **2.** Los Angeles County Museum. 99.1 × 76.2. Moir, 1961, Fig. 1 as Manfredi. **3.** Museum, Halle. **4.** Victor Spark Collection, New York. 81.9 × 76.8, as Vouet. **5.** Hermitage, Leningrad. 83 × 75.5. Linnik, 1975, illus. colour Pl. 94, as Fidani (an early 18th century attribution on the frame).

Tournier **Card and Dice Players.** Dresden No. 411.

Master J **Pomegranate Seller.** Private Collection, Italy.

*?Florentine School **Actor.** Ambrosiana, Milan, Codice Resta. Black chalk, 21.5 × 25. Moir, 1969, Fig. 10 as attr. to Manfredi.

*Tuscan or Emilian School **Anatomy Lesson.** Drawings. Albertina, Vienna, and Ashmolean Museum, Oxford.

MANZONI, Michele (active *c.* 1620–35)

From Faenza. Also called Biagio Manzoni. Perhaps trained in Rome, which would account for a strong Caravaggesque bias in a Bolognese-orientated city. All works listed. Longhi followed by stroke and plate number refers to Longhi, 1957.

Christ at the Column. Cathedral, Faenza. Longhi/Pl. 29.

Madonna with Infant St John and Saints. Private Collection, Milan (1957). Longhi/Pl. 28.

Martyrdom of St Eutropius. Pinacoteca Civica, Faenza. 272 × 178. B P. Longhi/Pl. 27.

St John the Baptist. Cathedral, Faenza. 200 × 120. Longhi/Pl. 30.

Martyrdom of St Sebastian. Musée du Louvre, Paris. 176 × 125. Longhi/Pl. 31 plus details, Pls. 32–3.

Incredulity of St Thomas. Convento di San Domenico, Faenza. 200 × 120. Corbara, 1957, Pl. 34.

MASTER A – MASTER L see CARAVAGGESQUES, Anon. non-Italian 'Masters', pp. 35f.

'MASTER OF THE JUDGEMENT OF SOLOMON' (active *c.* 1610–25)

This unnamed Franco-Flemish artist, around whom a number of works have been coherently grouped, was in the past wrongly identified with Guy François and with an early phase of Valentin, and later more persuasively with Gérard Douffet, with whom he may still turn out to be identical. The 'two' artists, if there are two, have much in common, though the unnamed master has closer links with contemporary Neapolitan painting, especially Ribera. As well as with Douffet, he is closely associated with Valentin, and must have worked in Rome as well as Naples. All works listed, except one or two mentioned in the literature which are unknown to me.

Philosopher. Ruspoli Collection, Torrella dei Lombardi (near Naples). U. Brejon/Cuzin, 1974, Fig. 25. C recorded in Florentine Collection. To the same series may belong:

Two Philosophers. Museum, Saint-Omer. Chabert, 1971, illus. p. 9. Variant with changes (figures become Saints) in Florentine Galleries. 120 × 186. 'French Painting', Florence, 1977, illus. p. 226.

David with the Head of Goliath. Whereabouts unknown. 126 × 92. Cuzin, *Florence*, 1977, Fig. 2.

Judgement of Solomon. Galleria Borghese, Rome (1959/119, illus.). 158 × 200. Rome/Paris, 1974 (12), illus.

Origen. Formerly Chiesa Collection, Milan.

Christ among the Doctors. Saint-Martin, Langres. 188 × 270. Rome/Paris, 1974 (16), illus.

Saints Peter and Paul. With Messrs P. & D. Colnaghi, London (1976). 120.7 × 96.5. *Burl. Mag.* Supplement of works on the market, Dec. 1976, Plate xx.

Denial of St Peter. Galleria Nazionale d'Arte Antica, Rome. 163 × 233. Exh. Naples, 1963 (45), illus.

Denial of St Peter. Certosa di S. Martino, Naples. 140 × 200. U. Voss, 1924, p. 103, illus. as Valentin.

Three Apostles with Cartellini (three canvases forming part of a series): **1.** *St James the Less.* Formerly with Jean Néger, Paris. **2.** *St Matthew.* Michel Laclotte Collection, Paris. 109 × 88. Rome/Paris, 1974 (14), illus. **3.** *St Thomas.* Szépmüvézseti Múzeum, Budapest (1967/788, as Jusepe Martínez). 105 × 84. Rome/Paris, 1974 (15), illus.

Five Apostles, ex-Casa Gavotti (five canvases forming part of series: all Longhi Collection, Florence; all 125.5 × 96.5): **1.** *St Bartholomew.* Longhi cat., 1971, Pl. 70 in colour. **2.** *St Matthew.* Longhi cat., 1971, Appendix Fig. IX. **3.** *St Paul.* Longhi cat., 1971, Appendix Fig. X. **4.** *St Philip.* Longhi cat., 1971, Appendix Fig. XI. **5.** *St Judas Thaddeus.* Rome/Paris, 1974, Fig. 3 under No. 12; Longhi cat., 1971, Pl. 71 in colour.

The following two appear to belong to the same series:

St James the Less and an **Apostle** (two canvases). Museo di Capodimonte, Naples. Each 125 × 96. Exh. 'Arte francese a Napoli . . .', Naples, 1967 (25, 26), both illus. Conceivably from the same series is:

St James the Great (?). With Julius Böhler, Munich (1961). 132 × 99. Reduced replica recorded at Leipzig in 1940 as ?Douffet, 107 × 82.

Two Saints. Florentine Galleries. See above under *Two Philosophers.*
Prophet (?). Museo dei Benedettini, Catania. 95 × 74. Rome/Paris, 1974 (17), illus.

The following is a wrong attribution to the 'Master of the Judgement of Solomon':

Caravaggesque (?Neapolitan) **Raising of Lazarus.** Herron Art Museum, Indianapolis.

MELLAN, Claude (May 1598–Sept. 1688)

Born at Abbeville (Somme). Leaves early for Paris, where he studies engraving from a Pole. In Rome, 1624–36. Academy of St Luke, 1624. Works in Villamena's studio (d. 1624) and then joins Vouet, after whose works he makes a number of engravings (1624 onwards; q.v.). Living with Vouet, mid-1620's. Engraver of the ex-S. Adriano *St Peter Nolasco* (see under Orazio Gentileschi imitator). Painter in his own right, and engraver of his own works. The attributions to him of the two known pictures listed below is ingenious but speculative.

Joseph interpreting Dreams. Galleria Borghese, Rome (1959/120, illus.). 168 × 241. Rome/Paris, 1974 (18), illus. with detail. One version recorded: Barone Scotti Collection, Bergamo.

Samson and Delilah. Lost. Engraved by Mellan himself, Rome/Paris, 1974, Fig. 4.
Herodias. Musée Fabre, Montpellier, 116 × 96. Rome/Paris, 1974 (19), illus.

MINNITI, Mario (Dec. 1577–1640)

From Syracuse. Apparently living with Caravaggio in mid-1590's, possibly accompanying him for a while to Del Monte's residence, Palazzo Madama (*c.* 1596). Leaves Rome well after turn of the century. Active in his native town from at latest 1618, in Messina and possibly Malta. Eliminates Caravaggesque and Saraceni-like elements from his style around 1630. Dies at Syracuse. A selection only is listed below.

Raising of the Son of the Widow of Nain. Museo Nazionale, Messina. 245 × 320. S. Moir, 1967, Fig. 236.
Christ shown to the People [Plate 192]. Three versions known: **1.** Museum für Kunst und Kulturgeschichte, Dortmund. Panel, 91.5 × 66.5. ?C. **2.** Private Collection, Rome. 93 × 74. C. Marini, 1974, No. C23, p. 319, illus. **3.** Private Collection, Rome. C. Longhi, 1954, Pl. 13a.
Christ shown to the People. Sacristy, Cathedral, Notabile (Malta). Panel, 93 × 62.5. S & D 1625. Exh.

'L'Arte Sacra a Malta', Floriana (Malta), 1960 (83), illus.
Christ shown to the People. Whereabouts unknown. U. Longhi, 1954, Pl. 13b.
Miracle of St Benedict. S. Benedetto, Syracuse. BP. Moir, 1967, Fig. 233.
Salome with Head of St John the Baptist. Museo Nazionale, Messina. Borea, 1972, Fig. 3 (detail).

The following is a wrong attribution to Minniti:

Cassarino or Cassavino **St Sebastian tended by Irene.** Co-Cathedral of St John, Valletta (Malta).

MOEYAERT, Claesz Cornelisz (*c.* 1590/91–1655)

Spends at least some of his youth in Amsterdam. A journey to Italy in second decade is presumed but not documented. The first dated picture of 1624 already in familiar, mature style. The four pictures listed below are believed on purely stylistic grounds to represent an earlier, undocumented phase; if they prove to be after 1624, they are not by him.

Orpheus, Pluto and Proserpine [Plate 187]. Pinacoteca Vaticana, Rome (1934/419 as Stomer). Formerly Castel Gandolfo. 88 × 126. Redig de Campos, 1943, illus. Pl. xxxvii, as Stomer.
Orpheus and Eurydice [Plate 188]. Rolf Schmoll Collection, Hamburg (1971); sale, Christie's, 1 June 1973 (27). 92.7 × 131.9.

Two Bacchanalian Scenes (two canvases) [Plates 185, 186]. Sir Francis Dashwood Collection, West Wycombe Park (Bucks.). One is poorly illus. colour in National Trust Guide, 1973, opp. p. 20.

MONOGRAMMIST 'ISH' or 'SIH' (active c. 1615–25)

Unknown artist in the tradition of Jan Wouters Stap but influenced by Terbrugghen soon after the latter's return to Utrecht, who signs with these initials the picture at Amersfoort. All known works listed.

Justice of Count William the Good. Stadhuis, Naarden. Presented before 1619. One copy known: Oudheidkundig Genootschap, Amsterdam; on loan to Rijksmuseum (1976/C529, illus.). 153 × 195. False signature 'F. Francke' and D 1617. Van de Waal, 1952, II, Pl. 106 (2).

Death of Ananias. St Peter's and Hospital, Amersfoort. 152 × 201. S & D 1624. Exh. Utrecht/Antwerp. 1952 (56), illus.

MOREELSE, Johan (c. 1603–Dec. 1634)

Son of the painter Paulus Moreelse of Utrecht. May visit Rome since he belongs to the Papal Order of St Peter, but nothing is known of a Southern journey, while there is clear evidence of strong Terbrugghen influence in the late 1620's. Dies at Utrecht. All works listed. N followed by stroke and Fig. number refers to Nicolson, *Moreelse*, 1974.

Narcissus. Tennant sale, Christie's, 21 June 1926 (115) as Terbrugghen. 74.9 × 62.2. U.
Democritus and **Heraclitus** (two canvases). Lord Sackville Collection, Knole. Each 88.9 × 78.7. *Democritus* S.; replica in Mauritshuis (q.v.). N/Figs. 88, 87.
Democritus and **Heraclitus** (two panels). Centraal Museum, Utrecht (1971-2/49, 50, illus.). Panels, each 54 × 68.8 (omitting later additions). Both S. N/Figs. 84, 85. One copy of *Democritus* known: Sale, Christie's, 7 Oct. 1960 (80). Panel.
Democritus, Heraclitus (two canvases). Art Institute of Chicago. Each 74.3 × 87. BP. N/Fig. 82, 83.
Democritus. Mauritshuis, The Hague (1977/705). 84.5 × 73. S. Replica at Knole (q.v.). Blankert, 1967, Fig. 20.
Democritus. Formerly with Francesco Pospisil, Venice (1954). 73.7 × 91.4. Bears signature and D 1634 (?). U. Blankert, 1967, Fig. 22.

St John the Baptist drinking at the Well. Musée des Beaux-Arts, Lyon. U. (see under Terbrugghen imitators).
St Mark (?). Paul Ganz Collection, New York. 72.4 × 97.8. N/Fig. 90.
Penitent St Peter. Lost. Engraving by A. Blotelingh after 'J. Moreels'. 35.9 × 21.3. De Jonge, 1938, Pl. 199.
Boy writing to Homer's Dictation. Southampton Art Gallery. 69.8 × 53.3. S. N/Fig. 86.
Girl (Muse) transcribing from a Book. K. Freemantle Collection, near Utrecht. Panel, 54.5 × 71.5. S. N/Fig. 89.

The following are wrong attributions to Johan Moreelse:

★Anon. **Geographer.** Centraal Museum, Utrecht (1952/193, illus.). 94 × 72. Said wrongly to be signed.
★Jacob Fransz van der Merck **Female Luteplayer.** (see under wrong attributions to Terbrugghen).

MUNNICKS, Hendrick

History painter; 1633 Master in Utrecht; 1643 Dean. In 1644 in The Hague Guild. One picture only known and listed, owing something to Bijlert.

Fluteplayer. With J. Dumont, Paris (1973). 81.2 × 63.5. S. Nicolson, 1974, Fig. 75.

MUSSO, Nicolò (c. 1595/1600—?after 1631)

Piedmontese, from Casale Monferrato. Presumed visit to Rome c. 1615, judging by strong Caravaggesque influence in the *Madonna del Rosario* of three years later, by which time he must be back in his native town. Identical with the 'Francesco Casale' patronized by Giustiniani. Said to be still living in

August 1631 but probably not the 'Niccolò Musso' recorded as living in 1661, since he is said to die young. Shows affinities with his compatriot Il Moncalvo, and probably in contact with Tanzio in the South. A few barely Caravaggesque pictures not listed. R followed by stroke and plate number refers to Romano, 1971.

Nativity. Formerly Private Collection, Rome. R/Pl. 33.

Christ carrying the Cross. Palazzo Giustiniani, Bassano di Sutri. 265 × 175. Salerno, 1960, Fig. 7.

Crucifixion with St Francis at the Foot of the Cross. S. Ilario, Casale Monferrato. 237 × 156. R/Pl. 37.

Madonna. Formerly J. Bernard Bunge Collection, Keyport (NJ). 100 × 75. S. R/Pl. 36.

Madonna with St Anne. Longhi Collection, Florence. 100 × 90. Longhi cat. 1971, Pl. 58 in colour.

Madonna del Rosario. S. Domenico, Casale Monferrato. D 1618. R/Pls. 28–32.

Self Portrait. Museo Civico, Casale Monferrato (from heirs of conti Mossi). 72 × 62. S. Gabrielli, 1967, Fig. 1.

OOST, Jacob van, the Elder (Feb. 1601–1671)

From Bruges. Bruges Guild, Jan. 1619 as pupil of his elder brother Frans; Master, 1621; Dean, 1633. In Italy, presumably Rome, from 1621 onwards but back in Bruges by Oct. 1628. First dated painting is the Louis Le Nainlike *Adoration* in the Hermitage (1630), but a near-Caravaggesque phase continues in the 1630's and even later, reflecting De Coster, Seghers and Honthorst. Sometimes approaches Van Loon. These are the only pictures listed out of a large *œuvre*.

Adoration of the Shepherds. Kunsthistorisches Museum, Vienna (1973/753, illus.). 258 × 189.

Adoration of the Shepherds. Hermitage, Leningrad. Panel, 147.5 × 114. S & D 1630. Exh. Leningrad, 1973 (36), illus. Linnik, 1975, illus. colour Pls. 185–7.

Adoration of the Shepherds. Saint-Sauveur, Bruges. 208 × 189. ?1642. D'Hulst, 1952, Fig. 5.

Christ at Emmaus. Notre-Dame, Bruges. 151 × 233.5. UU. Gerson/Kuile, 1960, Pl. 124A as Jacob van Oost (?).

Calling of St Matthew. Notre-Dame, Bruges, 156 × 237. S & D 1640 (?). D'Hulst, 1952, Fig. 3.

St Sebastian tended by Irene. Hospice de la Poterie, Bruges. D 1646 on frame. Gerson, 1959, Pl. 4a.

Guitar Player. With Heim Gallery, Paris (1955). 118 × 92. U. Exh. Heim, 1955 (12), illus., as Régnier.

Fluteplaying Shepherd. Musée des Beaux-Arts, Calais. 64.9 × 53.8. Exh. Lille/Calais/Arras, Flemish Exh. 1977 (43), illus.

Soldiers cheating at Cards, with a Woman [Plate 97]. Lost. One copy known: F. A. Tofte Collection, Flushing (New York), as ?Caravaggio. *c.* 68.6 × 109.2. Engraving by P. de Vlamynck, captioned 'J. van Oost. f. 1634', 57 × 95, D'Hulst, 1952, Fig. 2, pendant to original of *Card Playing and Drinking Scene* below:

Card Playing and Drinking Scene. Lost. Engraving by P. de Vlamynck, 1634, 58 × 86, D'Hulst, 1952, Fig. 1.

Boys blowing Bubbles. Art Museum, Seattle (Washington). 90.2 × 120.6. Mirimonde, 1965, Fig. 41.

The following is wrongly described by Longhi (see Boschetto, 1970, p. 55) as Van Oost copying Van Loon:

Master F **Allegorical Figure pointing to open Book labelled 'Cognitione'.** Assistance Publique, Bruges.

PAOLINI, Pietro (1603–April 1681)

Born in Lucca. Arrives in Rome *c.* 1619–20, remaining there until *c.* 1632. Probably works under Caroselli, and is influenced by Valentin. Patronized by the Buonvisi family. On his return, goes to Venice for two years but settles for the rest of his life in Lucca. Founds Accademia Lucchese di Pittura e Disegno, 1640. His most Caravaggesque period is the earliest, in the 1620's and early 1630's. After the Venetian visit he adopts a style similar to that of Ludovico Carracci's Emilian imitators in his large pictures, but continues for a time a modified Caravaggism in the smaller ones. Only the Caravaggesque or near-Caravaggesque works listed. M followed by stroke and Fig. number refers to Marabotti, 1963; O followed by stroke and plate number refers to Ottani, 1963; O 1965 followed by stroke and plate number refers to Ottani, *Paolini*, 1965.

Achilles among the Daughters of Lycomedes. With Colnaghi's, London (1978). O. 1965/Pl. 69a.

Allegory of Death. Museo Cerralbo, Madrid (No. 1918, as Manfredi). 113 × 176. BP. Spear, *Storia dell'Arte*, 1972, Fig. 14.

Vanitas and Three Ages of Man. Marchese Pietro Mazzarosa Collection, Lucca (1960). 118 × 158. M/Fig. 1.

Music, Astrology, Geometry, Philosophy (four octagonal canvases). Bertocchini Collection, Lucca 1(963). M/Figs. 3, 4, 5, 6.

Instruction in ?Alchemy. John Procopé Collection, Cambridge. 119.4 × 170.2. *Burl. Mag.*, Oct. 1974, Fig. 4.

Murder of General Wallenstein. Orsetti Collection, Lucca. After Feb. 1634. O/Pls. 10b. 11a and b.

Deposition. S. Frediano, Lucca. BP. O/details, Pls. 8a, b.

Martyrdom of St Bartholomew. Pinacoteca, Lucca. 250 × 170. O/Pl. 9b.

St John the Baptist at the Well. Auckland City Art Gallery (NZ). (1964, p. 29, illus. as Caravaggio follower). 99.1. × 74.9. U.

Conversion of the Magdalen. Galleria Pallavicini, Rome (1959/111, as Caroselli). 98.5 × 136.5. O/Pl. 5a.

Martyrdom of St Pontianus. Pinacoteca, Lucca. 250 × 170. O/Pl. 9a.

Warrior Saint. Whereabouts unknown. Borea, 1972, Fig. 12.

Double Portrait. Musée Fesch, Ajaccio. O/Pl. 6b.

Portrait of an Actor. Pincoteca Vaticana, Rome. O/Pl. 6c.

Portrait of a Poet. Mrs Alan Curtis Collection, Berkeley (Calif.). 54.5 × 48. BP. U. Spear, *Storia dell'Arte*, 1972, Fig. 15.

Portrait of a Sculptor. Lost. One copy known: Orsetti Collection, Lucca. M/Fig. 8, as original.

Portrait of a Man. Marchesi Collection, Rome. O/Pl. 6a.

Portrait of a Man with Dürer Frontispiece. Memorial Art Gallery, University of Rochester, Rochester (New York). 127 × 100.3. O/Pl. 10a.

Portrait of a Man writing (?Self Portrait). Pietro Mazzarosa Collection, Lucca. O/Pl. 6d.

Young Artist working by Lamplight. Boston Museum of Fine Arts.

Bacchic Concert (six figures). Museum of Fine Arts, Dallas (Texas), on loan from Hoblitzelle Foundation. 121.9 × 174. Spear, 1971 (48), illus.; O1965/Pl. 11 in colour.

Concert (five figures). Two versions known: **1.** White-Thomson Sale, Christie's, 1 Feb. 1924 (101). **2.** Open Gate Club, Rome (1965). S. O1965/Pl. 68b.

Concert (three figures plus angel). J. Paul Getty Museum, Malibu (ex-Czernin). 101 × 134. S. O/Pl. 5c.

Female Luteplayer and Youth holding Dead Game behind Parapet. Sale, Finarte, Milan, 15–16 May 1962 (15), illus. colour. 93 × 118. O/Pl. 15d.

Man tuning a Lute. Museo de Arte de Ponce (Puerto Rico) (1965/61.0217 as Novelli). 114.9 × 87.5. S. O/Pl. 16b.

Youth playing a Lute, with a Child. Weinmüller Sale, Munich 1–2 June 1949. O1965/Pl. 70b.

Lute-maker. Two versions known: **1.** with Julius Weitzner, New York (1946). 61.6 × 56.5. Exh. Wildenstein, New York, May–June 1946 (21), illus. as copy after La Tour. **2.** Formerly Mansi Collection, Lucca. Oval. O/Pl. 7b. The latter is a pair to the following oval:

Violin-maker. Formerly Mansi Collection, Lucca. O/Pl. 7a.

Boy Violinist and female Figure. Fine Arts Museums of San Francisco (Calif.). 112 × 82. Spear. 1971, Fig. 33.

Boy Violinist. University of Wisconsin, Madison (Wisconsin), Kress Collection. 84.5 × 69.9. Kress Catalogue, 1973 (K1784), illus. as Caroselli.

Fortune-Teller. City Art Gallery, Auckland (NZ). 109.2 × 172.7. O/Pl. 15c.

Old Woman and Young Courtesan; Courtesan and Young Lover (pendants, two canvases). Musée Départemental de l'Oise, Beauvais (1971/11, 12, both illus.). 96 × 136; 97 × 135.

Young Page. Formerly Mansi Collection, Lucca. Oval, *en suite* with two ex-Mansi Instrument-makers listed above. O1965/Pl. 70c.

Boy with Butterfly. Fine Arts Museum of San Francisco (Calif.). 59 × 48.3. Exh. 'Baroque Painters of Naples', Sarasota, 1961 (5), as Caracciolo, illus.

Head of a Boy. Malcolm Waddingham Collection, London.

'PENSIONANTE DEL SARACENI'

A perfectly coherent group of paintings largely put together by Longhi, though the implication that the author is Saraceni's pupil is arguable. He could be French though not Le Clerc as has been suggested. Active in the second decade. All works listed. L followed by stroke and plate number refers to Longhi, 1943.

Job mocked by his Wife. Two autograph versions known: **1.** Pinacoteca Vaticana, Rome (1934/385 as school of Caravaggio). 100 × 129. L/Pl. 50. **2.** National Gallery of Ireland, Dublin (1971/1178). 104 × 133. Nicolson/Wright, 1974, Fig. 59. The following versions are probably both copies: **1.** Rivera Schreiber

Collection, Lima (Peru) (1948). 101 × 119. Venturi etc., 1948, Pl. 1. **2.** Sale, Christie's, 22 April 1960 (65) as Honthorst. 104.1 × 129.5. R. Rome/Paris, 1974, p. 250, and Venturi etc., 1948, list further versions.

St Jerome. Ottani Cavina Collection, Bologna. 64 × 50. Rome/Paris, 1974 (21), illus.

Fishmonger. Galleria Corsini, Florence. 139 × 180. L/Pl. 48.

Fruit Vendor. Detroit Institute of Arts. 130 × 93. L/Pl. 47.

Chicken Vendor. Museo del Prado, Madrid (1972/2235). 95 × 71. L/Pl. 49.

Still Life. National Gallery of Art, Washington (DC) (Kress Catalogue, 1973/K306, illus. as follower of Caravaggio). 50.5 × 71.7. L/Pl. 4.

The following is surely not by the 'Pensionante' but half way between him and Le Clerc:

Christ among the Doctors. Pinacoteca Capitolina, Rome. 86 × 104. Longhi, S.G. 1961 (1913), Fig. 7.

The following are wrong attributions to the 'Pensionante':

Caravaggesque unknown (?South Spanish) **Card Sharpers.** Fogg Museum of Art, Cambridge (Mass.). *Roman School **Still Life.** Boston Museum of Fine Arts. 65.7 × 58. Marini, 1974, Pl. R14.

POLINORI, Andrea (Aug. 1586–1648)

From Todi. Lives and works almost continuously in his native town, except for a visit to Rome *c.* 1612–17. At first influenced by Barocci, later by the Bolognese and Lanfranco. *c.* 1617–20, momentarily comes within the orbit of Manfredi. Only two Caravaggesque works are so far identified, listed below.

Madonna dei Pellegrini. S. Nicolò, Todi. C of Caravaggio in S. Agostino, Rome.

Denial of St Peter. Vescovado, Todi. *c.* 110 × 160. Toscano, 1961, Fig. 134d. Pendant to non-Caravaggesque *Angel appearing to the Family of Tobias* of same size in same place.

PORTENGEN, Lumen (?–1649)

Utrecht school. Master of the Guild at Utrecht, 1638. Belongs to circle of Kuyl in the 1630's. W followed by stroke, number and plate reference is to Van de Watering, 1967.

Tobias healing his Father. Sale, Versailles, 5 Feb. 1967 (8). 100 × 124. Apparently signed '. . . Portengen . . . 163 . . .', but not in Lumen's style. W/Lumen No. 1, Pl. 7. Could be by another Portengen.

Concert (six figures). Cesare Olschki Collection, Pisa (1966); Sale, Christie's, 14 April 1978 (12). 136 × 173. S. Rosenthal, 1912, Pl. 83. W/Lumen No. 8, Pl. 8.

Luteplayer. Centraal Museum, Utrecht (1952/223, illus.). 85.5 × 66.5. S & D 1636. Exh. Utrecht/Antwerp, 1952 (57), illus. W/Lumen No. 4.

Shepherd with Flute. Mme. M. Joffe Collection, Châteauroux (Indre) (1956). Panel, 100 × 77. ?S & D 1636. U. W/Lumen No. 5.

Bagpipe Player; Tambourine Player (two panels, pendants). Both panels, 28 × 21.5. Both S. Sale, Dorotheum, Vienna, 30 May–2 June 1967 (95, 94), illus. W/Lumen No. 6.

The following two pictures, not obviously by the same hand, appear to be indistinctly signed by Lumen's cousin, Pieter Portengen (*c.* 1612–43). The Spark picture is strikingly Baburen-like in handling.

St Peter [Plate 220]. M. V. Lopez de Ceballos y Ulloa Collection, Madrid (1959). Panel, 72 × 65. ?S & D 1639. Exh. Bordeaux, 1959 (96).

Singing Youth. With Victor Spark, New York. Panel, 74.5 × 59. ?S. *Art Journal*, XXIV, 4, 1965, p. 359, illus. W/Petrus No. 2, Pl. 1.

PRETI, Mattia (Feb. 1613–Jan. 1699)

Known as 'Il Cavalier Calabrese', Preti comes from Catanzaro, but settles in Naples and in 1661 in Malta, where he dies. The date of his birth shows that he cannot have come to maturity until the 1630's, which explains why his early style is a combination of the tonality of Caracciolo and the neo-Venetian idiom in Rome best exemplified by Pier Francesco Mola. Documented in Rome intermittently from 1633 onwards till 1653; in Modena, *c.* 1653–*c.* 1656; Naples, 1656–60; Malta, 1659; Rome, 1660–61. The small group (which could be extended or further pruned) of relatively early religious and genre scenes listed below, some no doubt painted in the 1630's (but his early chronology is still unclear), shows his acquaintance with Caravaggesque themes, although his treatment of them is quite individual.

Diogenes. National Trust, Buscot Park (Oxfordshire). 95 × 65. Nicolson, 1975, Fig. 14.

Sophonisba receiving the Cup of Poison. With Gilberto Algranti, Milan (1971, cat. illus. colour). 96 × 129.

Tribute Money. Galleria Nazionale d'Arte Antica, Rome (exh. 1955/25, illus.). 123 × 173. Longhi, S. G. 1961 (1913), Fig. 12.

Tribute Money. Galleria Doria-Pamphilj, Rome. 147 × 298. Longhi, S, G. 1961 (1913), Fig. 11.

Tribute Money. Pinacoteca di Brera, Milan. 143 × 193. Moir, 1967, Fig. 174.

Calling of St Matthew. Kunsthistorisches Museum, Vienna (1973, Pl. 44). 104 × 164.

Denial of St Peter. Galleria Nazionale d'Arte Antica, Rome (exh. 1955/26, illus.). 126 × 98.

Concert (more than ten figures). Galleria Doria, Rome. 110 × 145. Moir, 1967, Fig. 173.

Concert (three figures). Two versions: **1.** Longhi Collection, Florence (1971 cat., Pl. 77 in colour). 103 × 140. ?C. Longhi, S. G. 1961 (1918), Fig. 174. **2.** Hermitage, Leningrad. 110 × 147. Linnik, 1975, Pls. 84–7 in colour. See New Orleans *Gamblers* below.

Concert (three figures) [Plate 197]. Schloss Rohoncz Foundation, Lugano-Castagnola. 107 × 145.5. S A.

Concert (three figures). Lost. One copy known: Park Ridge Public Library, Park Ridge (Illinois). 89 × 126.8. Spear, 1971 (50), illus. as original.

Singers (three figures). Municipio, Alba. 190 × 120. Longhi, 1943, Pl. 82.

Concert Party with Fortune-Teller [Plates 195, 196: details]. Two versions: **1.** Accademia Albertina, Turin. 195 × 285. Moir, 1967, Fig. 172. Longhi, S. G. 1961 (1916), illus. details Figs. 153–4. **2.** Galleria Capitolina, Rome.

Gamblers (three figures). Private Collection, Rome. Manini, 1976, Fig. 1.

Gamblers (three figures). Isaac Delgado Museum of Art, New Orleans. Probably C. Companion composition to Longhi and Leningrad *Concerts* listed above.

Draughtsplayers. B. Nicolson Collection, London. 120.6 × 156.2. Spear, 1971, Fig. 35.

Blind Man, Youth and Servant. With estate of T. P. Grange, London. 120 × 110. F. Spear, *Storia dell'Arte*, 1972, Fig. 13.

Boys begging. Ing. Giuseppe de Vito Collection, Milan. 172.7 × 123.2. Briganti, 1951, Pl. 24.

Almsgiving. Douglas John Connah Collection, Boston (1918). Longhi, S. G. 1961 (1918), Fig. 173.

Soldier gambling. Duke of Northumberland Collection, Alnwick Castle, as Rosa. F of ? *Denial of St Peter*. *Burl. Mag.*, July 1971, Fig. 93.

The following are wrong attributions to Preti:

Caracciolo **Crucifixion.** Real Casa Santa dell'Annunciata, Naples.

?Valentin **Crowning with Thorns.** Fogg Art Museum, Cambridge (Mass.).

QUANTIN, Philippe (*c.* 1600–Sept. 1636)

Active in Dijon and Langres. Italian journey is obligatory (?*c.* 1618–20) on account of Saraceni-like characteristics in the small selection of works listed below. The artist is also acquainted with works by the Bassano family.

Decorative Scheme. Château, Ancy-le-Franc (Yonne).

Adoration of the Shepherds [Plate 26]. Musée des Beaux-Arts, Dijon (1968/98). 260 × 351.

Visitation. Musée des Beaux-Arts, Dijon (1968/99). 207 × 239. R. Triptych: *Circumcision* flanked by *St Claude raising a Child* (left) and *St Margaret tempting the Dragon* (right). *Raising of Lazarus* on the reverse.

Musée des Beaux-Arts, Dijon (1968/101, illus.). Height, 227; width of central canvas, 184, and of lateral panels, 87. S & D 1635.

Mystic Communion of St Catherine of Siena [Plate 24]. Musée des Beaux-Arts, Dijon (1968/97, illus.). 382 × 260. Before 1624.

St Bernard [Plate 25]. Musée des Beaux-Arts, Dijon (1968/100). 180 × 120.

RAGUSA, Francesco (?–1665)

Possibly Sicilian. Influenced by Baglione and O. Gentileschi. Documented in Rome, 1636. Only one other certain work known, at Palermo, dated 1651.

Mystic Marriage of St Catherine, with St Charles Borromeo. S. Lucia, Spoleto. S & D 1618. 225 × 160. Casale etc., 1976, Pl. XVII.

RÉGNIER, Nicolas (Dec. 1591–Nov. 1667)

Born in Maubeuge. Pupil of Abraham Janssens at Antwerp. Recorded in Rome from June 1621 to 1625, but probably arrived there several years earlier. Patronized by Giustiniani. When in Rome, strongly influenced by Manfredi, but on leaving for Venice late 1625 (where he is first mentioned June 1626) he ceases to be Caravaggesque, pursuing an individual style more along Bolognese lines. In Venice, where he remains more or less for the rest of his life as 'Renieri', he enjoys a successful but dubious career as painter, dealer, art collector and 'expert'. Works of Roman period all listed, and a very few early Venetian ones where traces of Caravaggism survive. RP followed by stroke and number refer to catalogue numbers in Exh. Rome/Paris. 1973–74.

Bacchus pressing Grapes. Formerly Kaiser-Friedrich Museum, Berlin. (Destroyed). 128 × 103. Engraved as from Giustiniani Collection in Landon (1812). Voss, 1924, p. 145, illus.

Orpheus. Formerly Kaiser-Friedrich Museum, Berlin. Destroyed?. *c.* 116 × 97. Engraved as from Giustiniani Collection in Landon (1812) as 'Homer'.

Allegory of Summer. Busiri Vici Collection, Rome. 61 × 170. ?Still life by Master J (q.v.). RP/22, illus. Two pendants are:

Allegory of Autumn and **Allegory of Winter** (two canvases). B. Nicolson Collection, London. Both 54 × 164. RP/23, 24, illus. One copy of *Winter* recorded: Private Collection, Rome.

Tarquin and Lucretia. Musée des Beaux-Arts, Bordeaux. 161.3 × 114.3. Exh. Bordeaux, 1966 (13), illus.

David with the Head of Goliath and Girl holding Laurel. Galleria Nazionale d'Arte Antica, Rome. 118.5 × 97.3. U. Brejon, 1974 (Pl. 33), as Tournier.

David with the Head of Goliath. Galleria Spada, Rome (1954/202, illus.). 132.1 × 99.1. RP/25, illus.

David with Sling and Stone. Museo Civico, Padua. 70 × 51. RP/28, illus.

Crowning with Thorns [Plate 35]. With Silvano Lodi, Munich (1972). C of Manfredi in Florentine Galleries (q.v.).

Soldiers gambling for Christ's Garments. Musée des Beaux-Arts, Lille (1893/92). 135 × 190. Ivanoff, 1965, Fig. 5b.

Christ at Emmaus. Sanssouci, Potsdam (1964/80). 282 × 222. Ivanoff, 1965, Fig. 6a. Engraving in Landon from Giustiniani Collection (1812), as Manfredi.

St Jerome. Parish Church, Lozzo Atestino (near Padua). 110 × 100. RP/30. illus. Another version is recorded in Museum at Kiev, as Domenichino.

St John the Baptist. Hermitage, Leningrad (No. 5044). 175 × 142. Exh. Leningrad, 1973 (43), illus. Linnik, 1975, illus. colour Pl. 49.

St John the Baptist. Museo Civico, Bassano del Grappa. 93 × 80. BP. Fantelli, 1974, Fig. 3.

St Luke painting. Musée des Beaux-Arts, Rouen (Baderou Donation). Baderou cat. 1977, illus. 148.5 × 120.

Magdalen. Detroit Institute of Arts. 121.9 × 96.5. Spear, 1971 (54), illus.

St Sebastian. Chrysler Museum, Norfolk (Virginia). 104.1 × 78.7. Exh. Norfolk, 1967–8 (26), illus.

St Sebastian. Gemäldegalerie, Dresden (1960/409). 126 × 98. Voss, 1924, p. 144, illus.

St Sebastian tended by Irene. Musée des Beaux-Arts, Rouen (1966/107, illus.). 148 × 198. RP/27, illus.

Self Portrait [Plate 57]. New York art market (1942). 111 × 138. Richardson, 1942, Fig. 3.

Portrait of a Man in a Feathered Cap. Pomona College Art Gallery, Claremont (Calif.), Kress Study Collection (Kress Catalogue, 1977/K1823, illus.). 64.8 × 48.9. BP. ?F.

Concert Party. Accademia, Venice (1970/174, illus.). 119 × 135. Ivanoff, 1965, Fig. 8b. Pendant to *Card Sharpers* in same museum (q.v.).

Luteplayer and Female Singer. Formerly with Dr Benedict, Berlin. 108 × 132.

Card Sharpers. Accademia, Venice (1970/173, illus.). 117 × 133. Fantelli, 1974, Fig. 56. Pendant to *Concert Party* in same museum (q.v.).

Card Sharpers and Fortune-Teller. Two versions: **1.** Musée d'Art et d'Histoire, Geneva. 175 × 227. Exh. Helikon, London, 1974, illus. colour. **2.** Szépmővészeti Múzeum, Budapest (1967/610, as ?Manfredi). 174 × 228. RP/26, illus.

Fortune-Teller and Dice Players. Florentine Galleries. 172 × 232. U. Exh. Florence, 1970 (20), illus.

Fortune-Teller. Musée du Louvre, Paris (1972/366). 127 × 150. Von Schneider, 1933, Pl. 41b, as Rombouts.

Fortune-Teller. Formerly Kaiser-Friedrich Museum, Berlin (1931/476, as attr. to Valentin) (destroyed 1945). 164 × 215. Nicolson, 1972, Fig. 67.

Head of a Child. Musée Magnin, Dijon. Tondo, diameter, 39. RP, Fig. 6.

Sleeper being awakened through the Nose by lit Wick [Plate 54]. Musée des Beaux-Arts, Rouen (Baderou Donation). 90 × 116. Exh. Heim Gallery, Paris, 1955 (14), illus.

Sleeper being awakened through the Nose by lit Wick. With Heim Gallery, Paris (1976).

The following is a selection of wrong attributions to Régnier:

*Florentine School **David with the Head of Goliath, and Girl with Tambourine.** Busiri Vici Collection, Rome. 128 × 99. Bodart, 1970, Fig. 27. Perhaps by same hand as *Judith* in Dijon.
Manfredi (?copy by Tournier) **Fortune-Teller.** David Rust Collection, Washington (DC).

Manfredi imitator **Denial of St Peter.** Private Collection, Rome.
?Jacob van Oost the Elder **Guitar Player.** Heim Gallery, Paris (1955).
Vouet **Fortune-Teller.** National Gallery of Canada, Ottawa.

REMBRANDT Harmensz. van Rijn (July 1606–Oct. 1669)

From Leiden. Like his young fellow-townsman Lievens, though less frequently or obviously, Rembrandt, who never makes the journey to Rome, is intrigued by what Dutchmen bring back from there —not only his master Lastman but also the Utrecht artist Honthorst. Most of his earliest works from the mid- to the late 1620's are understandably Lastman-like and so do not concern us; but two just qualify for inclusion in these lists.

Esther's Feast. North Carolina Museum of Art, Raleigh (NC) (1956/65). 134.6 × 165.1. Bredius, 1969, No. 631, illus. Some authorities ascribe it to Lievens.
Money Changer. Museum Dahlem, Berlin (1975/ 828D). Panel, 32 × 42. S & D 1627. Bredius, 1969, No. 420, illus.

A third picture, from the circle of Rembrandt and Lievens and conceivably by the latter (mid-1620's), is influenced by Terbrugghen:

Pilate washing his Hands. Formerly Princess Labia Collection, Capetown (South Africa); sale, Sotheby's, 27 Nov. 1963 (22); with Speelman, London (1976). Panel, 83.8 × 106.7 (enlarged at top). Slive, 1963, Fig. 20 as Lievens.

RENI, Guido (Nov. 1575–Aug. 1642)

Guido's personality is so profoundly un-Caravaggesque that there is no excuse for listing more than a handful of works of *c.* 1604–6 where Caravaggio momentarily touches him. P followed by stroke and Fig. number refers to Pepper, 1971.

David with the Head of Goliath. Musée du Louvre, Paris (1926/1439). 220 × 160. P/Fig. 6.
Christ at the Column. Städelsches Kunstinstitut, Frankfurt am Main (No. 1103). 192 × 114. Before Oct. 1604. P/Fig. 1.
Saints Peter and Paul. Pinacoteca di Brera, Milan. 197 × 140. Finished 1606. P/Fig. 11.

Crucifixion of St Peter. Pinacoteca Vaticana, Rome. 1604. P/Fig. 2. Preliminary study: Szépművészeti Múzeum, Budapest, ink and wash, 22.9 × 13.9. P/Fig. 5.
Contest of Putti. Lost. 1605. Various copies known (listed by P, note 33), the best being: Galleria Doria Pamphilj, Rome. 118 × 151. P/Fig. 13.

RIBALTA, Francisco (1565–Jan. 1628)

Born in Solsona. Probably trained in Barcelona, but soon moves to Madrid where he is strongly influenced by the Italian Mannerist decorators of the Escorial. In 1599 settles in Valencia. Not recorded there between Jan. 1613 and Nov. 1615, a fact which has inclined critics to suppose he visits Italy then, judging by the existence of the copy of a Caravaggio signed by him listed below (the only strictly Caravaggesque picture in his *œuvre*), and judging by indications of familiarity with the Roman Caravaggesque milieu in his later work.

Crucifixion of St Peter (after the Caravaggio in S. Maria del Popolo). Principe Pio Collection, Mombello. 93 × 78. S. Ainaud, 1957, pp. 86–9, illus.

RIBERA, Jusepe de (Feb. 1591–Sept. 1652)

Born at Játiva, near Valencia. Said by Palomino to be pupil of Ribalta. Leaves for Italy early and remains there for the rest of his life, settling in Naples. Travels in Lombardy and studies in Parma. Documented

in Rome, 1615–16, but is in Naples by Sept. of the latter year. The only strictly Caravaggesque pictures known are the series of 'Five Senses' listed below, although there is a strong influence of Caracciolo in other early works. The *Philosopher looking into a Mirror* (sometimes called Socrates or Archimedes) just qualifies, in spite of being much later.

Sense of Taste. Wadsworth Atheneum, Hartford (Conn.). 113.6 × 88.3. 1615–16. Spear, 1971 (55), illus. Felton, 1969, note 17 records many copies, one of which is: Rampini Collection, Florence, Longhi, 1966, Pl. 47.

Sense of Smell. Lost, known only from Viennese copy (see below), Spear, 1971, Fig. 36.

Sense of Touch. Norton Simon Foundation, Los Angeles. 114.3 × 88.3. Spear, 1971 (56), illus.

Sense of Sight. Museo de San Carlos, Mexico City. 114.5 × 89. 1615–16. Spear, *Storia dell'Arte*, 1972, Fig. 1.

Sense of Hearing. Lost, known only from Viennese copy (see below), and other copies listed by Felton,

1969, note 17. C in O'Conner Lynch Collection, New York, illus. *Novità*, 1975, Gregori, Fig. 29.

Copies of all 'Five Senses' (114 × 79) formerly in Private Collection, Vienna; sale, Dorotheum, Vienna, 14 Jan. 1966 as 'Baburen after Ribera', Longhi, 1966, Pls. 49–51b.

Philosopher looking into a Mirror. Doña Angeles Solar Collection, Bilbao. S. M. Díaz Padrón, 1972, illus. Engraved in Jacques Couché, *Galerie du Palais Royal*, 1786, I, p. 59; Trapier, 1952, Fig. 156. Many variants known, of which one was in Giustiniani Collection in 1638 (No. 200), engraved in Landon (1812, p. 143). Another at Christie's, 21 July 1972 (180), 121 × 92, from Conte Matarazzo di Licosa Collection.

RIMINALDI, Orazio (Sept. 1594–Dec. 1631)

Born in Pisa of Lucchese parentage. Probably reaches Rome in second decade. Manfredi and Gentileschi are the points of departure for an early Caravaggesque phase, but in the 1620's he moves in the direction of the proto-Baroque of Lanfranco. His works are the most advanced Baroque paintings in Tuscany of their day (mid- to late 1620's). Also influenced by classical sculpture. Working for the Duomo at Pisa intermittently throughout the third decade, but is in Rome much of the time, being documented there in the company of Vouet in 1624, and again from Dec. 1628 to 1630. The decoration of the Baroque dome of the Cathedral of Pisa (commissioned 1627, executed 1628 onwards) is interrupted by his death. A small number of near-Caravaggesque works (which it has to be admitted form a somewhat incoherent group) is alone listed. G followed by stroke and plate number refers to Gregori, *Riminaldi*, 1972.

Daedalus fitting Icarus with wings. At least three versions known: **1.** Wadsworth Atheneum, Hartford (Conn.) (No. 1944.38 as Cavallino). 130 × 95. Borea, 1972, Fig. 15. **2.** Private Collection, Florence (1969). 132 × 99; sale, Christie's, 4 Feb. 1977 (59), illus.; again, 28 Oct. 1977 (6). **3.** Heirs of Vincenzo Bonello, Valletta (Malta). G/Pl. 61 seems to be the Hartford picture.

Juno placing Argus's Eyes on her Peacock's Tail. Galleria Doria-Pamphilj, Rome (1942/N.278 as Artemisia Gentileschi). 220 × 147. U. G/Pl. 45.

Sacred and Profane Love. Andrea Busiri Vici Collection, Rome (1959). 155 × 115. U. Exh. Bordeaux, 1959 (111), illus.

Love Triumphant [Plate 37]. National Gallery of Ireland, Dublin. 178 × 122. Exh. Bordeaux, 1969 (58), illus. Moir, 1976, Fig. 43, before cleaning.

Love Triumphant. Florentine Galleries. 141 × 112. G/Pl. 60.

Cain and Abel. Florentine Galleries. 171 × 122. G/Pl. 50.

Cain and Abel. National Museum, Valletta (Malta). U. G/Pl. 43.

Cain and Abel. Schloss Weissenstein, Pommersfelden. G/Pl. 47.

David with the Head of Goliath. Galleria Sabauda, Turin (1971(558), illus.) 100 × 80. Moir. 1967, Fig. 283.

Investiture of St Bona. S. Martino, Pisa. S. After March 1624. G/Pls. 48, 59.

Martyrdom of St Cecilia. Florentine Galleries. 315 × 171 (extended to 333.3 × 217.5). G/Pl. 46. Painted copy by G. D. Gabbiani (1697) in Seminario, Pisa; drawing by Gabbiani, Mirimonde, 1974, p. 25, illus.

Martyrdom of Saints Nereus and Achilleus. Galleria Nazionale d'Arte Antica, Rome. G/Pl. 44.

The following is a wrong attribution to Riminaldi:

★ ?Lombard School **St Sebastian tended by Irene.** Three versions known: **1.** Villa Albani, Rome. Longhi, S.G. 1961 (1922), Pl. 223. **2.** Musée des Beaux-Arts, Tours. **3.** Campori Collection, Modena. 76 × 83. Moir, 1967, Fig. 284. A fourth is said to have been at Vicenza.

RODRIGUEZ, Alonzo (1578–April 1648)

Born of Spanish parentage, he is trained in Messina, then travels to Venice. In Rome 1605–6 and no doubt longer. Returns *c.* 1610, certainly before 1614, *via* Naples to Messina where he proves most successful. Strongly influenced by Caravaggio's Sicilian period. Patronized by Antonio Ruffo in the year of his death in Messina. Sometimes assisted by his brother Antonio. M followed by stroke and Fig. number refers to Moir, 1962.

Last Supper [Plates 191, 194]. Parish Church, Fontanarosa (province of Avellino). U. Causa, 1972, Pl.293.
Last Supper. Museo Nazionale, Messina (on loan to Municipio). Mixed oil and fresco medium, 570 × 730 (transferred from wall to canvas). Probably 1617. R. M/Figs. 7–8, 10–11.
Last Supper. Museo Nazionale, Messina (on loan to Municipio). 202 × 308. M/Fig. 9.
Christ at Emmaus. Museo Nazionale, Messina. 148 × 200. B P. M/Figs. 3, 6.
Meeting of Saints Peter and Paul. Museo Nazionale, Messina. 261 × 191. M/Fig. 12.
Incredulity of St Thomas. Museo Nazionale, Messina. 148 × 200. B P. M/Fig. 1.

The following are thoroughly dubious attributions to Rodriguez:

Christ at Emmaus. R. Causa Collection, Naples. Marini, 1974, illus. p. 325 (C44).
Vision of St Jerome. Whereabouts unknown. Marini, 1974, illus. p. 325 (C43).

The following are wrong attributions to Rodriguez:

Gentileschi imitator **St Charles Borromeo in Prayer.** Museo Nazionale, Messina.
?Jan van Houbracken **Miracle of St Roch.** Museo Nazionale, Messina.

ROMBOUTS, Theodoor (?1597–Sept. 1637)

Born in Antwerp. Pupil of François van Lanckvelt, 1608. Leaves for Italy, Sept. 1616. Works in Rome (where he is recorded in 1620), Florence (to which he is called by the Grand Duke of Tuscany), and Pisa (1622). In Antwerp again as Master of the Guild, 1625; *doyen*, 1629–30. Influenced by Abraham Janssens. In Rome, seems to be in contact with Crabeth, and with De Haan whose style in S. Pietro in Montorio is astonishingly similar. Some religious and other works, where in later years he is seen to be moving in the direction of Rubens and Jordaens, are not listed here, but his genre scenes are, even though they may date from the end of his life, because he can hardly be said in this field to desert his Caravaggesque allegiance. M followed by stroke and Fig. number refer to Mirimonde, 1965.

Five Senses. Musée des Beaux-Arts, Ghent (1937/S–76). 207 × 288. S. Von Schneider, 1933, Pl. 44a.
Christ driving the Money Changers out of the Temple [Plate 86]. Koninklijk Museum voor Schone Kunsten, Antwerp (1958/801). 168 × 238. S. Exh. 'I Fiamminghi e l'Italia', Bruges/Venice/Rome, 1951 (67), illus.
Denial of St Peter. Two versions recorded: **1.** Musée des Beaux-Arts, Lille (1893/659) (burnt 1916). 87 × 134. S. **2.** Liechtenstein Collection, Vaduz. 94 × 206. Von Schneider, 1933, Pl. 42a.
St Sebastian [Plate 91]. Dr John A. Cauchi Collection, Rabat (Malta).
Concert (six figures). Lost. Three copies known: **1.** Museum, Valenciennes. 149 × 229. M/Fig. 16. **2.** With Ledbury Galleries, London (1975); sale, Sotheby's, 27 March 1974 (117), as G. van der Kuyl. 99 × 118. F of four left hand figures. **3.** With O. Poggi, Rome (1972). C of *Theorbo Player* alone (in foreground). 118 × 92.
Concert (four figures). Galleria Nazionale d'Arte Antica, Rome (1955/27). 61 × 76.5. S & D 162(?5). Spear, 1971, Fig. 40.
Concert (four figures). Sale, Mak van Waay, Amsterdam, 3 March 1942 (179). 112 × 174. ?S. U. M/Fig. 18.
Concert (three figures) [Plate 89]. Bayerische Staatsgemäldesammlung, Munich. 134 × 178. Three copies recorded: **1.** Herzog Anton Ulrich-Museum, Brunswick (1976/179). 93 × 139. **2.** Museum, Rheims. M/Fig. 15. **3.** Sale, Berlin (Lepke), 30 Nov. 1920 (124), illus. 113 × 151.
Two itinerant Musicians. Helen Foresman Spencer Museum of Art, University of Kansas, Lawrence (Kansas). 220 × 130. S. M/Fig. 11.
Two Musicians. Lost. Engraved by Bolswert, Bibliothèque Nationale, Paris, M/Fig. 12. Man alone engraved by J. A. Pierron (1790) in Lebrun Gallery.
Luteplayer and Singer. Musée des Beaux-Arts, Poitiers (*Dix Ans d'Acquisitions*, 1972/3 as attrib.). Panel, 107 × 80. A. *La Revue du Louvre*, 1970, p. 50, Fig. 5.
Musical Pair [Plate 88]. Two versions known: **1.**

Bayerische Staatsgemäldesammlung, Munich (No. 4836, as Manfredi). 101 × 83. **2.** Giscaro Collection, Toulouse (1957). Mesuret, 1957, No. 35, Fig. 8 as Tournier.

Luteplayer [Plate 90]. Many horizontal and upright versions known, of which the following appear to be autograph: **1.** Koninklijk Museum voor Schone Kunsten, Antwerp (1958/984). 114 × 99. S. M/Fig. 13. This is probably identical with: **2.** Vicomte de Ruffo de Bonneval de la Fare, sale, Brussels, 23 May 1900 (49), illus. as 117 × 102; again, sale, Aken (Lempertz), 18 Dec. 1907 (47), illus. in reverse. S. **3.** John G. Johnson Collection, Philadelphia (on loan to Philadelphia Museum) (1972/679). 111.3 × 99.7. S. The following are borderline cases: **1.** Musée du Louvre, Paris (1922/2413, as Honthorst). 70 × 79. Von Schneider, 1933, Pl. 41a. **2.** Sir William Dugdale Collection, Merevale Hall, Atherstone. The following is a copy: Museum, Dunkirk (1974, p. 59). 90 × 109. Inscribed ROM. . . Hoog, 1960, Fig. 8.

Female Guitar Player. Sir William Dugdale Collection, Merevale Hall, Atherstone.

Eating and Drinking Scene (thirteen figures). Two versions recorded (? the same): **1.** Private Collection, Paris (1952). 170 × 238. S. Roggen, 1952, p. 272, Fig. 2. **2.** Alfred S. Karlsen Collection, California. 154.9 × 223.5. *Connoisseur*, June 1962, illus.

Man smoking Pipe and drinking. Museum Boymans-van Beuningen, Rotterdam (1962/1331, as Utrecht School, *c.* 1625). 97 × 129. R. UU.

Card Players (eight figures). Museo del Prado, Madrid (1975 Flemish cat./1636, illus.). 100 × 225. Von Schneider, 1933, Pl. 42b. One copy recorded: Facultad de Farmacia, University of Barcelona (1975 Prado Flemish cat. (1634), illus.). By same hand as copy of Barcelona *Tooth Extractor* below.

Card Players (five figures). Three versions known: **1.** Koninklijk Museum voor Schone Kunsten, Antwerp 1958/358). 153 × 206. M/Fig. 17. **2.** Sale, Weinmüller, Munich 22–3 June 1960 (851), illus. 118 × 155. **3.** Russell Cotes Museum, Bournemouth. 142.2 × 208.3. A version was at Christie's, 24 Oct. 1958 (144) and 12 Dec. 1958 (125) as Valentin, which is probably not the Weinmüller sale picture. C, S & D 1878 by Edgard Farasyn, Walker Art Gallery, Liverpool (1977/508, illus.). 85.4 × 114.3.

Card Player (three figures). Galerie Saint-Lucas, Vienna (1956). 57 × 99. One copy known: sale, Parke Bernet, New York, 10 Oct. 1940 (56), illus. 91 × 119.

Male and Female Card Players. Sanssouci, Potsdam (1933). 105 × 206.

Backgammon Players. North Carolina Museum of Art, Raleigh (NC). 165.1 × 240. S & D 1634. Von Schneider, 1933, Pl. 44b.

Card Players with Luteplayer (six figures). Hermitage, Leningrad (1957/285, illus.). 143.5 × 223.5. Linnik, 1975, illus. colour Pls. 168–71 (and black and white).

Tooth Extractor [Plate 87]. Three versions known: **1.** Musée des Beaux-Arts, Ghent (1937/1920–0). 153.5 × 235.5. False Valentin signature. **2.** (With the addition of two figures). Museo del Prado, Madrid (1975 Flemish cat./1635, illus.). 116 × 221. Von Schneider, 1933, Pl. 4b. A third, signed 'Roelands', in Gallery at Prague. Five copies are recorded: **1.** Sale, Palais des Beaux-Arts, Brussels, 26–7 March 1974 (71), illus. 118 × 190. **2.** Musée d'Art et d'Archéologie, Clermont-Ferrand. **3.** Facultad de Farmacia, University of Barcelona (1975 Prado Flemish cat./1633, illus.). By same hand as copy of *Card Players* (see above). **4.** Museum, Saint-Omer. 100 × 159. Signed 'R.P.T.'. A copy in a private collection, USA, follows the Ghent version.

Vegetable and Poultry Shop. Hermitage, Leningrad (1957/284, illus.) Calais/Arras. 155 × 201. Still life by Adriaen van Utrecht. Variant is: Musée Municipal, Cambrai. 140.5 × 185. Illus. Flemish exh. (but not shown) Lille/Calais/Arras, 1977 as A. van Utrecht. Same three figures with quite different still life by Adriaen van Utrecht, Sir Francis Dashwood Collection, West Wycombe Park (Bucks.). Illus. colour National Trust Guide, 1973, opp. p. 24. Variant of two right-hand figures, with French & Co., New York (1956). Copy at Christie's, 3 May 1974 (48); with Ledbury Galleries, London (1975). 137 × 217.

Smokers (three male figures) [Plate 94]. Two versions known: **1.** Museo de Arte de Ponce (Puerto Rico) (1965/59.0095, illus.). 122.5 × 177.1. Bears unconvincing signature. Exh. 'Le Siècle de Rubens', Brussels, 1965 (180), illus. **2.** Marchese Litta-Modigliani Collection, Rome (1950's). 113 × 190.

The following are from the circle of Rombouts:

Banquet with Courtesans and Soldiers. Academia de San Fernando, Madrid, 160 × 255. Exh. Seville, 1973 (60), illus.

Card Players fighting. Statens Museum for Kunst, Copenhagen (1951/591, illus.). 150 × 241. Voss, 1924, p. 138, illus.

The following is a selection of wrong attributions to Rombouts:

Honthorst **Concert.** Galleria Borghese, Rome.

Master G **Singer and Drinker.** Galleria Spada, Rome.

Preti **Concert Party with Fortune-Teller.** Accademia Albertina, Turin.

Régnier **Fortune-Teller.** Musée du Louvre, Paris.

Baburen circle **Smoker.** Museum, Ghent.

RUBENS, Peter Paul (June 1577–May 1640)

In spite of his great admiration for Caravaggio, Rubens is too individual an artist ever to be described as Caravaggesque, even at the moment when he is resident in Rome while Caravaggio's name is on everyone's lips. He is responsible for one copy or (characteristically) adaptation of Caravaggio's *Entombment*, listed below. (See under O. Gentileschi for his partial copy of Gentileschi's *Apollo and the Nine Muses*.)

Entombment. National Gallery of Canada, Ottawa (1957/6431, illus.). Panel, 88.2 × 65.4. Von Schneider, 1933, Pl. 38a.

RUSTICI, Francesco (before 1600–1626)

Sienese, known as 'Rustichino'. At times close to Manetti but formed by Sienese Mannerism. Probably in Rome before 1619. Faintly influenced by Honthorst, but his affinities with Caravaggism are so remote that we even hesitate to list the three pictures below.

Death of Lucretia. Two versions known: **1.** Florentine Galleries. 175 × 259.5. BP. Exh. Florence, 1970 (35), illus. with detail. **2.** Museo Civico, Turin (1963, p. 105, as Honthorst). 180 × 240. Rosenberg, 1972, p. 114, Fig. 11.

Death of the Magdalen. Florentine Galleries. 121 × 169.5. Exh. Florence, 1970 (33), illus. Drawing by G. B. Wicar (1784) to be included as engraving in *Galerie de Florence*.

Death of the Magdalen. Florentine Galleries. 148.5 × 219. Exh. Florence, 1970 (34), illus.

The following is a wrong attribution to Rustici:

David de Haan **Entombment.** Formerly Kaiser-Friedrich Museum, Berlin.

SALINI, Tommaso (*c.* 1575–Sept. 1625)

Like Baglione, born in Rome of a Florentine father. Known as 'Mao'. Associated in his youth with G. B. Vanni. Pupil and friend of Baglione, he provides evidence at the famous trial of 1603 against the Caravaggisti. Elected to the Virtuosi, 1619; Cavaliere dello Speron d'Oro by 1623. Once famous as a painter of still life, flowers and fruit, including parrot pieces. The only three documented pictures by his hand listed below (the three without 'U') (and a fourth, *St Thomas of Villanova*, probably surviving in copies) are so poor that the other, finer, pictures ascribed to him must be by another artist, close to Giacomo Galli (q.v.).

Baptism. S. Giovanni dei Genovesi, Rome. U. Salerno, 1952, Fig. 4.

St Agnes liberated by the Angel. Lost. Formerly S. Agnese in Piazza Navona, Rome (Doria Collection until *c.* 1936). Zeri, 1955, Pl. 32.

St Francis. SS. Luca e Martina, Rome. Before 1618. Exh. Rome, 1968 (32), illus.

St Nicholas of Tolentino. Convent of S. Agostino, Rome. Salerno, 1952, Fig. 1.

St Thomas of Villanova. Lost. Formerly S. Agostino, Rome. Two copies recorded: **1.** S. Agostino, Rome. Partial C. Salerno, 1952, Fig. 2. **2.** S. Oliva, Cori (Lazio). Uncertain identifications.

Four Martyr Saints. Museo di Roma, Rome. Bears false Caravaggio signature. U. Salerno, 1952, Fig. 3. Engraved by Giuseppe Cades, 1793; Venturi, 1912, Fig. opp. p. 4.

The following are wrong attributions to Salini:

Circle of Galli **St Homobonus and the Beggar.** Vicariato, Rome.

Circle of Galli **St Thomas of Villanova.** Pinacoteca, Ancona.

Caravaggesque (Roman-based) **Madonna in Clouds with Saints John the Baptist and Evangelist.** Parish church, Torri in Sabina.

SANDRART, Joachim von (May 1606–Oct. 1688)

Born Frankfurt-am-Main. First journey to Prague, 1621–2. In Utrecht 1623–7 as pupil of Honthorst, with whom he goes to England where he meets Gentileschi. To Italy, 1628; Venice, 1629, thence Bologna

and Rome where he remains until 1635/36, staying in Giustiniani Palace. Also travels (1630–31) to Naples, Sicily, Malta. Again in Holland, 1636–7. Chiefly famous as author of art-historical treatise, Nuremberg, 1675–9. His early pictures down to 1644 alone listed, showing strong influence of Honthorst, but he may be in contact with Stomer in Rome or Naples in the early 1630's. However, he does not mention Stomer in his treatise and, as Mr Christian Klemm has pointed out to me, there remains some dispute about the attribution to Sandrart of the Stomer-like *Allegories* listed below.

Although the five *Allegories* are interconnected, they cannot actually have formed pendants because of discrepancies in dimensions.

Allegory of Wrath: Mars threatening Cupid. Hermitage, Leningrad (No. 7261). 112 × 80. Exh. Leningrad, 1973 (16), illus. Linnik, 1975, illus. colour Pl. 125.

Allegory of Avarice: Woman weighing Coins. Schloss Wilhelmshöhe, Cassel (1958/183; illus.). 126 × 103.5. D 1642. Exh. Berlin, 1966 (76), illus.

Allegory of Gluttony. Sale, Salsomaggiore, 9–12 June 1913 (94), as Honthorst. Linnik, 1975, illus. opp. Pl. 122.

Allegory of (?) Jealousy: Weeping Woman attempting to restrain Husband from being led away by the Devil. Sale, Fischer, Lucerne, 16–18 June 1964 (1609), illus., as Honthorst. 115 × 95. Nicolson, Russia, 1965, Fig. 49.

Allegory of Vanity: Young Woman at her Dressing Table. Hermitage, Leningrad (1957/425 illus. as Honthorst). 125 × 110. Nicolson, Russia, 1965, Fig. 48. Linnik, 1975, illus. colour Pls. 122–4.

One copy known: with Sloot, Amsterdam (1955). **Twelve Months** (twelve canvases). Bayerische Staatsgemäldesammlung, Munich; on show at Schleissheim. Each canvas, 149 × 123. 1642–4. The most Caravaggesque example (influenced by Stomer) is: *December.* D 1643. Exh. Berlin, 1966 (78), illus.

Death of Seneca. Formerly Kaiser-Friedrich Museum, Berlin (1931/445) (destroyed 1945). 171 × 215. S & D 1635. Voss, 1924, p. 138, illus. Drawing in reverse, S & D 1635, in preparation for engraving by Cornelis Bloemaert, Prof. E. Perman Collection, Stockholm; Reznicek, 1972, Fig. 7. Engraved as from Giustiniani Collection in Landon (1812).

Good Samaritan [Plate 170]. Pinacoteca di Brera, Milan (1935/702). 133 × 133. S & D 1632.

Martyrdom of St Lawrence. Ing. Alfredo Muratori Collection, Rome (1976); sale, Galleria d'Arte Bernini, Rome, 21 March 1977 (129), illus. 220 × 170. Nicolson, 1977, Fig. 19.

SARACENI, Carlo (*c.* 1580–June 1620)

Born in Venice, but spends almost his whole working life in Rome, arriving there about the turn of the century. Influenced by Elsheimer in first decade (in spite of the fact that in Sept. 1606 Baglione describes him as 'aderente al Caravaggio'), and by Borgianni *c.* 1611–3. Employed by Ferdinando Gonzaga of Mantua, 1615, and with Lanfranco, Tassi and others on fresco decoration at the Quirinal, 1616–17. Living in 1617–19 with Jean Le Clerc, his pupil, who engraves (1619) his *Death of the Virgin.* Employed on altarpieces for the German Church of S. Maria dell'Anima and for other Roman churches, 1617–19. Before the end of November 1619, accompanied by Le Clerc, he is back in Venice, where he dies in June of the following year. Le Clerc completes some of his last Venetian works after his death. After about 1611 and more obviously later in the decade adopts to limited extent the Caravaggesque idiom but always remains a Veneto-Elsheimerian at heart. Only works of his last eight or nine years are listed, and not all pictures (where landscape predominates) even in this period. O C followed by stroke and catalogue and plate number refer to Ottani Cavina, 1968.

Allegorical Figures and other Scenes. Sala Regia or Sala dei Corazzieri, Quirinal Palace, Rome. Frescoes. 1616–17. O C/62: two allegorical figures (Figs. 90–1); two scenes of oriental spectators in feigned loggias (Figs. 92–3); *Temperance* (Fig. 122); *Fortitude* (Fig. 123). Briganti, 1962, illus. Four figures of Orientals in colour, Pl. XVII, as well as the others in black and white. Saraceni's hand possibly traceable elsewhere in the Palace.

Doge Enrico Dandolo inciting to the Crusade. Sala del Maggior Consiglio, Doges' Palace, Venice.

630 × 440. 1619–20. Designed by Saraceni, largely executed by Le Clerc (q.v.), whose signature it bears. O C/85, Fig. 110.

Drunkenness of Noah. Private Collection, Milan. 96 × 129. R. O C/28, Fig. 87.

Judith with the Head of Holofernes. Three apparently autograph versions: **1.** Kunsthistorisches Museum, Vienna (1973, illus. Pl. 35). 90 × 79. O C/90, Fig. 70. Engraved in reverse by J. van Troyen in Teniers' *Theatrum Pictorium* (1660). **2.** Longhi Collection, Florence. 98 × 80. Longhi catalogue, 1971,

Pl. 62 in colour. OC/14, Fig. 72. **3.** Dr G. M. Manusardi Collection, Milan. 100 × 77. OC/29, Fig. 71. A fourth is a possibility: Musée des Beaux-Arts, Lyon. 81 × 65.5. U. OC/under No. 90. To the copies (one or two conceivably among private collections listed by OC) listed under OC/90 add: **1.** Graves Art Gallery, Sheffield. 91.4 × 74.9. **2.** With Venturi-Spada Antichità, Rome (1971). 86 × 75. Ad. *Burl. Mag.*, September 1971, p. XLIII. **3.** Sotheby Parke Bernet, New York, 6–7 March 1975 (200). 95 × 75. Copy listed under OC/90 as formerly Quixote Gallery, Madrid, now Federico Serrano Oriol Collection, Madrid. 95 × 77. C in Dayton Art Institute (1969/30, illus. colour). 86 × 77.4. Spear and others, 1975, Pl. V, as attr., VI after cleaning, and X-rays.

Christ in the Carpenter's Shop. Wadsworth Atheneum, Hartford (Conn.). 125.5 × 88.5. OC/20, Pl. IX in colour, Fig. 82.

Christ driving the Money Changers from the Temple. Lost. One copy recorded: formerly with Luigi Bellini, Florence. OC/under No. 112, Fig. 135.

Crowning with Thorns. S. Maria sopra Minerva, Rome. Painting by Saraceni over earlier work. R. OC/72, Fig. 125.

Flagellation. Formerly Conte Piscicelli Collection, Rome. 180 × 130. OC/53, Fig. 124.

Scenes from the Life of the Virgin; Angels; Saints. S. Maria in Aquiro, Rome. Oils on wall. S A. OC/70. *Death of the Virgin* (Fig. 67); *Presentation of the Virgin in the Temple* (Fig. 113); *Assumption* (Fig. 115); *Birth of the Virgin* (Fig. 114); *Four Saints* (Figs. 116–19). One detail not illus. in OC is: Salerno, 1971, Pl. 5. Three copies known of *Presentation*, two in Bayerische Staatsgemäldesammlung, Munich, and one on Roman market, OC/Figs. 36, 141–2. One copy known of *Assumption* upright, Munich, OC/Fig. 38. Two copies known of *Death of the Virgin*: **1.** Sale, Christie's, 10 November 1967 (143). Copper, 26.5 × 40. OC/26, Pl. VI in colour, Fig. 66. **2.** Muzeul Brukenthal, Sibiu. Copper, 30 × 41. OC/under No. 70, Fig. 136.

Annunciation. Parish Church, Santa Giustina (Feltre). 220 × 160. S & D 1621 (on instigation of Le Clerc, who finished it after Saraceni's death a year earlier). Pallucchini, 1963, illus. colour, p. 179. OC/76, Fig. 109.

Death of the Virgin. One version known with Virgin's eyes open, and chorus of angels on clouds above: S. Maria della Scala, Rome. 459 × 273. OC/69, Fig. 120. One version known with Virgin's eyes open, against architecture: formerly Ampleforth Abbey, York; with Heim Gallery, London/Paris (1976). 304.8 × 231. S. OC/92, Fig. 83. One variant copy at Monserrat, OC/Fig. 149. Three versions known with Virgin's eyes closed, against architecture: **1.** Alte Pinakothek, Munich (1975/185, illus.). Copper, 46 × 27. OC/37, Fig. 84. **2.** Private Collection, Chicago (1964). Copper, 48.3 × 27.9. Nicolson,

1970, Fig. 49. **3.** Accademia, Venice (1970/194, illus.). Copper, 97 × 62. OC/82, Fig. 121. This last composition etched by Le Clerc, 46.8 × 28.2. S & D 1619. OC/Fig. 34. OC lists various copies under No. 69.

Madonna with St Anne. Galleria Nazionale d'Arte Antica, Rome. 180 × 155. OC/58, Figs. 75–7, 79. Spear, 1971, under No. 59, notes two copies.

Madonna with St Anne and Angel. Original or good workshop replica is: Muzeum Narodowe, Warsaw. 92.7 × 127. OC/under No. 129, Fig. 151. Two copies known in Galleria Pallavicini, Rome (OC/Fig. 152) and formerly Aldo Briganti Collection, Rome, small copper.

Madonna worshipped by St James of Compostella and Pilgrims. Lost fresco in S. Maria in Monserrato, Rome. Engraving of 1615 by Philippe Thomassin, illus. *Revue de l'Art*, 1971, No. 11, p. 107, Fig. 1.

Madonna di Loreto. Florentine Galleries. Small copper copy of Caravaggio in S. Agostino, Rome. Exh. Florence, 1970 (*hors catalogue*).

Community of the Blessed adoring the Holy Trinity. Metropolitan Museum of Art, New York (1973/1971.93, illus.). Copper, 53.4 × 45.8. Nicolson, 1970, Fig. 53 in colour.

St Benno restores the Keys to the City of Meissen; Martyrdom of St Lambert (two canvases). S. Maria dell'Anima, Rome. Each 239 × 178. 1617–18. OC/67–8, Figs. 95–8. *St Benno* engraved (?Le Clerc) in reverse.

St Charles Borromeo giving Communion to the Plague-stricken. Madonna dell'Addolorata (formerly dei Servi), Cesena. 296 × 195. OC/8, Pl. X in colour, Figs. 100–2.

St Charles Borromeo carrying the Holy Nail in Procession. S. Lorenzo in Lucina, Rome. 280 × 196. OC/66, Fig. 99. C in Cathedral, Catania.

Martyrdom of St Erasmus. Cathedral, Gaeta. 316 × 260. S. BP. OC/17, Fig. 85. One copy known: Janos Scholz Collection, New York. Pen, 20.8 × 14. *Burl. Mag.*, May 1967, Fig. 30.

St Eugene, see under *St Leocadia*.

Ecstasy of St Francis. Two versions known: **1.** Alte Pinakothek, Munich (1975/113, illus.). 244 × 167.5. S. 1620. OC/36, Fig. 105. **2.** Sacristy, Redentore, Venice. 181 × 115. 1620. OC/86, Figs. 106–8. OC/under No. 36 cites four copies (OC/105 being probably one of them).

St Francis. Lost. One copy known: Accademia dei Lincei, Rome. 132 × 98. OC/131, Fig. 140.

St Gregory the Great. Marquis of Exeter Collection, Burghley House, Stamford. 165.7 × 126.5. OC/7, Fig. 103.

St Ildefonso, see under *St Leocadia*.

Saints Jerome, Anthony, Magdalen and Francis. Bayerische Staatsgemäldesammlung, Munich (1908/1161; inv. No. 929). 340 × 234. S. 1619–20. ?With help of Le Clerc. OC/35, Fig. 104. Reduced copy in

Chapel at Schleissheim; another in Sale, Christie's, 8 May 1974 (148), illus. 49 × 33.

St Lambert, see under *St Benno*.

St Leocadia in prison; Investiture of St Ildefonso with the Chasuble; Martyrdom of St Eugene (three canvases) [Plates 21, 22]. Cathedral, Toledo. All originally 169 × 137 but enlarged. 1613–14. B P. Exh. Seville, 1973 (31–3), illus.

Penitent Magdalen. Two versions known: **I.** Accademia, Venice (1970/195, illus.) 99 × 74. O C/81, Fig. 94. **2.** Museo Civico, Vicenza (1962/A205, illus.). 100 × 80. ?1614. ?C. O C/under No. 81, Fig. 153.

Preaching of St Raymund. S S. Annunziata a Piazza Buenos Aires, Convento dei Mercedari (formerly S. Adriano), Rome. 300 × 210. O C/63, Fig. 88. Engraving by Johann Friedrich Greuter, 1614. Drawing after was: Instituto Jovellanos, Gijon (Spain), pen and sepia wash, 21 × 14.

St Roch. Museo di Capodimonte, Naples. 180 × 121. O C/46, Fig. 73. Longhi, 1943, note 41, lists replica in Principe Giovannelli Collection, Rome (O C/110). C on Lucca art market (1975), large scale. As with Glasgow *St Sebastian*, transformed into *Landscape with St Roch* in: Private Collection, Gothenburg. Copper, 17 × 21. B P. Cavina, 1976, Fig. 36.

St Roch with Angel. Galleria Doria-Pamphilj, Rome (1942/261). 190 × 125. O C/56. Pl. VIII in colour, Figs. 74, 78, 80. Excellent full-scale replica at Château de Beloeil, near Brussels.

Burial of St Stephen [Plate 23]. Formerly Duke of Northumberland Collection, Alnwick Castle. U.

St John the Baptist; St Matthew and Angel; Unidentified Saint. S. Maria in Vallicella, Rome. Oils on wall. B P. Salerno, 1971, Pl. 4 (*St Matthew*).

Portrait of Cardinal Capocci. Longhi Collection, Florence. 69.3 × 54.4. ?1613. Longhi Catalogue, 1971, Pl. 61 in colour. O C/13, Fig. 81.

Shipwreck Scene. Villa Camerini (ex-Contarini),

Piazzola sul Brenta (Padua). 255 × 430. 1619–20. O C/48, Fig. 126.

The following is by an imitator, perhaps Italian, of Saraceni; it could reflect a lost work:

St Gregory the Great. Galleria Nazionale d'Arte Antica, Rome. 102 × 73. O C/59. Fig. 89.

The following is a selection of recent wrong attributions to Saraceni. For a more complete list see O C, pp. 137–9.

★Eberhard Keyl **Head of Seneca.** Galleria Spada, Rome (1954/114, illus.). Ivanoff, *Arte Veneta*, 1964, note 4.

★Follower of Elsheimer **Susanna and the Elders.** Detroit Institute of Arts, O C/134. Richardson, 1942, Fig. 5.

?Guy François **Holy Family with Infant St John.** Musée des Beaux-Arts, Brest.

Galli **St Anthony and the Christ Child.** S S. Cosma e Damiano, Rome.

?Guy François **St Cecilia and the Angel.** Galleria Nazionale d'Arte Antica, Rome. O C/57, Figs. 44, 47, 49.

Circle of Bigot **St Francis in Meditation.** Modena, Rovigo, Munich, Dijon etc. O C/137; *Revue de l'Art*, 1971, p. 107.

Copies of ?Caravaggio **St John the Baptist.** Louvre, Geneva. O C/140.

★Variants of Caravaggio **Conversion of the Magdalen** (Detroit) by two artists reflecting style of Saraceni. Nantes; Rizzoli Collection; O C/102.

Le Clerc **Denial of St Peter.** Galleria Corsini, Florence; F in Stuttgart and Venice. O C/15, 79.

Magnone **Luteplayer,** copying Leningrad Caravaggio. Ex-Barberini Collection, Rome.

De Coster **Two Men with Statuettes.** Statens Museum for Kunst, Copenhagen.

★Anon. **'Lo Spinario'.** Formerly B. Nicolson Collection, London; Roman art market in 1960's. 64 × 36. O C/136.

SARBURG or SARBURGH, Bartholomäus (*c.* 1590–?)

Born in Trier. ?Trained at The Hague. By 1620 in Berne where he remains for three years. Back there in 1628. 1631 in Cologne; 1632 in The Hague again. Chiefly known as portrait painter and copyist after Holbein, but one near-Caravaggesque genre scene identified, listed below.

Boy Fluteplayer [Plate 242]. Paul Wallraf Collection, London. Panel, 67 × 51. S & D 1630.

SCHEDONI, Bartolomeo (Jan. 1578–1615)

Modenese. In Rome in early youth; Parma at turn of century. 1602–6, Modena. Spends much of his mature life in the service of the Farnese at Parma (1607 to his death). Only one picture remotely Caravaggesque, listed below.

Tobias and the Angel. Corsham Court (Wilts.), Lord Methuen Collection (1939/15, illus.). 95.2 × 129.5. Exh. R A, 1939 (293), illus., as ascribed to Caravaggio, perhaps Neapolitan. Moir, 1976, Fig. 50.

SEGHERS, Gerard (1591–1651)

Antwerp School. Master of the Guild there, 1608. Still resident in Antwerp in 1611 but there is a gap in the records between then and 1620, during which period he is assumed to travel to Italy and Spain. He is thought to have encountered in Milan or (more likely) Rome Cardinal Zapata, who encouraged him to visit Spain where he is said to be in the service of the King; nevertheless no pictures by him have been traced in Spain which can be shown to have been there in the seventeenth century. Cited in Antwerp documents from autumn 1620 continuously until his death except for a brief period 1624–6. Influenced in Rome and again back in Antwerp (1620–7) by Honthorst, but after 1627 he abandons the Caravaggesque style in favour of the current Rubensian language. With very few exceptions, only pre-1628 pictures listed. N followed by stroke and Fig. number refers to Nicolson, 1971; RP followed by stroke and Fig. number refers to Roggen/Pauwels, 1955–6.

Hercules and Omphale [Plate 85]. Staderini Collection, Rome. 167 × 235. Bodart, 1973, Pls. 3–4.

Emperor Tiberius. Jagdschloss Grunewald, Berlin. 68 × 53. D 1625.

David and the sleeping Saul [Plate 83]. Formerly Alfred Bader Collection, Milwaukee. 127 × 106.7. U. Exh. Milwaukee Art Center, 1976 (43), illus.

Judith with the Head of Holofernes. Galleria Nazionale d'Arte Antica, Rome. 100 × 135. Bodart, 1973, Pls. 1–2.

Christ and Nicodemus. Lost. Engraving by Pieter de Jode II. RP/Fig. 13.

Capture of Christ, with Kiss of Judas. D. Manuel González Collection, Madrid. 154 × 239. Nicolson, Minneapolis, 1974, Fig. 4.

Christ at the Column. St Michael's, Ghent. 268 × 144. RP/Fig. 17. Engraving by Vorstermann after Seghers, Von Schneider, 1933, Pl. 47b. Variant in same direction as engraving: Sale, Christie's, 23 March 1973 (20), illus. Panel, 74.9 × 57.2. ?C. Drawing in Musée Fabre, Montpellier, RP/Fig. 18.

Madonna appearing to St Francis Xavier. Museo Nazionale, Palermo. RP/Fig. 16. F. Engraving by Schelte a Bolswert, RP/Fig. 15.

St Cecilia (five figures) [Plate 82]. Formerly with Julius Weitzner, New York. 96.5 × 137.2. Exh. Sarasota, 1960 (13), illus.

St Cecilia (four figures). With Xavier Scheidwimmer, Munich (1961). 121.9 × 152.4. Ad. *Weltkunst*, 10 December 1961, illus. Engraving in same direction by M. Lauwers. 31.6 × 36.9. Mirimonde, 1965, Fig. 25. One copy known: Museo Civico, Vicenza (1940/294). Copper, 40 × 51. R. Mirimonde, 1965, Fig. 24.

St Jerome. Saint-Leu-Saint-Gilles, Paris. 90 × 121. ?C. Pariset, 1948, Pl. 31 (1). One copy known: Museum, Honfleur (from Chapel of Notre-Dame-de-Grâce). 91.4 × 129.9. N/Fig. 17.

Penitent Magdalen. Sale, Fischer, Lucerne, 21–5 and 27 June 1960 (2055), illus. as La Tour. 96 × 82. ?C.

Penitent Magdalen. Lost. Engraving by J. B. Massard (1772–1810/12) after Seghers, RP/Fig. 4.

Denial of St Peter (eight figures). Earl of Mansfield Collection, Scone Palace, Perth. 153 × 203. Bears false signature. N/Fig. 11. Engraving in reverse by Schelte a Bolswert, 35 × 47, RP/Fig. 8. The best other version (?with collaboration of Seghers) is: North Carolina Museum of Art, Raleigh (NC). 185.4 × 256.5. Spear, 1971 (61), illus. colour. Ten copies cited under Spear, 1971 (61), and Nicolson, 1971, to which add (all after the engraving): **1.** with O. Poggi, Rome (1973). **2.** National Museum, Valletta (Malta). **3.** A. Battesti Collection, Toulouse (three figures only).

Denial of St Peter (eight figures). What may have been a lost original appears on floor in Mauritshuis *Studio of Apelles* (N/Fig. 14). One copy known: Dr Z. Procházka Collection, Berlin (1971). Gouache on paper, 46 × 54.5.

Denial of St Peter (four figures). With Gilberto Algranti, Milan (1970). 25 × 163. N/Fig. 12. One copy known: Private Collection, Courtrai (1950); Roggen, 1950, p. 256. illus.

Denial of St Peter (four figures). Musée des Beaux-Arts, Tours (1975 *Guide*, Fig. 18). 119 × 161.5. N/Fig. 15.

Denial of St Peter (four figures). Hermitage, Leningrad. 122.5 × 160.5. Exh. Leningrad, 1973 (53). Linnik, 1975, illus. colour Pl. 164.

Denial of St Peter (three figures). Lost. One copy known (in same direction as Haarlem drawing, reversed from engraving by de Paullis, see below): with Agnew's, 1921, as Elsheimer. 21.6 × 16.5. Engraving (in same direction as lost painting) by Andrea de Paullis. 24.5 × 23, RP/Fig. 6. Drawing made for engraving (? by de Paullis): Teyler Museum, Haarlem. Chalk and Indian ink, 24.3 × 23.2. RP/Fig. 5.

The following compositions of the *Denial* are only known in copies or adaptations of Seghers:

Denial of St Peter (four figures). Six copies known: **1.** Sale, Hôtel Rameau, Versailles, 27 January 1968, as La Tour. **2.** Private Collection, Biarritz (1948). 109 × 152. Pariset, 1948, Pl. 44 (3). **3.** Saint-Rémi, Dieppe. **4.** Donovan Cobb Collection, Margate. N/Fig. 16. **5.** Musée des Beaux-Arts, Bordeaux. 105 × 160. **6.**

Orth Sale, Heilbron, Berlin, November 1912 (584) as after Honthorst. 92 × 96. F (left three figures only).

Denial of St Peter (four figures). Two copies known: **1.** with Wildenstein, New York (1947). 91 × 117. Pariset, 1948, Pl. 44 (5). **2.** Sale Hôtel Drouot, Paris, 26 February 1934. 86 × 123. N/Fig. 19.

Denial of St Peter (three figures). Mrs J. Maxwell Murphy Collection, Milwaukee. 103.5 × 81.9. R.

Ecstasy of St Teresa. Koninklijk Museum voor Schone Kunsten, Antwerp (1958/509). 264 × 195. Von Schneider, 1933, Pl. 40a.

Drinking and Smoking Party. Regional Art Museum, Irkutsk (USSR). 145 × 202. False Schalcken signature, transformed from Seghers's. Exh. Leningrad, 1973 (52). Linnik, 1975, illus. colour Pls. 161–3. Engraving by Lauwers, RP/Fig. 11.

The following is a wrong attribution to Seghers:

Honthorst **Magdalen.** Hermitage, Leningrad.

SELLITTO, Carlo (July 1580–Oct. 1614)

Even precedes Caracciolo as the first Neapolitan Caravaggesque painter. Works in studio of the Fleming Loise Croys (or Cruis or Crois), *c.* 1591, where also work Filippo d'Angelo (Filippo Napolitano) and the Metz mannerist François Nomé ('Monsù Desiderio'). Already active as an independent artist, 1607. Influenced by Guido Reni. Recorded as portraitist, still life and landscape painter, but no paintings of this character identified. More pictures about which I have no precise information have recently turned up in Sardinia. All works known to me are here listed except for a Mannerist *Madonna* at Alieno (Matera). P followed by stroke and Fig. number refers to Prohaska, 1975. S followed by catalogue and Pl. numbers refers to Sellitto exh., 1977.

Bacchus. Private Collection, Valletta (Malta). ?C of lost work. R. U. Prohaska, 1978, Fig. 97. One copy known: Städelsches Kunstinstitut, Frankfurt-am-Main. 95 × 125. BP. U. Berne-Joffroy, 1959, Pl. LXXIV, S/5 (Pl. XXIII).

David with the Head of Goliath [Plate 28]. National Gallery, Salisbury (Rhodesia). 127.6 × 92.7. U. Exh. Agnew's, 1954 (17) illus. S/6 (Pl. XXIV).

Adoration of the Shepherds. S. Maria del Popolo agli Incurabili, Naples. 258 × 175.6. R. P/Fig. 7. S/3 (Pls. XVI–XVIII).

Christ handing over the Keys to St Peter; St Peter saved from the Waters (two canvases). S. Maria di Monteoliveto (from S. Anna dei Lombardi, Naples). Each 234 × 180. After 1607. P/Figs. 2, 3. S/1, 1a (Pls. I–XI).

Christ washing the Disciples' Feet. Private Collection, Naples. Prohaska, 1978, Fig. 92.

Crucifixion. S. Maria di Portanova, Naples. 255 × 175. BP. Landscape? by another hand (doubtfully Filippo Napolitano). 1613–14. P/Fig. 6. S/9 (Pls. XXXII–XXXIX).

St Anthony of Padua. Tempio dell'Incoronata Madre del Buon Consiglio a Capodimonte, Naples. Unfinished in 1614. 229 × 140. S/10 (Pls. XL–XLI).

Vision of Santa Candida. S. Angelo a Nilo, Naples. 263 × 126. S/8 (Pls. XXVI–XXXI).

St Cecilia and Angels. Museo di Capodimonte, Naples. 245 × 184. 1613. D'Argaville, 1972, Fig. 96. S/4 (Pls. XIX–XXII).

St Charles Borromeo. S. Maria delle Grazie a Caponapoli (deposited at Museo di Capodimonte), Naples. 320 × 200. After Nov. 1610. P/Fig. 4. S/2 (Pls. XII–XV).

St Lucy. Museo Nazionale, Messina. 75 × 100. U. S/7 (Pl. XXV).

The following are thoroughly dubious attributions to Sellitto:

Mystic Marriage of St Catherine. Museo Campano, Capua. 250 × 200. P/Fig. 10. S/21 (Pl. XLVI).

*****?Neapolitan School **St Januarius.** Mr and Mrs Morton B. Harris Collection, New York. 126.3 × 92.4. Exh. Cleveland 1971–2 (26), illus. S/22 (Pl. XLIV).

St Mary of Egypt. Private Collection, Naples. Stoughton, 1977, Figs. 1–2 (circle of Sellitto).

The following is a selection of wrong attributions to Sellitto:

Caracciolo **St Charles Borromeo.** S. Maria dell' Incoronata a Capodimonte, Naples.

*****?Tuscan around Dandini **Love of Virtue.** Museum of Western Art, Riga. 93.5 × 71. S/16 (Pl. XVIII).

*****Copy after Lanfranco **Magdalen borne aloft by Angels.** Museo del Prado, Madrid (No. 563). 66 × 49. S/14.

Vitale **Magdalen.** Museo di Capodimonte, Naples (No. 292).

*****Neapolitan School **St Mary of Egypt.** Museo di Capodimonte, Naples (No. 461). 51 × 79. P/Fig. 8. S/13.

*****Azzolino **S. Paolino redeeming a Slave.** Pio Monte della Misericordia, Naples. 306 × 210. 1626. P/Fig. 11. S/11 (Pl. XLII).

*****Circle of Vitale **Martyrdom of St Sebastian.** S. Maria di Monteoliveto, Naples (sacristy). 180 × 128. S/15 (Pl. XLVIII).

SERODINE, Giovanni (1600–Dec. 1630)

Born in Ascona, but spends his active working life in Rome, where he dies. Sculptor as well as painter. In his youth, deeply indebted to Caravaggio and Borgianni, but later develops a markedly individual style. Possible contact with Terbrugghen in the early 1620's. All works listed. L followed by stroke and number refers to Longhi, *Serodine*, 1955 catalogue numbers, pp. 27–57.

Allegorical Figure (?Liberal Arts). Ambrosiana, Milan (1969, p. 202). 89 × 124. L/10 (Fig. 26).

Archimedes. Musée Départemental de l'Oise, Beauvais. 103 × 73. UU. Cammas-Laclotte, 1964, Fig. 1.

Aristarchus of Samos. Gemäldegalerie, Dresden (1975, p. 53, as Fetti). 38 × 28. Askew, 1965, Pl. 1.

Tribute Money. National Gallery of Scotland, Edinburgh (1970/1513). 145 × 227. BP. Pendant to *Meeting of St Peter and St Paul* (q.v.). L/7 (Fig. 22).

Calling of the Children of Zebedee. Parish Church, Ascona. 210 × 146 (cut at top). 1623. Companion to *Invitation to Journey to Emmaus* (q.v.). L/1 (Figs. 1–4).

Invitation to Journey to Emmaus. Parish Church, Ascona. 228 × 147. Fragmentarily S. 1623. Companion to *Calling of the Children of Zebedee* (q.v.). L/2 (Fig. 5).

Coronation of the Virgin, with Cloth of St Veronica and Saints below. Parish Church, Ascona. 400 × 272. L/6 (Figs. 11–21).

Holy Family. Private Collection, Ascona. 71 × 65. L/9 (Figs. 24–5).

St Jerome. Museo Civico, Turin (1970, p. 11). 67 × 50. Volpe, 1972, Pls. 22 and II in colour.

St John the Evangelist. Galleria Sabauda, Turin. 105 × 136. L/14 (Fig. 33).

St Lawrence distributing Alms. Abbazia, Casamari. 303 × 171. S. Pendant to *Arrest of St Lawrence* (q.v.). L/3 (Figs. 6–8). Engraved by Prestel, *c.* 1760–6 (illus. Papini, 1923, p. 125) and by Abbé de Saint-Non, 1771, after Fragonard drawing, both as after Guercino. Two copies known: **1.** Musée Calvet, Avignon. 97 × 61. **2.** Schloss Weissenstein, Pommersfelden. 68 × 58. For further details, see Moir, 1967, p. 141, note 34.

Arrest of St Lawrence. Museo di Palazzo Venezia, Rome. 298 × 168. R. Pendant to *St Lawrence distributing Alms* (q.v.). L/4 (Fig. 9). One copy known: Musée Calvet, Avignon. 97 × 61.

St Margaret raising a Child from the Dead. Museo del Prado, Madrid (1972/246). 141 × 104. BP. L/12 (Figs. 30–1).

Meeting of St Peter and St Paul [Plate 47: detail]. Galleria Nazionale d'Arte Antica, Rome (from Palazzo Mattei). 144 × 220. R. Pendant to *Tribute Money* (q.v.). L/8 (Fig. 23).

St Peter in Prison. Giovanni Züst Collection, Rancate. 90 × 127. L/11 (Fig. 27–9). Two drawings known: **1.** Wiesner Collection, St Gall (?18th century) (1944); **2.** Whereabouts unknown (probably 17th century).

Father of the Church (?) writing. Galleria Estense, Modena (1948/481, illus.). 82 × 141. F. BP. L/13 (Fig. 32). Full-length version (?C): Certosa, Pavia. BP.

Portrait of the Artist's Father Cristoforo. Museo Civico, Lugano. 152 × 98. 1628. L/5 (Fig. 10).

Five Heads [Plate 46]. Vassar College Art Gallery, Poughkeepsie (New York) (1967/66.25). 64.8 × 81. U.

The following is a selection of wrong attributions to Serodine:

Caravaggesque unknown (North Italian) **Supper at Emmaus.** Kunsthistorisches Museum, Vienna.

Terbrugghen **Pilate washing his Hands.** Schloss Wilhelmshöhe, Cassel.

Terbrugghen **Beheading of St Catherine.** Chrysler Museum, Norfolk (Virginia).

Circle of Bigot **St Jerome contemplating a Skull.** Bob Jones University, Greenville (SC).

SPADA, Lionello (1576–1622)

Bolognese. Documented in Emilia (although not continuously) from 1603 to 1607, suggesting that the affirmation of the first historians of early contact with Caravaggio is at fault. Though his movements are not known before 1603, it seems quite unlikely that he is in Rome then. This is confirmed by his style from 1603 onwards, which is more Emilian than Roman, more Ludovico- than Annibale-like, with occasional echoes of Baglione about 1608. Moves south not before 1608. In Malta around 1610, executing frescoes in the Palace of the Grand Masters, still Carraccesque. Also in Rome at the turn of the first-second decade when the Emilian style is modified in a Caravaggesque direction (the only pictures here listed, *c.* 1611 to at latest 1616). Back in Emilia *c.* 1612, where he carries on a near-Caravaggesque style. Executes frescoes in Reggio 1614–16 which are quite un-Caravaggesque. Settles at the Farnese Court at Parma until his death there. F followed by stroke and plate number refers to Frisoni, 1975.

Aeneas and Anchises. Musée du Louvre, Paris (1926/1537). 194 × 133. F/Pl. 57.

Cain and Abel. Museo di Capodimonte, Naples. 118 × 165. U. F/Pl. 52a.

David with the Head of Goliath. Gemäldegalerie, Dresden (1930/334). 73.5 × 99.5. F/Pl. 53.

Prodigal Son. Musée du Louvre, Paris. 160 × 119. F/Pl. 56b.

Crowning with Thorns. Musée Condé, Chantilly (1899/72). Panel, 205 × 134. F/Pl. 54.

Christ at the Column. Private Collection, Catanzaro. F/Pl. 56a.

Christ at the Column. Gemäldegalerie, Dresden (1896/333). 68.5 × 54. F/Pl. 52b.

Way to Calvary. Galleria Nazionale, Parma. 125 × 170. F/Pl. 55.

Miracle of the Fire: St Dominic burning the Heretical Books. S. Domenico, Bologna. Before Nov. 1614–Aug. 1616. F/details, Pl. 58.

Salome with the Head of the Baptist (seven figures). With Il Fiorino, Florence (1966), as Paolini. 114 × 162. U. One copy known: Sale, Christie's, 9 April 1965 (17), as Gramatica.

Concert (seven figures). Galleria Borghese, Rome. 138 × 177. Della Pergola, 1955, No. 122, illus.

Concert (four figures). Musée du Louvre, Paris. 141.9 × 173. Spear, 1971 (63), illus. Engraved as Domenichino by Picard, Chauveau, Morel, and Lerouge and Géraut. Small copy (25.1 × 32.1) by H. Poterlet, Oct. 1818, deposited at Château Saint-Germain from Louvre.

SPADARINO see GALLI

STOMER, Matthias (*c*. 1600–?*c*. 1650)

Said to have come from Amersfoort, but a strong South Netherlandish streak (A. Janssens, Van Dyck, Rubens, Jordaens) indicates contact with Antwerp. Usually described in sources as 'Stom'. Recorded in Rome 1630–2. Remains some years in Naples before moving to Sicily, where he is known to be in 1641 and where he appears to remain until his death, active in Messina and Palermo. Strongly affected by Honthorst and Baburen and slightly by Neapolitan painters of the 1630's. All works listed, except for a few which cannot be traced. P followed by stroke and Fig. number refers to Pauwels, 1953. N followed by stroke and Fig. number refers to Nicolson, 1977.

The Taunting of Ceres. Alte Pinakothek, Munich (1967/112, illus.). 176 × 221. Pigler, 1974, Pl. 187.

The Taunting of Ceres. Dr Rag. Giuseppe Bacchetta Collection, Cassano d'Adda (1973).

Prometheus. Private Collection, Rome (1974). N/Fig. 16.

Satyr with Peasant Family (five figures) [Plate 171]. With Heim-Gairac, Paris (1974). 66 × 88. Ad. *Burl. Mag.*, November 1974, p. CXLII, illus.

Satyr with Peasant Family (four figures). With Brian Sewell, London. 118.1 × 136. N/Fig. 4.

Roman Charity [Plate 167]. Szépművészeti Múzeum, Budapest (1967/369). 158 × 141. U. Two variants not by Stomer known, with semi-effaced inscription on wall: **1.** Museo del Prado, Madrid (1975 Flemish cat./127, as Anon. Flemish, illus.). 198 × 141. Exh. Seville, 1973 (59), illus. as Caravaggesque unknown. **2.** Hampton Court Palace, as Caravaggio (1929, No. 713, p. 164). One copy after Prado variant known: D. Eusebio Vasco Gallego de Valdepeñas Collection.

Roman Charity. Possible lost original, from which derives: Villa Albani, Rome, as Giordano. Longhi, S.R., 1967, Fig. 72b.

Death of Brutus (?) [Plate 166]. With Richard L.

Feigen, New York (1973). 131 × 212. Ad. *Burl. Mag.*, April 1975, p. XLVIII, illus. N/Fig. 13, detail.

Death of Cato. Pinacoteca, Cento (Ferrara). 106.5 × 136.

Death of Cato. National Museum, Valletta (Malta). 145.4 × 193. P/Fig. 13.

Death of Cato [Plate 165]. Museo dei Benedettini, Catania. 207 × 305. Exh. 'I Fiamminghi e l'Italia', Bruges, Venice, Rome, 1951 (76), illus.

Mucius Scaevola before Porsenna [Plate 163]. Art Gallery of New South Wales, Sydney (NSW). 152.4 × 205.7. Pendant to Houston *Judgement of Solomon* (q.v.). Ad. *Burl. Mag.*, April 1969, illus. New South Wales Picture Book, 1972, illus. colour.

Mucius Scaevola before Porsenna. Museo Nazionale, Messina. *c*. 208 × 260. BP. ?SA.

Death of Seneca. Museo dei Benedettini, Catania. Bottari, 1949, Fig. 20.

Death of Seneca. Museo di Capodimonte, Naples. 161 × 323. BP. N/Fig. 12.

Death of Seneca. Sale, Ernst-Museum, Budapest, 21 Feb. 1921 (247), illus. as Honthorst. 44.5 × 71.

Adam and Eve finding the Body of Abel. National Museum, Valletta (Malta). 147.9 × 205.7. P/Fig. 12.

Sarah brings Hagar to Abraham. Konstmuseum, Gothenburg. 82.5 × 100.4. False Honthorst signature now cleaned off. Bauch, 1956, Fig. 4, as on Swiss art market.

Sarah bringing Hagar to Abraham. Staatliche Museen, Berlin-East. P/Fig. 8.

Lot's Flight from Sodom. Bob Jones University, Collection of Sacred Art, Greenville (SC) (1962/169, illus.). 158.7 × 128. P/Fig. 9.

Esau selling his Birthright. Hermitage, Leningrad (1957/423, illus.). 118 × 164. Linnik, 1975, illus. colour Pls. 146-8.

Esau selling his Birthright. Staatliche Museen, Berlin-East (Kaiser-Friedrich 1931/434). 132 × 166. Von Schneider, 1933, Pl. 49a (reversed). Engraved by J. Falck as after Honthorst (Hollstein, 1949ff., IX, p. 111, No. 12).

Esau selling his Birthright. With Gilberto Algranti, Milan (1974). R.

Isaac blessing Jacob in the Presence of Rebecca. Lost. One copy known: Musée du Louvre, Paris. 95 × 132.

Samson and the Philistines [Plate 169]. Galleria Sabauda, Turin. 211 × 272. 2nd Exh. Gall. Sabauda, Palazzo Madama, 1956-7, Pl. 33. One copy known: Museo dei Benedettini, Catania (as *Death of Seneca*).

Samson and Delilah. Galleria Nazionale d'Arte Antica, Rome. 99 × 125. *Bollettino d'Arte*, 1962, p. 365, illus.

David with the Head of Goliath. With Trafalgar Galleries, London (1976). 110.5 × 79.3. Bears false Terbrugghen monogram. Exh. Trafalgar Galleries, 1968 (11), illus. colour.

King David with his Harp. Musée des Beaux-Arts, Marseille. 96 × 115. P/Fig. 20.

Judgement of Solomon [Plate 164]. Museum of Fine Arts, Houston (Texas). 152.4 × 205.7. Pendant to Sydney *Mucius Scaevola* (q.v.). Ad. *Burl. Mag.*, April 1969, illus.

Elijah throws down his Mantle to the Prophet Elisha. Musée de l'Université Laval, Quebec. 160 × 129.5.

Scene of Judgment (? from Old Testament). S. Maria Assunta, Soncino (between Bergamo and Cremona). N/Fig. 17.

Tobias and the Angel. Bredius Museum, The Hague (1978/161, illus.). 111 × 125. S. P/Fig. 1.

Tobias healing his Father. Four versions known: **1.** Longhi Collection, Florence. 155 × 207. Longhi cat. 1971, Pl. 74 in colour. **2.** Museo dei Benedettini, Catania. 153 × 200. ?C. Fokker, 1929, Fig. IV. **3.** Bartolini Collection, Florence. 118 × 173. Bodart, 1976, Fig. 60. **4.** Formerly Standish Collection. Exh. Spanish Art, Hôtel Charpentier, Paris, 1925 (20), illus. as School of Seville.

Tobias healing his Father. Barone Scotti Collection, Bergamo. P/Fig. 2.

Tobias healing his Father. Rospigliosi Sale, Rome, 12-24 Dec. 1932 (375), as Stomer, illus. 156 × 213.

Adoration of the Shepherds (more than nine figures). Palazzo del Municipio, Monreale. 224 × 294.5. After 1641. Palermo, 1975, Pls. CII-CV, which records autograph replica in Chiesa dei Cappuccini, Palermo, and a copy in the Palazzo at Monreale.

Adoration of the Shepherds (seven figures). With David Koetser, Zurich (1968). 95.2 × 123.2. Kaplan Sale, Sotheby's, 12 June 1968 (92), illus.

Adoration of the Shepherds (seven figures). Museo Provinciale del Sannio, Benevento (on deposit from Capodimonte, Naples). 125 × 182. N/Fig. 2. Two copies known: **1.** Monastery, Monserrat. 127 × 180. Valdivieso, 1973, Fig. 6. **2.** Sale, The Hague (Van Marle and Bignall), 20 Dec. 1950 (72), as Honthorst. 125 × 180.

Adoration of the Shepherds (six figures). Liechtenstein Collection, Vaduz (1931/110, as Honthorst). 117 × 166. Krönig, 1968, Pl. 3.

Adoration of the Shepherds (six figures with sheep). Museo di Capodimonte, Naples (transferred 1953 to Museo Civico 'Gaetano Filangieri'). 127 × 178. Voss, 1908, p. 988, illus.

Adoration of the Shepherds (six figures). North Carolina Museum of Art, Raleigh (NC) (1956/69, illus.). 111.8 × 160.

Adoration of the Shepherds (six figures). Museo Civico, Turin (1963, illus). 135 × 165.

Adoration of the Shepherds (six figures with ram). Formerly Mrs Catherine O'Neill, Hull (province of Quebec), as Ribera; sale, Christie's, 27 Nov. 1970 (46), illus. 120.6 × 144.8. BP. C.

Adoration of the Shepherds (six figures with chicken). City Art Gallery, Leeds (1976/9/67). 124.5 × 175.3. *Leeds Art Calendar*, No. 61, 1968, p. 10, illus. *Leeds City Art Gallery* booklet, 1977, Pl. 1 in colour.

Adoration of the Shepherds (five figures, one angel). Casadei Collection, Rome. Exh. Rome, 1973 (73). 130 × 178. Bodart, 1976, Fig. 58.

Adoration of the Shepherds (five figures). Musée des Beaux-Arts, Nantes (1953/529, as Honthorst). 146 × 114. Benoist, 1961, illus. as Honthorst.

See also under *Holy Family* below for Stomer at Saratov.

Adoration of the Magi (ten figures). Nationalmuseum, Stockholm (1958/1792). 175 × 172. N/Fig. 1.

Adoration of the Magi (eight figures). Musée des Augustins, Toulouse. 229 × 180. Exh. Paris, 1970-1 (204), illus.

Adoration of the Magi (seven figures). With Brian Sewell, London. 147.3 × 182.9. F. Whole composition before cutting, Von Schneider, 1923-4, p. 226, illus.; as now: Sale, Christie's, 26 Nov. 1965 (108), illus.

Adoration of the Magi (seven figures). Musée des

Beaux-Arts, Rouen (1966, p. 235). Original measurements, 96 × 136. Exh. Paris, 1970–1 (206), illus.

Christ among the Doctors. Bayerische Staatsgemäldesammlung, Munich (1967/1796, illus.). 201.7 × 148.4. Exh. Metropolitan Museum, New York; Toledo; Toronto, 1954–5 (79), illus. One copy known: Sale, Bonham's, London, 15 Dec. 1977 (30). 198 × 147.5.

Christ and Nicodemus. Formerly with Sestieri, Rome. 127 × 177.

Christ and Nicodemus. Cathedral, Dax (Les Landes), as Honthorst. N/Fig. 14.

Christ and Nicodemus. Hessisches Landesmuseum, Darmstadt (1914/281 as Honthorst). 130 × 180. Von Schneider, 1933, Pl. 49b.

Christ and the Samaritan Woman. With David Koetser, Zurich (1975). 157.5 × 121.9.

Good Samaritan (?). National Museum, Valletta (Malta). 146 × 180.3. P/Fig.11.

Miracle of the Money. Palazzo Francavilla, Palermo. 222 × 302. Pendant to *Martyrdom of St Stephen* (q.v.). Fokker, 1929, Fig. 11.

Christ and Adulteress. With Gilberto Algranti, Milan (1971; cat. illus. colour). 124 × 174. *Burl. Mag.*, July 1971, Fig. 94.

Christ driving out the Money Changers. Art Collectors' Association Ltd., London (1920). UU.

Last Supper. Pavoncelli Collection, Rome (1953). P/Fig. 5.

Agony in the Garden. Museum Dahlem, Berlin (1975/2/69, illus.). 152.4 × 201.9. Pendant to Ottawa *Capture of Christ* (q.v.).

Capture of Christ. National Gallery of Canada, Ottawa (1957/4094, illus. as Honthorst). 154.9 × 206.3. Pendant to Berlin *Agony in the Garden* (q.v.). Spear, 1971 (64), illus.

Capture of Christ, with Malchus episode. National Gallery of Ireland, Dublin (1971/425). 201 × 279. *Emporium*, March 1954, p. 127, illus.

Capture of Christ. Two versions known: **1.** Museo di Capodimonte, Naples. 152 × 206. BP. Probably C. Voss, 1908, p. 991, illus. **2.** With Gilberto Algranti, Milan (1970); Sale, Finarte, Milan, 16 Dec. 1971 (37), illus. 145 × 197. Exh. Algranti, Milan, 1970, illus. colour.

Capture of Christ. Private Collection, Milan (1952). R[oberto] L[onghi], 1952, Pl. 27, detail ?Preparatory study for this: Gabinetto dei Disegni, Galleria degli Uffizi, Florence. Pen and wash, 41.2 × 31.6. Longhi, 1943, Pl. 81.

Christ before Pilate. Private Collection, Oxford. 152.4 × 203.2. Spear, 1971, Fig. 41.

Pilate washing his Hands. Musée du Louvre, Paris (No. 2408). 153 × 205. Exh., Paris, 1970–1 (205), illus. Engraved in Musée Napoléon (Landon, XIV, 1807, p. 119) as Honthorst.

Christ before Caiaphas. Art Collectors' Association

Ltd., London (1920), as Honthorst. Nicolson, 1974, p. 615, Fig. 77.

Mocking of Christ and Crowning with Thorns. With Matthiesen Fine Art Ltd, London (1978). 129.5 × 183. *Burl. Mag.* Supplement, June 1978, Pl. XIX.

Mocking of Christ. Museo dei Benedettini, Catania. Bottari, 1949, Fig. 21. One copy known: Palazzo del Municipio, Monreale.

Mocking of Christ. Museum, Hôpital Saint-Jean, Brussels. 115 × 159. Von Schneider, 1933, Pl. 48.

Mocking of Christ. Marchese Giuseppe Persichetti-Ugolini de Giudici Collection, Rome (1947). 128 × 182. Fokker, 1947, illus.

Mocking of Christ [Plate 168]. Private Collection, Madrid (1977). *c.* 200 × 165.

Mocking of Christ. With Richard Feigen, New York (1977). 109.2 × 160.3. N/Fig. 3.

Crowning with Thorns. With C. Benedict, Paris (1938). 60 × 51.

Christ shown to the People. Rijksmuseum, Amsterdam. 137.7. × 115.5. N/Fig. 10.

Christ at the Column. Rhode Island School of Design, Province (RI). 182.9 × 114.4. Spear, 1971 (65), illus.

Flagellation. Oratorio del Rosario, Palermo. Longhi, 1954, Pl. 14, detail (reversed). Fokker, 1929, Pl. VI.

Christ carrying the Cross. Private Collection, Budapest (1933), Von Schneider, 1933, Pl. 37b.

Christ at Emmaus (Christ on right, oil lamp, blessing). Museo di Capodimonte, Naples. 157 × 202. Fokker, 1929, Pl. IX.

Christ at Emmaus (Christ on right, blessing, dog jumping). Two versions known: **1.** Kunsthistorisches Seminar, Göttingen. ?C. P/Fig. 4. **2.** Formerly Private Collection, Randazzo (Province of Catania). F of right hand side only. Bottari, 1965, Pl. 23c.

Christ at Emmaus (Christ on right, candle, bread broken). Schloss Rohoncz Foundation, Lugano-Castagnola (1977/289a). 110 × 150. S. Pariset, 1953, Fig. 1.

Christ at Emmaus (Christ on right, candle, bread broken, dog jumping). Musée de Peinture et de Sculpture, Grenoble (exh. Paris, 1935/56 as Honthorst). 130 × 164. Pariset, 1953, Fig. 2.

Christ at Emmaus (Christ on right, candle). Schloss Weissenstein, Pommersfelden. 119 × 172. N/Fig. 15. Two variants known, both copies: **1.** With A. C. Beeling & Son, Leeuwarden (1952); sale, Sotheby's, 15 Dec. 1976 (58), illus. 106 × 159. Pariset, 1953, Fig. 3. **2.** Rieder Collection, Munich (1931). 120 × 165. Pariset, 1953, Fig. 5.

Christ at Emmaus (Christ on left, candle). Museo di Capodimonte, Naples. 153 × 205. Fokker. 1929, Pl. X. One copy known: sale, Dorotheum, Vienna, 17–20 September 1963 (105), illus. 132 × 174.

Christ at Emmaus (Christ in centre). Lost. Possible adaptation of a Stomer design by a different hand is:

Galleria Doria-Pamphili, Rome (1942/86). 120 × 165.
Christ at Emmaus (Christ in centre). Private Collection, Bellagio (1953). P/Fig. 3.
Annunciation. Kunsthistorisches Museum, Vienna (1973/486A, illus.). 117 × 173.
Annunciation. Casadei Collection, Rome (1973). 111 × 165. Exh. Rome 1973 (72). Bodart, 1976, Fig. 59.
Annunciation (two canvases). Regional Museum, Zhitomir (USSR). Each 148 × 119. Linnik, 1975, illus. colour Pls. 150–3.
Angel announcing to the Virgin and St Joseph the Flight into Egypt. Longhi Collection, Florence. 99 × 124.8. Longhi Catalogue, 1971, Pl. 73.
Assumption of the Virgin. Parish Church, Chiusdino (near Bergamo). *Inventario delle Opere d'Arte . . . Bergamo*, illus. as Sacchi.
Holy Family with Shepherd and Wife. Radishchev Art Museum, Saratov (USSR). 103 × 99. Linnik, 1975, Pl. 149.
Holy Family with Infant St John. Museo di Capodimonte, Naples. 145 × 208. Fokker, 1929, Fig. XI.
St Ambrose or St Augustine. Musée des Beaux-Arts, Rennes. 110 × 130. P/Fig. 21.
St Ambrose or St Augustine. Öffentliche Kunstsammlung, Basle, as De Crayer. 89.5 × 115.5. Pendant to Basle *St Gregory* (q.v.). N/Fig. 6.
Martyrdom of St Bartholomew. Gargallo Collection, Syracuse. UU. Bottari, 1965, Pl. 23b.
St Cecilia and the Angel. Duke of Wellington Collection, Stratfield Saye. 86.4 × 109.2. Exh. 'European Pictures from an English County', Agnew's, 1957 (1), illus.
St Dominic of Silos. Collegiata del SS. Crocifisso, Monreale. 286 × 218. R. Palermo, 1975, (42), Pls. CVI–CVII.
St Gregory the Great. Öffentliche Kunstsammlung, Basle (1946/187 as De Crayer). 89.5 × 115.5. P/Fig. 19, as *St Augustine*. Pendant to Basle *St Ambrose or St Augustine* (q.v.).
St Gregory the Great. Jean Savin Collection, Paris (as De Crayer). 108 × 125. N/Fig. 5. Probably pendant to Rennes *St Ambrose or St Augustine*.
St Isidore Agricola. Chiesa degli Agostiniani, Caccamo (stolen 1971). 357 × 255. S & D 1641 (retouched). BP. Fokker, 1929, Fig. I, where copies are noted.
St Jerome. Musée des Beaux-Arts, Nantes (1913/24 as Cambiaso). 117 × 98. P/Fig. 22.
St Jerome. Formerly Belden Collection, New York. R.
St Jerome. Centraal Museum, Utrecht. Anamorphic painting, 42.5 × 58.5. U. De Meyere, 1974, Pls. 8a, 8b.
St John the Baptist. Rijksmuseum, Amsterdam (1976/A216, illus. as attributed). 73 × 60. P/Fig. 23.
St John the Baptist. Oppé Collection, London. Wash drawing, 21 × 17.2. Inscribed 'Mattia Stomer'.

Free variant of Capitoline Caravaggio. Pauwels, 1954, Fig. 4.
Beheading of St John the Baptist. Formerly Christopher Norris Collection, Polesden Lacey (destroyed). 96.5 × 73.7. Pauwels, 1954, Fig. 2. Two copies known: **1.** with B. Marco, Lyon (1962) as G. Seghers (without architecture); **2.** Rocca dei Borromei, Angera.
Beheading of St John the Baptist. National Museum, Valletta (Malta). 146 × 197. P/Fig. 10.
Executioner with Head of the Baptist. Denis Mahon Collection, London. 105.4 × 152.4. Nicolson, 1952, Fig. 5. One copy known by William Dobson (q.v.).
Salome with Head of the Baptist. Palazzo Bianco, Genoa. Pauwels, 1954, Fig. 3.
St John the Evangelist. Musée des Beaux-Arts, Rennes. Pendant to Rennes *St Mark* and lost *St Luke* (q.v.). 110 × 130. Walsh, 1976, Fig. 87.
Martyrdom of St Lawrence. Biblioteca Casanatense, Rome. P/Fig. 7.
St Luke. Lost. Engraved in Landon, XIV, 1807, p. 47 as Seghers 'St Matthew'. Walsh, 1976 Fig. A. Pair to Rennes *St John* and *St Mark* (q.v.).
St Matthew and St John. Columbia University, New York. 114.3 × 154.9. Walsh, 1976, Figs. 83, 85–6. Pendant to Trafalgar Galleries *St Mark and St Luke* (q.v.).
St Mark and St Luke. With Trafalgar Galleries, London (1976). 113 × 154. Exh. Trafalgar Galleries, 1976 (13), illus. colour. Walsh, 1976, Fig. 84. Pendant to Columbia University *St Matthew and St John* (q.v.).
St Mark. Musée des Beaux-Arts, Rennes. 110 × 130. Walsh, 1976, Fig. 88. Pendant to Rennes *St John the Evangelist* and lost *St Luke* (q.v.).
St Onuphrius. Quadreria dei Girolamini, Naples. N/Fig. 9. Pendant to Girolamini *St Sebastian* (q.v.).
St Paul. Mark Allen Collection, Burford (Oxfordshire). 82 × 113. N/Fig. 7.
Liberation of St Peter. Kunsthaus, Zurich. 125.7 × 179.1. Exh. Utrecht/Antwerp, 1952 (64), illus.
Liberation of St Peter. Museo di Capodimonte, Naples (on deposit at Pinacoteca Provinciale, Bari). 127 × 182. Voss, 1908, p. 993, illus.
Denial of St Peter. Sale, Ernst-Museum, Budapest, 26 Nov. 1928 (201), illus. as Honthorst. 120 × 145.
Denial of St Peter. Brun Collection, Pellisanne (Bouches-du-Rhône), as Georges de La Tour.
St Sebastian. Bayerische Staatsgemäldesammlung, Munich (Inv. No. 13068). 128 × 113. N/Fig. 11.
St Sebastian. Quadreria dei Girolamini, Naples. N/Fig. 8. Pendant to Girolamini *St Onuphrius* (q.v.).
St Sebastian tended by Irene. Museo Provincial, Valencia. 136 × 96. Nicolson/Wright, 1974, Fig. 64.
Martyrdom of St Stephen. Palazzo Francavilla, Palermo. 222 × 302. Pendant to *Miracle of the Money* (q.v.). Fokker, 1929, Fig. III.

Incredulity of St Thomas. Barone Scotti Collection, Bergamo. P/Fig. 6.

Incredulity of St Thomas. Two versions known: **1.** Museo del Prado, Madrid (1972/2014 as Terbrugghen but see correction, p. 900). 126 × 99. Valdivieso, 1973, illus. **2.** Formerly Giorgio Franciosi Collection, Rome. 127 × 102. ?C. Exh. Utrecht/Antwerp 1952 (65), illus.

Luteplayer and Fluteplayer. Residenzgalerie, Salzburg, Schönborn-Buchheim Collection (1958/169, illus. as Honthorst). 94.5 × 79. Von Schneider, 1933, Pl. 45b.

Fluteplayer and Luteplayer. With Martin Ascher, London (before 1970).

Man with Jug, Woman with Guitar. Lost. One copy known: National Gallery of Scotland, Edinburgh (1970/1446). 91.4 × 78.7

Violinist with Wineglass. Bankes Collection, Kingston Lacy, as Frans Hals. Mirimonde, 1965, Fig. 28 as ?G. Seghers.

Man with Flute. With Duits, London (1927). P/Fig. 16.

Man with Decanter by Candlelight. Accademia Carrara, Bergamo (1967/438, illus.) 72 × 58. Pendant to Bergamo *Boy lighting Candle from Firebrand* (q.v.). P/Fig. 15.

Man holding up Glass. Lost. One copy known: Museo di Capodimonte, Naples. 50 × 75. Pendant to Naples *Woman examining Coin by Candlelight* (q.v.).

Old Woman and Youth by Lamplight. Statens Museum for Kunst, Copenhagen (1951/684, illus.). 115 × 101. P/Fig. 18.

Old Woman and Boy by Candlelight. City Art Museum, Birmingham (1960/P.1'58). Panel, 58.4 × 71.1. P/Fig. 17.

Soldier lighting Candle from Oil Lamp. Private Collection, London (1976). 95.8 × 71.1. Colnaghi's 'Old Masters' exh. 1962 (10), illus. N/Fig. 24.

Soldier lighting Pipe from Oil Lamp. Principe di Galati Collection, Palermo, 133 × 95. Nicolson, 1958, Pl. 33a.

Man lighting Candle from Firebrand. Bartels Collection, Cassel (*c.* 1920). *Cicerone*, 1921, XIII, p. 273, Pl. 6 as Honthorst. One copy known: Piero Mora Collection, Milan (1958).

Soldier lighting Candle from Firebrand. Museum Narodowe, Warsaw (1970/1248). 74 × 63.2. Fokker, 1929, Fig. VIII.

Boy lighting Candle from Firebrand. Accademia Carrara, Bergamo (1967/437). 72 × 58. Pendant to Bergamo *Man with Decanter by Candlelight* (q.v.) P/Fig. 14.

Man blowing on Firebrand. Museo Nazionale, Palermo. 44.5 × 33. Fokker, 1929, Fig. v.

Boy reading by Candlelight. Sale, Bukowski, Stockholm, 28–30 Sept. 1937 (120), illus. as Terbrugghen. 56 × 67. Ad. *Burl. Mag.* Aug. 1937, illus. when with S. Hartveld Galleries, Antwerp, as Baburen.

Old Woman with Moneybag by Candlelight. Lost. One copy known: formerly James Murnaghan Collection, Dublin, 90.2 × 90.2. R.

Woman with Moneybag, Chest and Coins by Candlelight. Musée de Peinture et de Sculpture, Grenoble. 65 × 80. N/Fig. 21.

Old Woman with Coins by Candlelight. Hermitage, Leningrad (1957 Vol. of illustrations, No. 422, illus.). 91 × 82.

Old Woman with Coins by Lamplight. One copy known: Musée des Beaux-Arts, Chambéry. 80 × 119.

Woman examining Coin by Lamplight. Lost. One copy known: Museo di Capodimonte, Naples. 50 × 75. Pendant to Naples *Man holding up Glass* (q.v.).

Old Woman telling Beads. Formerly B. Nicolson Collection, London, 78.7×63.5. Pauwels, 1954, Fig. 1.

Old Woman telling Beads by Lamplight with Skull and Book. Muzeul Brukenthal, Sibiu. 74 × 84. Bears or bore false Honthorst signature and illegible date. N/Fig. 20. Upright version (?C.): Hospice, Cachan. 100 × 76. Boyer, 1956, Fig. 4. Autograph fragment (eliminating skull and book): Prague Castle (1967/62, illus.). 54 × 41. Copies of the latter are: **1.** R. J. Sergejev Collection, Geneva (1942); **2.** (eighteenth century) in monastery at Osek (Czechoslovakia). 53 × 43.2; **3.** Kozel Castle, near Plzeň (Pilsen) (Czechoslovakia). 74 × 57.

Old Woman with Hand on Chalice. Sale, Sotheby's, 10 December 1975 (186). 72 × 62.5. N/Fig. 22.

Old Woman praying by Candlelight. Pushkin Museum, Moscow. 68 × 63. Nicolson, Russia, 1965, Fig. 50. One copy known: Fürstenberg Collection, Herdringen, as Schalcken. 85 × 67.

Old Woman by Lantern Light. With C. Aubry, Paris (1928). ?C.

Old Woman with Chalice and Stick. Sale, Lepke, Berlin, 16–17 May 1933 (324), illus. 69 × 60.

Old Woman holding Stick. Staatliche Kunsthalle, Karlsruhe. 75 × 65. Von Schneider, 1933, Pl. 50b.

Old Woman shading Candle. Gemäldegalerie, Dresden (1960/1253). 71 × 57.5 Von Schneider, 1933, Pl. 50a.

Unidentified Subject. Formerly Private Collection, Milan. 170 × 250. Bottari, 1965, Pl. 26b.

The following is a selection of wrong attributions to Stomer:

Honthorst circle **Vanitas.** Ashmolean Museum, Oxford.

?Moeyaert **Orpheus, Pluto and Proserpine.** Pinacoteca Vaticana, Rome.

Bigot **Judith and Holofernes.** Walters Art Gallery, Baltimore, and other Bigots listed by Sterling as early Stomer, 1951, note 10.

★?Neapolitan **Susanna and the Elders.** Musée du Louvre, Paris (RF. 2331). 96 × 127. *Emporium*, 1956, p. 248, Fig. 19.

Bigot **St Jerome listening to the Trumpet of the last Judgement.** Sale, Sotheby's, March 1975.

Terbrugghen imitator (?Johan Moreelse) **St John the Baptist at the Well.** Musée des Beaux-Arts, Lyon.

*?Circle of De Gheyn **St Mark.** Städtische Gemälde-sammlungen, Wiesbaden (1937/104, as Stomer). 118 × 100.

Rombouts **Concert.** Galleria Nazionale d'Arte Antica, Rome.

Sandrart **Young Lady at her Dressing Table (Vanity)** (Hermitage, Leningrad); **Woman weighing Coins (Avarice)** (Schloss Wilhelmshöhe, Cassel); **Allegory of Gluttony** (Sale, 1913).

TANZIO DA VARALLO (*c.* 1575–80–before April 1635)

From Alagna. Recorded at Varallo, 1611, but probably in Rome shortly before or after. In Abruzzi and Naples before 1616. Working at the Sacro Monte at Varallo, 1616–17, with his brother Giovanni, a sculptor; again 1618–20. Decorates Chapel at Novara, 1629. Apparently no direct links with Caravaggio, but Borgianni, Gentileschi and Bassetti make the strongest impression on him, in spite of the fact that (as his mature works show) his roots are in the Valsesia. Tanzio cannot be described as strictly Caravaggesque at any moment, but the first known works in Naples and the Abruzzi, alone listed below, reflect Roman art of the first decade and anticipate Zurbarán.

Circumcision. Parish Church, Fara San Martino (Abruzzi). Before 1616. Bologna, 1953, Pls. 12–14.

Madonna and music-making Angels on Clouds, with Saints and Donor. Collegiata, Pescocostanzo (Abruzzi). Before 1616. Bologna, 1953, Pls. 10, 11.

St Charles Borromeo giving Communion to the Plague-stricken. Parish Church, Domodossola. 258 × 165. U. Tanzio exh., Turin, 1959–60 (3), Pls. 3–6 and colour (before restoration); Borea, 1974, Fig. 17 (after restoration).

Five Saints (from a single altar-piece). S. Restituta (Duomo), Naples. Before 1616. BP. Previtali, 1969, Pls. 48a, b, c.

TERBORCH, Jan (?–after 1646)

Member of the Terborch family of Zwolle. Pupil of Paulus Moreelse in Utrecht, 1624.

Boy drawing Statuettes. Formerly Colonel Charles Brocklehurst Collection, Macclesfield (Cheshire); Sale, Christie's, 2 Dec. 1977 (85), illus. 94 × 124.5. S & D 1634. Nicolson, 1960, Fig. 14.

Drawing Lesson. Rijksmuseum, Amsterdam (1976/A1331, illus.). 118 × 158. S & D 1634.

TERBRUGGHEN, Hendrick (1588–Nov. 1629)

Born near Deventer of a Catholic family but settles in Utrecht. Pupil of Abraham Bloemaert. Spends ten years in Italy (*c.* 1604–14), chiefly in Rome, and returns to Utrecht autumn 1614. May be in Italy again *c.* 1620–1, in contact with Serodine. Influenced by Bassano family, Saraceni, Gentileschi, Reni, sixteenth-century Netherlandish and German graphic work as well as by Caravaggio. Works in association with Baburen, *c.* 1621–3, in Utrecht. All works listed. N followed by stroke and number refers to Nicolson, 1958 catalogue numbers, pp. 43–130.

Bacchante with Monkey and Grapes. With Galleria Poletti, Milan (1967). 130 × 90. S & D 1627. N/A47 (Pl. 77).

Sleeping Mars. Many versions listed under N/A71 of which the following appear to be autograph or largely so: **1.** Centraal Museum, Utrecht (1952/52). Panel, 106 × 93. S & D 162(?). N/A71 (Pl. 40). **2.** Pall Mall Studios, London (1922). ?127 × 101.6. N/A42 (Pl. 41a). **3.** With Edward Speelman, London (1957). 105.5 × 82.5. ?S A. N/A44 (Pl. 41b).

Allegory of Winter. Formerly with Jean Néger, Paris. 100 × 85. C. N/D92 (Pl. 37d).

Democritus. Two versions: **1.** Rijksmuseum, Amsterdam (1976/A2783, illus.). 85 × 70. S & D 1628. N/A3 (Pl. 94). **2.** Formerly Contessa Spiridon Collection, Rome. 73 × 61. N/B82. Nicolson, 1960, Fig. 4.

Heraclitus. Two versions: **1.** Rijksmuseum, Amsterdam (1976/A2784, illus.). 85 × 69.5. S & D 1628. N/A4 (Pl. 95). **2.** Formerly Contessa Spiridon Collection, Rome. 73 × 61. N/B81. Nicolson, 1960,

Fig. 5. Pairs, respectively, to the pictures listed above.

Democritus and Heraclitus. With Trafalgar Galleries, London (1977). 93 × 111. N/B79 (Pl. 101b). Trafalgar Galleries Catalogue, RA 1977 (29), illus. colour cover. See also under *St Jerome*.

Emperor Claudius. Jagdschloss Grunewald, Berlin. Panel, 69 × 53. S & D 162(?). BP. N/A9 (Pl. 31a). Mezzotint by J. F. Leonart.

Mucius Scaevola before Porsenna. With Gilberto Algranti, London (1974) (exh. Helikon, illus. colour). 183 × 222. Before March 1625. Nicolson, 1973, Figs. 7, 8.

Athenaïs banished by her husband the Emperor Theodosius II (after Jacob Cats). Jean Decoen Collection, Knokke-Zoute (on loan to Musée des Beaux-Arts, Tournai). 173 × 261. Bears inscription and date: 'Meer fecit 1654'. UU. Wright, 1976, Fig. 2.

Daifilo and Dorilea (?). J. Paul Getty Museum, Malibu (1972 exh. Minneapolis (50)). 121 × 157. N/E109 (Pl. 105b).

Esau selling his Birthright. Staatliche Museen, Berlin-East (Kaiser-Friedrich Museum 1931/1982). 96 × 118. N/A7 (Pl. 81a). The following shows a similar composition:

Esau selling his Birthright. Private Collection, Lombardy (1958). *c.* 110 × 140. N/A39 (Pl. 81b). See same subject under imitator of Terbrugghen.

Jacob, Laban and Leah (?). Wallraf-Richartz Museum, Cologne (1967/1026). 123 × 157. S & D 162(?8). N/A16 (Pls. 85, 86, 110b).

Jacob, Laban and Leah. National Gallery, London (1960/4164). 98 × 115. S & D 1627. N/A40 (Pls. 80, 83, 87).

David with the Head of Goliath. Formerly Duke of Sutherland Collection. 76.2 × 68.6. ?C. R. Nicolson, 1958, Pl. 25b.

David saluted by Women. Three versions: **1.** North Carolina Museum of Art, Raleigh (NC), Kress Collection (Kress Catalogue, 1977/K1542, illus.). 80 × 102.9. S & D 1623. N/A50 (Pls. 89, 110d). **2.** Muzeul Brukenthal, Sibiu (1964/52). 80 × 102. S & D 1623. Von Schneider, 1933, Pl. 21b. **3.** Centraal Museum, Utrecht (1952/8, illus.). 82.5 × 102. D 1624. C. Another copy cited under N/A50.

King David harping, surrounded by Angels. Four versions: **1.** Muzeum Narodowe, Warsaw (1969/170). Panel, 150 × 190. S(?) & D 1628. N/A77 (Pl. 96b). **2.** Wadsworth Atheneum, Hartford (Conn.) (1978/155 as attr., illus., wrongly as on panel). 143.5 × 218. Illegible D. 139.7 × 213.4. Dayton/Baltimore, 1965–6 (15), illus. **3.** Kunsthalle, Kiel (1958 p. 23). 142 × 201. Nicolson, 1958, Pl. 96b. **4.** Städelsches Kunstinstitut, Frankfurt am Main. 147.5 × 194. C.

Adoration of the Magi. Rijksmuseum, Amsterdam (1976/A4188). 131 × 158. S & D 1619. Van Thiel, 1971, Fig. 1 plus details.

Lazarus and the Rich Man. Centraal Museum,

Utrecht (1961/17). 168 × 207.5. S & D 1625. N/A70 (Pls. 65, 66). Copy noted under N/A70.

Pilate washing his Hands. Four versions (plus a poor copy on panel): **1.** Schloss Wilhelmshöhe, Cassel (1958/589). 103.5 × 147.5. N/A13 (Pl. 12). **2.** Museum, Lublin. 100.7 × 128.7. Nicolson. 1973, Fig. 1. **3.** Shipley Art Gallery, Gateshead (1951/424). 99.1 × 134.7. A. Longhi, SR, 1967, Figs. 137–40. **4.** Private Collection, Madrid. C.

Crowning with Thorns. Musée des Beaux-Arts, Lille (1893/258). Original canvas, 173.8 × 134.5. U. Nicolson, 1960, Fig. 8.

Crowning with Thorns. Art Museum, Irkutsk (USSR). 119 × 116. Exh. Leningrad, 1973 (59), illus. Linnik, 1975, illus. colour Pls. 109–11.

Crowning with Thorns. Statens Museum for Kunst, Copenhagen (1951/105). 207 × 240. S & D 1620. N/A18 (Pls. 7, 6, 10).

Crowning with Thorns. Private Collection, Washington (DC). 95.2 × 125.7. SA. Nicolson, 1973, Fig. 10.

Mocking of Christ [Plate 130]. Three versions: **1.** Marques de Vivot Collection, Palma (Mallorca). 147 × 100. Nicolson, 1973, Fig. 12. **2.** Musée de l'Assistance publique, Paris. 154 × 117. Exh. Paris, 1970 (32), illus. **3.** Klaus Driessen Collection, Hamburg. 150 × 105. Nicolson, 1973, Fig. 13 (detail).

Crucifixion with Mary and St John. Metropolitan Museum of Art, New York. 154.9 × 102.2. S & D 162 (?). N/A49 (Pls. 54, 53, 55c, 56, 57). Copy with members of the Plois family below, The Hague art market (1957). 106 × 80.5. C (except for portraits which are not after Terbrugghen). Nicolson, 1958, Pl. 55a.

Christ at Emmaus [Plate 128]. Two versions: **1.** Neues Palais, Sanssouci, Potsdam (1964/102). 109 × 141. N/A59 (Pl. 13). **2.** Church of Marienfred, near Castle Gripsholm, Sweden. ?C.

Annunciation. Begijnhofkerk, Diest. 218 × 177. S & D 1629. N/A25 (Pl. 100).

Annunciation. With Edward Speelman, London (1974). 103 × 85. Bloch, 1968, Pl. 1.

Virgin Mary praying for the Souls in Purgatory (?). Dr Alfred Bader Collection, Milwaukee (1974/26) Panel, 77 × 62. Nicolson, 1973, Figs. 3, 4. Copy with Agnew's London (1965). 75 × 62.5.

Mater Dolorosa. Galerie Harrach, Vienna (1926/418). 68.3 × 57.2. BP. N/A75 (Pl. 30b) Copy on Viennese art market (1971). 72 × 57.5. Nicolson, 1973, Fig. 2.

Beheading of St Catherine. Chrysler Museum, Norfolk (Virginia). Panel, 99 × 75.5. N/A45 (Pls. 29, 31b).

Penitent St Jerome. Museum Boymans-van Beuningen, Rotterdam (1972/2435). 110.5 × 87. S & D 162(?). Nicolson, *Boymans*, 1958, Figs. 1–2, 4–5.

St Jerome contemplating a Skull. Cleveland Museum of Art. 124.5 × 101.6. S & D 1621. Variant

of Trafalgar Galleries *Heraclitus*. Nicolson, 1973, Fig. 14. Exh. Trafalgar Galleries, 1976 (6), illus. colour and detail of inscription in black and white.

St Jerome reading. Lost. Before 1621. Engraved by Willem van de Passe, 29.3 × 36.2. N/D87 (Pl. 2a).

St John the Baptist preaching. Lost. Copy, Ecole des Beaux-Arts, Paris red chalk, 20.7 × 31.5. N/D93 (Pl. 105a).

Beheading of St John the Baptist. Nelson Gallery-Atkins Museum, Kansas City (Missouri). 148.6 × 86.4. S & D 1622. F. N/A12 (Pl. 28).

Beheading of St John the Baptist. National Gallery of Scotland, Edinburgh (1970/28). 167.6 × 217.8. S. N/A28 (Pls. 5, 8).

Penitent Magdalen. Schloss Weissenstein, Pommersfelden. 67 × 56.5. N/A58 (Pl. 75).

Calling of St Matthew (see also below under *Evangelists*). Centraal Museum, Utrecht (1952/51). 102 × 137.5. S & D 1621. N/A69 (Pls. 27, 26 and colour detail frontispiece).

Calling of St Matthew. Musée, Le Havre. 152 × 195. N/A36 (Pl. 43).

Penitent St Peter. Centraal Museum, Utrecht (1971-2/18). 65.5 × 83.5. Bears signature and date 161(?6). ?C. N/D90 (Pl. 2b).

Penitent St Peter. Christie's, 16 November 1973 (54) as 'Matthias Stomer'. 68.6 × 96.5. C.

Liberation of St Peter [Plate 132: detail]. Formerly Private Collection, Montrouge (near Paris); with Heim Gallery, Paris (1975). 136 × 170. N/A48 (Pl. 41c).

Liberation of St Peter. Mauritshuis, The Hague (1977/966, illus.). 105 × 85. S & D 1624. N/A19 (Pl. 97). Engraved 1778.

Liberation of St Peter. Staatliches Museum, Schwerin (1962/332). 152 × 210. S & D 1629. N/A61 (Pls. 102, 111a).

Denial of St Peter. Art Institute of Chicago. 130 × 176. N/A30 (Pl. 73). Small variant listed under N/A30.

St Sebastian tended by Irene. Allen Memorial Art Museum, Oberlin (Ohio) (1967/53.256). 150.2 × 120 (reduced from 162 × 127). S & D 1625. N/A54 (Pls. 58–61).

St Sebastian tended by Irene. Formerly Aldo Briganti Collection, Rome. U.

Incredulity of St Thomas. Rijksmuseum, Amsterdam (1976/A3908, illus.). 108.1 × 136.5. N/A2 (Pls. 50–2).

Four Evangelists (four canvases). Stadhuis, Deventer. *St Matthew:* 76 × 101. N/A21 (Pls. 16, 15). *St Mark:* 74.5 × 102. N/A22 (Pl. 17). Copy at Christie's, 16 Dec. 1960 (185) as 'St Jerome', 81.3 × 99.1. *St Luke:* 75.5 × 102. N/A23 (Pl. 18). *St John:* 77 × 102. S & D 1621. N/A24 (Pl. 19).

Four Evangelists (four canvases). Private Collection, Münster (Westphalia).

Concert (three figures). Hermitage, Leningrad. 102 ×

83. S & D 1626. N/A38 (Pl. 76). Linnik, 1975, illus. colour Pl. 112. Later copy formerly R. J. Sergejef Collection, Geneva. 92 × 79. Copy of boy violinist (but without violin) was: Sale, Jürg Stuker, Berne, 26–30 Nov. 1957 (2769), illus. as Honthorst. 64 × 48.

Concert (three figures). Hon. Mrs E. Hervey-Bathurst, Eastnor Castle, Herefordshire. 99.1 × 116.8. N/A37 (Pl. 72).

Concert (two figures). Galleria Nazionale d'Arte Antica, Rome. 90 × 127. S & D 1629. N/A60 (Pl. 103). Two copies of details known, one of which is: Centraal Museum, Utrecht (1952/53) (the girl's head). 47 × 41.5. F. N/E117 (Pl. 109a).

Concert (two figures) [Plate 129]. Three versions: **1.** Musée du Louvre, Paris. 106 × 82. S & D 1628. N/A56 (Pl. 93). **2.** (with addition by another hand of third figure of child). Formerly Mrs Edward A. Shapiro Collection, New York (1971). 109.2 × 91.4. Nicolson, 1973, Figs. 5, 6. **3.** Private Collection, Rome (1963). 108 × 82. ?S A.

Luteplayer and Girl with Glass. Three versions (besides poor copy listed under N/A11): **1.** Dr Heinrich Beckmann Collection, Berlin-Zehlendorf (1960). *c.* 95 × 80 (?). S. N/A11 (Pl. 67). **2.** Museo de Arte de Ponce (Puerto Rico) (1965/61.0180). 107.9 × 96.5. Dayton/Baltimore, 1965–6 (8), illus. **3.** Michael T. Shen Collection, Paris, 94 × 84. Partly R. Nicolson, 1960, Fig. 9.

Violinist and Girl with Glass. Kaiser Wilhelm Museum, Crefeld. 103 × 86. S & D 1624. Partly R. N/A20 (Pl. 35a). Copy at Christie's, 28 July 1955 (170), Nicolson, 1958, Pl. 37b. detail.

Luteplayer (male, facing spectator). Four versions: **1.** National Gallery, London. 101.6 × 74.9. S & D 1624. N/A26 (Pl. 44). **2.** Private Collection, Turin (1972). 104.5 × 90.5. N/A43 (Pl. 47a). **3.** Sale, Sotheby's, 26 March 1969 (60). 100.9 × 83.8. **4.** Private Collection, Copenhagen (1960), sale, Sotheby's, 21 June 1961 (81). 105.5 × 87.5. C.

Luteplayer (male, lost profile to left). Four versions: **1.** Musée National des Beaux-Arts, Algiers (1951/12). 100 × 78. S. N/A1 (Pl. 45). **2.** Musée des Beaux-Arts, Bordeaux (1966/61). 103.8 × 89.5. N/A10 (Pl. 47b). **3.** With Messrs Knoedler, New York (1960). 98 × 81. N/A57 (Pl. 46b). **4.** Formerly Kupferstichkabinett, Berlin-Dahlem. Charcoal, Indian ink with white highlights, 26.5 × 20.2. N/A8 (Pl. 46a). (Study for the painted composition).

Luteplayer (male, three-quarters to right). Two versions: **1.** Formerly Morris Kaplan Collection, Chicago. 101.6 × 81.3. N/B78 (Pl. 37a). **2.** Musée, Boulogne-sur-mer. A. Hoog, 1960, Fig. 6.

Luteplayer (male, looking up to right). Württembergische Staatsgalerie, Stuttgart (1962, p. 216). 84.5 × 69.5. S & D 162(?8). N/A66 (Pl. 92.) Five copies listed under N/A66, the best known being; **1.** The Fine Arts Museum, San Francisco (Calif.). 82 ×

66.7. **2.** Hessisches Landesmuseum, Darmstadt. A sixth copy is: Private Collection, Paris (1960). 100 × 70, with false Hals signature. N/A66, copy No. 2 is perhaps Fischer, Lucerne, Nov. 1974 (2301).

Luteplayer (boy). Nationalmuseum, Stockholm 1958/1487). Pendant to Stockholm *Girl with Tankard and Glass* (see below). 103 × 84. ?D1626. BP. N/A62 (Pls. 69, 71).

Luteplayer (girl). Four versions: **1.** Kunsthistorisches Museum, Vienna (1973, illus. Pl. 35). 71 × 85. N/A74 (Pl. 42). **2.** B. Nicolson Collection, London. 69.8 × 92.1 (later enlarged). N/A41 (Pl. 43). **3.** Private Collection, Rome (1973). 71 × 90. Sale, Dorotheum, Vienna, 24–8 April 1913 (18), illus. C. **4.** Władysław Macharski Collection, Cracow.

Bass Viol Player with Glass. Hampton Court Palace. 104.1 × 85.1. S & D 1625. N/A35 (Pls. 63, 64b). Two copies: **1.** Formerly Biehn Collection, Budapest. **2.** Walters Art Gallery, Baltimore. 99.1 × 82.5. *Art Quarterly*, winter 1973, p. 439, illus.

Treble Viol Player (boy). Lost. Copy: formerly Kunsthandel P. de Boer, Amsterdam. 114 × 96. N/D89 (Pl. 55b).

Violinist with Glass. Three versions: R. T. C. Street Collection, Bournemouth. 103.5 × 85.2. S & D 1627 (partly effaced). Nicolson/Wright, 1972, Fig. 2. **2.** With Julius Weitzner, London (1973) (Munich cat. 1957/Inv. 12499). 101.5 × 85.5. Nicolson, 1960, Fig. 2. **3.** Musée, Boulogne-sur-Mer. S A. Hoog, 1960, Fig. 7.

Violinist with Glass. Lost. Engraving by T. Matham, 21.1 × 15.8, N/D88 (Pl. 37c). Painted copies listed under N/D88. Two further ones are in Musée des Beaux-Arts, Lille, one: Marcus, 1976, Fig. LXIX as François Watteau (1758–1823).

Violinist with Glass. Three versions: **1.** Formerly Sven Boström Collection Stockholm. 103 × 83. ?S A. N/under A33 (Pl. 38b). **2.** Whereabouts unknown. ?D1625. ?S A. **3.** Kunsthandel P. de Boer, Amsterdam. Drawing, 28 × 28.5. C by competent artist. See also Terbrugghen *Man laughing* and Follower of Terbrugghen *Concert* (drawing).

Violinist (boy). Two versions: **1.** Dayton Art Institute, Dayton (Ohio). 104.1 × 72.2. S & D 1626. N/A51 (Pl. 62). **2.** Hans v. Kantzow Collection, Hallstahammar (Sweden). 104 × 81. S & D 1626. N/A76 (Pl. 64a).

Violinist (boy). Acquavella Galleries, New York (1965). 71.8 × 57.8. S. N/A65 (Pl. 39b). Four mezzotints listed under N/A65, one by Verkolije (1681), Pl. 39a. Preparatory drawing for engraving in Oslo Print Room.

Penorcon Player (girl). Kunsthalle, Hamburg. Indian ink, white chalk on grey paper, 25.7 × 20.4. N/A34 (Pl. 104).

Fluteplayer (boy, lost profile to right). Schloss Wilhelmshöhe, Cassel (1958/179). 70 × 55. S. N/A15

(Pl. 20), where two copies are noted, the second in the Robert Lehman Collection, New York, with another figure.

Fluteplayer (boy to left). Schloss Wilhelmshöhe, Cassel (1958/180). 70 × 55. S & D 1621. N/A14 (Pls. 21, 24a). Pendant to above. Copies noted under N/A14.

Fluteplayer (boy to left). Musée d'Art Ancien, Blois. 69 × 59. A. R. N/E94. Exh. Paris, 1970 (35), illus.

Fluteplayer (male, facing spectator). Formerly Herzogliche Gemäldegalerie, Gotha. 85 × 69. S & D 1627. N/A31 (Pls. 78, 111b).

Bagpipe Player (profile to right). Wallraf-Richartz-Museum, Cologne (1967/2613). 100 × 82. S & D 1624. N/A17 (Pl. 48). Copy from Kling Collection, Stockholm, at H. Shickman Gallery, New York (1971), 88 × 81.

Bagpipe Player (facing spectator). Ashmolean Museum, Oxford (1962/428). 92.7 × 73.7. S & D 1624. N/A55 (Pl. 49).

Singer (male). Vera Würthenberger Collection, Cologne (1966). 105 × 85. S A. Nicolson, 1973, Fig. 11.

Singer (boy, looking up). Konstmuseum, Gothenburg. 104 × 83. S & D 162(?). N/A32 (Pl. 90).

Singer (boy, looking down). Museum of Fine Arts, Boston. 85.5 × 71.5. S & D 1627. N/A27 (Pl. 30a).

Singer (girl). Öffentliche Kunstsammlung, Basle (1946, p. 83). 78.5 × 65.5. S & D 1628. N/A6 (Pl. 99).

Backgammon Players. Formerly Madame Streletsky Collection, Stockholm: sale, Christie's, 8 Dec. 1972 (60). 116.8 × 152.4. S & D 1627. N/A67 (Pls. 84, 110c).

Backgammon Players. Centraal Museum, Utrecht 1952/54). 85.5 × 115. ?S. BP. ?S A. N/E116 (Pl. 33c).

Gamblers. Minneapolis Institute of Arts. 69.8 × 96.5. S & D 1623. N/A52 (Pls. 34, 110a). Copy with two further figures, Galerie Rapp, Stockholm (1953), 90 × 125.

Scene of Mercenary Love. Claes Philip Collection, Stockholm (1958). 71.1 × 83.8. S & D 16(?). N/A64 (Pl. 88).

Man with Tankard and dried Fish. Centraal Museum, Utrecht (1961/16). 74.2 × 61.7. S & D 16(?). N/A72 (P . 91).

Man with Tankard and Bread. Alte Pinakothek, Munich (1963/Inv. 4845). 70.1 × 60.6. S & D 1627. N/A5 (Pls. 79, 111c). Copy or copies listed under N/A5.

Boy with Wine Glass. North Carolina Museum of Art, Raleigh (NC) (1956/70). 67.3 × 56.6. S & D 1623. R. N/B80 (Pl. 35b).

Girl with Tankard and Glass. Nationalmuseum, Stockholm (1958/1488). 103 × 84. Pendant to Stockholm *Fluteplayer.* ?S. R. N/A63 (Pls. 68, 70).

Pipe Smoker [Plate 131]. With Malcolm Waddingham, London (1977). 66 × 55.2. S.

Boy lighting a Pipe from a Candle. Museum,

Erlau (Eger, Hungary). 67.6 × 55. S & D 1623. N/A29 (Pl. 32).

Girl lighting a Candle from a Firebrand. Sale, Dorotheum, Vienna, 3 Dec. 1959 (52). 85 × 77. Nicolson, 1960, Fig. 3.

Old Man writing. Smith College Museum of Art, Northampton (Mass.). 66.7 × 53.3. S & D 16(?). N/A53 (Pl. 74).

Man with Dog. Formerly Lord Talbot de Malahide Collection, Malahide Castle (Co. Dublin); sale, Christie's, 2 April 1976 (69), illus. 82.7 × 69.8. S & D 1628. N/A46 (Pl. 98).

Man laughing. With Newhouse Galleries Inc., New York (1974). 76 × 60. Same design as *Violinist with Glass* (q.v.). N/A33 (Pl. 38a).

A. Some works by followers of Terbrugghen and Baburen where the same hand can be detected in more than one picture are listed under Masters A to D. Three further Terbrugghen-like pictures are by the same hand:

Apostle or Father of the Church. P. M. Bardi Collection, São Paulo (Brazil). 101.7 × 82.5. N/under A53 (Pl. 25c).

Old Man reading (Sense of sight) [Plate 134]. Dr Alfred Bader Collection, Milwaukee, as Keil. 48.3 × 38.1.

Old Man writing [Plate 133]. Private Collection, Paris. 87 × 72.

B. The following are by imitators of Terbrugghen who need not necessarily have worked in his studio.

Esau selling his Birthright. Bob Jones University Collection of Sacred Art, Greenville (SC) (1962/165). 121.9 × 134.6. Derived from the two *Esau* pictures listed under Terbrugghen. Close to Master C. N/under A7 (Pl. 101a).

St John the Baptist drinking at the Well. Musée des Beaux-Arts, Lyon. 149 × 171. Close to (and perhaps by) Jan Moreelse. Nicolson, 1960, Fig. 7.

Calling of St Matthew. Szépművészeti Múzeum, Budapest. 106 × 128. Pigler, 1974, Pl. 106.

Concert. Institut Néerlandais, Fondation Custodia, Collection F. Lugt, Paris. Black chalk and bistre wash, 26.6 × 34.8. Right hand violinist from *Violinist with*

Glass (see under Terbrugghen). N/under A33 (Pl. 36b).

Female Luteplayer. With Trafalgar Galleries, London (1976). 98.4 × 78.7. Exh. Trafalgar Galleries, 1976 (8), illus. colour. (Influenced by late Terbrugghen, perhaps not Utrecht).

Violinist with Glass; Fluteplayer (two pictures). [Plate 136]. Staatliches Museum, Schwerin (1962/334, 333). Both 63.5 × 51.1. Both S: HVTB (?) and D 1633. N/E144, 113.

Fluteplayer (boy). Private Collection, Brussels (1958). Panel. N/E98.

Boy with Tankard and dried Fish. Private Collection, Great Britain (1958). 68.6 × 59. N/under A72 (Pl. 108a).

Old Woman with Spectacles [Plate 137]. Two versions: **1.** Gemäldegalerie, Dresden (1930/1254). 61 × 47. N/E103 (Pl. 109b). **2.** Earl of Lonsdale Collection, Askham. Panel, 62.9 × 51.5. N/under E103.

C. The following is a selection of wrong attributions to Terbrugghen (apart from some of those listed under 'imitators'). For a more complete list, see N/E 94–119. Some pictures listed under wrong attributions to Baburen (q.v.) have also been known as Terbrugghens.

Caravaggesque unknown (North Netherlandish) **Lot and his Daughters.** With Rothmann, London (1958). N/E105.

?Jacob van Oost the Elder **Christ at Emmaus.** Notre-Dame, Bruges. N/E95.

Caravaggesque unknown (North Italian) **Christ at Emmaus.** Kunsthistorisches Museum, Vienna N/A73.

Valentin (copy) **Crowning with Thorns.** With E. Speelman, London (1960). Nicolson, 1960, Fig. 1.

Serodine **St John the Evangelist.** Galleria Sabauda, Turin. N/A68.

★Bramer (copy) **Denial of St Peter.** Musée, Narbonne. N/D91.

★Jacob Fransz van der Merck **Female Luteplayer.** Cummer Gallery of Art, Jacksonville (Florida) (1965, p. 23, illus.). Panel, 78.7 × 66.1. S. N/p. 119.

Master A **Luteplayer** and *Violinist with Glass* (two pictures). Cassel, N/E101, 100.

Caravaggesque unknown (North Netherlandish) **Painter in his Studio.** Galleria Nazionale d'Arte Antica, Rome. N/E110.

TILMANN, Simon Peter (1601–1668)

Born at Lemgo in Lippe. Known as Tilmann-Schenk. Taken by his father to Bremen, 1614. Apprenticeship in Utrecht. Travels to Italy and Hungary. Returns to Bremen in 1630's, where he works as portraitist. In Utrecht, *c.* 1637–47, as follower of Honthorst and Bijlert. Dies in Bremen. A few Bijlert-like paintings known, but only one (listed below) truly Caravaggesque.

Fortune-Teller. Schloss Wilhelmshöhe, Cassel (1958/937, illus.). 81 × 106. S & D 1633. Exh. Berlin, 1966 (104), illus. One copy known: Sale, Christie's, 21 June 1957 (114) as 'Baburen'.

The following is a doubtful attribution to Tilmann: Caravaggesque (North Netherlandish) **Concert with Drinker.** Dr Henri Barbier Collection, Geneva (*c.* 1950).

TORNIOLI, Nicolò (?–c. 1652)

Sienese. No news of him before 1622, in Siena, but goes to Rome, where he becomes the master of the Toulouse painter Hilaire Pader. Influenced by Manetti, Riminaldi and perhaps Manfredi. Four pictures listed where he catches the fringes of the Caravaggesque spirit.

Astronomers. Galleria Spada, Rome (1954/365, illus.). 148 × 218.5.

Christ driving the Money Changers from the Temple. Galleria Spada, Rome (1954/226, illus.). 153 × 198.

St Catherine [Plate 32]. Sale, Christie's, 17 Jan. 1947 (154), as Manfredi.

Calling of St Matthew. Musée des Beaux-Arts, Rouen (1966/232, illus.). 217 × 329. Hoog, 1960, Fig. 10.

TOURNIER, Nicolas (July 1590–before Feb. 1639)

Born at Montbéliard of Protestant parents who were refugees from Besançon. The family probably moves to Narbonne around the turn of the century. In Rome by 1619, until at earliest 1626, but recorded back in France (Carcassonne) only at end of 1627. Settles in Toulouse before Nov. 1632. Strongly influenced by Manfredi, later by Valentin, and by Piero della Francesca. Almost all works listed, including the very individual late Toulouse phase (parallel to La Tour), but not Narbonne *Consuls*. RP followed by stroke and number refers to catalogue numbers in Exh. Rome/Paris, 1973–4, and B followed by stroke and plate number refers to Brejon, 1974.

Battle of Constantine. Musée des Augustins, Toulouse. 260 × 550. R. B/Pl. 38, and in colour in *Du*, July 1951.

Joseph and Potiphar's Wife [Plate 58]. Sale, Lempertz, Cologne, 14 Nov. 1963 (64), as Manfredi. 94 × 131.

Joseph telling his Dreams. Formerly Palazzo Chigi, Rome. B/Pl. 35.

David with the Head of Goliath. Museum Narodowe, Warsaw (1970/1310, illus.). 91 × 72. B/Pl. 34.

David with the Head of Goliath [Plate 56]. Lost. Some copies recorded, one of which is: formerly Duca d'Aosta Collection, Turin, as Caravaggio.

Triumph of David. Art Collectors' Association, London (1920), as Manfredi.

Judgement of Solomon. Schloss Weissenstein, Pommersfelden (No. 603). B/Pl. 36.

Tobit and his Wife taking leave of their Son Tobias. Rafael Ramirez Collection, Caracas (Venezuela). 98 × 144. Nicolson, *Margin*, 1958, Fig. 33. Two other versions known, both presumed copies: **1.** John and Mable Ringling Museum, Sarasota (Florida) (1940/110, illus. as Manfredi). 90.2 × 120.6. **2.** Opocno Castle, Czechoslovakia (No. 115), as Valentin.

The Mote and Beam. Florentine Galleries. 100 × 128 (increased in height by 5.5). Exh. Florence, 1970 (21), illus.

'Sinite Parvulos'. Galleria Nazionale d'Arte Antica, Rome. 125 × 170. RP/34, illus.

Crucifixion with Virgin and St John and (?) St Joseph of Arimathea. Saint-Paul-Serge, Narbonne. Mesplé, 1950, illus.

Crucifixion with Virgin, Magdalen, St John and

St François de Paule. Musée du Louvre, Paris (1974/807, illus.). 422 × 292. 1628. Louvre catalogue of illustrations, 1974, Pl. 807.

Deposition. Musée des Augustins, Toulouse. 237 × 183. *Réalité*, 1934 (109), illus.

Entombment. Musée des Augustins, Toulouse. 305 × 154. *L'Age d'Or*, 1947 (31), illus.

Madonna. Musée des Augustins, Toulouse. 118 × 105. *Réalité*, 1934 (110), illus.

Guardian Angel. Cathedral, Narbonne. 240 × 190. Mesuret, 1957, Fig 2.

St John the Evangelist. Galleria Spada, Rome (1954/117, illus.). 115 × 83. RP/35, illus.

Denial of St Peter. Museo del Prado, Madrid (1972/2788, as Valentin). 172 × 252. B/Pl. 32.

Denial of St Peter. Gemäldegalerie, Dresden (1930/413). 127 × 175. B/Pl. 31. One copy known: Musée, Le Havre, as Valentin.

Denial of St Peter. Nino Salocchi Collection, Florence (1965).

Denial of St Peter. With Silvano Lodi, Munich (1972). 160 × 240. B/Pl. 29. ?Identical with version, Sale, Paris, Galliéra, 6–7 Dec. 1962 (14), as Valentin, 156 × 236. Four copies known: **1.** Musée des Augustins, Toulouse. 160 × 242. Mesuret, 1957, Fig. 11. **2.** Formerly Sir Alec Martin Collection, London. Panel, 34.3 × 52.1. **3.** and **4.** Possibly parts of the same picture: Private Collection, Paris, F of top left half, B/Pl. 30; and Messrs Durlacher, New York (1954), as Manfredi, 76.2 × 64.8. F of right-hand half, exh. 'Pictures of Everyday Life', Carnegie Institute, Pittsburgh, 1954 (17), illus. as Manfredi.

Concert (five figures). Musée du Louvre, Paris (1974/808, illus.). 188 × 224. Mesuret, 1957, Fig. 7.

Concert (four figures). National Museum, Belgrade. De Vito, 1974, Pl. 25.

Concert (three figures). Two versions known: **1.** Formerly Aldo Briganti Collection, Rome. B/Pl. 27. **2.** Bukowski Sale, Stockholm, 9–12 Nov. 1966 (160), illus., as Manfredi. 120 × 165.

Man with Lute, and Violin behind. Novakovic Collection, Belgrade (1938). 135 × 97. U. Brejon/ Cuzin, 1974, Fig. 22.

Luteplayer. Hermitage, Leningrad (No. 5568). 105 × 77. Brejon/Cuzin, 1974, Fig. 23. Linnik, 1975, illus. colour Pl. 30, as Manfredi.

Fluteplayer. Pinacoteca Tosio e Martinengo, Brescia (1931/215, as Manfredi). 76 × 60. RP/33, illus.

Concert, Eating and Drinking Party (seven figures). Musée de Tessé, Le Mans. 129 × 192. C after Manfredi (q.v.). RP/32, illus. Engraving in reverse by Haussard in *Recueil d'Estampes . . . dans le Cabinet du Roy* (1742) (Trafalgar Galleries catalogue, RA 1977. Fig. 6a), and in Musée Napoleon (Landon, v, p. 23), both as Manfredi. Replica recorded in Marchesa Raggi Collection, Rome (1943). One variant copy recorded: Private Collection, Rouen.

Eating and Drinking Party with Fluteplayer (ten figures). Private Collection, Madrid (1947). Brejon/ Cuzin, 1974, Fig. 21.

Eating and Drinking Party with Luteplayer (five figures). City Art Museum, St Louis (Missouri). 120.6 × 165.1. Spear, 1971 (69), illus. Two copies known: **1.** Szépművészeti Múzeum, Budapest (1967/ 624 as ?Tournier). 125.5 × 170.5. **2.** With Dr Katz Dieren (1938). 109.2 × 166. Grimaldi Sale, Amsterdam 4–5 Dec. 1912 (68), illus. as Valentin.

Eating and Drinking Party with Luteplayer (four figures). Musée du Berry, Bourges. 120 × 160. Exh. Milan, 1951 (176), illus.

Man raising Glass. Galleria Estense, Modena (1948/ 525, as Manfredi?, illus.) 130 × 93. Before 1624. ?C after lost Manfredi. RP, Fig. 8. Its pendant is:

Man raising Flask. Galleria Estense, Modena (1948/ 526, as Manfredi?). 124 × 93. Before 1624. ?C after lost Manfredi. RP, Fig. 9. Partial copy recorded (1948) in Schloss Frohsdorf, Austria.

Card and Dice Players (nine figures). Gemälde-galerie, Dresden (1960/411). 169 × 239. RP/31, illus.

Dice Players (five figures). Anson Collection, Catton Hall, Burton-on-Trent. Nicolson, 1967, Fig. 8.

Dice Players (four figures). National Trust, Atting-ham Park, Shrewsbury. 127 × 172.7. B/Pl. 26.

Fortune-Teller. David Rust Collection, Washington (DC). 165.4 × 135.2. ?C of part of Manfredi in Dresden (No. 412) (q.v.) or of another, lost, version. Brejon/Cuzin, 1976, Fig. 7 as Régnier.

Two Soldiers. Private Collection, Paris. ?CFB/Pl. 28.

Solier. Private Collection, Paris. 73 × 61. RP, Fig. 10.

The following is a selection of wrong attributions to Tournier:

★Fournier **Judah kneeling before Joseph.** Cathedral, Narbonne. S & D 1655. Mesuret, 1957, Fig. 1.

Attr. to Régnier **David with the Head of Goliath, and Girl holding Laurel.** Galleria Nazionale d'Arte, Antica, Rome.

★Anon. **Adoration of the Shepherds.** Saint-Pierre-aux-Chartreux, Toulouse. Mesuret, 1957, Fig. 10 (detail).

★Circle of Abraham Janssens **Lamentation over the Body of Christ.** Cathedral, Narbonne. Mesuret, 1957, Fig. 3.

★Ribera **Lamentation over the Body of Christ.** National Gallery, London (No. 235).

Caravaggesque (French) **Christ at Emmaus.** Museum, Nantes.

★Dutch School (?P. de Grebber) **St Augustine.** Museum, Narbonne. Mesuret, 1957, Fig. 5.

Valentin **St Paul.** Pritchard Collection, Chippenham (Wilts.).

O. Gentileschi imitator **St Sebastian.** Musée Fabregat, Béziers.

Rombouts **Musical Pair.** Giscaro Collection, Toulouse (1957).

Manfredi imitator **Guitar Player.** Florentine Galleries.

TRAIVOEL, Henry (active in 1620's)

Only one undoubted picture so far identified by him (on basis of early inscription) listed below.'Henrico Travers pictore' who must be this Vouet-like artist, is with Vouet on his return from Genoa to Rome early in 1622.

Portrait of Young Man (?Self Portrait). Private Collection, Neuilly-sur-Seine. 50 × 40. Inscribed on reverse in 17th century: HENRY TRAIVOEL PIᵗ. Exh. Rome/Paris, 1974 (36), illus.

Portrait of Young Man. Ashmolean Museum, Oxford (1962/59, as Bernini). 45 × 39. U U. Witt-kower, 1951, p. 55, Fig. 21.

VALENTIN (Jan. 1591–Aug. 1632)

Described in documents as 'Valentin de Boulogne'. Born Coulommiers-en-Brie, but probably out of France before the age of twenty. In Rome at latest by 1612, possibly the 'Valentino francese' at S. Nicola

dei Prefetti in 1611. Nothing recorded of his very early youth, but in parish of S. Maria del Popolo from 1620 (when he shares studio with Douffet) until his death. Strongly influenced by Manfredi. Patronized by the Barberini. All works listed. RP followed by stroke and number refers to Catalogue numbers in Exh. Rome/Paris, 1973–4.

Four Ages of Man. National Gallery, London (1946/4919). 95.2 × 132.1 (Cut all round). RP/49, illus. Engraved in Orléans Catalogue, 1786ff. Five copies or variants known: **1.** Vassar College Art Gallery, Poughkeepsie (New York) (1967/39.5, illus.). 97.8 × 130. Exh. Florida, 1970 (46), illus. Probably different from **2.** Wawra Sale, Vienna, 17 Dec. 1920 (18), illus. as Rombouts. 106 × 134. Frimmel, *Studien und Skizzen zur Gemäldegalerie*, v, Pl. XXII. **3.** (luteplayer alone), in 1954 in unknown collection as school of Manfredi. **4.** Pastiche attributed to Grimou. Musée des Beaux-Arts, Bordeaux. 112 × 146. Hoog, 1960, Fig. 13. **5.** Sale Fischer, Lucerne, 29 June 1973 (541), illus. as Honthorst. 110 × 138.

Allegory of Italy. Finnish Institute, Villa Lante, Rome. 330 × 245. Before March 1628. RP/55, illus.

Erminia and the Shepherds. Alte Pinakothek, Munich (1972/937, illus.). 134.6 × 185.6. Illus. colour plus details Figs. 2, 3, 5, 7, 8, *Pantheon*, iii, 1964. Two copies known: **1.** Earl Spencer Collection, Althorp House (Garlick, 1976(649) as original). 122 × 173. Illus. with details *Pantheon*, iii, 1964, Figs. 4, 6. **2.** Gallotti Collection, Rome.

Sacrifice of Isaac. Museum of Fine Arts, Montreal. 148 × 185. BP. RP/56, illus.

Moses and the Tablets of the Law. Kunsthistorisches Museum, Vienna (1973, illus. Pl. 141). 131 × 103.5. Engraved in Teniers' *Theatrum Pictorium*.

Samson. Cleveland Museum of Art. 135.6 × 102.8 (since removal of strips). 1631. Pendant to Barberini *David* (q.v.). Spear, 1972 (14), illus.

David with the Head of Goliath. Formerly Galleria Barberini, Rome (Sale, Rome, 13–23 Jan. 1935/475). 177 × 102. Pendant to Cleveland *Samson* (q.v.). 1627. Spear, 1971, Fig. 44.

King David Harping. Hornstein Collection, Montreal. *L'Oeil*, June–July, 1968, illus.

Triumph of David. Schloss Rohoncz Foundation, Lugano-Castagnola (1977/314). 99 × 134. RP/43, illus. Engraving by Domenico del Pino, 1817. One copy known: Wallraf-Richartz-Museum, Cologne (1973/1456, illus.). 105.5 × 133.

Judgement of Solomon. Musée du Louvre, Paris (1974/825, illus.). Pendant to *Innocence of Susanna* (q.v.). *Paragone* 269, July 1972, P.l 6.

Judgement of Solomon. Galleria Nazionale d'Arte Antica, Rome. 130 × 160. BP. *Bollettino d'Arte*, Oct.–Dec. 1955, p. 372, illus.

Judith beheading Holofernes. National Museum, Valletta (Malta). 106 × 141. RP/47, illus.

Judith with the Head of Holofernes. Musée des Augustins, Toulouse. 97 × 74. RP/45, illus. Engraved in Musée Napoléon (Landon, XIV, 1807, p. 47). Two copies recorded: **1.** Museum, Toulon (No. 205). **2.** Reduced copy, American Private Collection.

Innocence of Susanna. Musée du Louvre, Paris (1974/824, illus.). 175 × 211. Pendant of *Judgement of Solomon* (q.v.). Two copies known: **1.** Shipley Art Gallery, Gateshead (1951/378). 170.2 × 205.7. **2.** Malmö, as Van Loon.

Christ and the Samaritan Woman. Prince Augusto Barberini Collection, Rome. 144 × 190. RP/54, illus.

Christ and the Samaritan Woman. Galleria Nazionale dell'Umbria, Perugia. 135 × 98. Pendant to *Noli me Tangere* (q.v.). RP/41, illus.

Prodigal Son. Sala Collection, Florence (1958).

Christ and the Adulteress. Private Collection, Milan (1964). 220 × 168. Longhi, 1958, Fig. 4.

Christ driving the Money Changers out of the Temple. Hermitage, Leningrad (1958/182, illus.). 192 × 266.5. Exh. Leningrad, 1973 (11), illus. Linnik, 1975, illus. colour and black and white Pls. 34–8.

Christ driving the Money Changers out of the Temple. Galleria Nazionale d'Arte Antica, Rome. 195 × 260. RP/39, illus.

Tribute Money. Château de Versailles. 111 × 154. Voss, 1924, p. 104, illus. Engravings: **1.** by Baudet in *Tableaux du Cabinet du Roi* (1677). **2.** In Musée Napoléon (Landon, X, 1805, p. 47). One copy known: Bishop's Palace, Autun.

Last Supper. Galleria Nazionale d'Arte Antica, Rome. 139 × 230. RP/46, illus.

Crowning with Thorns. Lost. One copy known: Musée des Beaux-Arts, Bordeaux. 123 × 162. U. Hoog, 1960, Fig. 11.

Crowning with Thorns. Fogg Art Museum, Cambridge (Mass.). 196.5 × 147. RU. Moir, 1976, Fig. 79 as Preti.

Crowning with Thorns. Avv. Rainoldi Collection, Milan (1943). Longhi, 1960, Pl. 44. One copy known: with Edward Speelman, London (1960). 134.6 × 102.2. Nicolson, 1960, Fig. 1, as Terbrugghen.

Crowning with Thorns. Alte Pinakothek, Munich (1972/477, illus.). 173 × 241. Voss, 1924, p. 102, illus.

Crowning with Thorns. Alte Pinakothek, Munich (1972/188, illus.). 132 × 96.3. Longhi, 1960, Pl. 43.

Mocking of Christ. Lost. Two copies known: **1.** Musée des Beaux-Arts, Lille (1893/93). 133 × 186. **2.** Musée du Louvre, Paris (1974/826, illus.). 128 × 175. Louvre volume of illustrations, 1974, Pl. 826.

Soldiers gambling for Christ's Garments. ?Lost. Two versions known: **1.** O. Lord Collection, Geneva (1975, deposited in Musée d'Art et d'Histoire, Geneva). 179 × 238. ?C., but a good chance of being the

original. Cuzin, 1975, Fig. 16. **2.** Florentine Galleries. 150 × 220. C. Exh. Florence, 1970 (19), illus. Drawing of the left-hand figure by Manetti (q.v.).

Noli me Tangere. Galleria Nazionale dell'Umbria, Perugia. 135 × 98. Pendant to *Christ and the Samaritan Woman* (q.v.). RP/42, illus.

Holy Family with Infant St John. Galleria Spada, Rome (1954/159, illus.). 140 × 186.

Holy Family with two Angels [Plates 50, 55]. Madrid art market (1976).

Martyrdom of St Bartholomew. Accademia, Venice (1970/415, illus.). 121 × 165. Engraving by D. Angeloni and G. Cabrini (1829).

St Jerome. Galleria Sabauda, Turin. 102 × 145. RP/40, illus. A similar, lost, picture is known from a copy: Mr and Mrs J. V. Feather Collection, Bridley Manor, near Woking (Surrey).

St Jerome. With Galerie Heim, Paris (1966). 122 × 168. RP, Fig. 14.

St Jerome. Jewett Art Center, Wellesley (Mass.) (1955/16). 133 × 95. U. Cuzin, 1975, Fig. 4.

St Jerome. Private Collection, Rome (1958).

St Jerome. S. Maria in Via, Camerino. 130 × 93. Pendant to *St John the Baptist* (q.v.). RP/53, illus.

St John the Baptist. S. Maria in Via, Camerino. 130 × 93. Pendant to *St Jerome* (q.v.). RP/52, illus.

St John the Baptist. Collegiata, S. Urbano, Apiro. 135 × 100. Dania, 1974, Fig. 81.

St John the Baptist. Cathedral, Saint-Jean-de-Maurienne

Herodias with the Head of St John the Baptist. Galleria Spada, Rome (1954/389, illus.). 102 × 72. BP.

St John the Evangelist. William Hayes Ackland Memorial Art Center, Chapel Hill (NC) (1971/58, illus.). 95.8 × 133.9. Spear, 1971 (70), illus.

Martyrdom of St Lawrence. Museo del Prado, Madrid (1972/2346). 195 × 261. Exh. Seville, 1973 (48), illus.

Penitent Magdalen. Musée des Beaux-Arts, Chambéry (No. 435). C. RP/Fig. 15.

Conversion of the Magdalen. Ernst-Museum, Sale, Budapest, 15 Nov. 1923 (22, 23) as Fetti. Two F's. Left, 93 × 78; right, 93 × 85. Cuzin, 1975, Figs. 7, 8.

St Paul destroying the Serpent [Plate 48]. Sale, Christie's, 6 Nov. 1953 (103) as Caracciolo. 157.5 × 210.8.

St Paul. R. C. Pritchard Collection, Kingston Langley, Chippenham (Wilts.). 96 × 129. Brejon, 1974, Fig. 37.

St Paul. Musée Départemental de l'Oise, Beauvais. 63 × 49. U. Beauvais Exhibition Catalogue 1971 (16), illus.

Denial of St Peter. Longhi Collection, Florence. 171.5 × 241. Longhi Catalogue, 1971, Pl. 68 in colour.

Denial of St Peter. Lost. One poor copy known: Graves Art Gallery, Sheffield, as School of Utrecht.

Denial of St Peter. Pushkin Museum, Moscow.

119 × 172. Nicolson, Russia, 1965, Fig. 54. Linnik, 1975, illus. colour and black and white, Pls. 39–42. Engraved in reverse by F. Basan in Brühl Collection (1754), No. 28; Moir, 1976, Fig. 100; J. Walker and J. Sanders. One copy known: Hôpital de la Salpêtrière, Paris.

Liberation of St Peter. Puglisi-Calzavara Collection, Rome (1958).

Martyrdom of Saints Processus and Martinian. Pinacoteca Vaticana, Rome. 1629. S. Voss, 1924, p. 105, illus. Engraved in Musée Napoléon (Landon, XI/1806). Three copies known: **1.** St Peter's, Rome. Mosaic (1726–30) by Liverio Fattori and G. B. Brughi. **2.** Saint-Germain, Rennes. **3.** Musée des Beaux-Arts, Dijon, by Jean-Baptiste Regnault (1780). 308 × 165.

St Sebastian. Formerly Langton Douglas Collection, London. Cuzin, 1975, Fig. 6.

Four Evangelists (four canvases). Château de Versailles. Each, 120 × 146 (enlarged). Spear, 1971, Fig. 43 (*St John*); Hoog, 1960, pp. 267–8, illus.

St Mark and St Luke. Engravings by Gilles Rousselet (1677); by Nicolas Bazin (1701); by J. Gole; in Musée Napoléon (Landon v, p. 141, *St Luke*; vi, p. 27, *St Mark*; vii, p. 101, *St Matthew*; xv, p. 97, *St John*; illus. Bertin-Mourot, 1963, Pls. XII and XIII). Two sets of copies: **1.** Musée des Beaux-Arts, Tours. **2.** Musée des Beaux-Arts, Dijon (oval busts only) (1968/32–5). Each, 81 × 62.

Portrait of Scipione Filomarino. Lost. One copy known: SS. Apostoli, Naples. Mosaic by G. B. Calandra, 1641.

Portrait of Raffaello Menicucci. John Herron Art Museum, Indianapolis (1970/56. 72, illus. as Lanfranco) 80 × 65. Cuzin, 1975, Fig. 1.

Concert Party (eight figures). Musée du Louvre, Paris (1974/822, illus.). 175 × 216 (strip added at top). RP/48, illus. Engraved in Musée Napoléon (Landon III). One copy known: Musée Mandet, Riom, as Italian 17th century. F.

Concert Party (eight figures). Museum der bildenden Künste, Leipzig (1973, p. 26, illus.). 127 × 177. Cuzin, 1975, Fig. 19.

Luteplayer. Private Collection, Paris. 130 × 98. BP. RP/50, illus. Two copies known: **1.** Marquis of Exeter Collection, Burghley House, Stamford (No. 530). 125.7 × 95.2. **2.** Private Collection, Brescia (1946), as School of Manfredi.

Fluteplayer crowned with Laurel. ?Original documented in photograph in Longhi Foundation. Probable copy: Private Collection, Milan (1958). Longhi, 1958, Fig. 5. Two further copies recorded: **1.** formerly Laschi Collection, Florence. Cuzin, 1975, Fig. 9. **2.** Périgueux, Museum.

Boy Fluteplayer crowned with Laurel. ?Copy in Campori Collection, Modena (early 1930's). 69 × 50. Campori Catalogue, 1931, Pl. LXX.

Musicians, Drinkers and Games Players (six

figures). Lost. At least two copies known: **1.** Private Collection, Rome. 121 × 168. RP, Fig. 17. **2.** Sale, Sotheby's, 27 March 1968 (52). 120 × 165.7.

Musicians and Drinkers (seven figures). Musée du Louvre, Paris (1974/823, illus.). 173 × 214. Voss, 1924, p. 100, illus. Engraved in Palais Royal by Félix Massard, and in Musée Napoléon (Landon III, p. 89).

Musicians and Drinkers (five figures). With Messrs Wildenstein, New York (1960). 111.8 × 146.6. Exh. Sarasota, 1960 (9), illus. Engraved in Palais Royal by Jacques Couché (1786), and by J. J. Huber (1808), and at Stafford House (1818). Two copies are recorded: **1.** Acquavella Galleries, New York (1960). 101.6 × 148.6. Ad. in *Burl. Mag.* Supplement, June 1960, Pl. IX. **2.** Hessisches Landesmuseum, Darmstadt. 117 × 168. Other copies listed in Hoog, 1960.

Musicians and Drinkers (five figures). John Herron Art Museum, Indianapolis (1970/56.162, illus.). 119.4 × 158.7. BP. Spear, 1971 (71), illus. Two copies known (without woman left): **1.** Sale, Sotheby's, 6 March 1957 (128). 139.7 × 151.1. **2.** Formerly W. Duff Murdoch Collection, London. 152.4 × 182.9. Bore false Caravaggio signature and date 1603 or 1605.

Musicians and Drinkers (five figures). Two versions known: **1.** Statens Museum for Kunst, Copenhagen (1951/415). 142 × 195. ?C. **2.** Musée des Beaux-Arts, Strasbourg. 155 × 200. BP. Exh. Heim 1955 (20), illus.

Drinkers and Musicians (four figures). Musée du Louvre, Paris (1974/820, illus.). 96 × 133. RP/44, illus.

Musicians and Drinker (three figures). Devonshire Collection, Chatsworth. 93.3 × 127. Longhi, 1943, Pl. 78. Engraving by Chambers for Boydell.

Musicians and Drinker (three figures). ?Lost. Three copies known: **1.** Chigi Saracini Collection, Siena. RP, Fig. 12. **2.** With H. Shickman Gallery, New York (1971). 72 × 94. **3.** Signora Mocenni Collection, Vitignano, near Siena (1932) (head of youth on left only). Other copies cited in RP, p. 253.

Dice Players. With Colnaghi's and Trafalgar Galleries, London (1974). 126 × 184. Exh. Trafalgar Galleries, 1976 (3), illus. colour. One copy known: Chambre de Commerce, Dieppe. Illus. exh. Trafalgar Galleries, 1976 under No. 3.

Card Sharpers. Gemäldegalerie, Dresden (1960/408). 94 × 137. RP/37, illus. Copy at Sibiu. Another copy was sale, Parke-Bernet, New York, 14 Nov. 1951 (73), illus. 101.6 × 133.3. Engraved in 18th century by Pierre Tanjé, as Caravaggio, illus. *Novità*, 1975, p. 243, and in reverse by R. Lowie in mezzotint, illus. Moir, 1976, Fig. 12.

Fortune-Teller with Concert Party. Schloss Weissenstein, Pommersfelden (on loan to Museum at Toronto). 190 × 265. 1631. RP/57, illus. Copies noted by RP, p. 184.

Fortune-Teller with Musicians. Musée du Louvre, Paris (1974/821, illus.). 125 × 175. RP/51, illus. Copy known: Hon. Claud Phillimore, London (centre group only). RP note further copies, p. 166.

Fortune-Teller with Drinkers. Formerly Fitz-william Museum, Cambridge; sale, Sotheby's 1 July 1953 (157). 149.9 × 236.2. RP, Fig. 18. Two copies recorded: **1.** Musée Calvet, Avignon. **2.** Formerly Museo Filangieri, Naples (destroyed).

Fortune-Teller with Drinker and Luteplayer [Plate 53]. Statens Museum for Kunst, Copenhagen (1951/414). 142 × 191. ?C.

Fight in Guard Room [Plate 49]. ?Lost. Engraving by Ganière, 1640 (Wildenstein, 1950, Fig. 70). Four versions known: **1.** Musée des Beaux-Arts, Besançon. C. **2.** Bayerische Staatsgemäldesammlung, Munich (1908/1318). 123 × 182. C. **3.** Musée des Beaux-Arts, Tours. 127 × 171. ?C. Exh. Bordeaux 1955 (108), illus. **4.** Formerly Earl of Lonsdale Collection, Lowther Castle. Panel, 28 × 36. ?C. Engraving by Baillie published by Boydell, 1769.

The following are by unidentified imitators of Valentin:

Apollo [cf. Plates 51, 52]. Museo Civico, Turin (1963, illus. as French Caravaggesque *c.* 1620). 66 × 50. RP/77, illus., as Anonymous. A similar picture in Nantes (1913/81 as after Guercino). 66 × 49. Apparently by this hand is: *Poet* (?) *crowned with laurel, holding apple.* With estate of T. P. Grange, London (1977), as Luca da Reggio. 70 × 60.

Denial of St Peter. Formerly with Roland, Browse & Delbanco, London. 127 × 152.4. Possible C of lost Valentin.

The following is a selection of wrong attributions to Valentin:

Manfredi imitator **Five Senses,** engraved in Orléans catalogue (1786).

Mellan **Joseph interpreting Dreams.** Galleria Borghese, Rome.

Baglione **Ecce Homo.** Galleria Borghese, Rome.

Caravaggesque unknown (Neapolitan) **St John the Baptist.** Private Collection, Italy. 132 × 98. Rome/Paris, 1974 (38), illus.

Master of the Judgement of Solomon **Denial of St Peter.** Galleria Nazionale d'Arte Antica, Rome.

?Master of the Judgement of Solomon **Denial of St Peter.** Certosa di S. Martino, Naples.

VERMIGLIO, Giuseppe

Born in Alessandria. Documented in Rome in 1604, 1605 (in prison), in 1611; again in 1619. Perhaps influenced by Borgianni. Only one Caravaggesque picture so far identified (listed below) but other works known show him developing in the direction of the young Guercino and French classicism.

Incredulity of St Thomas. S. Tommaso in Vincis, Rome. S & D 1612. Longhi, 1943, Pl. 70.

VIGNON, Claude (May 1593–May 1670)

From Tours. Possibly trained in workshop of Lallemand in Paris before 1616. Brought up in Lallemand-Bellange tradition. In Rome by 1616–17, where he probably remains until 1622. In Paris, Jan. 1623. Believed to visit Spain *c.* 1623–4 and again *c.* 1625–8, and is likely to be in Venice not too late in the 1620's. In Italy in 1630 and also towards the end of his life (1659–61) as art dealer. Affinities with Borgianni, Bramer, Vouet, Fetti, Honthorst and the Rembrandt circle. Only a sporadic near-Caravaggesque phase in late 1610's and 1620's. Some but by no means all paintings of this period listed. F 1962, 1963 followed by stroke and plate number refers to Fischer, 1962, 1963.

Croesus exacting payment. Two versions known: **1.** Museé des Beaux-Arts, Tours. 105 × 149. S & D 1629. F 1963/Pl. 38. **2.** Poincet Collection, Bron (Rhône). 50 × 60. S & D 1629.

Joseph telling his Dreams. Museo de Arte de Ponce (Puerto Rico). 136 × 185. S &D 162(?). F 1963/Pl. 51.

David with the Head of Goliath. Suida Manning Collection, New York. 134 × 98. Rome/Paris, 1974 (61), illus.

David with the Head of Goliath. Lost. Engraved by Paiot. One copy recorded in Reims by Rome/Paris, 1974, under No. 61.

Christ among the Doctors. Musée de Peinture et de Sculpture, Grenoble. 153 × 224. S & D 1623. F 1962/Pl. 15.

Feast at Cana. Formerly Neues Palais, Potsdam (destroyed). 214 × 291. F 1962/Pl. 14. Engraved in Landon, 1812 in Giustiniani Collection, p. 53.

Salome bringing the Head of St John the Baptist to Herod. Avv. Fabrizio Lemme Collection, Rome. 73 × 96. Brejon/Cuzin, 1974, Fig. 1.

Martyrdom of St Matthew. Museum, Arras. 142 × 96. S & D 1617. F 1962/Pl. 8. Illus. colour *La Revue des Arts*, Jan.–Feb. 1958, opp. p. 48.

Denial of St Peter. Etching inscribed 'Caravaggio F Roma 1603'. U. Nicolson, May 1972, Fig. 106.

Bust Portrait of a Boy. Private Collection, Washington (DC). Brejon/Cuzin, 1974, Fig. 10.

Boy Bagpipe Player. Two versions known: **1.** Earl Spencer Collection, Althorp House (Garlick, 1976 /673 as attributed to). 81.9 × 62.2. ?C. F 1962/Pl. 6 as portrait of François Langlois. **2.** Stone Sale, Parke-Bernet, New York, 1 April 1942 (72), illus. as Judith Leyster. 81.3 × 66. Could be original. Engraving in same direction by C. David after Vignon, F 1962/Pl. 5. A similar boy is portrayed in A. Bloemaert's *Rommelpot Player* (q.v.).

Young Singer. Musée du Louvre, Paris (1972/R.F. 1966-6). 95 × 90. Rome/Paris, 1974 (62), illus.

Young Singer. Private Collection, London, as Fetti.

Two Drinkers. Whitbread Collection, Southill Park (Beds.). C recorded at Tournus.

Two Lovers. Etching (1618) after Vouet (q.v.).

Men eating [Plate 69]. Muzeum Narodowe, Warsaw (1969/1387). 111 × 81. Exh. Poznán, 1973 (63), illus. Engraving by Charles David after Vignon in reverse, Pariset, 1948, Pl. 8 (10). Preparatory red chalk drawing for the main head: Tristan Klingsor Collection, Paris (1953).

The following is a selection of wrong attributions to Vignon:

Vouet **Portrait of a Young Man.** Earl Spencer Collection, Althorp House.

Caravaggesque (?German) **Concert** and **Fortune-Teller.** Pallavicini Collection, Rome, with drawing and etching associated with the latter.

VITALE, Filippo (*c.* 1585 or later–1649)

Neapolitan. Already Caravaggesque by beginning of second decade, moving in the circles of Sellitto and Caracciolo. The majority of his surviving pictures belongs to a later period in the 1630's and 1640's, when he moves out of a strictly Caravaggesque orbit in the direction of Ribera. Only a few earlier works are listed.

Guardian Angel. Pietà dei Turchini, Naples. S.
St Francis. S. Anna dei Lombardi, Naples. 1613 or
soon after.
Magdalen. Museo di Capodimonte, Naples (Inv. No.
292). 51 × 77. Prohaska, 1975, Fig. 9. Sellitto exh.,
1977 (12), Pl. XLV.

Liberation of St Peter. Musée des Beaux-Arts,
Nantes (1953/30, as attr. to Caracciolo). 129 × 154.
Benoist, 1961, illus.

VOLMARIJN, Crijn Hendricksz. (*c.* 1604–1645)

Rotterdam painter and art dealer, active in the 1630's, influenced by Honthorst and G. Seghers. All
works listed. G followed by stroke and Fig. number refers to Gudlaugsson, 1952.

Christ and Nicodemus. Bukowski sale, Stockholm,
5–8 Nov. 1958 (217), illus. as Honthorst. 89 × 112.
? inscribed G.H.P. U.
Christ and Nicodemus. Ten Cate Collection,
Hilversum (1952). Panel, 73 × 108. S & D 1631.
G/Fig. 2.
Christ and Nicodemus. Formerly Antwerp Art
Market, as Stomer. ?Panel, 77 × 93. U.
Christ at Emmaus. Van de Wall Repelaer Collection,
Dordrecht (1906). Panel, *c.* 160 × 120. S & D 1631.
G/Fig. 1.
Christ at Emmaus. Ferens Art Gallery, Kingston
upon Hull. Panel, 90.1 × 121.9. S & D 1632. *Burl.
Mag.*, Nov. 1966, Fig. 70.
Christ at Emmaus. Sale, Fred. Muller, Amsterdam,
5 Nov. 1940 (26). Panel, 88 × 124. S & D 1637.
G/Fig. 3.
Teacher instructing his Pupils [Plate 174]. Ninian

Brodie of Brodie Collection, Brodie Castle, Forres
(Morayshire). 87.6 × 113.
Child dressed up as a Monk, with Skull [Plate 172].
Galleria Nazionale, Parma (1968/106, illus. as ?Vol-
marijn). 59.5 × 54. U.

The following is by an imitator of Volmarijn:

Christ at Emmaus. J. Schenaerts Collection, Eind-
hoven (1952) as Jan de Bray. Panel, 91 × 124.

The following is a selection of wrong attributions to
Volmarijn:

Honthorst workshop **Christ at Emmaus.** Wadsworth
Atheneum, Hartford (Conn.).
Honthorst workshop **Gamblers.** Wiesbaden Museum.
Adam de Coster **Boy blowing on Firebrand.**
Formerly Busiri Vici Collection, Rome.
All Bigots illustrated with question-mark by Judson,
Volmarijn, 1955, Figs. 1–8.

VOUET, Simon (Jan. 1590–June 1649)

Born in Paris. Pupil of his father in Paris. Travels to London (?*c.* 1605), Constantinople (Nov. 1612) and
Venice (1612–13), arriving in Rome winter 1613–14. In Rome more or less continuously 1615–20, in the
latter year living with his brother Aubin. In Genoa in service of the Doria family from 1620 to autumn
1621. On return to Rome: early in 1622 living with Travers or Traivoel (q.v.); 1623 probably with
Mellin; 1624 with Tuscans like Riminaldi (q.v.) and also with de Lestin (q.v.), Jacques and Jean Lhomme
and Poussin. Recognized as leader of the French Colony, and *principe* of Academy of St Luke (Oct.
1624), a post which he retains until his departure from Rome in 1627. Living with engraver Claude
Mellan, mid-1620's. In Venice again, late summer 1627; before the end of that year back for good in
Paris, where he becomes the leading painter. Vouet moves from a Borgianni-like Caravaggism *c.*
1614–20 in the direction of Lanfranco and the Bolognese, in the process gravitating towards the sophisti-
cated circles of the Barberini and Cassiano dal Pozzo, both generous patrons. Only part of his activity
during his first ten years is therefore listed and there are many borderline cases from 1622 to 1626. DT
followed by stroke, catalogue and plate numbers refers to Dargent/Thuillier, 1965; C followed by stroke,
catalogue and Fig. numbers, to Crelly, 1962.

Sophonisba receiving the Poison Cup. Schloss
Wilhelmshöhe, Cassel (1958/571). 127 × 158. C/No.
43, Fig. 24. Three copies recorded: **1.** Sanssouci,
Potsdam (1964/116, as Vouet). 121 × 170. **2.** Lechi
Collection, Brescia. **3.** Head of male figure only: sale,
Weinmüller, Munich, 22 Oct. 1969 (698), illus,

David with the Head of Goliath. Palazzo Bianco,
Genoa (1953, p. 14). 132 × 102. 1620–1. C/No. 36,
Fig. 10.
David with the Head of Goliath. Gaston Palewski
Collection, Paris. 97 × 73. U. DT/No. V16, Pl. 44.
King David harping [Plate 234]. Bob Jones Univer-

sity, Collection of Sacred Art, Greenville (SC) (1962/99). 93.3 × 120.3. U.

Judith with the Head of Holofernes, with Servant [Plate 238]. Private Collection, Genoa. 131 × 105 (enlarged from *c.* 110 × 97). 1620–1. Rome/Paris, 1974, Fig. 24. Pendant to *St Catherine* (q.v.). Four copies known: **1.** William Rockhill Nelson Gallery of Art, Kansas City (Missouri). 117.8 × 97.5. **2.** Musée Crozatier, Le Puy. 116 × 90. BP. DT/No. V9, Pl. 23. **3.** Slezske Museum, Opava (Troppau). 117 × 77. Cut on right. **4.** With Galerie Hofstatter, Vienna (before 1974).

Judith with the Head of Holofernes. Kunsthistorisches Museum, Vienna (1973, illus. Pl. 141). 115 × 86. U. DT/No. A5, Pl. 10.

Judith with the Head of Holofernes. Bayerische Staatsgemäldesammlung, Munich (1957/2279). 96 × 72. U. C/No. 70, Fig. 29.

Birth of the Virgin. S. Francesco a Ripa, Rome. 217 × 329. C/No. 127, Figs. 13, 14. *Sibyls* in pendentives. Frescoes. A. BP. DT/Pls. 20, 21.

Mater Dolorosa [Plate 222]. Formerly Tomás Harris Collection, London. 70 × 51.5.

Angels with Symbols of the Passion (two canvases). Museo di Capodimonte, Naples (1963/71, 72, both illus.). Each 102 × 76. C/No. 80, Figs. 3, 4. Studio variant of one of these: Dr Alfred Bader Collection, Milwaukee. Canvas stuck to panel, small.

St Agatha visited by St Peter in Prison. Damaged original or copy is: Estate of Hamilton Smith III, Old Greenwich (Conn.). 129.8 × 183.2. Spear, 1971 (75), illus. Three copies known: **1.** Museum, Trapani. **2.** With Christopher Gibbs, London (1974). **3.** With Julius Weitzner, London (1974).

St Catherine. Private Collection, Genoa. 132 × 100 (enlarged from 108 × 95). S & D 1621. Rome/Paris, 1974, Fig. 23. Pendant to *Judith* in same collection (q.v.).

St Catherine. With Victor Spark, New York (1971). 101.6 × 78.7. BP. DT/No. D8, Pl. 74.

Investiture of St Francis; Temptation of St Francis (two canvases). Alaleona Chapel, S. Lorenzo in Lucina, Rome. Each 185 × 252. Frescoes in cupola, pendentives and two lateral lunettes. All 1623–4. C/No. 128, Figs. 17–20 (lateral canvases); Fig. 16 (general view of the vault). Schleier, *Vouet*, 1971, Fig. 6 (*St John the Evangelist*). Schleier, *Burl. Mag.*, 1972, Fig. 46 (*Two Angels*); Fig. 47 (*Assumption*). DT/No. A18, Pl. 37 (*Visitation*).

St Jerome and the Angel. National Gallery of Art, Washington (DC), Kress Collection (1975/1415, illus.; Kress Catalogue, 1977/K1891, illus.) 144.8 × 179.8. C/No. 153, Fig. 25. One copy recorded: Sale, Brussels, 19 Oct. 1966 (980) as Guercino. C said to be at Chambéry.

Herodias. Galleria Nazionale d'Arte Antica, Rome. 82 × 122. Probably A. C/No. 133, Fig. 30. Variant of lost Vouet engraved anonymously, published by Lagniet, DT/No. A28, Pl. 49. One copy known: Pinacoteca, Bologna.

Herodias or **Salome.** Lost. Engraved by Claude Mellan, DT/No. A30, Pl. 52.

Conversion of the Magdalen. Kunsthistorisches Museum, Vienna (1973, illus. Pl. 141). 110 × 139. DT/No. D11, Pl. 78. Two copies known: **1.** University of Glasgow, Hunterian Collection, as Italian School, 17th century. Copper, 19 × 26. **2.** Once loaned by Mrs H. Taylor to Smithsonian Institution, Washington (DC), as Régnier. Moir, 1976, Fig. 32.

St Martha; St Ursula (two canvases). Wadsworth Atheneum, Hartford (Conn.). Each 99.1 × 74.3. Griseri, 1961, both illus.

Portrait of Giancarlo Doria. Formerly Doria Collection, Genoa, 1620. Engraved by Michel Lasne after drawing, DT/No. A8, Pl. 22.

Portrait of Marcantonio Doria. With Gilberto Algranti, Milan (1974). 129 × 95. 1621. Rome/Paris, 1974 (68), illus.

Self Portrait. Musée Réattu, Arles. 63.8 × 48.3. Rome/Paris, 1974 (65), illus.

Self Portrait. Florentine Galleries. Oval, 65 × 55. BP. Exh. 'French Painting', Palazzo Pitti, 1977 (1) illus. DT/No. V17, Fig. 55. Engraving by P. A. Pazzi after drawing by G. D. Ferretti, *c.* 1750. C in Musée de Picardie, Amiens. 64 × 51. BP. DT/No. V17, Fig. 56.

Male Portrait. Galleria Pallavicini, Rome (1959/534, illus.) 62.8 × 49.1. Rome/Paris, 1974, Fig. 22.

Male Portrait [Plate 232]. Mr & Mrs J. McMicking Collection, San Francisco. 56 × 43.8.

Male Portrait. Earl Spencer Collection, Althorp House (Garlick, 1976/675 as attributed to Vignon). 76 × 59. Rome/Paris, 1974 (59), as Vignon.

Male Portrait. Mr and Mrs Harry H. Weldon Collection, New York. 76.8 × 61. Spear, 1971 (74), illus.

Guitarist. Patrizi Collection, Rome. 107 × 75. C/No. 136, Fig. 7.

Fortune-Teller. National Gallery of Canada, Ottawa (1957/6737, illus.). 120 × 170. Rome/Paris, 1974 (64), illus. Two copies recorded: **1.** Formerly F. Leclerc Collection, Orléans (?18th century); **2.** Formerly Private Collection, Rome (repetition of top part of left hand figure only), Longhi, 1955, Pl. 30. Two engravings known: **1.** Anon. 17th century (in reverse), DT/Pl. 14; **2.** Boerner Sale, Leipzig, 22 May 1933 (Cat. 181, No. 36, illus.) (leering figure second from left only (in reverse), in company of tambourine player, the original of which (103 × 81.5), whereabouts unknown, is in direction of Crabeth).

Two Lovers. Galleria Pallavicini, Rome (1959/533, illus.). 97.6 × 136. BP. C/No. 134, Fig. 5. Two copies recorded: **1.** Pinacoteca Civica, Faenza; **2.** Musée des Beaux-Arts, Nantes, 87 × 102. Etched in reverse by Claude Vignon, 1618, DT/Pl. 7.

Man making obscene Gesture. Lost. One copy known: Musée des Beaux-Arts, Caen. DT/No. V5, Pl. 9.

Halberdier. Musée National des Beaux-Arts, Algiers (1936/1725, illus.). On loan to Louvre. 115 × 92. C/No. 1, Fig. 32. Four replicas (status of some uncertain) recorded: **1.** Marqués de Casa Torres Collection, Madrid (before second world war); **2.** Museum, Gubbio; C; **3.** Musée des Beaux-Arts, Rouen (1966 (141), illus. as after Vouet), 103 × 85; **4.** Private Collection, Brussels.

Halberdier. Dayton Art Institute, Dayton (Ohio). 104.1 × 82.3. C/No. 84, Fig. 31.

'Bravo'. Herzog Anton Ulrich-Museum, Brunswick (1976/497, illus.). 74 × 58. C/No. 13, Fig. 2. Four copies recorded: **1.** Musée des Beaux-Arts, Tours, 84 × 69; **2.** Whereabouts unknown, 36 × 24, with false Vermeer signature and date 1675; **3.** Jos. Schrader Collection, Cologne (1934), 81 × 66; **4.** Kupferstich-kabinett, Berlin (No. 26039) (drawing of head only). Engraved in reverse by Charles David, DT/Pl. 4.

The following is a selection of pictures by unidentified imitators of Vouet, reflecting his Caravaggesque phase:

Vanitas. Muzeum Narodowe, Warsaw. 100 × 75. Exh. Bordeaux, 1961 (130), illus.

Joseph and Potiphar's Wife. Fogg Art Museum, Harvard University, Cambridge (Mass.), Kress Gift. 231.7 × 194.9. Kress 1973 catalogue (K1690), illus. as attr. to Artemisia Gentileschi.

David with the Head of Goliath [Plate 239]. Sale, Sotheby's 12 July 1972 (77). 134 × 98. In direction of Régnier.

Herodias. Bob Jones University, Collection of Sacred Art, Greenville (SC) (1961). Variant of DT/No. A28 above.

Salome. Heim Gallery, Paris (1968); sale, Sotheby's, 10 July 1974 (97), illus. 132 × 96.

Portrait of a Young Man. Galleria Estense, Modena (1945/103, illus. as Ludovico Lana). 63 × 51. One copy recorded: Istituto d'Arte A. Venturi, Modena.

Male Portrait. Hampton Court Palace. 89 × 70. Blunt, 1946, p. 270, Pl. 1B.

Tambourine Player. Musée Municipal, Lons-le-Saunier. 88 × 76. BP. Hoog, 1960, Fig. 9.

Head of a Girl. With Agnew's, London (1967); ex-Cook Collection (1913/201). 61 × 44. F. In direction of Mellan.

One portrait (by a close Vouet follower in Rome, doubtless French), may conceivably turn out to be an early phase of Lestin (q.v.):

Portrait of a Man. [Plate 231]. With Colnaghi's, London (1956).

The following is a selection of wrong attributions to the young Vouet:

★ ? Werner van Valckert **Homer.** With Galerie Rudolph Schmidt, Berlin (1927), as unknown, *c.* 1700. 77 × 63. Brejon/Cuzin, 1974, Fig. 14. A replica in the Walters Art Gallery, Baltimore, panel, 72.1 × 56.8, D 1639, is ascribed by Bauch to Valckert.

'Giusto Fiammingo' **David.** Abbazia, Cava dei Tirreni.

'Giusto Fiammingo' **Angels with the Symbols of the Passion** (six canvases). Galleria Pallavicini, Rome.

Caravaggio (copy) **Conversion of the Magdalen.** Christ Church, Oxford.

Henry Traivoel **Portrait of a Young Man.** Private Collection, Neuilly-sur-Seine.

Plates

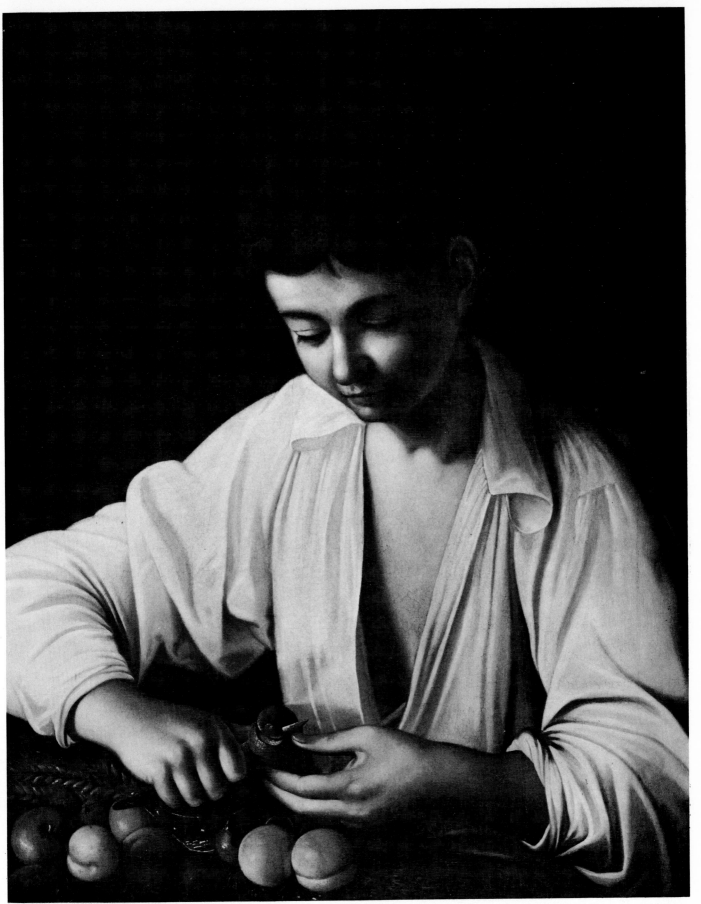

I. CARAVAGGIO: *Boy peeling a bitter Fruit*. Private Collection, England (1978)

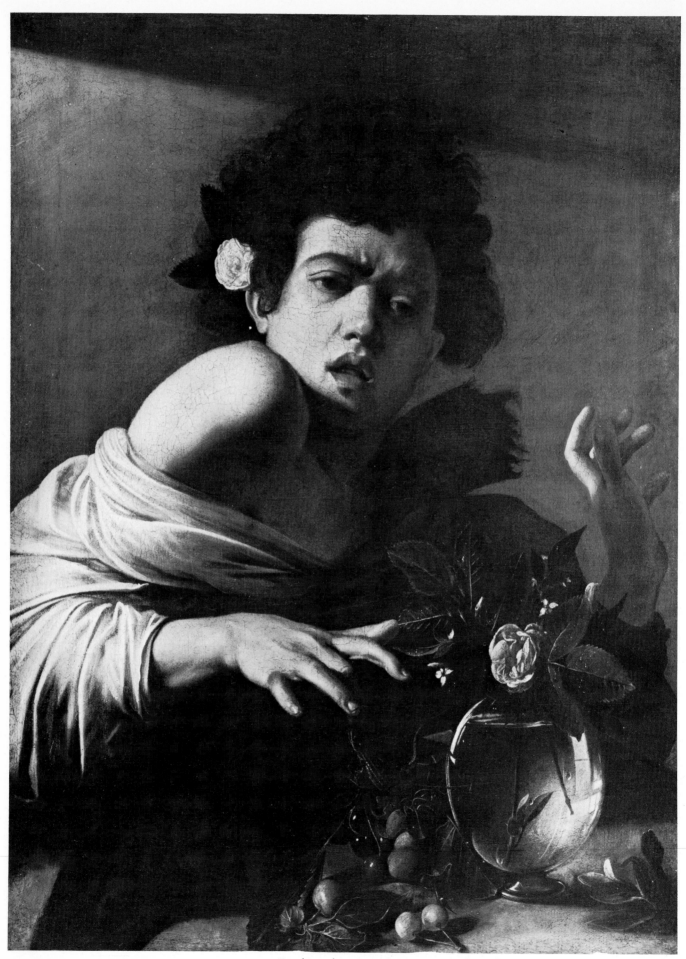

2. ATTRIBUTED TO CARAVAGGIO: *Boy bitten by a Lizard*. Vincent Korda Collection, London

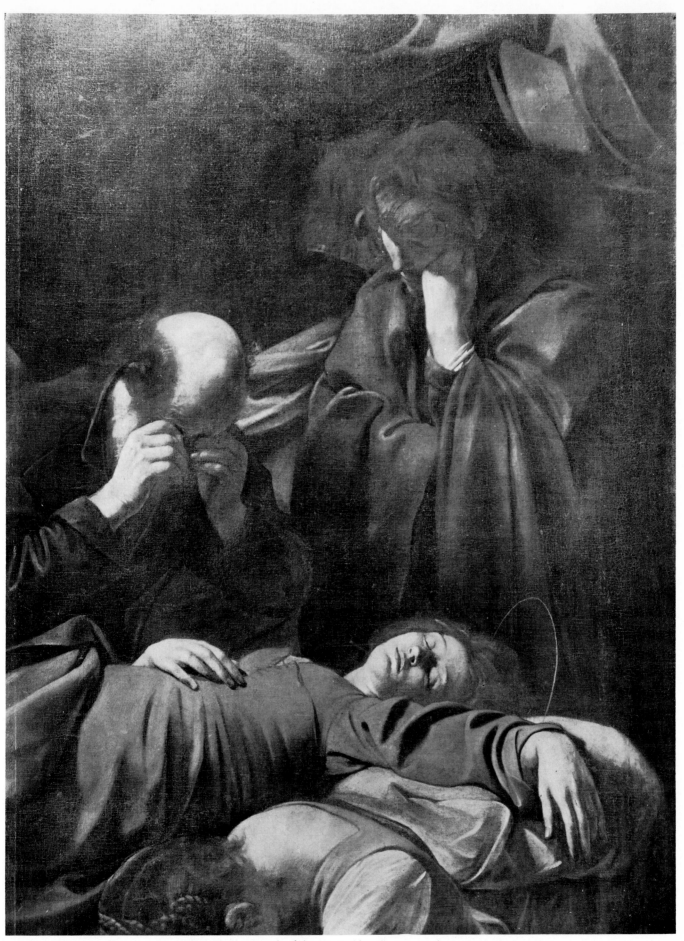

3. CARAVAGGIO: *Death of the Virgin* (detail). Musée du Louvre, Paris

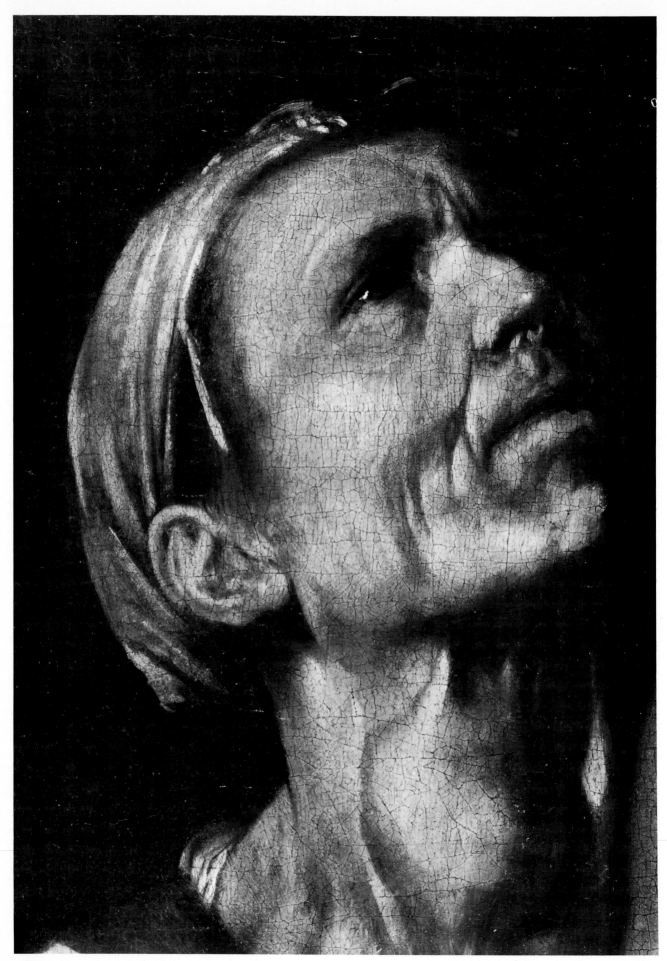

4. CARAVAGGIO: *Crucifixion of St Andrew* (detail). Cleveland Museum of Art

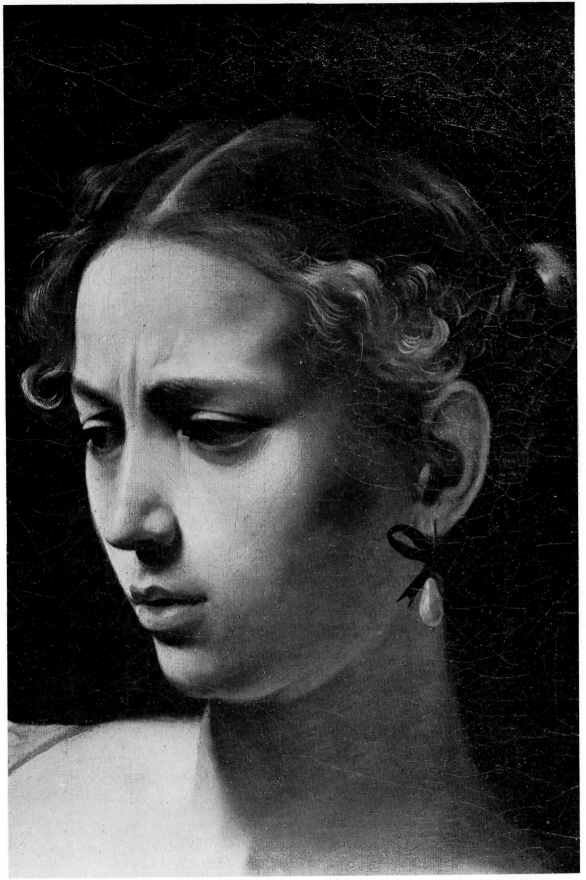

5. CARAVAGGIO: *Judith and Holofernes* (detail). Galleria Nazionale d'Arte Antica, Palazzo Barberini, Rome

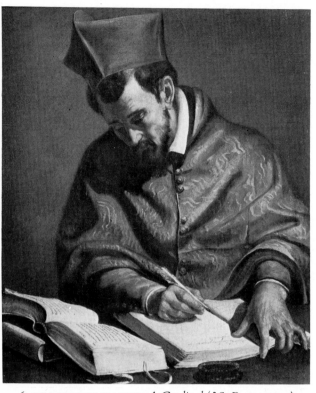

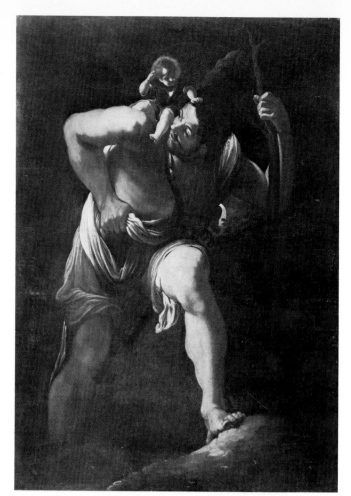

6. ORAZIO BORGIANNI: *A Cardinal (?St Bonaventura)*.
Formerly Morris Kaplan Collection, Chicago

7. ORAZIO BORGIANNI: *St Christopher*.
Private Collection, England (1978)

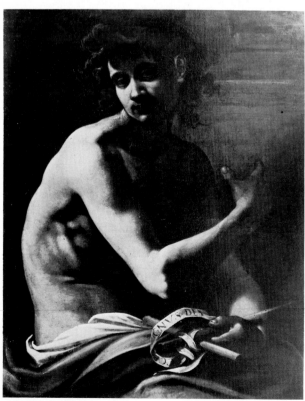

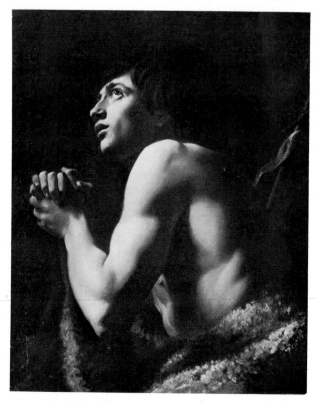

8. CARAVAGGESQUE UNKNOWN (ROMAN-BASED):
St John the Baptist. Galleria Nazionale d'Arte Antica, Rome

9. CARAVAGGESQUE UNKNOWN (ROMAN-BASED):
St John the Baptist. With David Peel, London (1977)

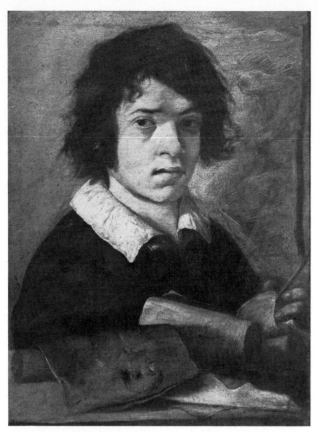

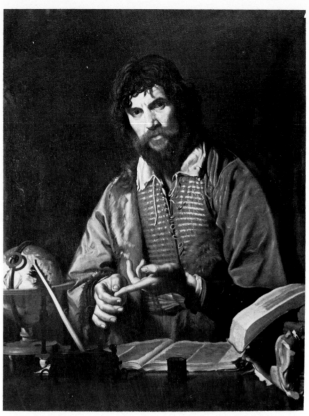

10. CARAVAGGESQUE UNKNOWN (ROMAN-BASED):
Self-Portrait of a Youth of about 17. Private Collection, London

11. CARAVAGGESQUE UNKNOWN (ROMAN-BASED):
Portrait of a Scholar. Norton Simon Foundation, Los Angeles

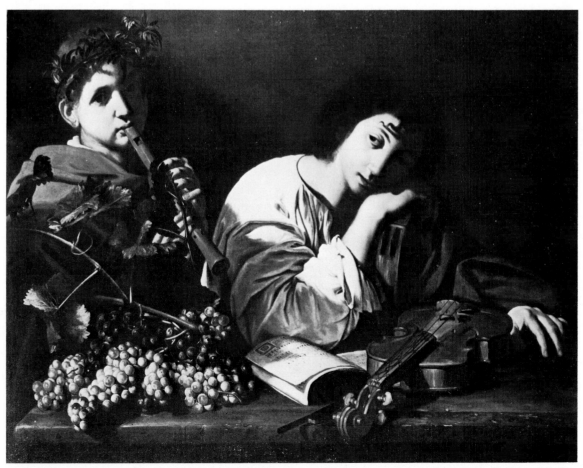

12. CARAVAGGESQUE UNKNOWN (ROMAN-BASED): *Two Musicians.* Franco Piedimonte Collection, Naples

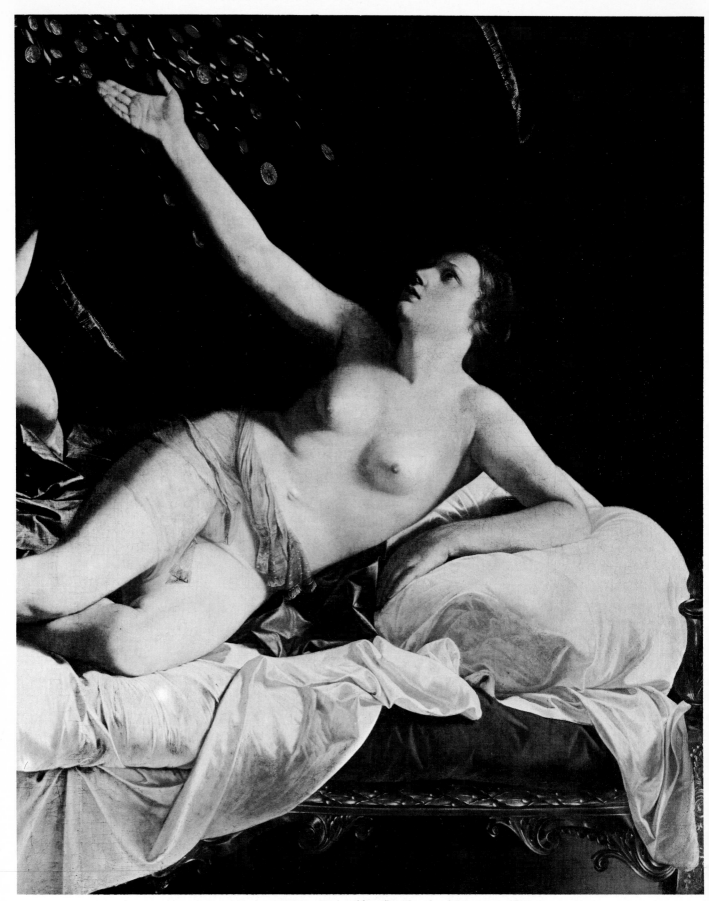

13. ORAZIO GENTILESCHI: *Danaë* (detail). Cleveland Museum of Art

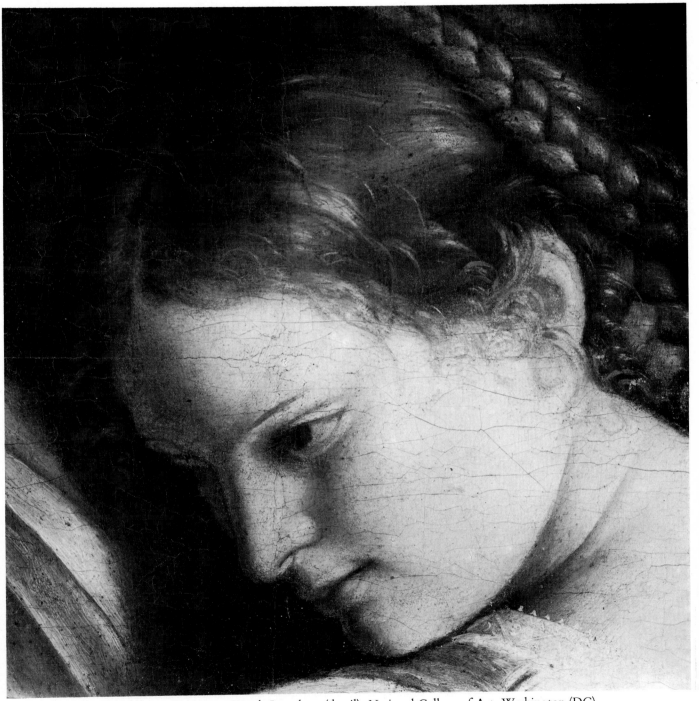

14. ORAZIO GENTILESCHI: *Female Luteplayer* (detail). National Gallery of Art, Washington (DC)

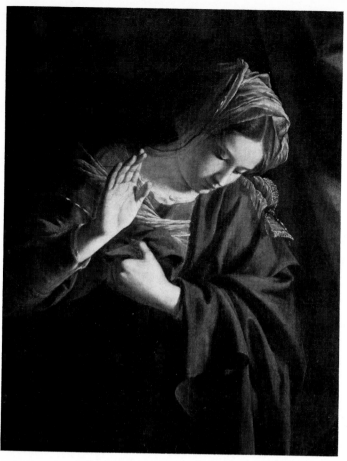

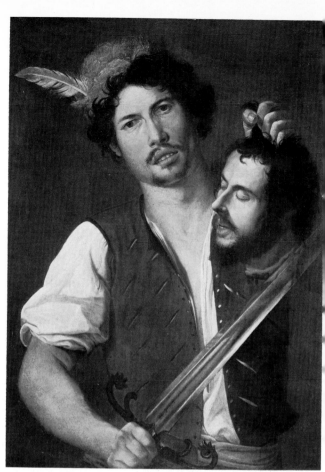

15. ORAZIO GENTILESCHI: *Annunciation* (detail).
Galleria Sabauda, Turin

16. ORAZIO GENTILESCHI: *Executioner with the Head of
St John the Baptist*. Museo del Prado, Madrid

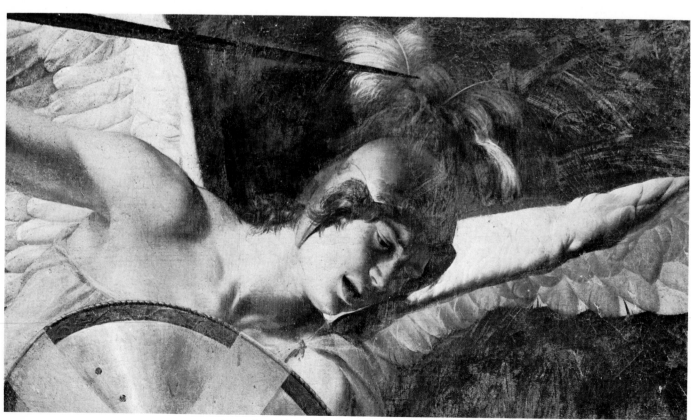

17. ORAZIO GENTILESCHI: *St Michael the Archangel overcoming the Devil* (detail). San Salvatore. Farnese

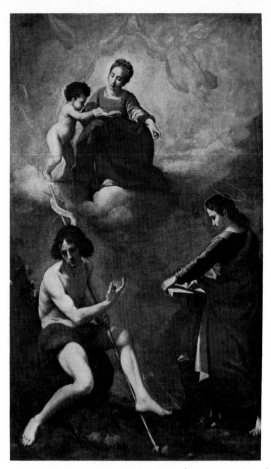

18. ORAZIO GENTILESCHI: *Decorative Scheme*. Casino delle Muse, Palazzo Rospigliosi-Pallavicini, Rome

19. CARAVAGGESQUE UNKNOWN (ROMAN-BASED): *Madonna in Clouds with Saints John the Baptist and John the Evangelist*. Parish Church, Torri in Sabina

20. ORAZIO GENTILESCHI: *Decorative Scheme*. Casino delle Muse, Palazzo Rospigliosi-Pallavicini, Rome

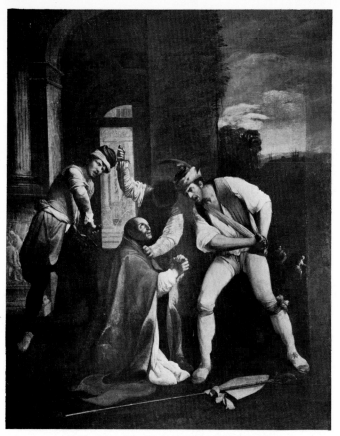

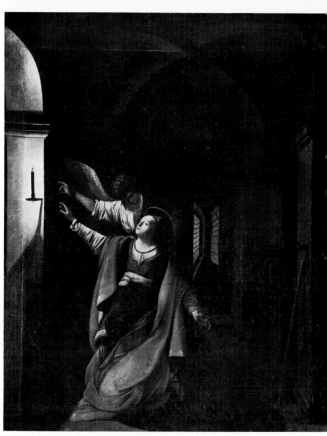

21. CARLO SARACENI: *Martyrdom of St Eugene.*
Cathedral, Toledo (Spain)

22. CARLO SARACENI: *St Leocadia in Prison.*
Cathedral, Toledo (Spain)

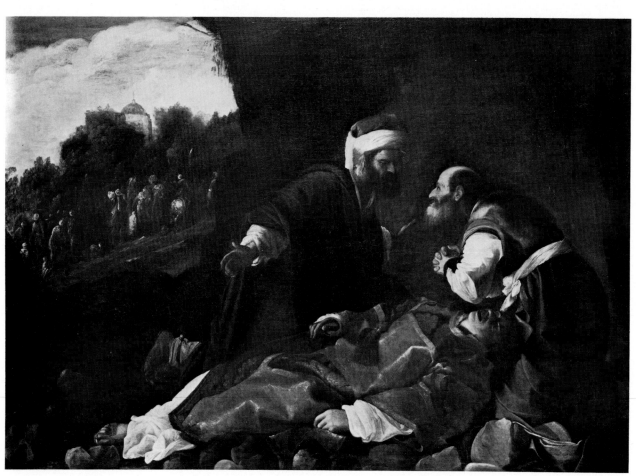

23. CARLO SARACENI: *Burial of St Stephen.* Formerly Duke of Northumberland Collection, Alnwick Castle

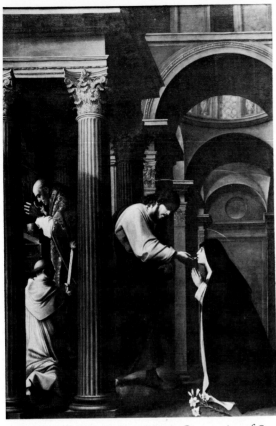

24. PHILIPPE QUANTIN: *Mystic Communion of St Catherine of Siena*. Musée des Beaux-Arts, Dijon

25. PHILIPPE QUANTIN: *St Bernard*. Musée des Beaux-Arts, Dijon

26. PHILIPPE QUANTIN: *Adoration of the Shepherds*. Musée des Beaux-Arts, Dijon

28. CARLO SELLITTO: *David with the Head of Goliath.*
National Gallery, Salisbury (Rhodesia)

27. CECCO DEL CARAVAGGIO: *Resurrection* (detail). Art Institute of Chicago

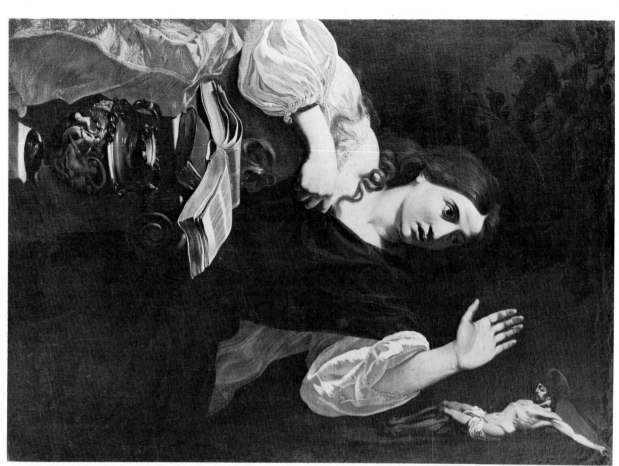

29. CECCO DEL CARAVAGGIO: *Penitent Magdalen.*
Städtische Kunstsammlungen, Augsburg

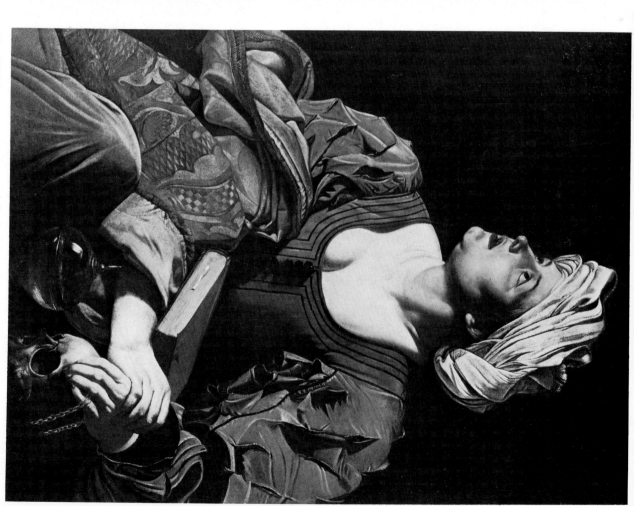

30. CECCO DEL CARAVAGGIO: *Penitent Magdalen.* With Silvano Lodi, Munich (1969)

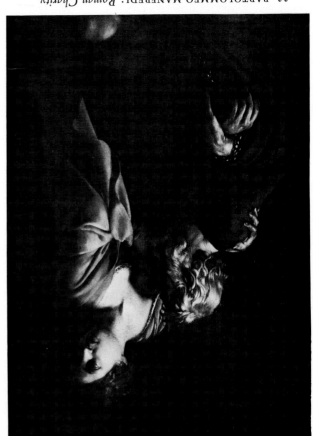

33. BARTOLOMMEO MANFREDI: *Roman Charity.*
Private Collection, Milan (1968)

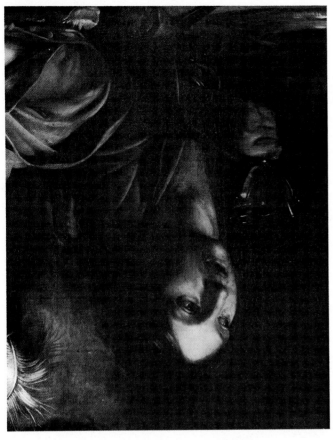

34. BARTOLOMMEO MANFREDI: *Concert, Eating and Drinking
Party* (detail). With Trafalgar Galleries, London (1976)

31. BARTOLOMMEO MANFREDI: *Female Tambourine
Player.* Marchese de Mari Collection, Florence (1960)

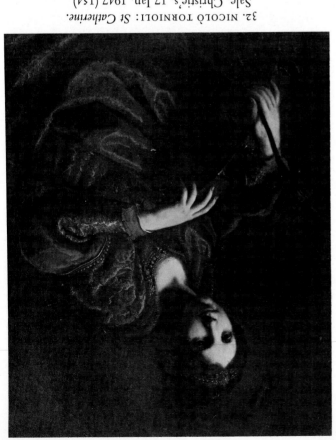

32. NICOLÒ TORNIOLI: *St Catherine.*
Sale, Christie's, 17 Jan. 1947 (154)

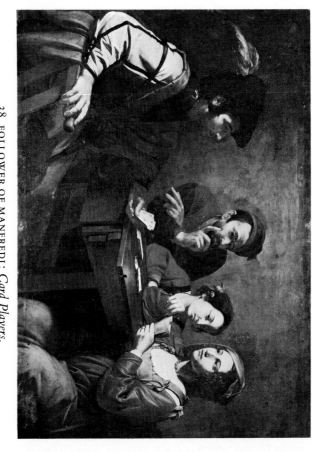

38. FOLLOWER OF MANFREDI: *Card Players.*
Gemäldegalerie, Dresden

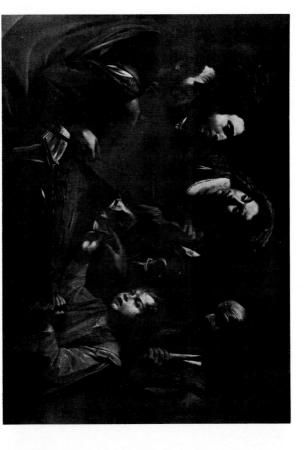

40. FOLLOWER OF MANFREDI: *Concert.*
Hessisches Landesmuseum, Darmstadt

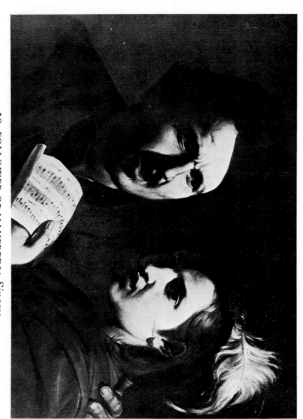

39. FOLLOWER OF MANFREDI: *Singers.*
Formerly Modiano Collection, Bologna

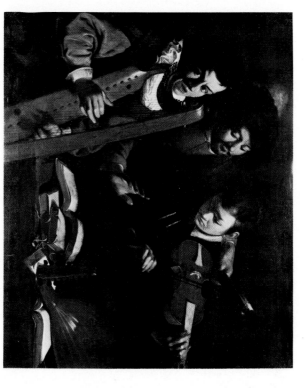

41. FOLLOWER OF MANFREDI: *Concert.*
Bayerische Staatsgemäldesammlung, Munich

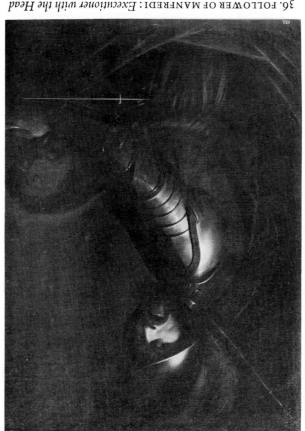

36. FOLLOWER OF MANFREDI: *Executioner with the Head
of St John the Baptist*, Museo del Prado, Madrid

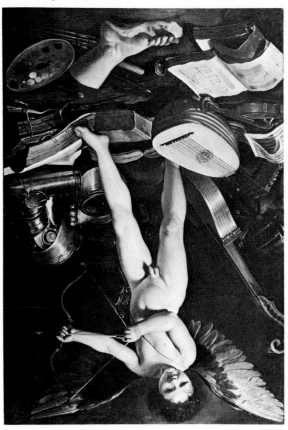

37. ORAZIO RIMINALDI: *Love Triumphant*,
National Gallery of Ireland, Dublin

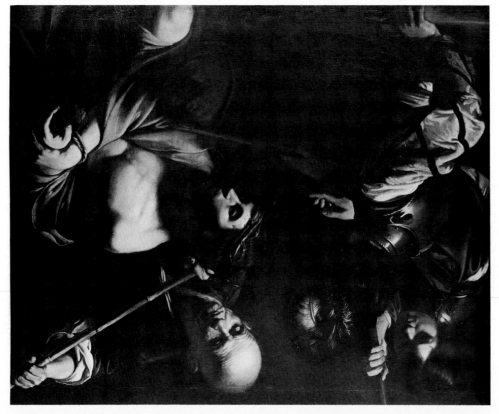

35. NICOLAS RÉGNIER AFTER MANFREDI: *Crowning with Thorns*,
With Silvano Lodi, Munich (1972)

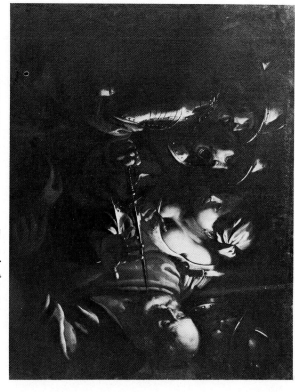

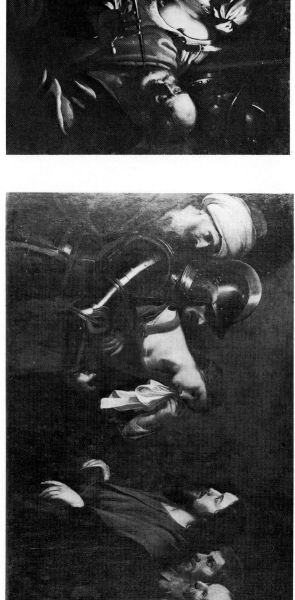

42. FOLLOWER OF MANFREDI: *Denial of St Peter.*
Musée des Beaux-Arts, Nantes

43. CLOSE TO MANFREDI: *Christ and the Adulteress.*
Musée des Beaux-Arts, Brussels

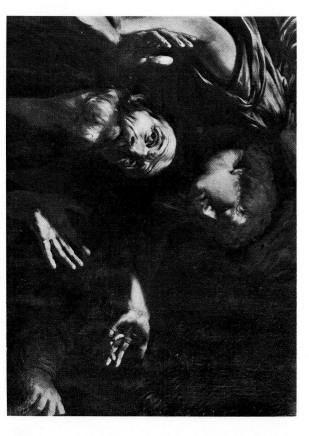

44. FOLLOWER OF MANFREDI: *Liberation of St Peter* (detail).
Ing. Giuseppe De Vito Collection, Milan

45. FOLLOWER OF MANFREDI: *Denial of St Peter.*
Marquess of Exeter Collection, Burghley House, Stamford

47. GIOVANNI SERODINE: *Meeting of St Peter and St Paul* (detail).
Galleria Nazionale d'Arte Antica, Rome

46. ATTRIBUTED TO SERODINE: *Five Heads*. Vassar College Art Gallery, Poughkeepsie (New York)

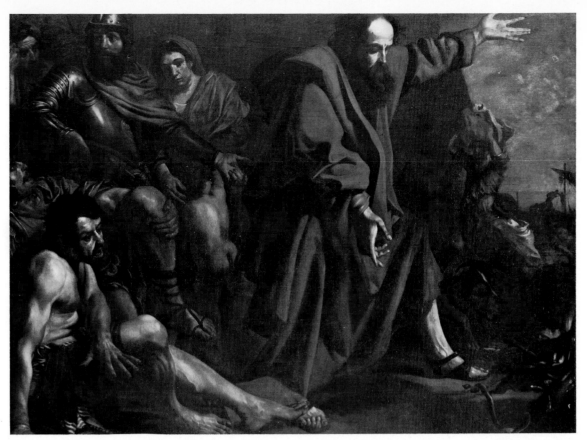

48. VALENTIN: *St Paul destroying the Serpent*. Sale, Christie's, 6 Nov. 1953 (103)

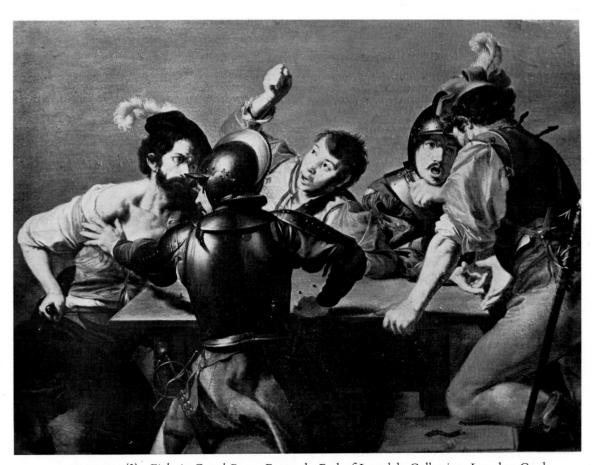

49. VALENTIN(?): *Fight in Guard-Room*. Formerly Earl of Lonsdale Collection, Lowther Castle

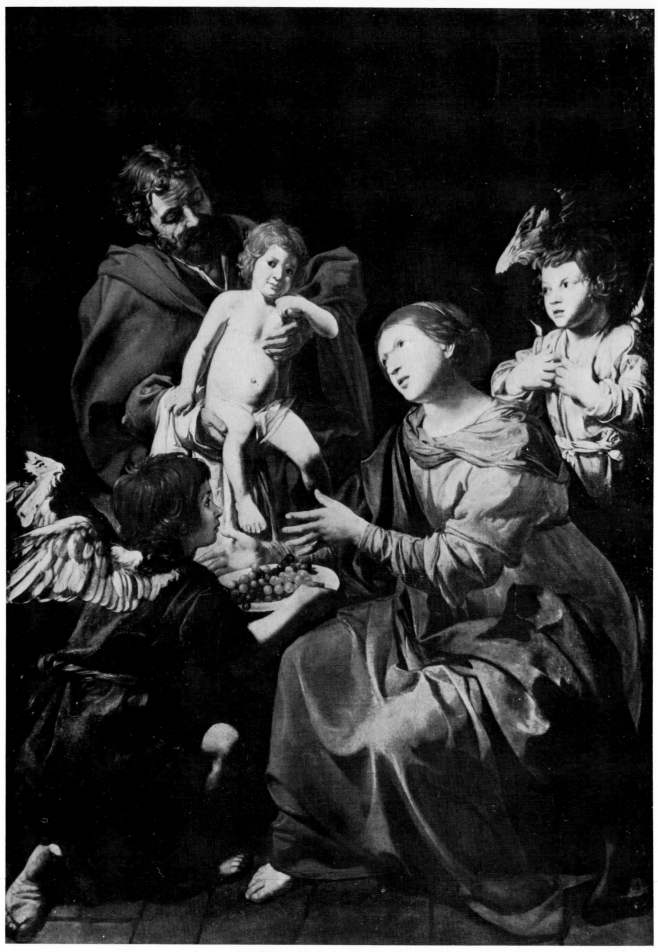

50. VALENTIN: *Holy Family with Two Angels*. Madrid Art Market

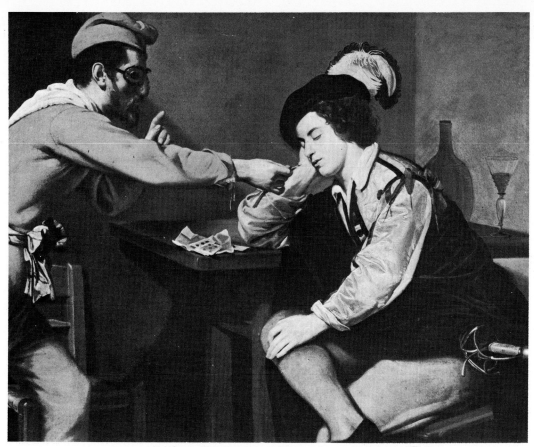

54. NICOLAS RÉGNIER: *Sleeper being awakened through Nose by lit Wick.*
Musée des Beaux-Arts, Rouen

55. Detail from Plate 50

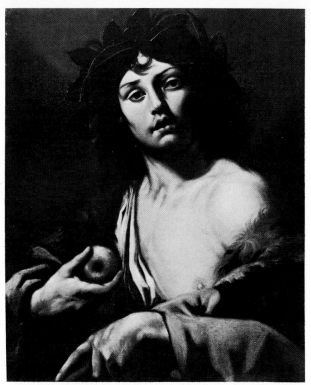

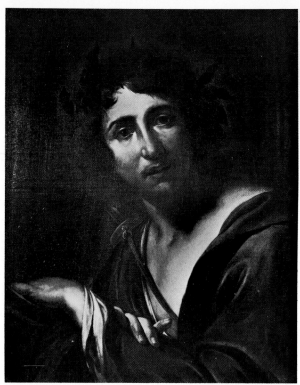

51. FOLLOWER OF VALENTIN: *Youth crowned with Laurel.*
With estate of T. P. Grange, London (1977)

52. FOLLOWER OF VALENTIN: *Youth crowned with Laurel.*
Musée des Beaux-Arts, Nantes

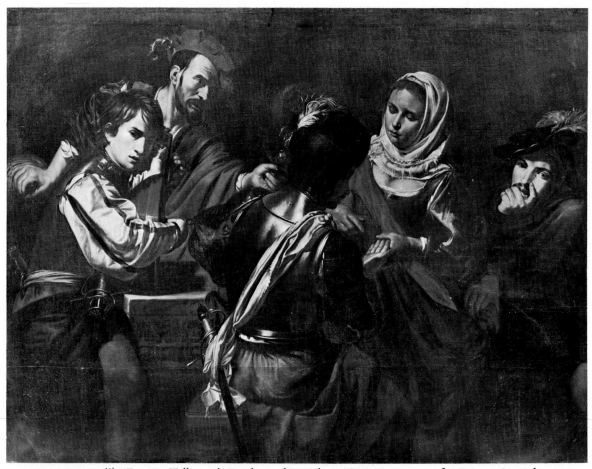

53. VALENTIN(?): *Fortune-Teller with Drinker and Luteplayer.* Statens Museum for Kunst, Copenhagen

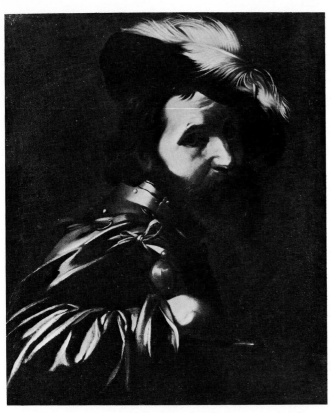

65. MASTER J: *Soldier resting his Arm on Sword Hilt.*
Sale, Finarte, Milan, 6 May 1971 (8)

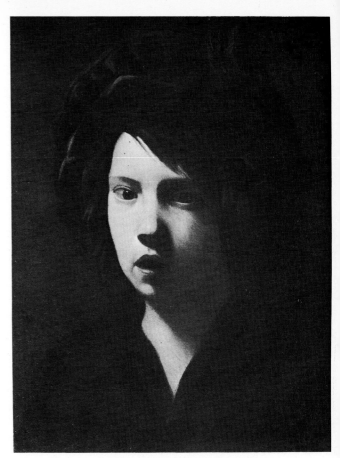

66. MASTER K: *Head of Boy.*
Wadsworth Atheneum, Hartford (Conn.)

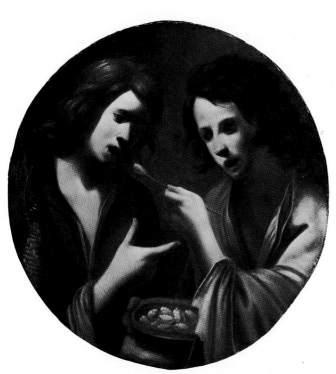

67. MASTER K: *Esau selling his Birthright.*
With Hazlitt Gallery, London (1967)

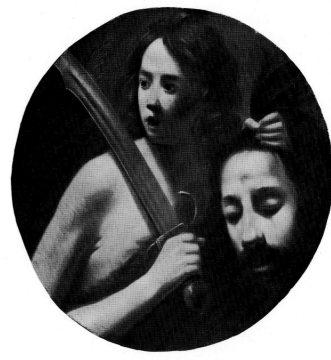

68. MASTER K: *David with the Head of Goliath.*
With Hazlitt Gallery, London (1967)

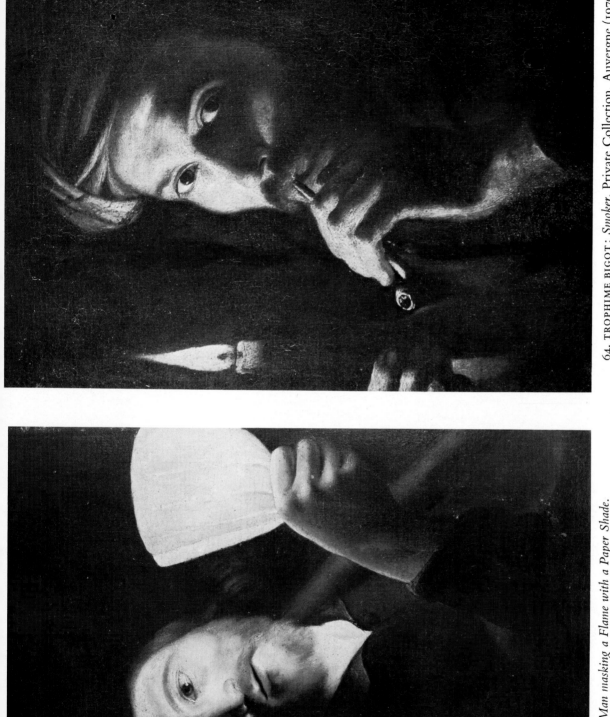

63. TROPHIME BIGOT: *Man masking a Flame with a Paper Shade.*
Dr Alfred Bader Collection, Milwaukee

64. TROPHIME BIGOT: *Smoker.* Private Collection, Auvergne (1970)

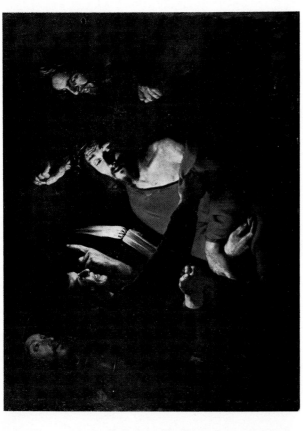

60. TROPHIME BIGOT: *Mocking and Crowning with Thorns*.
M. Chappert Collection, Montpellier (1971)

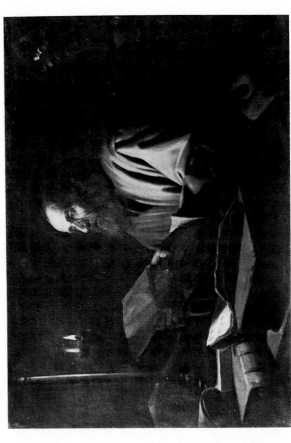

62. CIRCLE OF BIGOT: *St Luke*.
Musée d'Art et d'Histoire, Chambéry

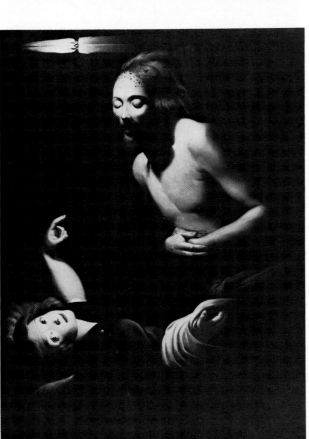

59. TROPHIME BIGOT: *Angel watching over the Dead Christ*.
La Salle College, Philadelphia

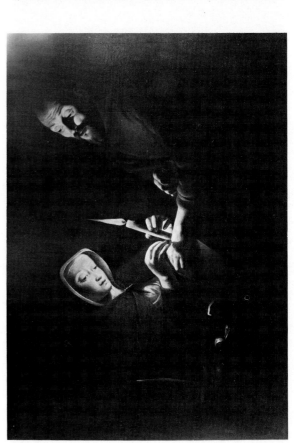

61. TROPHIME BIGOT: *St Francis and St Clare*.
Guglielmo Maccaferri Collection, Bologna

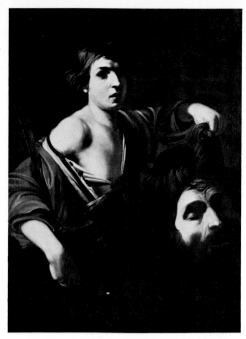

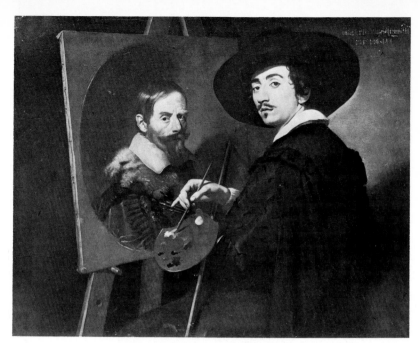

56. AFTER NICOLAS TOURNIER: *David with
the Head of Goliath.* Formerly Duca d'Aosta
Collection, Turin

57. NICOLAS RÉGNIER: *Self-Portrait.*
New York Art Market (1942)

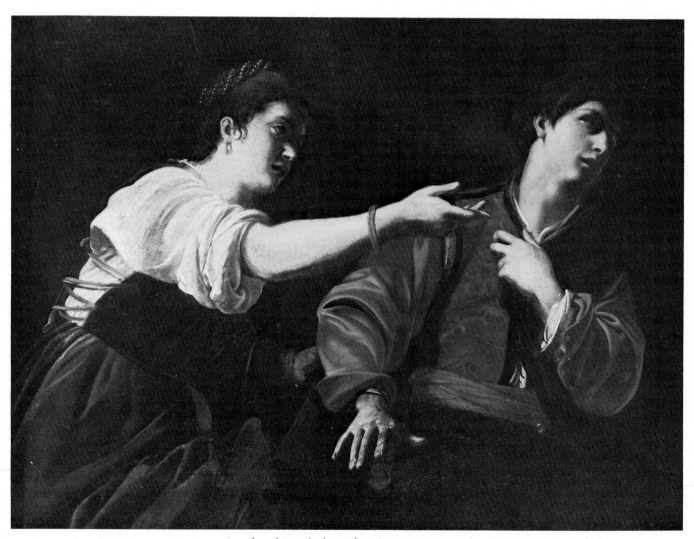

58. NICOLAS TOURNIER: *Joseph and Potiphar's Wife.* Sale, Lempertz, Cologne, 14 Nov. 1963 (64)

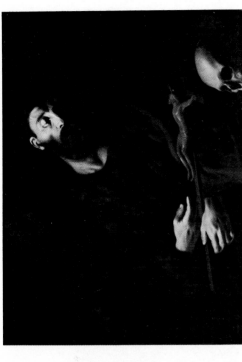

72. CARAVAGGESQUE UNKNOWN (FRENCH): *Luteplayer*.
With E. Speelman, London (1973)

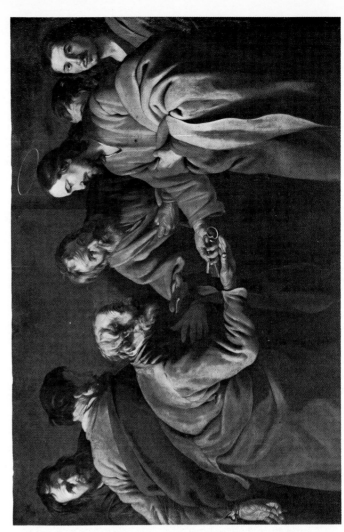

73. CARAVAGGESQUE UNKNOWN (FRENCH?): *St Francis and
the Angel*. With J. Dumont, Paris (1973)

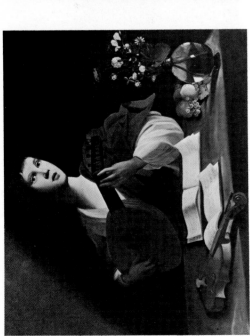

74. CARAVAGGESQUE UNKNOWN (FRENCH?): *Denial of St Peter*.
Musée des Beaux-Arts, Rouen

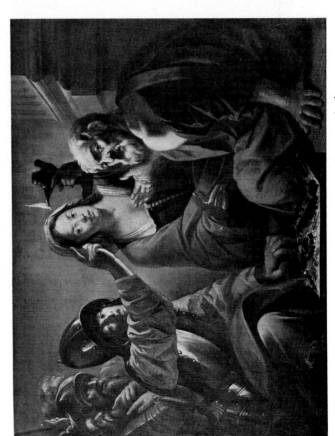

75. CARAVAGGESQUE UNKNOWN (FRENCH?): *Christ handing over the Keys to St Peter*.
With Galerie Pardo, Paris (1977)

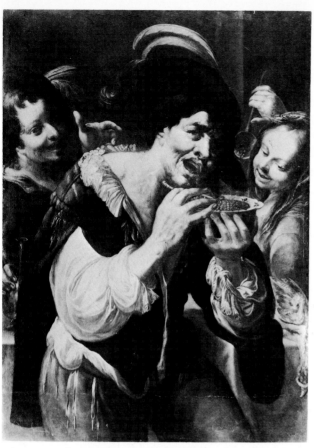

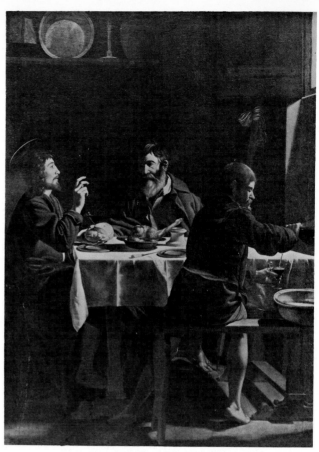

69. CLAUDE VIGNON: *Man eating.*
Muzeum Narodowe, Warsaw

70. CARAVAGGESQUE UNKNOWN (FRENCH):
Christ at Emmaus. Musée des Beaux-Arts, Nantes

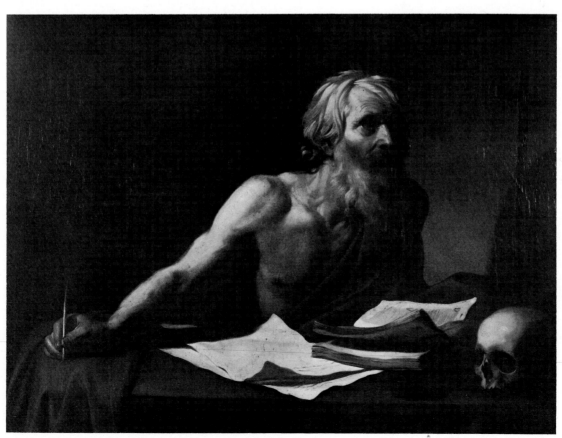

71. CARAVAGGESQUE UNKNOWN (FRENCH?): *St Jerome.* Galleria Corsini, Florence

76. CARAVAGGESQUE UNKNOWN (NEAPOLITAN): *Christ at Emmaus* (detail). J. Paul Getty Museum, Malibu (Calif.)

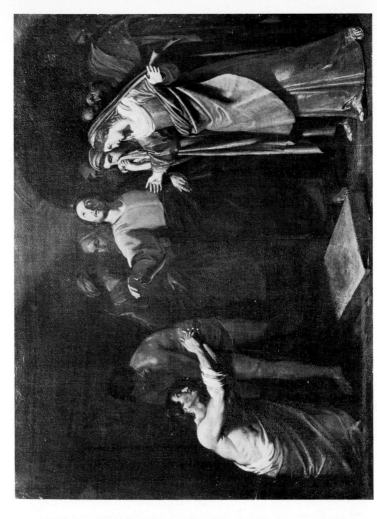

79. CARAVAGGESQUE UNKNOWN (NEAPOLITAN?): *Raising of Lazarus.* John Herron Art Museum, Indianapolis (Indiana)

77. ATTRIBUTED TO GÉRARD DOUFFET: *St Sebastian* (detail). With Gilberto Algranti, Milan (1973)

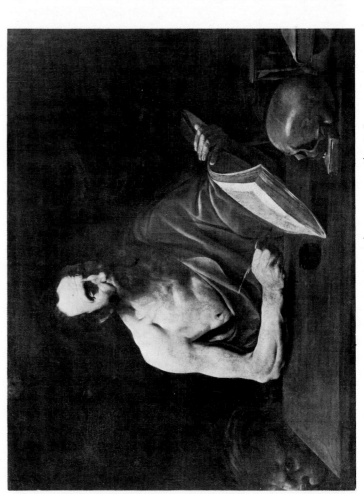

78. CARAVAGGESQUE UNKNOWN (NEAPOLITAN?): *St Jerome.* Sale, Sotheby's, 27 March 1963 (79)

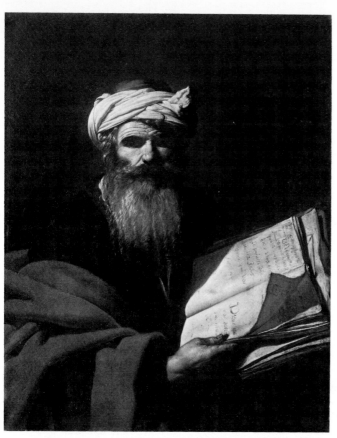

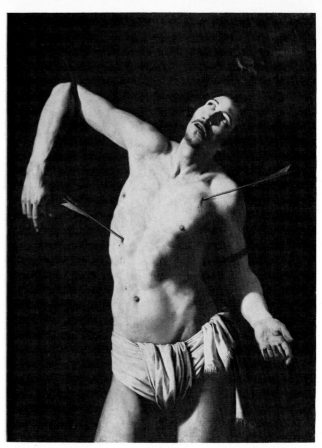

80. CIRCLE OF DOUFFET: *Prophet with a Book.*
Kunsthalle, Karlsruhe

81. CARAVAGGESQUE UNKNOWN (NEAPOLITAN?):
St Sebastian. Galleria dell'Arcivescovado, Milan

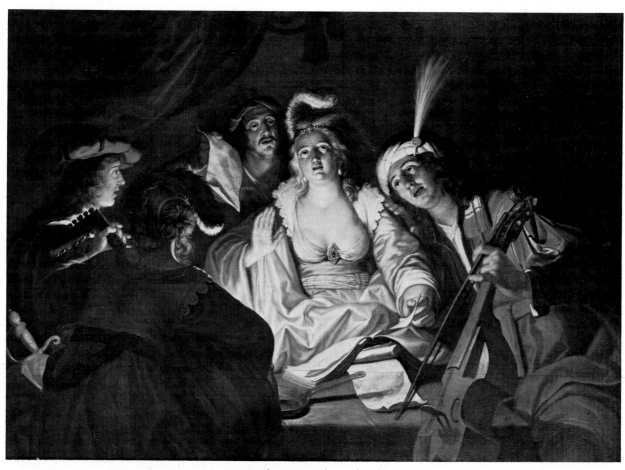

82. GERARD SEGHERS: *St Cecilia.* Formerly with Julius Weitzner, New York

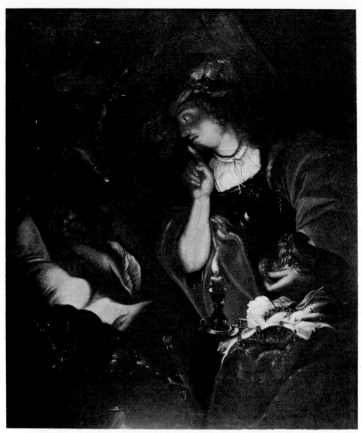

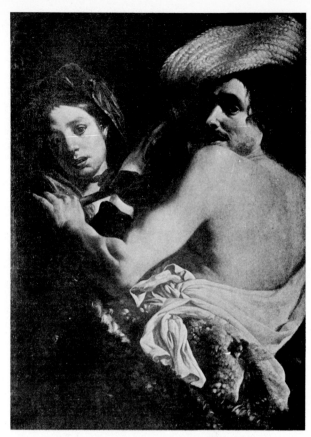

83. GERARD SEGHERS(?): *David and the sleeping Saul.*
Formerly Alfred Bader Collection, Milwaukee

84. ABRAHAM JANSSENS: *Fluteplayer and Girl.*
Matzwansky Collection, Vienna (1943)

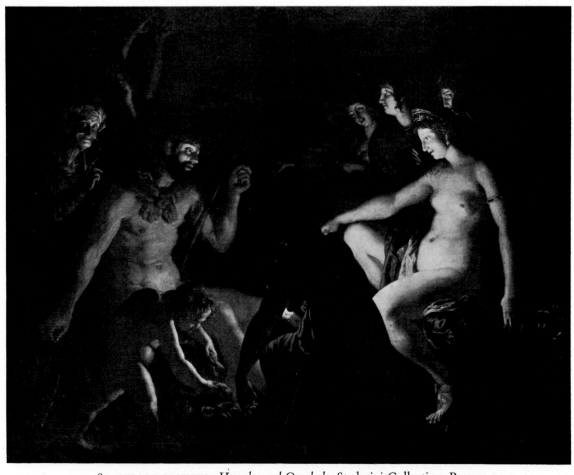

85. GERARD SEGHERS: *Hercules and Omphale.* Staderini Collection, Rome

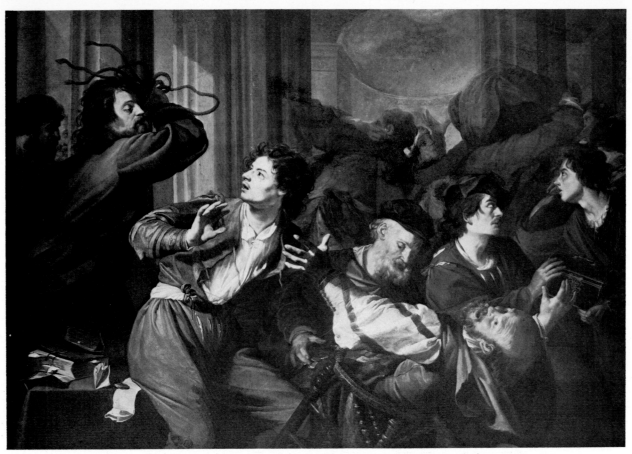

86. THEODOOR ROMBOUTS: *Christ driving the Money-Changers out of the Temple.*
Koninklijk Museum voor Schone Kunsten, Antwerp

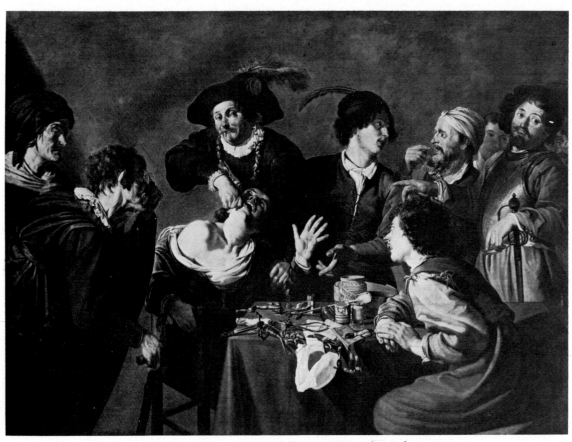

87. THEODOOR ROMBOUTS: *Tooth Extractor.* Národní Galerie, Prague

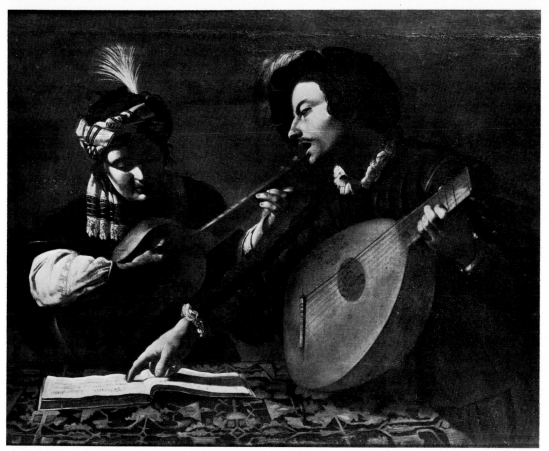

88. THEODOOR ROMBOUTS: *Musical Pair*. Bayerische Staatsgemäldesammlung, Munich

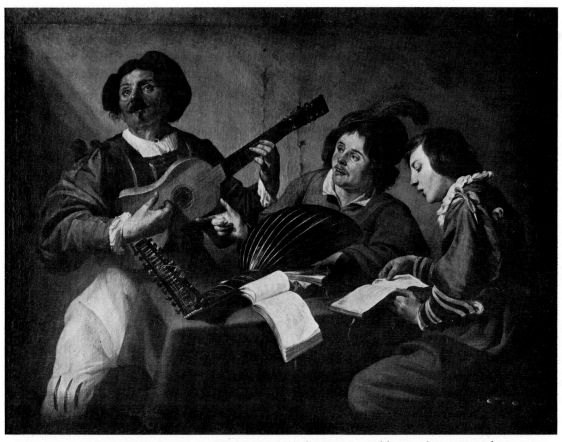

89. THEODOOR ROMBOUTS: *Concert*. Bayerische Staatsgemäldesammlung, Munich

91. THEODOOR ROMBOUTS: *St Sebastian.*
Dr John A. Cauchi Collection, Rabat (Malta)

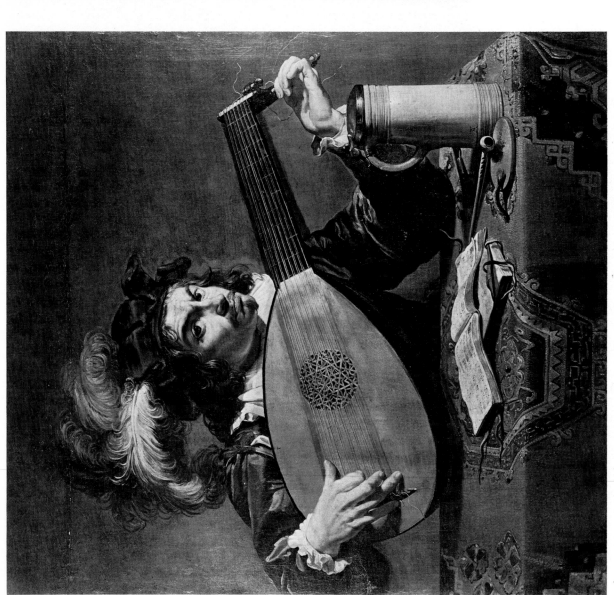

90. THEODOOR ROMBOUTS: *Luteplayer.* John G. Johnson Collection, Philadelphia

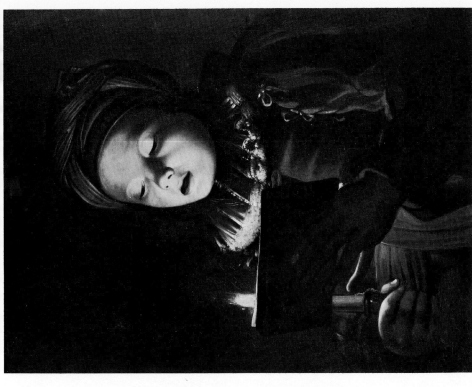

93. ADAM DE COSTER: *Boy Singer*.
With Ira Spanierman, New York (1970)

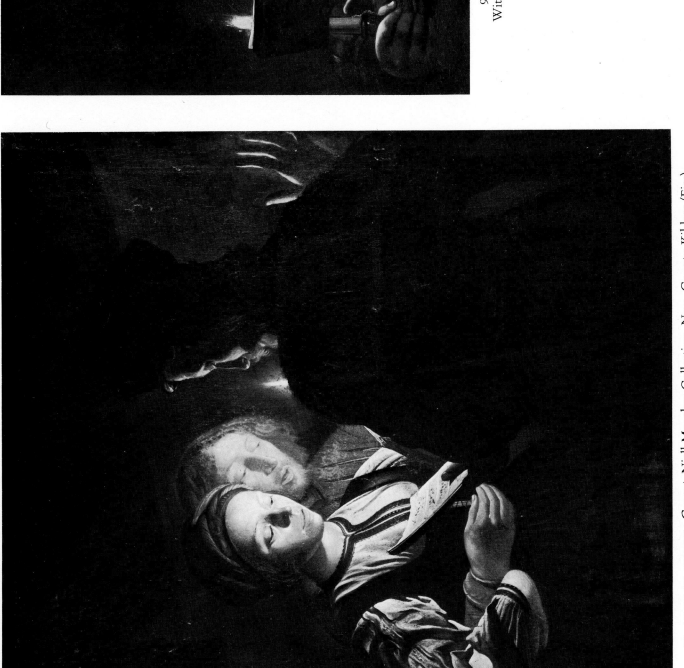

92. ADAM DE COSTER: *Concert*. Niall Meagher Collection, Naas, County Kildare (Eire)

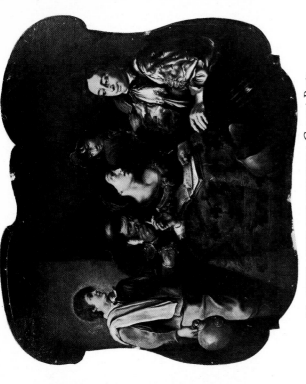

95. COPY AFTER JAN COSSIERS: *Concert Party.*
Residenz, Würzburg

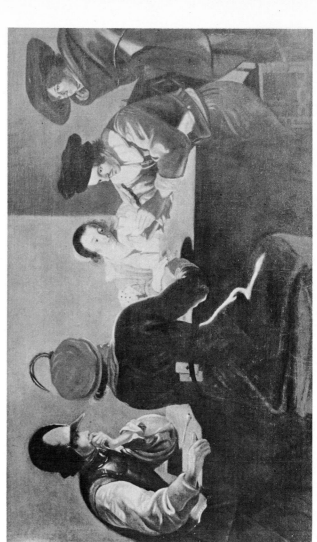

97. COPY AFTER JACOB VAN OOST THE ELDER: *Soldiers cheating at Cards, with a Woman.*
F. A. Tofte Collection, Flushing (New York)

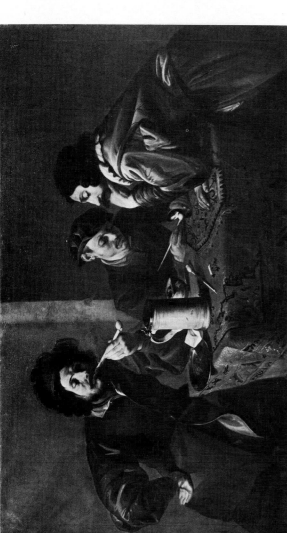

94. THEODOOR ROMBOUTS: *Smokers.* Marchese Litta–Modigliani Collection, Rome (1950's)

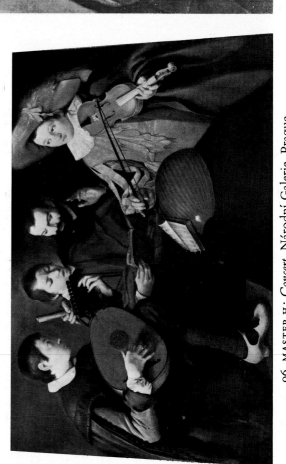

96. MASTER H: *Concert.* Národní Galerie, Prague

98 and 99. THEODOOR VAN LOON: *Presentation of Mary in the Temple* (details). Church of Montaigu, Belgium

100. JAN COSSIERS: *Fortune-Teller*. Bayerische Staatsgemäldesammlung, Munich

101. THEODOOR VAN LOON: *Daniel and the Priests of Bel*. Koninklijk Museum voor Schone Kunsten, Antwerp

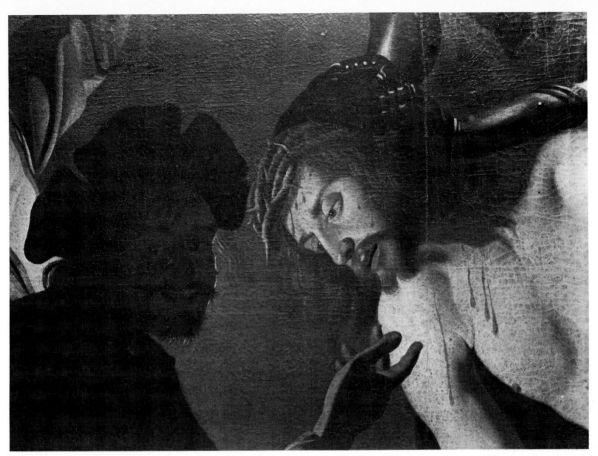

102. JAN JANSSENS: *Crowning with Thorns* (detail). Musée des Beaux-Arts, Ghent

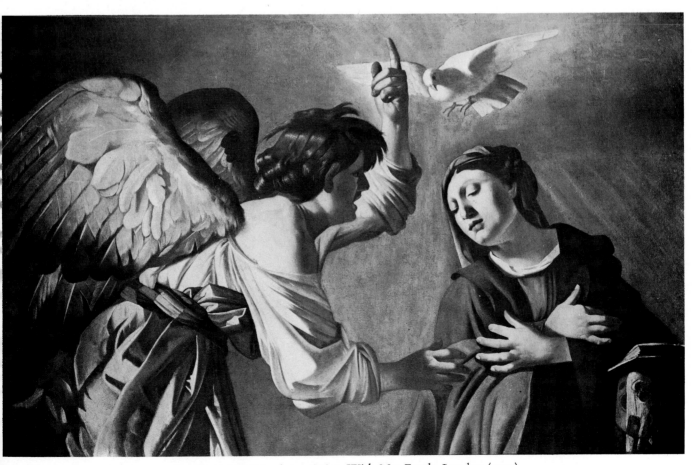

103. JAN JANSSENS: *Annunciation*. With Mrs Frank, London (1952)

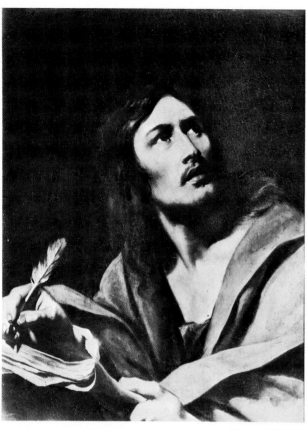

104. CARAVAGGESQUE UNKNOWN (FLEMISH): *St John the Evangelist*. Musée de Tessé, Le Mans

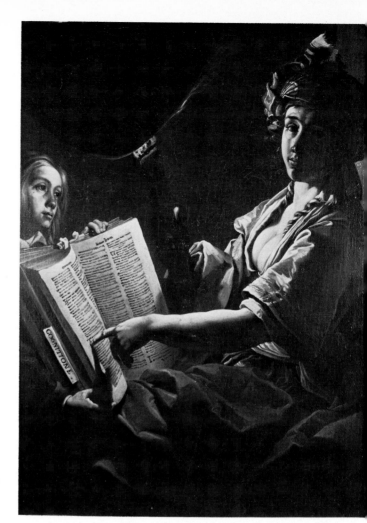

105. MASTER F: *Allegorical Figure pointing to open Book labelled 'Cognitione'*. Assistance Publique, Bruges

106. ANTON VAN DEN HEUVEL: *Liberation of St Peter*. Private Collection, Scotland

107. CARAVAGGESQUE UNKNOWN (NORTH NETHERLANDISH?): Unidentified subject. With Heim Gallery, London (1977)

108. ABRAHAM BLOEMAERT: *St Jerome*.
Alfred Bader Collection, Milwaukee

109. HENDRICK BLOEMAERT: *King David in Prayer*.
Národní Galerie, Prague

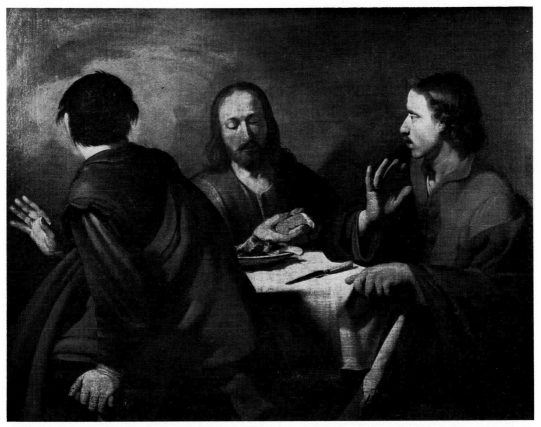

110. CARAVAGGESQUE UNKNOWN (SOUTH NETHERLANDISH): *Christ at Emmaus*. City Art Gallery, York

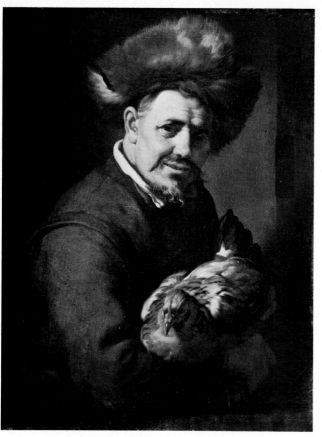

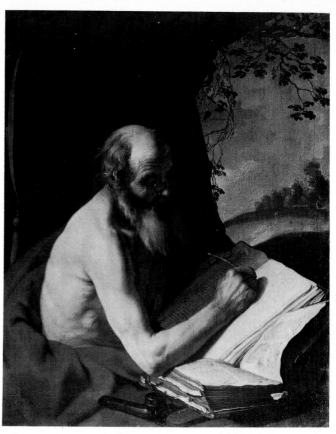

111. HENDRICK BLOEMAERT: *Man with Chicken.*
Nationalmuseum, Stockholm

112. HENDRICK BLOEMAERT: *St Jerome.*
Nasjonalgalleriet, Oslo

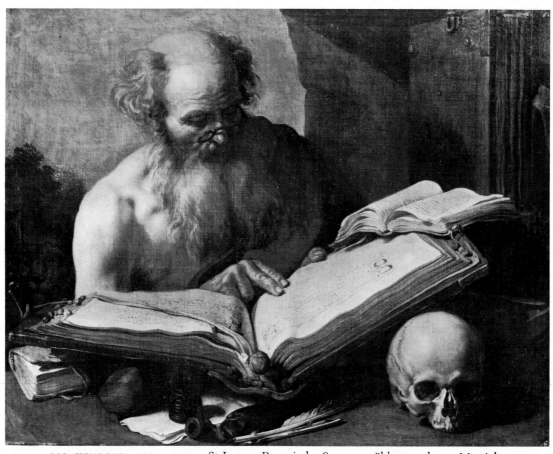

113. HENDRICK BLOEMAERT: *St Jerome.* Bayerische Staatsgemäldesammlung, Munich

114. DIRCK VAN BABUREN AND ASSISTANT:
Christ among the Doctors (detail of Plate 116).
With Colnaghi's, London, and Richard Feigen,
New York (1977)

115. HENDRICK BLOEMAERT: *Allegory of Winter*.
Major the Hon. Robert Bruce Collection,
Dunphail (Morayshire)

116. DIRCK VAN BABUREN: *Christ among the Doctors*. With Colnaghi's, London, and Richard Feigen, New York (1977)

117. DIRCK VAN BABUREN: *Granida and Daiflo* (fragment).
With E. V. Thaw & Co., New York

118. DIRCK VAN BABUREN: *Granida and Daiflo* (fragment).
With estate of T. P. Grange, London (1977)

119 and 120. DIRCK VAN BABUREN: *St Sebastian tended by Irene* (details). Kunsthalle, Hamburg

121. DIRCK VAN BABUREN: *Capture of Christ with Malchus Episode*. With Colnaghi's, London (1977)

122. FOLLOWER OF DIRCK VAN BABUREN (?CRABETH): *Christ among the Doctors*. Kunsthistorisches Museum, Vienna

123. 'R. VAN ADELO': *St John the Baptist preaching*. Private Collection, Lübeck

124. 'R. VAN ADELO': *Joseph before Pharaoh*. Formerly Wallraf-Richartz-Museum, Cologne

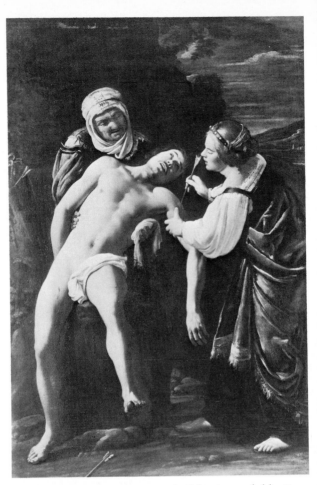

125. IMITATOR OF BABUREN: *Smoker*.
Musée des Beaux-Arts, Ghent

126. IMITATOR OF BABUREN: *St Sebastian tended by Irene*.
Formerly with F. Mont, New York

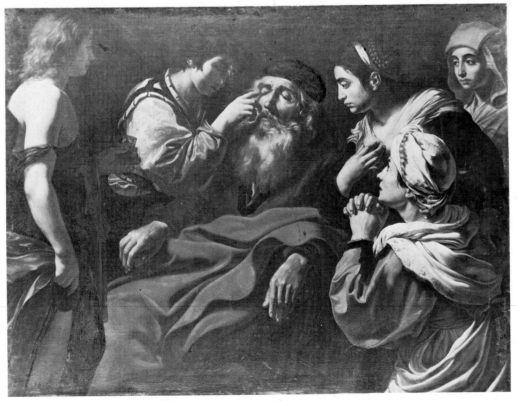

127. IMITATOR OF BABUREN: *Tobias healing his Father*. Kunsthistorisches Museum, Vienna

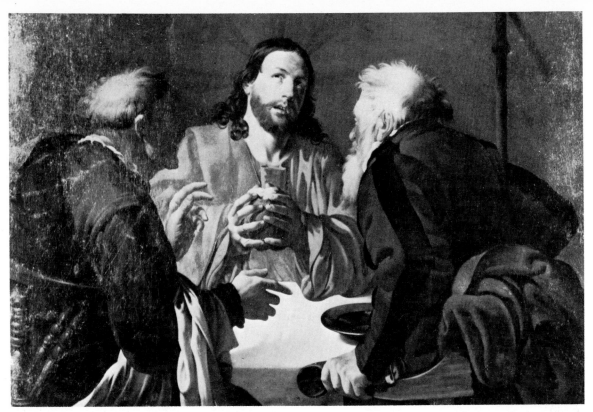

128. HENDRICK TERBRUGGHEN(?): *Christ at Emmaus*. Church of Marienfeld, near Castle Gripsholm, Sweden

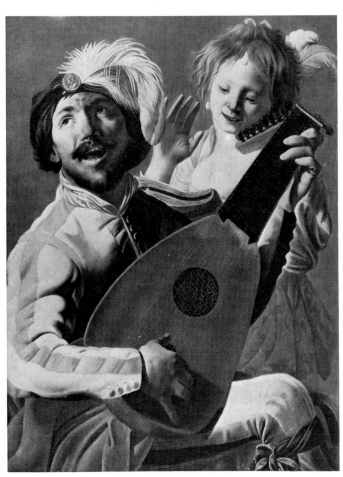

129. HENDRICK TERBRUGGHEN: *Concert*.
Private Collection, Rome (1963)

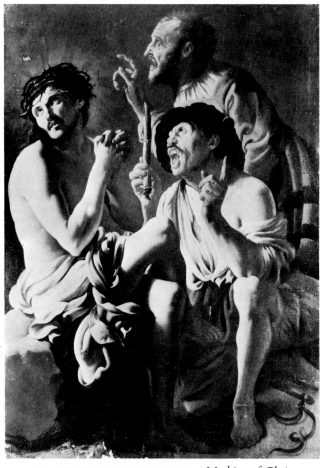

130. HENDRICK TERBRUGGHEN: *Mocking of Christ*.
Klaus Driessen Collection, Hamburg

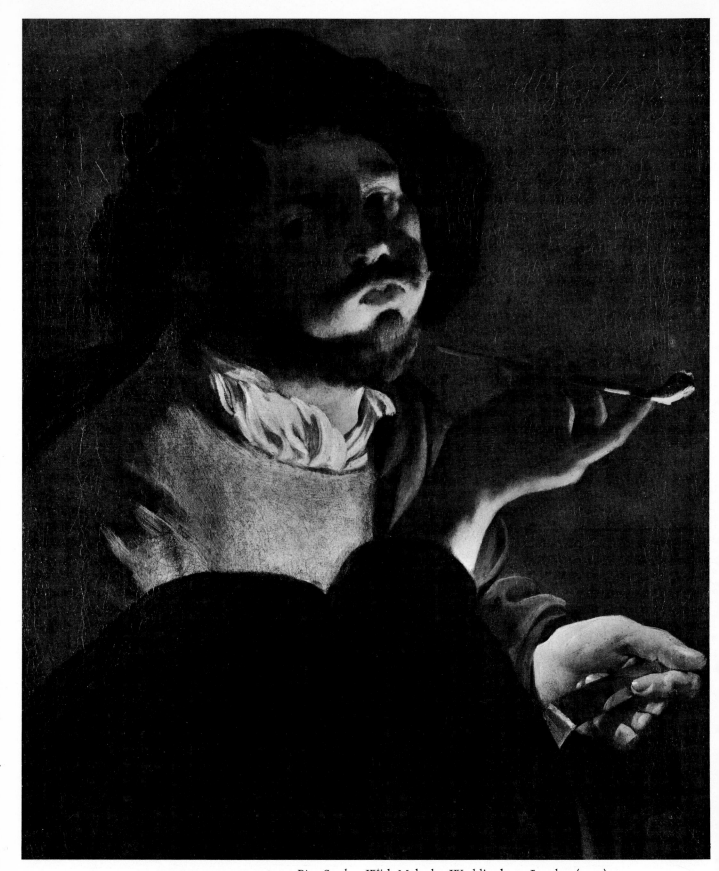

131. HENDRICK TERBRUGGHEN: *Pipe Smoker*. With Malcolm Waddingham, London (1977)

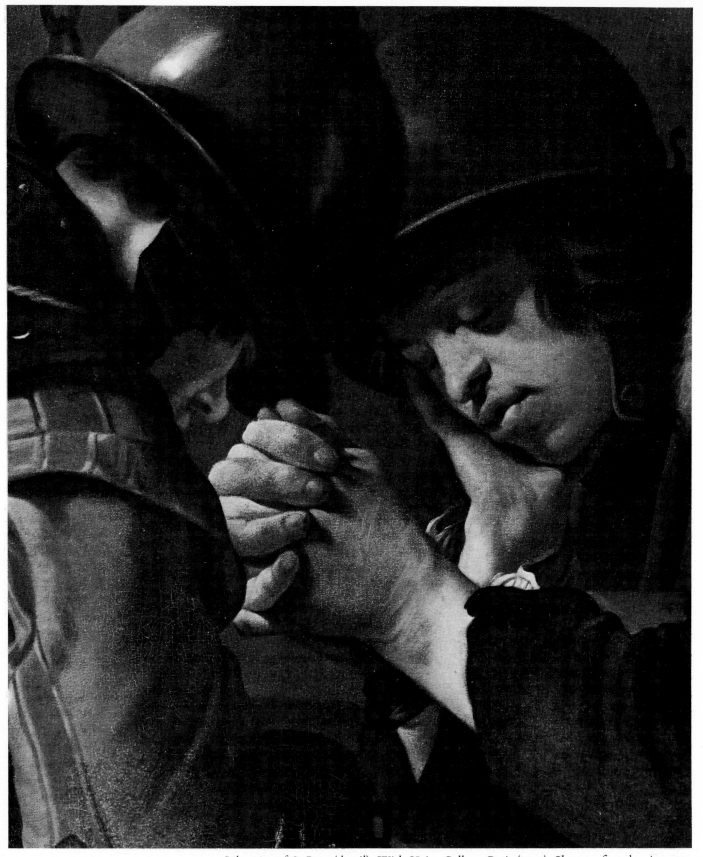

132. HENDRICK TERBRUGGHEN: *Liberation of St Peter* (detail). With Heim Gallery, Paris (1975). Shown after cleaning

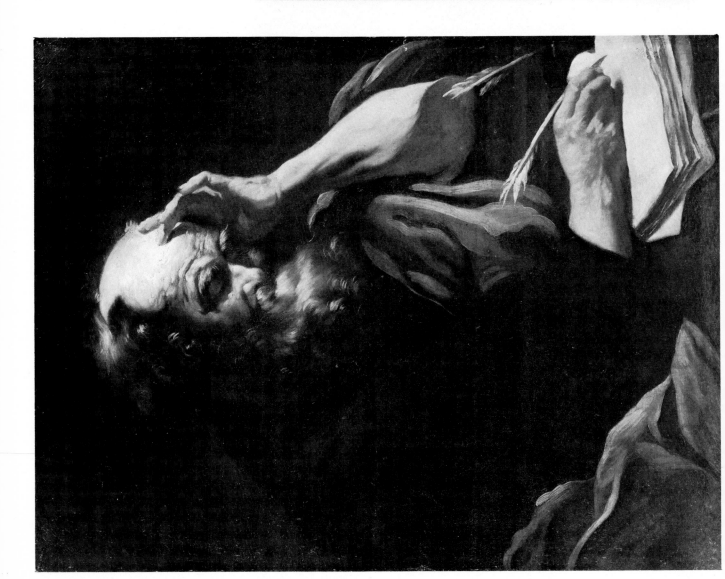

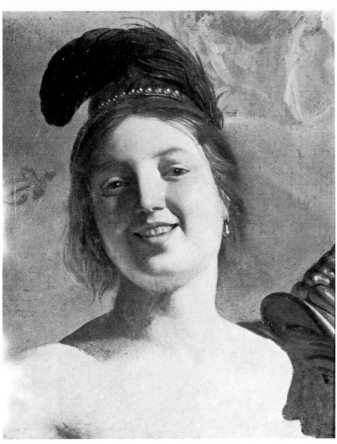

143. GERRIT VAN HONTHORST: *Unidentified Subject* (fragment).
Julius S. Held Collection, New York

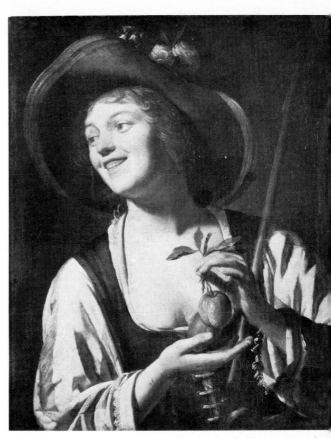

144. GERRIT VAN HONTHORST: *Shepherdess holding up* (?) *Plum*
Anson Collection, Catton Hall, near Burton-on-Trent

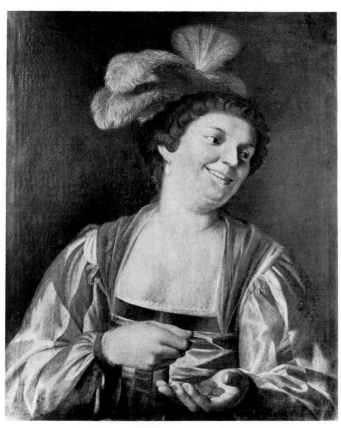

145. GERRIT VAN HONTHORST: *Girl counting Money.*
Schloss Weissenstein, Pommersfelden

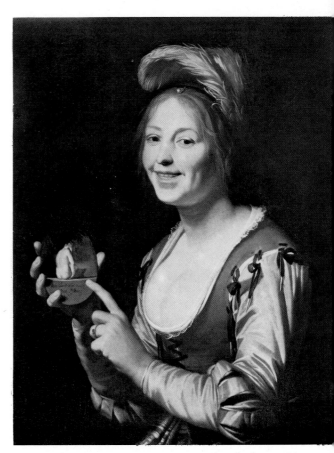

146. GERRIT VAN HONTHORST: *Girl with obscene Picture.*
City Art Museum, St Louis (Missouri)

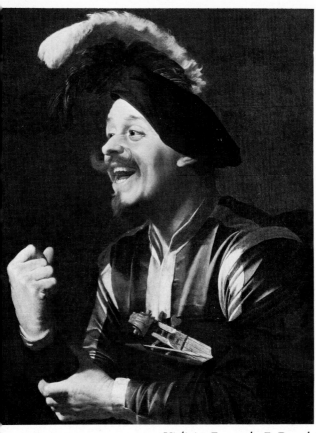

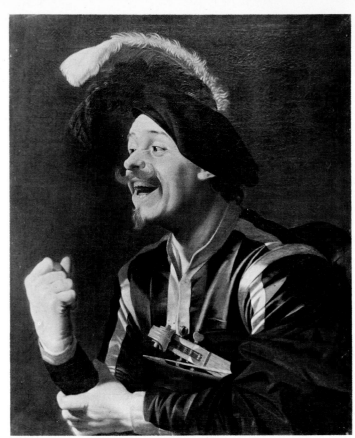

139. GERRIT VAN HONTHORST: *Violinist*. Formerly F. Brandeis Collection, Qualicum Beach (British Columbia)

140. GERRIT VAN HONTHORST: *Violinist*. Schloss Weissenstein, Pommersfelden

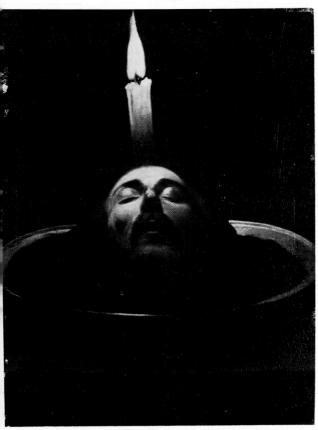

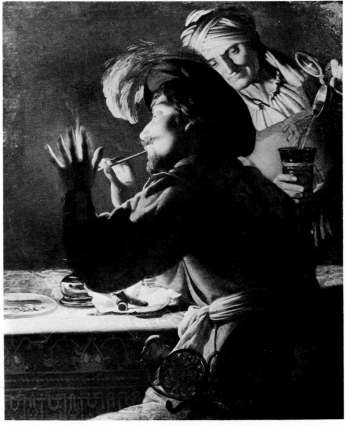

141. ATTRIBUTED TO GERRIT VAN HONTHORST: *Head of St John the Baptist on a Charger*. With Colnaghi's, London (1965)

142. ATTRIBUTED TO GERRIT VAN HONTHORST: *Drinking and Smoking Scene*. Beningbrough Hall (North Yorkshire), National Trust

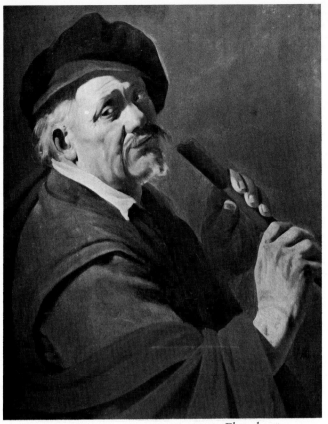

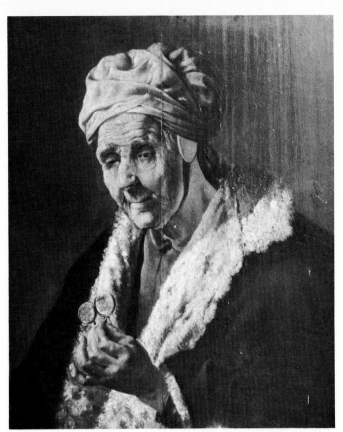

136. IMITATOR OF TERBRUGGHEN: *Fluteplayer.*
Staatliches Museum, Schwerin

137. IMITATOR OF TERBRUGGHEN: *Old Woman with Spectacles.*
Earl of Lonsdale Collection, Askham

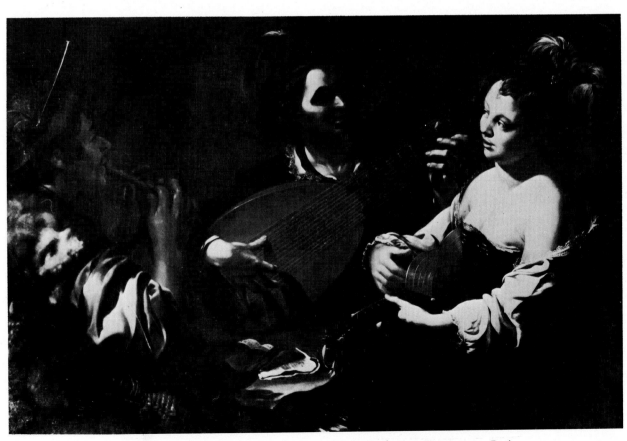

138. WOUTER PIETERSZ. CRABETH II: *Concert.* With Guy Darrieutort, Paris

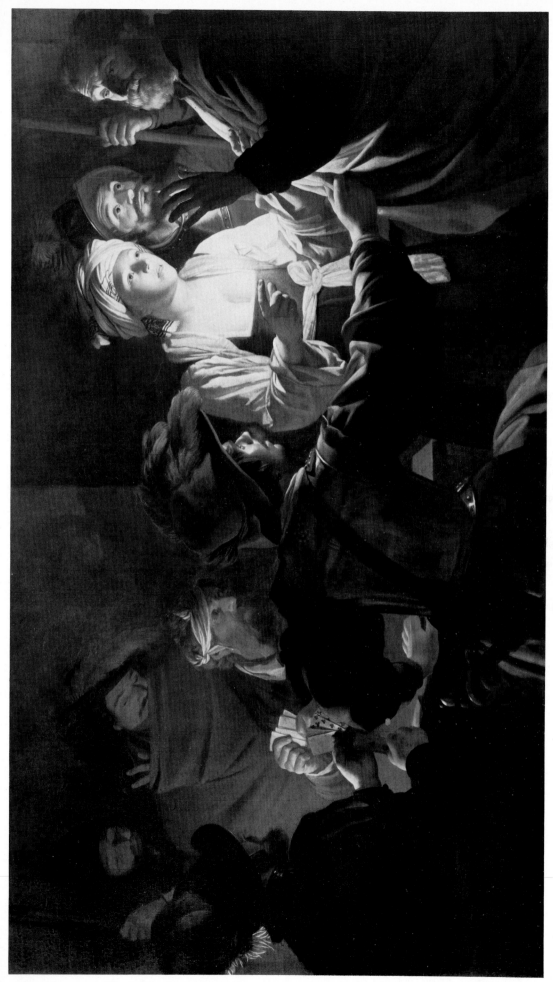

135. GERRIT VAN HONTHORST: *Denial of St Peter*. London Art Market (1975)

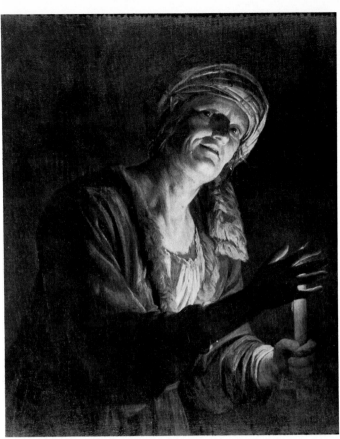

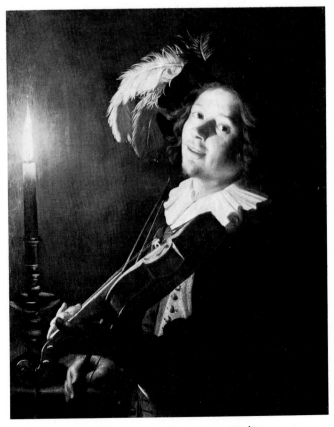

147. GERRIT VAN HONTHORST: *Violinist*.
Musée des Beaux-Arts, Angers

148. GERRIT VAN HONTHORST: *Old Woman masking Candle*.
Marquess of Waterford Collection, Portlaw (Eire)

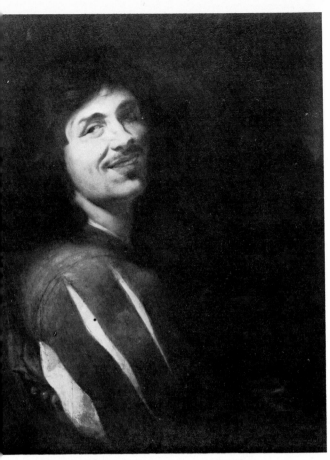

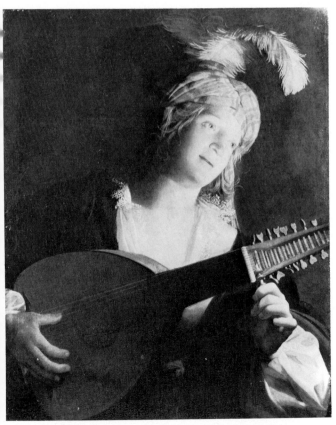

149. GERRIT VAN HONTHORST: *Girl Luteplayer*.
Museum der Bildenden Künste, Leipzig

150. GERRIT VAN HONTHORST: *Violinist*.
Museum der Bildenden Künste, Leipzig

152. GERRIT VAN HONTHORST: *Christ and Nicodemus* (drawing).
Seattle Art Museum

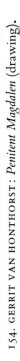

154. GERRIT VAN HONTHORST: *Penitent Magdalen* (drawing).

151. GERRIT VAN HONTHORST: *Brothel Scene* (drawing).
Ashmolean Museum, Oxford

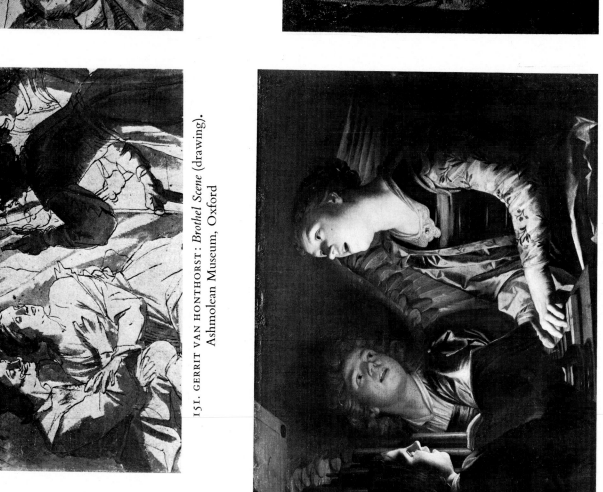

153. GERRIT VAN HONTHORST: *St Cecilia playing the Organ.*

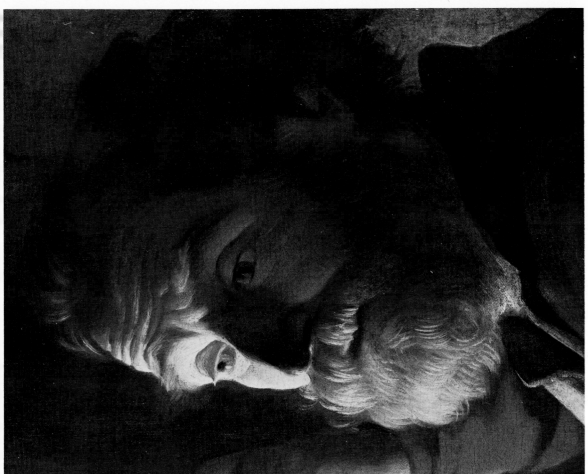

156. GERRIT VAN HONTHORST: *Denial of St Peter* (detail from Plate 135).
London Art Market (1975)

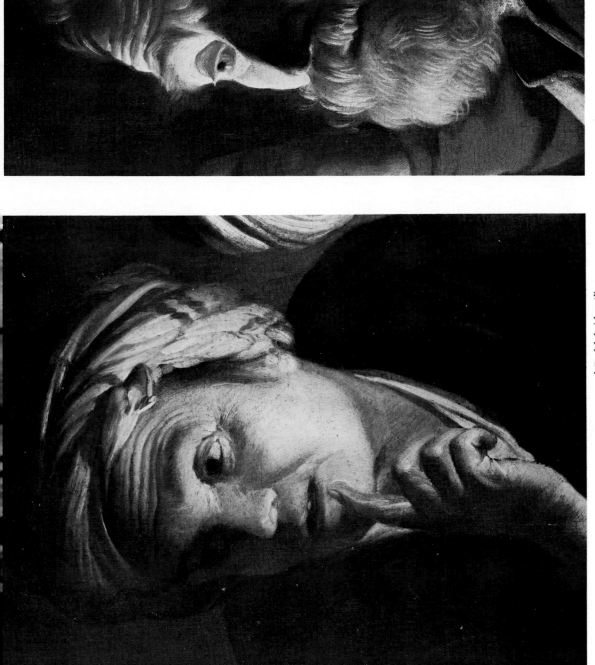

155. GERRIT VAN HONTHORST: *Samson and Delilah* (detail).
Cleveland Museum of Art

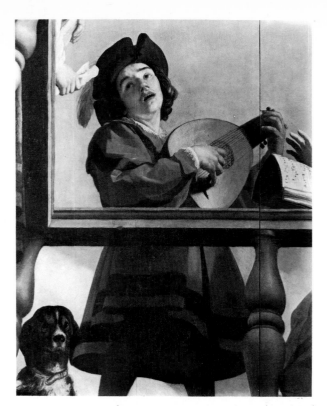
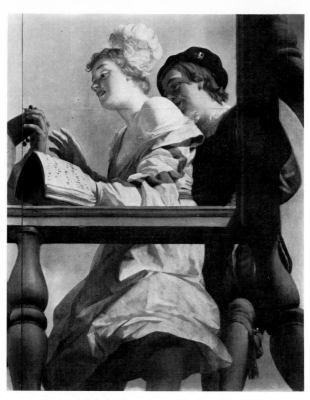

157 and 158. GERRIT VAN HONTHORST: *Ceiling Painting: Musicians behind a Balustrade* (details).
J. Paul Getty Museum, Malibu (Calif.)

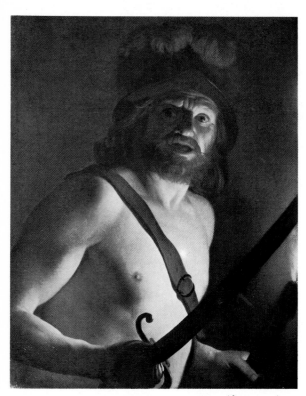

159. GERRIT VAN HONTHORST: *Mars* (fragment).
Milwaukee Art Center

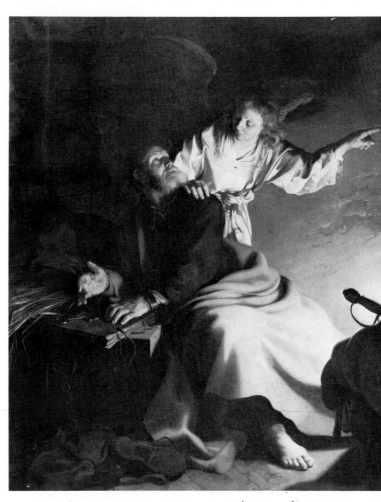

160. GERRIT VAN HONTHORST: *Liberation of St Peter*.
With Richard Feigen, New York (1975)

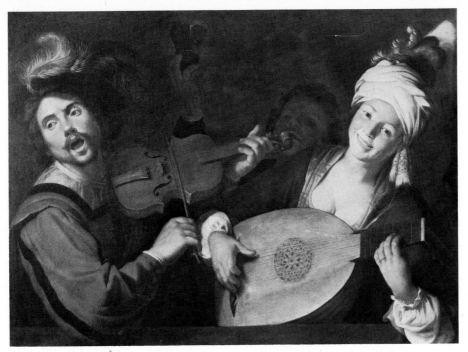

161. GERRIT VAN HONTHORST: *Concert*. Musée des Beaux-Arts, Lyons

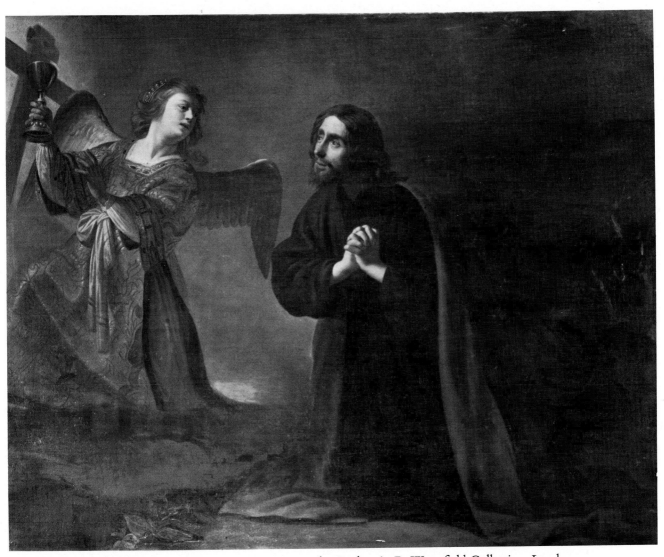

162. GERRIT VAN HONTHORST: *Agony in the Garden*. A. B. Waterfield Collection, London

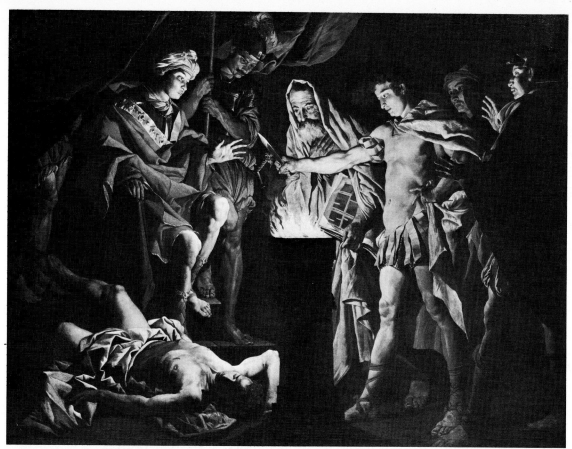

163. MATTHIAS STOMER: *Mucius Scaevola before Porsenna.* Art Gallery of New South Wales, Sydney

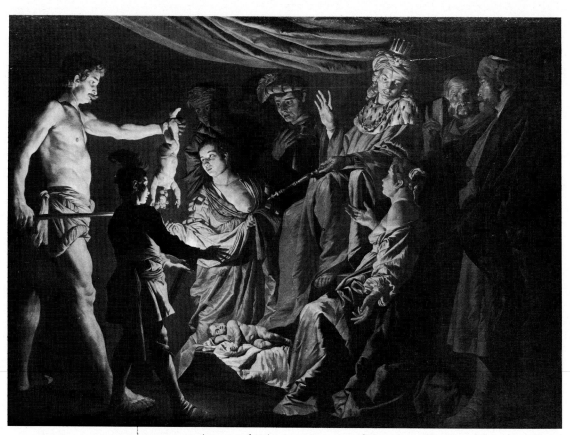

164. MATTHIAS STOMER: *Judgement of Solomon.* Museum of Fine Arts, Houston (Texas)

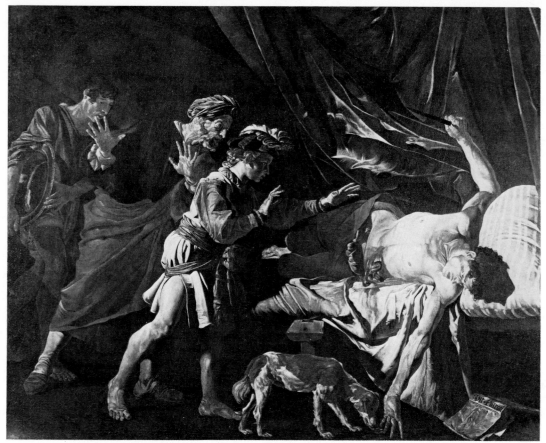

165. MATTHIAS STOMER: *Death of Cato*. Museo dei Benedettini, Catania

166. MATTHIAS STOMER: *Death of Brutus(?)*. With Richard Feigen, New York (1973)

167. MATTHIAS STOMER(?): *Roman Charity.*
Szepmüvészeti Múzeum, Budapest

168. MATTHIAS STOMER: *Mocking of Christ.*
Private Collection, Madrid (1977)

169. MATTHIAS STOMER: *Samson and the Philistines.* Galleria Sabauda, Turin

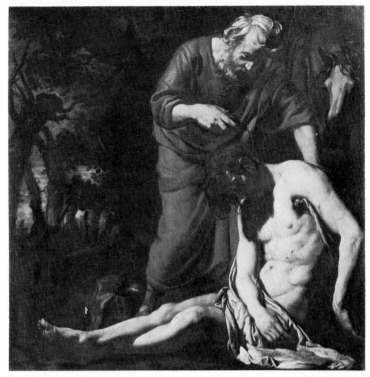

170. JOACHIM VON SANDRART: *Good Samaritan*. Pinacoteca di Brera, Milan

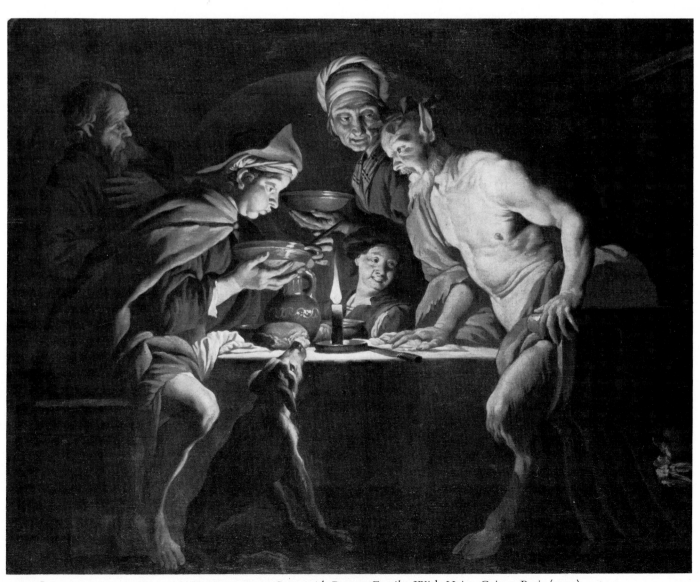

171. MATTHIAS STOMER: *Satyr with Peasant Family*. With Heim-Gairac, Paris (1974)

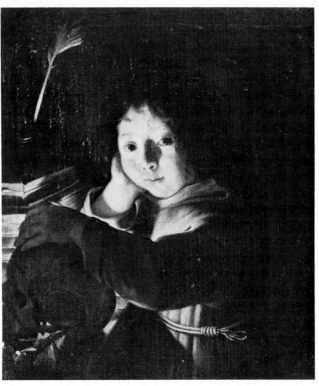

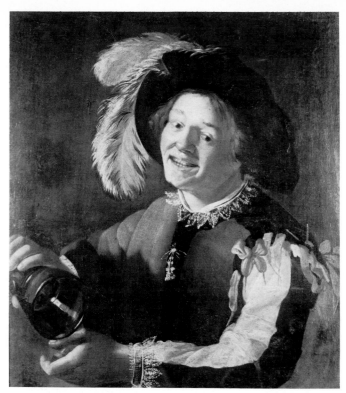

172. CRIJN HENDRICKSZ. VOLMARIJN: *Child dressed up as a Monk, with Skull.* Galleria Nazionale, Parma

173. MASTER B: *Boy with empty Glass.* Národní Galerie, Prague

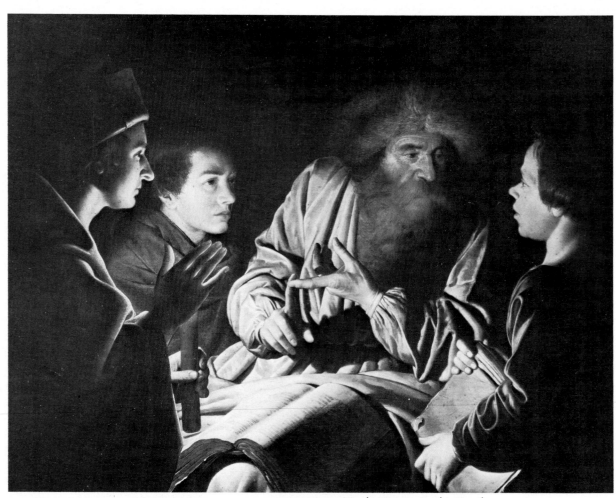

174. CRIJN HENDRICKSZ. VOLMARIJN: *Teacher instructing his Pupils.*
Ninian Brodie of Brodie Collection, Brodie Castle, Forres (Morayshire).

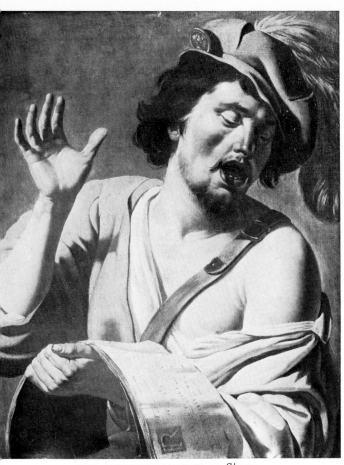

175. CIRCLE OF MASTER A: *Singer*.
Rheinisches Landesmuseum, Bonn

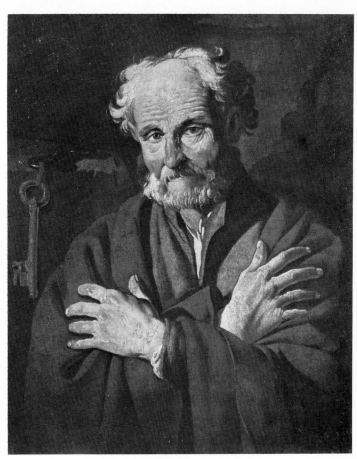

176. CIRCLE OF MASTER C: *St Peter*.
With Poletti, Milan

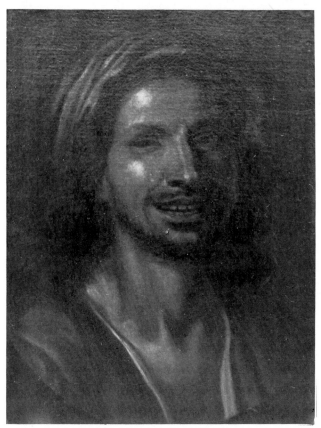

177. MASTER G: *Man laughing*.
Filberto Catinari Collection, Fermo

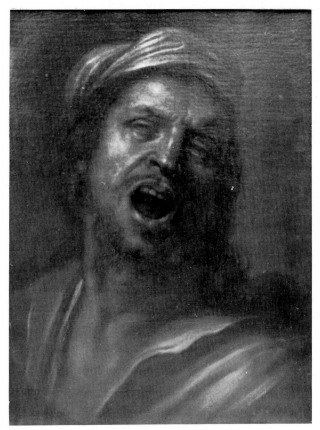

178. MASTER G: *Singer*.
Filiberto Catinari Collection, Fermo

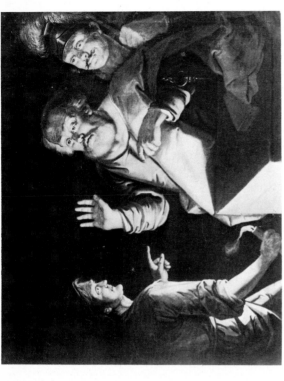

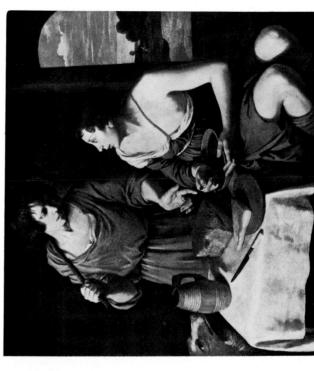

180. MASTER E: *Denial of St Peter.* H. W. Streit Collection, Hamburg (1935)

182. CARAVAGGESQUE UNKNOWN (NORTH NETHERLANDISH): *Esau selling his Birthright.* Mrs C. A. W. Beaumont Coll. London

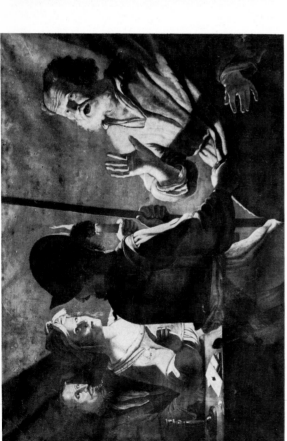

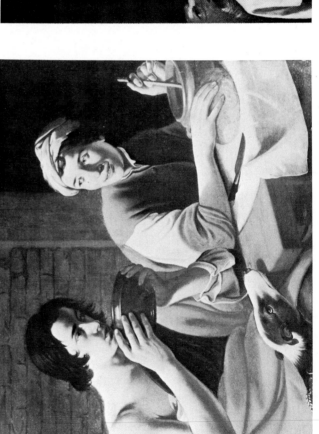

179. MASTER E: *Denial of St Peter.* Abbé Jean Jacquart Collection, Catholic University, Argens (1942)

181. CARAVAGGESQUE UNKNOWN (NORTH NETHERLANDISH): *Esau selling his Birthright.* National Westminster Bank, London

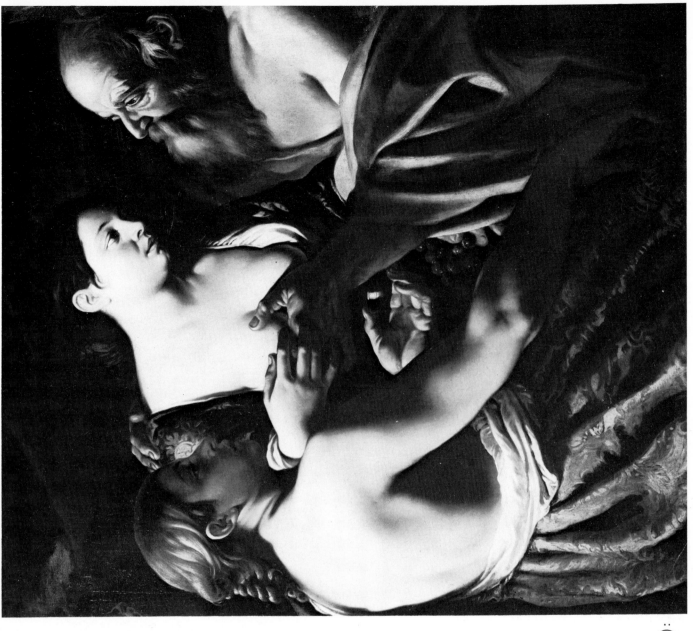

183. CARAVAGGESQUE UNKNOWN (NORTH NETHERLANDISH):
Boy with Candle. Commander J. B. Laing Collection, London

184. CARAVAGGESQUE UNKNOWN (NORTH NETHERLANDISH):
Lot and his Daughters. With Rothmann, London (1958)

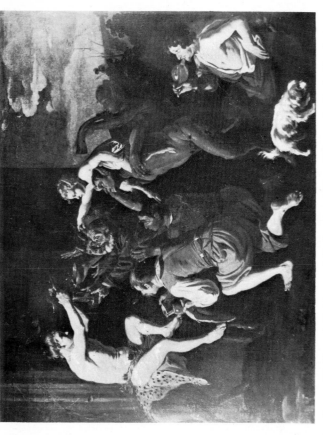

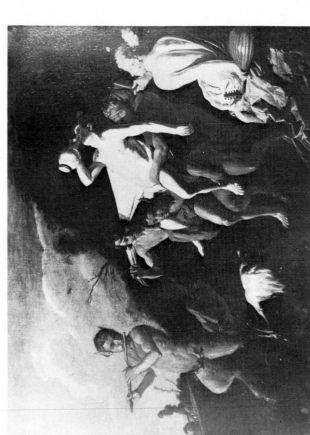

185 and 186. ATTRIBUTED TO CLAESZ CORNELISZ. MOEYAERT: *Two Bacchanalian Scenes*. Sir Francis Dashwood Collection, West Wycombe Park (Bucks.)

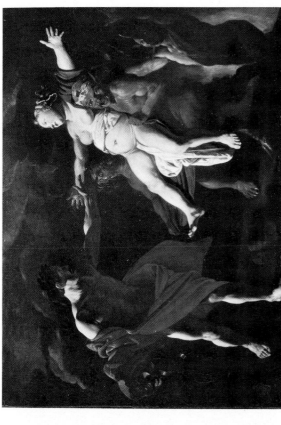

188. ATTRIBUTED TO CLAESZ CORNELISZ. MOEYAERT: *Orpheus and Eurydice*. Rolf Schmoll Collection, Hamburg (1971)

187. ATTRIBUTED TO CLAESZ CORNELISZ. MOEYAERT: *Orpheus, Pluto and Proserpine*. Pinacoteca Vaticana, Rome

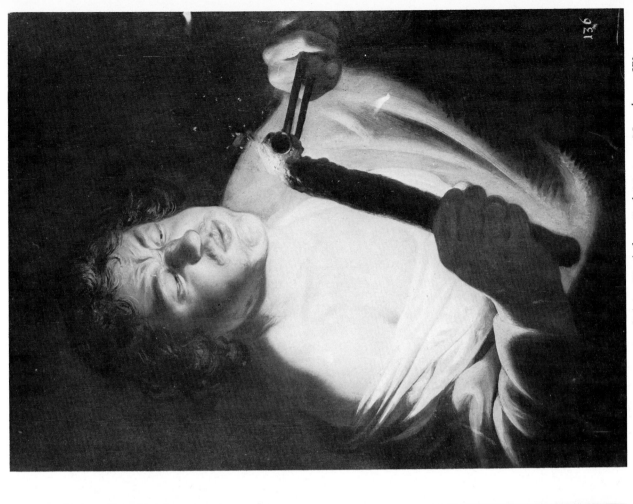

190. JAN LIEVENS: *Boy lighting Torch from Coal.* Museum Narodowe, Warsaw

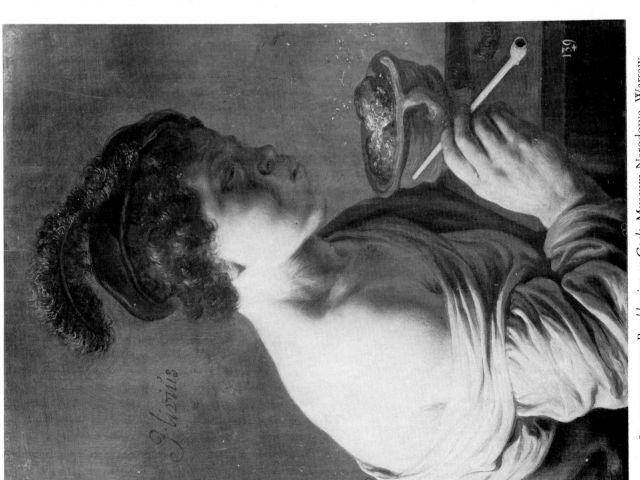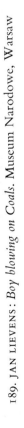

189. JAN LIEVENS: *Boy blowing on Coals.* Museum Narodowe, Warsaw

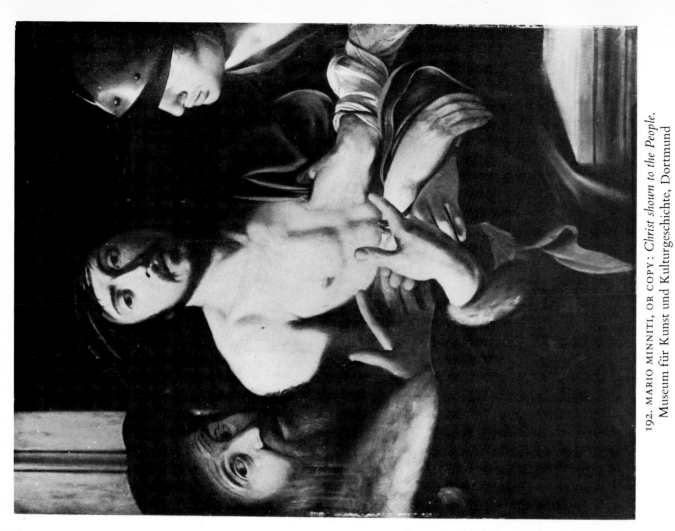

192. MARIO MINNITI, OR COPY: *Christ shown to the People*.
Museum für Kunst und Kulturgeschichte, Dortmund

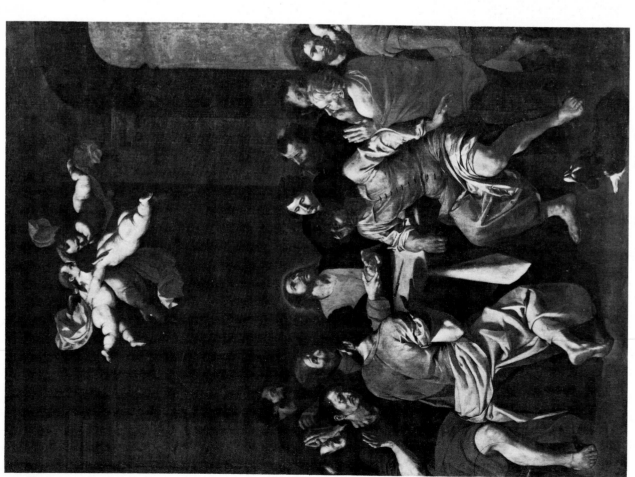

191. ATTRIBUTED TO ALONZO RODRIGUEZ: *Last Supper*.
Parish Church, Fontanarosa (Province of Avellino)

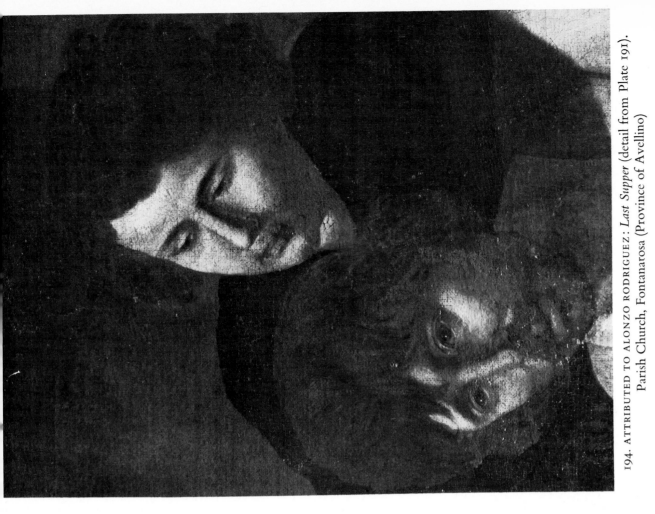

194. ATTRIBUTED TO ALONZO RODRIGUEZ: *Last Supper* (detail from Plate 191). Parish Church, Fontanarosa (Province of Avellino)

193. JAN VAN HOUBRACKEN: *Sense of Touch.* Chiesa Madre, Caccamo

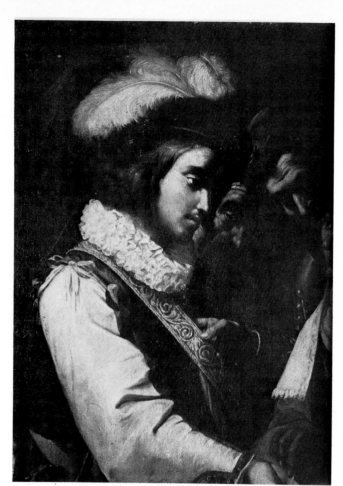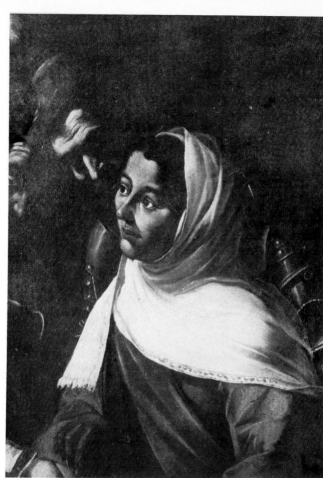

195 and 196. MATTIA PRETI: *Concert Party with Fortune-Teller* (details). Accademia Albertina, Turin

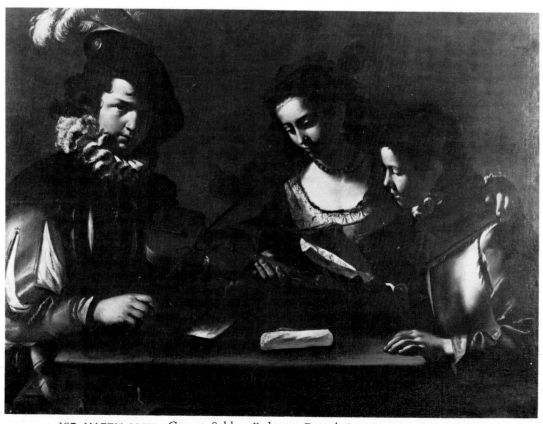

197. MATTIA PRETI: *Concert*. Schloss Rohoncz Foundation, Lugano-Castagnola

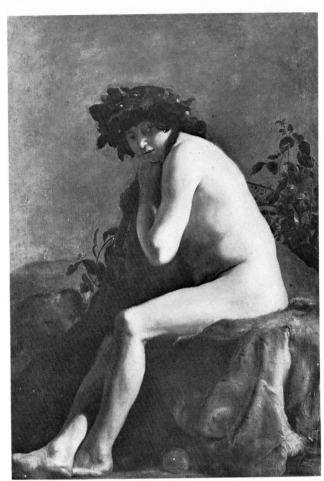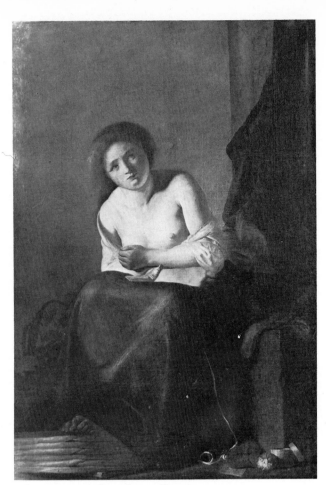

198 and 199. PAULUS BOR: *Bacchus* and *Ariadne*. Museum Narodowe, Poznán

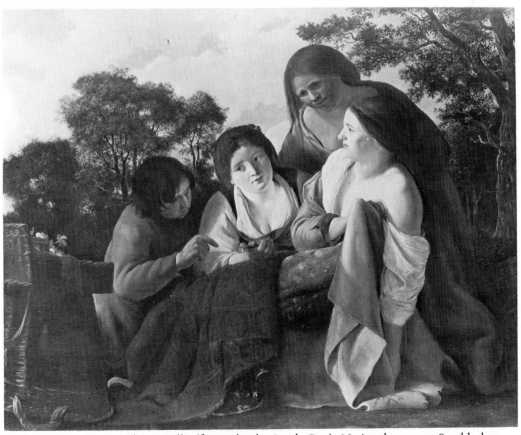

200. PAULUS BOR: *Flower-Seller* (from play by Jacob Cats). Nationalmuseum, Stockholm

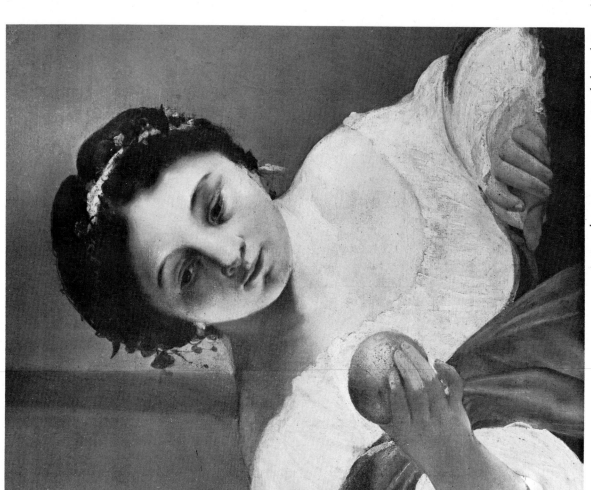

201 and 202. PAULUS BOR: *Mythological Figure* (*?Pomona*) (details). Rijksmuseum, Amsterdam

203 and 204. PAULUS BOR: *Flower-Seller* (from play by Jacob Cats) (details from Plate 200). Nationalmuseum, Stockholm

205. JAN VAN BIJLERT: *Adam and Eve*. Wawel Castle, Cracow

207. JAN VAN BIJLERT: *Soldier drilling with Spear.*
With Robert Noortman, London (1978)

208. JAN VAN BIJLERT: *Mercury.*
Formerly Kaiser-Friedrich-Museum, Berlin
(destroyed 1945)

209. JAN VAN BIJLERT: *Venus chastising blind Cupid.*
Mario Lanfranchi-Anna Moffo Collection, Rome (1972)

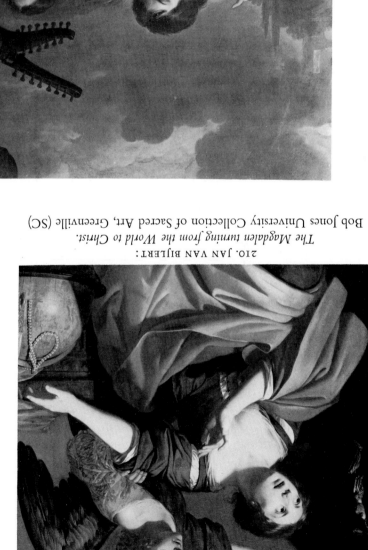

212. JAN VAN BIJLERT: *Concert*. Ault Collection, Brooklyn (NY) (1956)

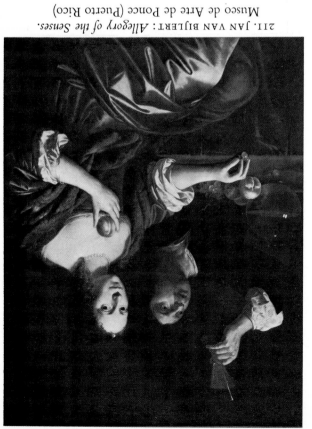

211. JAN VAN BIJLERT: *Allegory of the Senses*.
Museo de Arte de Ponce (Puerto Rico)

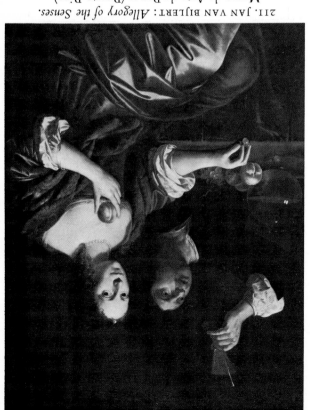

210. JAN VAN BIJLERT:
The Magdalen turning from the World to Christ.
Bob Jones University Collection of Sacred Art, Greenville (SC)

215. JAN VAN BIJLERT: *Christ washing St Peter's Feet*. With Messrs Appleby Bros., London (1965)

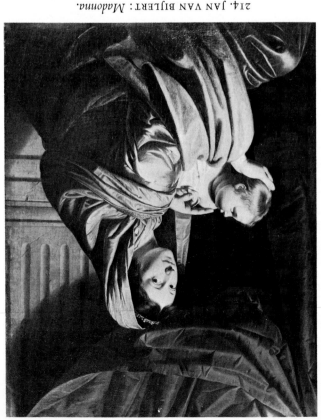

214. JAN VAN BIJLERT: *Madonna*.
Herzog Anton Ulrich-Museum, Brunswick

213. JAN VAN BIJLERT: *Flute-playing Shepherd*.
Lord Lothian Collection

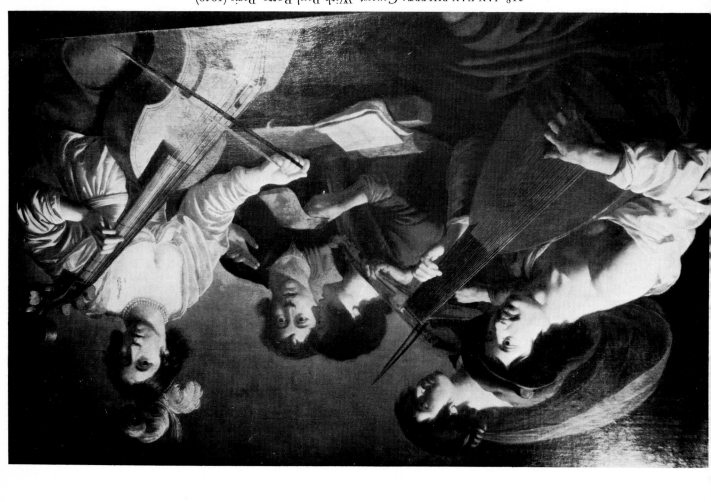

218. JAN VAN BIJLERT: *Concert.* With Paul Botte, Paris (1959)

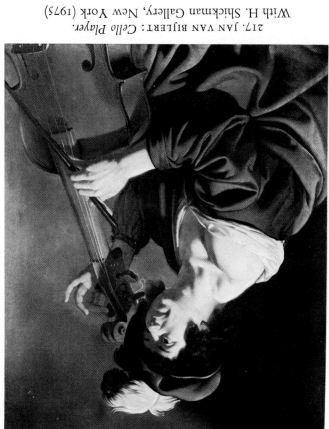

217. JAN VAN BIJLERT: *Cello Player.*
With H. Shickman Gallery, New York (1975)

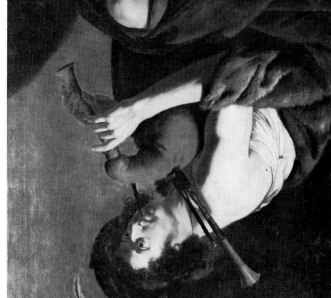

216. JAN VAN BIJLERT: *Bagpipe Player.*
Private Collection, Ireland

221. GERARD VAN KUYL: *Narcissus*. John and Mable Ringling Museum of Art, Sarasota (Florida)

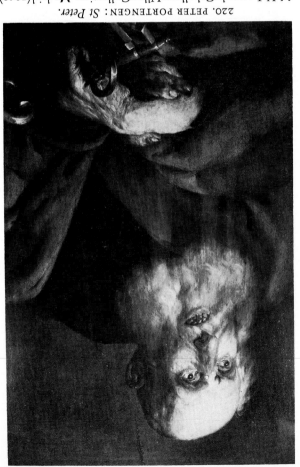

220. PETER PORTENGEN: *St Peter*.
M.V. Lopez de Ceballos y Ulloa Collection, Madrid (1959)

219. JAN GERRITSZ. VAN BRONCKHORST: *Concert* (fragment).
Formerly Baron A. Reedtz-Thott Collection, Gaunø (Denmark)

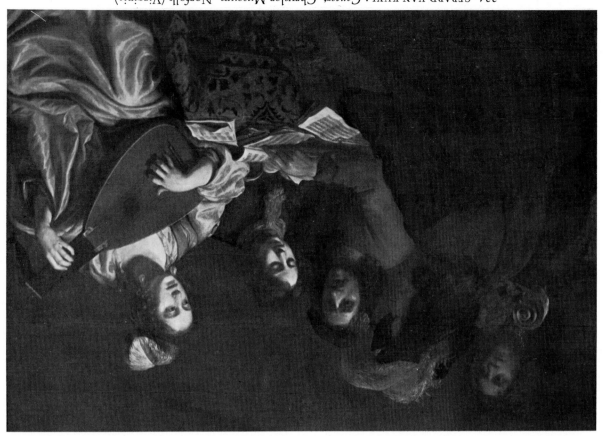

224. GERARD VAN KUYL: *Concert.* Chrysler Museum, Norfolk (Virginia)

223. ATTRIBUTED TO GERARD VAN KUYL: *St Sebastian.*
Bayerische Staatsgemäldesammlung, Munich

222. SIMON VOUET: *Mater Dolorosa.*
Formerly Tomás Harris Collection, London

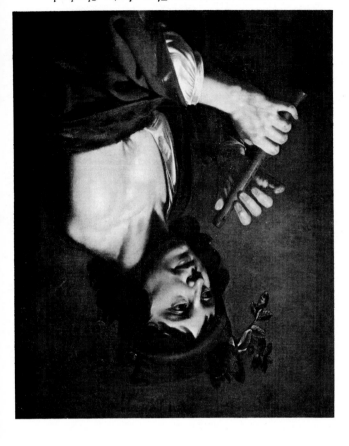

228. JAN VAN BIJLERT: *Flute-playing Shepherd.*
Centraal Museum, Utrecht

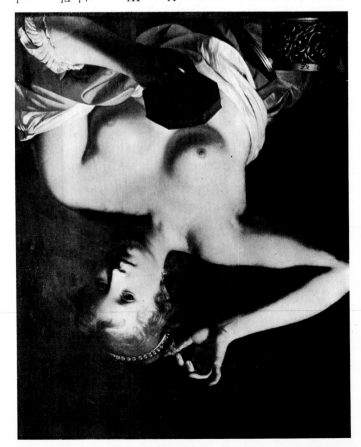

227. JAN VAN BIJLERT: *Flute-playing Shepherd.*
With Julius Weitzner, New York (1956)

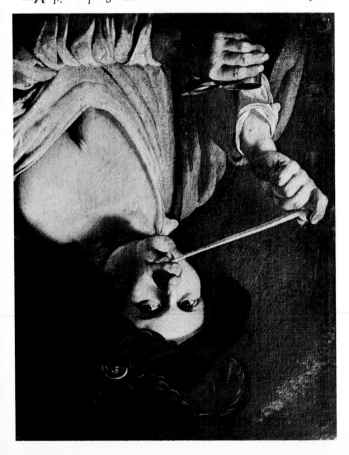

226. CHRISTIAAN VAN COUWENBERGH: *Smoker with Mug.*
Museo Nazionale di San Martino, Naples

225. CESAR VAN EVERDINGEN: *Young Woman with Flower and
Hand Mirror.* Schloss Weissenstein, Pommersfelden

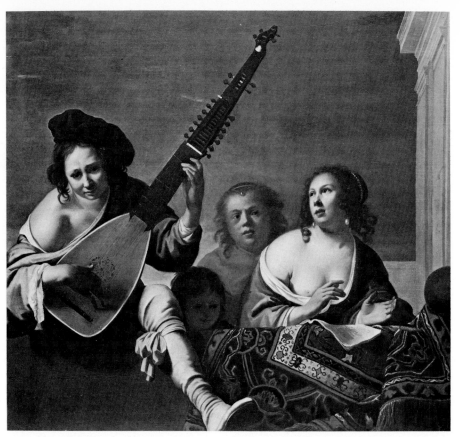

229. JAN GERRITSZ. VAN BRONCKHORST: *Concert*. With Heim Gallery, Paris (1957)

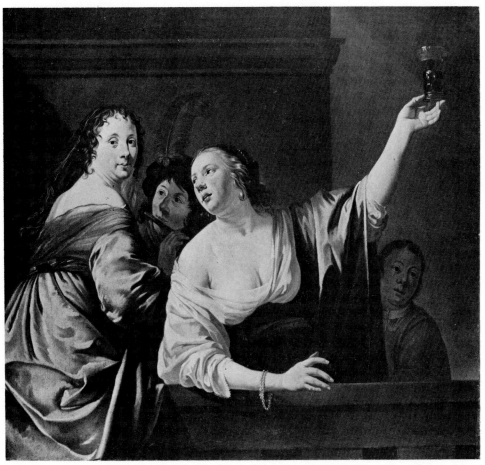

230. JAN GERRITSZ. VAN BRONCKHORST: *Party with Drinker*. With Francesco Pospisil, Venice (1950's)

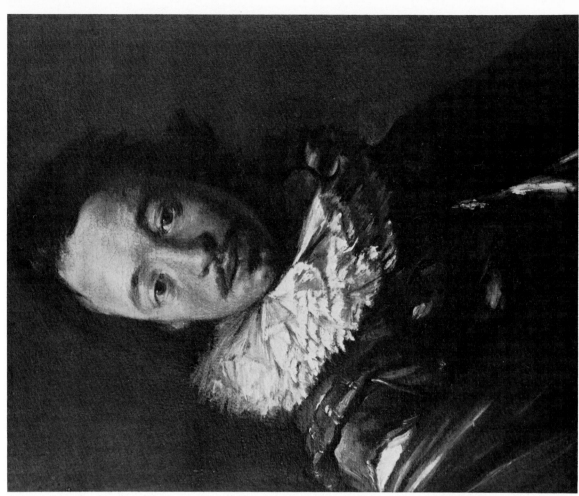

232. SIMON VOUET: *Portrait of a Man*. Mr & Mrs McMicking Collection, San Francisco

231. FOLLOWER OF SIMON VOUET (?LESTIN): *Portrait of a Man*. With Colnaghi's, London (1956)

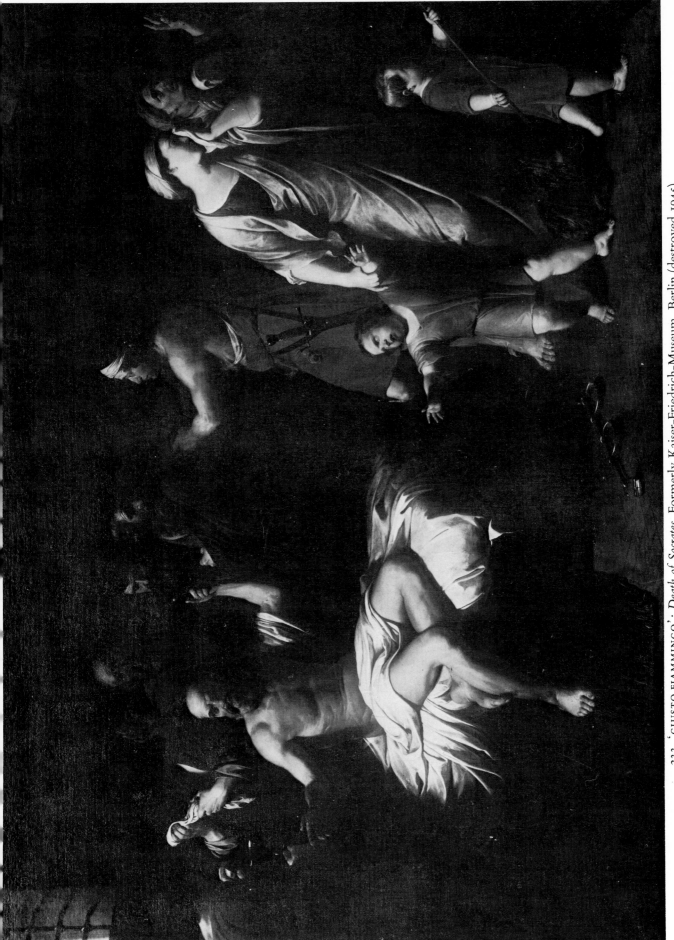

233. 'GIUSTO FIAMMINGO': *Death of Socrates*. Formerly Kaiser-Friedrich-Museum, Berlin (destroyed 1945)

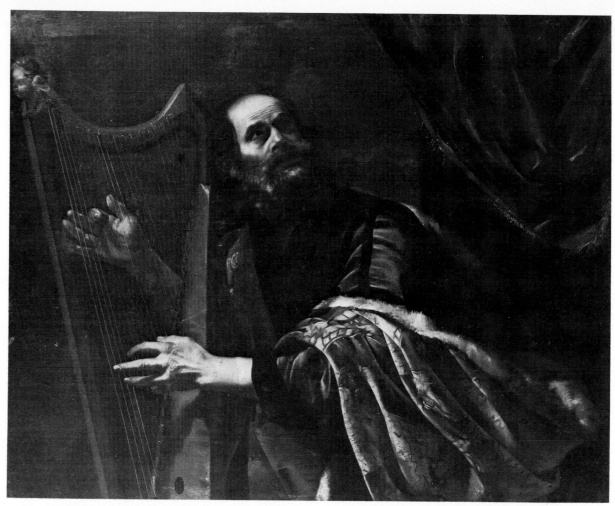

234. SIMON VOUET(?): *King David harping*. Bob Jones University Collection of Sacred Art, Greenville (SC)

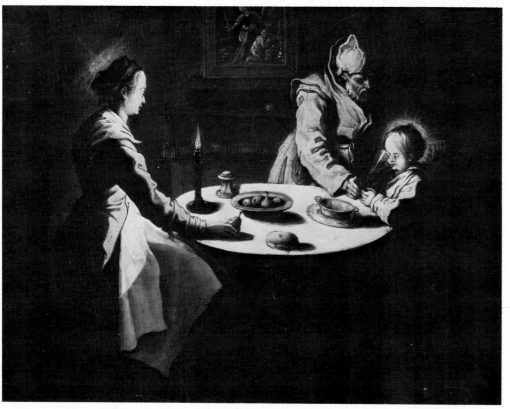

235. JEAN LE CLERC AFTER CALLOT(?): *Bénédicité*. Wadsworth Atheneum, Hartford (Conn.)

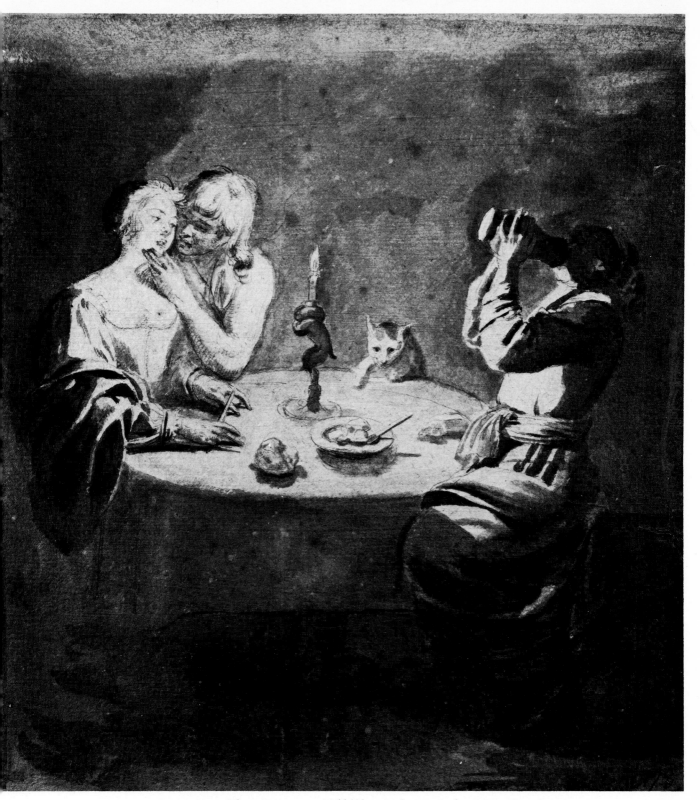

236. JEAN LE CLERC: *Three Figures at a Table* (drawing). Musée des Beaux-Arts, Rennes

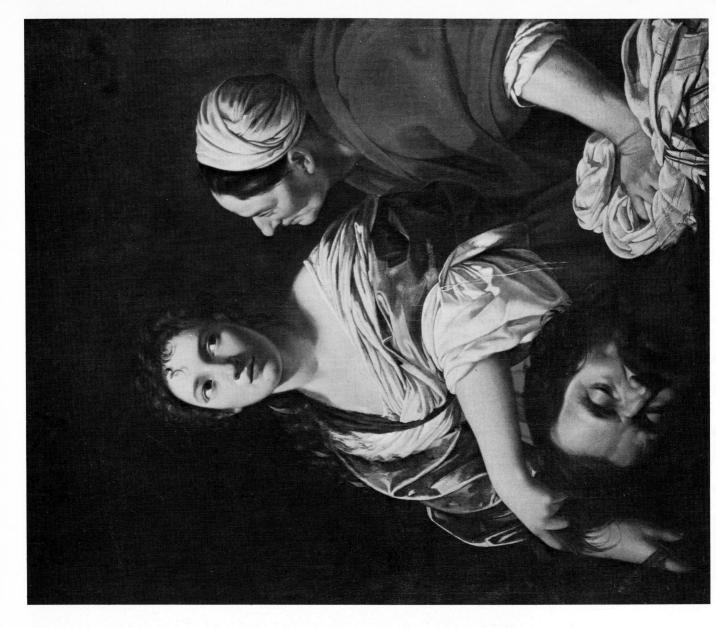

237. GEORGES DE LA TOUR(?): *Head of a Woman* (fragment).
Schloss-Fasanerie, Adolphseck bei Fulda

238. COPY AFTER SIMON VOUET:
Judith with the Head of Holofernes, with Servant.
William Rockhill Nelson Gallery of Art, Kansas City (Missouri)

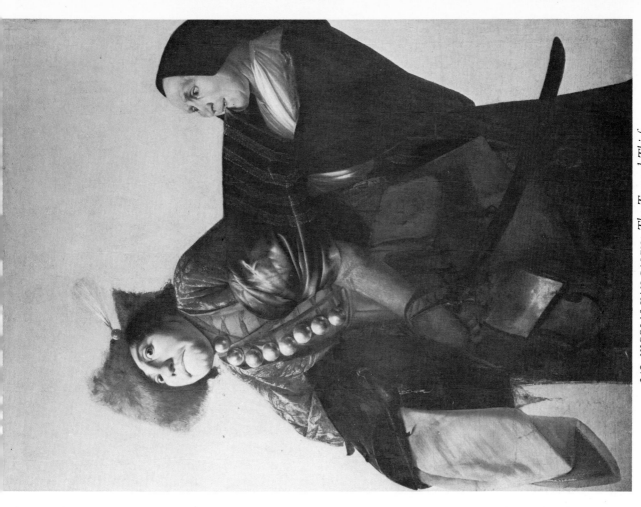

240. NICOLAS VAN GALEN: *The Trapped Thief.*
Sale, Christie's, 25 Nov. 1960 (105)

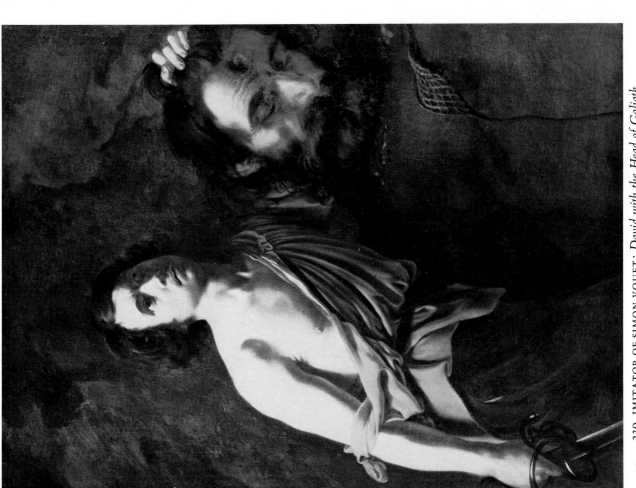

239. IMITATOR OF SIMON VOUET: *David with the Head of Goliath.*
Sale, Sotheby's, 12 July 1972 (77)

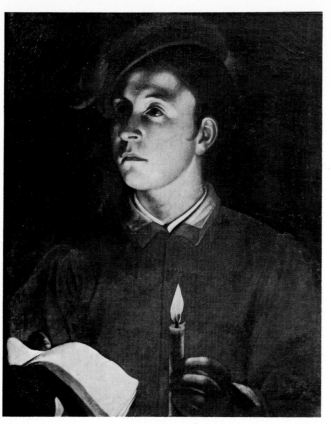

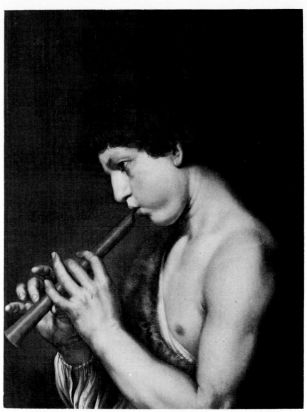

241. CARAVAGGESQUE UNKNOWN (CENTRAL EUROPEAN):
Boy with Candle and Book.
Bayerische Staatsgemäldesammlung, Munich

242. BARTOLOMÄUS SARBURG OR SARBURGH:
Boy Fluteplayer. Paul Wallraf Collection, London

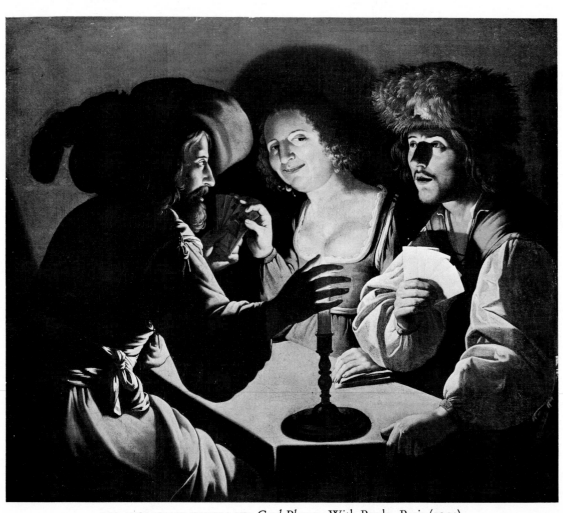

243. WOLFGANG HEIMBACH: *Card Players.* With Pardo, Paris (1955)

Iconographical Index

This index, which takes as its admirable model the *Census of Pre-Nineteenth-Century Italian Paintings in North American Public Collections* by Burton B. Fredericksen and Federico Zeri (Harvard U.P.), 1972, repeats all the paintings in the Lists under subjects, divided into the following categories:

1. Greek Mythology (alphabetical)
2. Roman Mythology (alphabetical)
3. Allegory (alphabetical)
4. Classical History (alphabetical)
5. Post-classical History
6. Post-classical Literature
7. Old Testament (Bible chronology)
8. Apocrypha (Bible chronology)
9. New Testament (Bible chronology)
10. Life of the Virgin
11. Madonnas, Holy Families
12. Miscellaneous Devotional Subjects
13. Saints (alphabetical)
14. Prophets, Hermits, Monks
15. Portraiture
16. Concerts and musicians
17. Musicians combined with other genre activity
18. Feasting Scenes
19. Games Players (alphabetically under games)
20. Fortune-Tellers
21. Love and Lust
22. Brawls, Guard Room fights
23. Genre, miscellaneous, groups
24. Genre, miscellaneous, single figures, a) Men; b) Women; c) Children
25. Smokers
26. Still life
27. Unidentified Subjects

Just as Fredericksen and Zeri broke down their fullest categories (such as certain episodes from the New Testament, and the Madonnas) into innumerable sub-categories, so that their entries should not become long, unmanageable lists, so I have broken down my fullest categories (such as New Testament, Concerts, Feasting Scenes and miscellaneous genre) into subdivisions. The name of an author is only listed here once under a given category (except in cases where the subject is split up into sub-categories, into more than one of which the author falls), even though he may have painted more than one composition with this subject. Some of the paintings are cross-referenced under different headings where there could be an ambiguity. Since the lists under authors follow the same order as they do here, it has not been thought necessary to repeat the locations in this index, since they can be found in their appropriate places in the lists within seconds. There is one exception, in that here musical instruments are listed alphabetically when they are unaccompanied by other instruments, whereas in the lists they are given roughly in descending order of status, from lute to rommelpot and mouth organ.

I have gone on the principle that if only six compositions are covered by a given category or sub-category, it should not be necessary further to sub-divide the category. But where more than six works are covered, then further explanatory sub-divisions are made. An exception has been made for self portraits, which are all indexed together. By this method it should be possible, with nothing but an unmarked photograph of a Caravaggesque picture in one's hand, to discover where it is listed, or that it has been omitted.

1. GREEK MYTHOLOGY

ACHILLES, among the daughters of Lycomedes. Paolini.

ASSEMBLY ON OLYMPUS. Galli.

APOLLO, alone. Valentin imitator.

—, with Diana. Honthorst.

—, with Marsyas. Baburen.

—, with Nine Muses (see also under Muses). O. Gentileschi (lost).

ARIADNE. Bor.

BACCHANALS. Bijlert. ?Moeyaert.

BACCHANTE. Terbrugghen.

BACCHUS, alone. (See also under Genre, Children, single figures). Bor. Caravaggesque (Roman-based). Régnier (lost). ?Sellitto (?copy).

—, with Ceres. Couwenbergh. Honthorst.

—, with drinker. Manfredi.

—, with putto. Caracciolo.

CEPHALUS, with Procris. 'Giusto Fiammingo'.

?CERES, offering to. Baburen (under unidentified subject).

CERES, taunting of (see also under Bacchus). Stomer.

DAEDALUS, with Icarus. ?Caracciolo. Riminaldi.

DANAË. O. Gentileschi.

DIANA the Huntress (see also under Apollo). O. Gentileschi.

HERCULES, with Omphale. Seghers.

JUNO placing Argus's eyes on her peacock's tail. ?Riminaldi.

JUPITER, with Neptune and Pluto (see also under Orpheus). ?Caravaggio.

LOVE, Divine, alone (see also under Cupid). Caravaggio. Caravaggesque (Roman-based). O. Gentileschi circle. Riminaldi.

—, Divine, 2 figures. Baglione. ?Riminaldi.

MEDUSA. Caravaggio.

MERCURY. Bijlert (lost).

MUSES (see also under Apollo). O. Gentileschi.

NARCISSUS. ?Caravaggio. ?Kuyl. ?Moreelse.

NYMPH, with Cupid and Satyr. Bijlert.

—, with Satyr. Honthorst.

ORPHEUS, alone. Honthorst. Régnier (?lost).

—, with Eurydice. ?Moeyaert.

—, with Pluto and Proserpine. ?Moeyaert.

PHILOCTETES. Kuyl.

PROMETHEUS. Baburen. Stomer.

SATYR, with peasant family (from Aesop and Vondel). Stomer.

SILENUS, Triumph of. Honthorst.

SORCERESS or CIRCE. Bor.

2. ROMAN MYTHOLOGY

AENEAS, with Anchises. Spada.

CIMON, with Pero (Roman Charity), facing to right. Couwenbergh. ?Douffet. Manfredi. Stomer (plus derivation).

—, facing to left. Baburen. Honthorst (after). J. Janssens.

CUPID, asleep (see also under Love; Mars; Nymph and Satyr; Venus). Caracciolo and ? Caravaggio. ?O. Gentileschi.

—, at the fountain. Cecco del Caravaggio.

—, with Psyche. Bigot. O. Gentileschi circle.

MARS, alone (see also under Cupid, and Venus). Honthorst, Terbrugghen.

—, with Cupid. Bijlert. Manfredi.

MARS, with Venus. Honthorst.

?POMONA. Bor.

VENUS, with Cupid. Bijlert. Cesar van Everdingen.

3. ALLEGORY

AGES OF MAN. Manetti. Paolini. Valentin.

AVARICE. A. Bloemaert. Bijlert. Sandrart.

CARITAS. Bijlert.

DEATH. Bigot. Ducamps and ? Paolini.

FELICITY, Public. O. Gentileschi.

GLUTTONY. Sandrart.

ITALY. Valentin.

?JEALOUSY. Sandrart.

?LIBERAL ARTS. Serodine.

LIBERALITY. A. Bloemaert (after).

LOGIC. Bor.

MELANCHOLY (see under Penitent Magdalen).

MUSIC, ASTROLOGY, GEOMETRY, PHILOSOPHY. O. Gentileschi circle. Paolini.

SEASONS, all months. Sandrart.

—, all four seasons. Manfredi.

—, Spring. Caroselli.

—, Summer. Caroselli. Régnier.

—, Autumn. Caroselli. Régnier.

—, Winter, single figure. A. Bloemaert. H. Bloemaert (lost). Cesar van Everdingen.

—, Winter, more than one figure. Honthorst. Régnier. Terbrugghen (copy).

SENSES, all five senses on same canvas. Bijlert. Caravaggesque (South Netherlandish). 'Giusto Fiammingo'. Manfredi imitator. Rombouts.

—, Hearing. Van Houbracken. Ribera (copy).

—, Sight. Van Houbracken. Ribera.

—, Smell. Cesar van Everdingen. Van Houbracken. Ribera.

—, Taste. Van Houbracken. Ribera.

—, Touch. Van Houbracken. Ribera.

TEMPERANCE. A. Bloemaert.

VANITAS, VANITY, Ages of Man or (see also under Love and Lust). Paolini.

—, Death or. Bigot.

—, three figures. Sandrart.

—, two figures. Bijlert. Caroselli. Vouet imitator.

—, single figures. Honthorst imitator. Lievens.

WRATH. Sandrart.

Allegorical figure with book inscribed 'Cognitione'. Master F.

Allegories, unclassified. Honthorst. Saraceni.

4. CLASSICAL HISTORY

ARCHIMEDES. ?Serodine.

ARISTARCHUS of Samos. Serodine.

?BRUTUS, Death of. Stomer.

CATO, Death of. Caravaggesque (Roman-based). Stomer.

CLAUDIUS, Emperor. Terbrugghen.

CLEOPATRA. A. Gentileschi.

CONSTANTINE, Emperor, Battle of. Tournier.

CROESUS (see also under Solon), exacting payment. Vignon.

DEMOCRITUS, alone (see also under Heraclitus) Honthorst imitator. Moreelse.

DIOGENES (see also under Plato). Van Campen. Preti.

HERACLITUS, DEMOCRITUS, two paintings. Baburen assistant. Moreelse. Terbrugghen.

—, single painting. Bijlert.

LAIS, with Xenocrates. Honthorst.

LUCRETIA, Death of. Caravaggesque (French). A. Gentileschi. Rustici.

—, with Tarquin. Régnier.

MUCIUS SCAEVOLA. Stomer. Terbrugghen.

ORIGEN. 'Master of the Judgement of Solomon'.

PLATO, with Diogenes. H. Bloemaert.

SCIPIO, Magnanimity of. Kuyl.

SENECA, Death of. Honthorst. Sandrart. Stomer.

SERTORIUS, Roman Emperor. Kuyl.

SOCRATES, Death of. 'Giusto Fiammingo'.

SOLON, before Croesus. Honthorst.

SOPHONISBA receiving the poison cup. Preti. Vouet.

TIBERIUS, Emperor. Seghers.

TITUS, Emperor. Baburen.

ASTRONOMERS. Tornioli.

PHILOSOPHERS. Baburen assistant. 'Master of the Judgement of Solomon'. Ribera.

?ALCHEMY, instruction in. Paolini.

SIBYLS. Caravaggesque (French). ?A. Gentileschi. O. Gentileschi. Vouet (see under *Birth of the Virgin*).

5. POST-CLASSICAL HISTORY

DANDOLO, Doge Enrico, inciting to the Crusades. Le Clerc/Saraceni.

NICHOLAS V, Pope, at tomb of St Francis. Douffet

WALLENSTEIN, Murder of General. Paolini.

WILLIAM THE GOOD, Justice of. Van Galen. Monogrammist 'ISH' or 'SIH'.

6. POST-CLASSICAL LITERATURE

CATS. Bor. ?Terbrugghen.

DANTE. Manetti.

HOOFT. Baburen. Honthorst. Terbrugghen.

TASSO. Valentin.

VONDEL, see under Satyr, Greek Mythology.

7. OLD TESTAMENT

ADAM, with Eve. Bijlert. Caracciolo.

CAIN, with Abel. Riminaldo and attributed. ?Spada.

ADAM AND EVE finding the body of Abel. Caracciolo. Stomer.

NOAH, Drunkenness of. Saraceni.

SARAH brings Hagar to Abraham. Stomer.

LOT, Flight from Sodom. Stomer.

—, in landscape with Sodom burning. O. Gentileschi.

—, on left of daughters. Baburen. Caracciolo.

—, between daughters. Caracciolo. Honthorst (after). Manetti and attr.

—, on right of daughters. Caravaggesque (North Netherlandish).

ISAAC, Sacrifice of. Gentileschi.

—, Sacrifice of, with head on block. Caravaggio. Caravaggesque (Roman-based).

—, Sacrifice of, with elbow propped on block. Caravaggio (copy). Caravaggesque (Roman-based).

—, Sacrifice of, with arms crossed. Caravaggesque (Roman-based).

—, Sacrifice of, squatting. Caracciolo.

—, Sacrifice of, kneeling. Gentileschi circle. Valentin.

ESAU selling his Birthright, tondo. Master K.

—, selling his Birthright, two figures. Caravaggesque (North Netherlandish).

—, selling his Birthright, three figures. Stomer.

—, selling his Birthright, four figures. Terbrugghen, and imitator.

ISAAC blessing Jacob. Stomer (copy).

?JACOB, LABAN, LEAH. Terbrugghen.

LABAN, RACHEL. ?Bronckhorst.

JUDAH, THAMAR. Baburen.

JOSEPH, with Potiphar's wife. Couwenbergh. O. Gentileschi. Tournier. Vouet imitator.

—, interpreting dreams. Kuyl. Mellan. Tournier. Vignon.

—, before Pharaoh. 'Van Adelo'.

MOSES, Finding of. O. Gentileschi.

—, with Tablets of the Law. Valentin.

SAMSON, with Philistines. Finson. Stomer.

—, with Delilah, more than three figures. H. Bloemaert. Couwenbergh. Stomer.

—, with Delilah, three figures. Honthorst. Manetti.

—, with Delilah, two figures. Mellan (after).

—, alone. Valentin.

DAVID, with sleeping Saul. ?Seghers.

—, execution of Goliath. Borgianni. O. Gentileschi.

—, with head of Goliath, tondo. Master K.

—, full length, with head of Goliath. Caravaggio. Caravaggesque (Roman-based). O. Gentileschi. Reni. ?Sellitto.

—, three quarters or near full length, with head of Goliath to left. Régnier. Stomer.

—, three quarters or near full length, with head of Goliath to right on slab. Vignon. Vouet and imitator.

—, three quarters or near full length, with head of Goliath held in hand. Caravaggio. Finson. Riminaldi. Tournier (copy). Valentin.

—, half length, with head of Goliath. O. Gentileschi. Master of the Judgement of Solomon. Terbrugghen (?copy). Tournier. Vouet.

—, with head of Goliath and soldier. Spada.

—, with head of Goliath and girl with laurel. ?Régnier.

—, with head of Goliath and two other figures. Valentin.

—, with four girls with musical instruments. Manetti.

—, with girl with tambourine. Tournier.

—, saluted by women singing. Terbrugghen.

—, with sling, stone and/or sword. Caravaggesque (Neapolitan etc.). 'Giusto Fiammingo'. Régnier.

—, harping, alone. Honthorst. Stomer. Valentin. ?Vouet.

—, harping, with Angels. Terbrugghen.

—, King, in prayer. H. Bloemaert.

SOLOMON. Judgement of. 'Master of the Judgement of Solomon'. Stomer. Tournier. Valentin.

ELIJAH, throwing mantle to Elisha. Stomer.

ESTHER, with Ahasuerus. Rembrandt.

JOB. Caravaggesque (Neapolitan etc.). La Tour. 'Pensionante del Saraceni'.

SCENE OF JUDGEMENT (?from Old Testament). Stomer

8. APOCRYPHA

TOBIT, with his wife taking leave of their son Tobias. Tournier.

—, being healed of blindness by Tobias and Angel Raphael. Baburen imitator. ?Feti. Galli. Member of Portengen family. Stomer.

TOBIAS, with Angel Raphael. Galli. Schedoni. Stomer.

JUDITH, murder of Holofernes. Bigot. Caravaggio. A. Gentileschi. Valentin.

—, with body and severed head of Holofernes. Baglione. Caravaggesque (?Sicilian). ?Manfredi.

—, alone, with head of Holofernes. Valentin. Vouet.

—, with servant, placing head of Holofernes in sack or shroud. ?De Coster. A. Gentileschi.

—, with servant, head of Holofernes in basket. A. and O. Gentileschi. Gramatica.

—, with servant, holding head of Holofernes by hair. Saraceni. Seghers. Vouet.

SUSANNA, Innocence of. Valentin.

—, with attendants (?). Bronckhorst.

—, with elders. A. Gentileschi.

DANIEL, with priest of Bel. Van Loon.

9. NEW TESTAMENT

ANNUNCIATION see under 10. Life of the Virgin

DREAM OF ST JOSEPH see under 10. Life of the Virgin

VISITATION see under 10. Life of the Virgin

NATIVITY (see also under Holy Family). A. Bloemaert. Honthorst. Musso.

—, with Saints. Caravaggio.

ADORATION OF THE SHEPHERDS (see also under Holy Family), more than nine figures, with *Putti* carrying scrolls. Guy François.

—, (see also under Holy Family), more than nine figures, with angels or *putti*. Heimbach. Honthorst. Maino. Van Oost. Sellitto.

—, (see also under Holy Family), more than nine figures, without angels or *putti*. Quantin.

—, (see also under Holy Family), more than nine figures, with Annunciation to Shepherds in distance. Stomer.

—, nine figures. Maino. Van Oost.

—, eight figures. Master L.

—, seven figures. Van Oost. Stomer.

—, six figures, Madonna left. Caravaggio. La Tour. Le Clerc. Stomer.

—, six figures, Madonna right. Gramatica. Stomer.

—, six figures, Madonna centre. Honthorst.

—, five figures, Le Clerc. Stomer.

ADORATION OF THE MAGI. Finson. Van Loon. Maino. Stomer. Terbrugghen.

CIRCUMCISION. Finson. O. Gentileschi. Quantin. Tanzio da Varallo.

PRESENTATION OF CHRIST IN THE TEMPLE. Guy François. Van Loon.

MASSACRE OF THE INNOCENTS. Finson.

FLIGHT INTO EGYPT. Caravaggio. Heimbach.

REST ON THE FLIGHT. Caracciolo. Caravaggesque (North Italian). O. Gentileschi.

RETURN FROM THE FLIGHT. Caracciolo.

CHRIST IN THE CARPENTER'S SHOP. Bigot, and after, and circle. Honthorst, and imitator. La Tour. Saraceni.

CHRIST AMONG THE DOCTORS, full length figures. Baburen, and assistant. 'Master of the Judgement of Solomon'. Stomer.

—, three quarters or half length figures, with tables in front. Baburen circle. Vignon.

—, three quarters or half length figures, more than six figures. Borgianni. Manfredi.

—, three quarters or half length figures, five figures. Galli. Gramatica.

—, three quarters or half length figures, four figures. ?Caracciolo (copies). Artist between 'Pensionante' and Le Clerc.

BAPTISM. Caracciolo. O. Gentileschi. ?Salini.

CALLING OF SAINTS PETER AND ANDREW. ?Caravaggio. ?Galli.

CALLING OF THE CHILDREN OF ZEBEDEE. Serodine.

CALLING OF ST MATTHEW see 13. Saints

FEAST AT CANA. Vignon.

CHRIST AND NICODEMUS. Honthorst. Seghers (after). Stomer. Volmarijn.

CHRIST AND THE SAMARITAN WOMAN. Caracciolo. O. Gentileschi. Stomer. Valentin.

RETURN OF THE PRODIGAL SON (genre feasting scenes are often given this title; see under Feasting Scenes). Caravaggesque (Roman-based). Spada. Valentin.

GOOD SAMARITAN. Sandrart. Stomer (subject uncertain).

THE MOTE AND THE BEAM. Tournier.

LAZARUS AND THE RICH MAN. Terbrugghen.

MIRACLE OF THE MONEY. Stomer.

CHRIST HEALING THE SICK. Caravaggesque (Neapolitan etc.).

CHRIST HANDING OVER THE KEYS TO ST PETER. Caravaggesque (French). Sellitto.

ST PETER SAVED ON THE WATERS. Sellitto.

'SINITE PARVULOS'. Van Loon. Tournier.

RAISING OF THE SON OF THE WIDOW OF NAIN. Minniti.

WOMAN TAKEN IN ADULTERY, Adulteress facing left. Caravaggesque (Neapolitan etc.). Caroselli. Stomer.

—, Adulteress facing right. Baburen (?copy). Finson. ?Manfredi. Valentin.

CHRIST IN THE HOUSE OF MARY AND MARTHA. Couwenbergh.

RAISING OF LAZARUS. Caravaggio. Caravaggesque (Neapolitan etc.). Finson. Quantin.

CHRIST DRIVING OUT THE MONEY CHANGERS, Christ on right. Cecco del Caravaggio. Manfredi, and copy (fragment). ?Stomer.

—, Christ on left. Rombouts. Saraceni (copy). Valentin.

—, Christ in centre. Tornioli.

—, Baburen imitator.

TRIBUTE MONEY. Manfredi. Preti. Serodine. Valentin.

CHRIST WASHING THE DISCIPLES' FEET. Baburen. Bijlert. Caracciolo. Sellitto.

LAST SUPPER. Rodriguez and after. Stomer. Valentin.

AGONY IN THE GARDEN, with Apostles asleep. Baburen. Borgianni. Caravaggio.

—, Christ alone with Angel. Baglione. Caracciolo. O. Gentileschi. Honthorst. Stomer.

CAPTURE OF CHRIST, with Malchus episode. Baburen. O. Gentileschi. Stomer.

—, with Kiss of Judas. Baburen. Caravaggio (?copy). Caravaggesque (Roman-based). Seghers.

—, six figures. Manfredi (after). Stomer (?copy).

—, four figures. Bigot.

—, three figures. Manfredi imitator.

—, two figures. Bigot.

—, upright compositions. Stomer.

CHRIST BEFORE PILATE. Stomer.

DENIAL OF ST PETER see under 13. Saints

PILATE WASHING HIS HANDS. Bijlert. Rembrandt or Lievens. Stomer. Terbrugghen.

CHRIST AND CAIAPHAS. Caracciolo. Honthorst. Stomer.

CROWNING WITH THORNS, more than nine figures. Saraceni. Terbrugghen.

—, nine figures. Caravaggesque (French). Manfredi.

—, seven figures. Honthorst. Valentin.

—, six figures. Caravaggesque (Roman-based). ?Terbrugghen.

—, five figures. Baburen. Caravaggesque (South Netherlandish). Honthorst. Jan Janssens. Manfredi copy, and imitator.

—, four figures. Caravaggio (copy). O. Gentileschi. Manfredi. Régnier.

—, three figures, horizontal. O. Gentileschi. Manfredi (copy). Terbrugghen. Valentin (copies).

—, three figures, upright. Bigot. Caravaggio. Jan Janssens. Spada. Valentin, and copy.

—, three figures approx. square. Terbrugghen.

—, two figures. O. Gentileschi circle. Manfredi.

—, combined with Mocking of Christ. Bigot. Stomer.

MOCKING OF CHRIST (see also under Crowning with Thorns), five figures. De Haan. Honthorst (copy). Stomer. Valentin (copies).

—, four figures. Stomer.

—, three figures. Bigot. O. Gentileschi circle (with Flagellation). Terbrugghen.

—, two figures. Bigot.

ECCE HOMO, five figures. Kuyl.

—, four figures. Stomer.

—, three figures. Baburen circle?.Caravaggio. Minniti.

—, two figures. Baglione. Caracciolo.

MAN OF SORROWS, single figure. Caravaggesque (North Netherlandish).

FLAGELLATION (see also under Mocking of Christ), more than five figures. Manfredi imitator. Saraceni. Stomer.

—, four figures. Caravaggio.

—, three figures. Bigot. Caravaggio. O. Gentileschi.

CHRIST AT THE COLUMN and CHRIST BOUND, four figures. Manzoni.

—, three figures. Caravaggio (copies). Seghers.

—, two figures. Caracciolo. Finson. Spada. Stomer.

—, Christ alone. O. Gentileschi circle. Reni. Spada.

WAY TO CALVARY and CHRIST CARRYING THE CROSS, full length. Baburen. O. Gentileschi. Musso.

—, half length. Borgianni. Spada. Stomer.

—, Christ taking leave of his Mother. Caracciolo.

—, Christ alone. Borgianni. Caracciolo.

CHRIST AND SIMON THE CYRENEAN. Caracciolo.

CRUCIFIXION, five figures. Caracciolo. Tournier.

—, four figures. Guy François. O. Gentileschi.

—, three figures. Terbrugghen.

—, with Angels. Sellitto.

—, with St Francis at foot of Cross. Musso.

—, with Magdalen at foot of Cross. Finson.

SOLDIERS GAMBLING FOR CHRIST'S GARMENTS. Régnier. Valentin (?copy).

DEPOSITION. Paolini. Tournier.

LAMENTATION OVER THE BODY OF CHRIST and PIETÀ. Bigot. Borgianni. Caracciolo. A. Janssens. studio

ANGEL WATCHING OVER THE DEAD CHRIST. Bigot (copy). A. Janssens.

ENTOMBMENT, more than five figures. Baburen. Caracciolo. Caravaggio. ?Douffet. Rubens.

—, four figures. De Haan.

—, three figures. Tournier.

RESURRECTION. Cecco del Caravaggio. Finson. Jan Janssens. Maino.

NOLI ME TANGERE. Caracciolo. Valentin.

CHRIST APPEARING TO THE MADONNA AFTER THE RESURRECTION. Manfredi.

INCREDULITY OF ST THOMAS see under 13. Saints

INVITATION TO THE JOURNEY TO EMMAUS. Serodine.

CHRIST AT EMMAUS. H. Bloemaert. Volmarijn imitator.

—, five figures. Caravaggio. Honthorst workshop. ?Van Oost. Rodriguez. Stomer.

—, four figures, Christ in centre. A. Bloemaert. Caravaggio. Caravaggesque (Neapolitan etc.). Caravaggesque (North Italian). Van Loon.

—, four figures, Christ on right. Stomer.

—, four figures, Christ on left. Bigot. Caravaggesque (North Netherlandish). Stomer.

—, three figures. Caravaggesque (South Netherlandish). Stomer. Terbrugghen. Volmarijn.

—, upright composition. Caravaggesque (French). Régnier. Volmarijn.

PENTECOST see under 10. Life of the Virgin

DEATH OF ANANIAS. Monogrammist ISH or SIH

LIBERATION OF ST PETER see under 13. Saints

10. LIFE OF THE VIRGIN

MEETING AT THE GOLDEN GATE. Van Loon.

IMMACULATE CONCEPTION. Caracciolo.

BIRTH OF THE VIRGIN. Borgianni. Van Loon. Saraceni. Vouet.

TOILET OF THE VIRGIN. Van Loon.

VIRGIN AND ST ANNE (including Education of the Virgin). Circle of Galli (copies). La Tour.

PRESENTATION OF THE VIRGIN IN THE TEMPLE. Van Loon. Saraceni.

ANNUNCIATION, two canvases. Bernardi. Stomer.

—, Angel to left, horizontal. Finson. Jan Janssens.

—, Angel to left, upright. Caracciolo. Finson. Jan Janssens. Terbrugghen.

—, Angel to left, Angel above. Caravaggio. Saraceni/Le Clerc.

—, Angel to right. O. Gentileschi. Van Loon. Stomer.

DREAM OF ST JOSEPH. ?O. Gentileschi. La Tour. See also Bigot *Denial of St Peter*

ANGEL ANNOUNCING TO THE MADONNA AND ST JOSEPH THE FLIGHT INTO EGYPT. Stomer.

VISITATION. Van Loon. Quantin.

PENTECOST. Maino.

MATER DOLOROSA. Terbrugghen. Vouet.

DEATH OF THE VIRGIN. Caravaggio. Saraceni (and Le Clerc).

ASSUMPTION OF THE VIRGIN. O. Gentileschi. Van Loon. Saraceni. Stomer.

CORONATION OF THE VIRGIN. Serodine.

11. MADONNAS, HOLY FAMILIES

MADONNA, with Child alone, Child on her knees. Tournier.

—, with Child alone, Child in her lap. Bijlert. Caravaggio. O. Gentileschi.

12. MISCELLANEOUS DEVOTIONAL SUBJECTS

13. SAINTS

14. PROPHETS, HERMITS, MONKS

15. PORTRAITURE

16. CONCERTS AND MUSICIANS

Note. Where fewer instruments are cited than there are figures represented, the others can be assumed to be singing or listening. Musicians accompanied by feasting and drinking companions, lovers, games players etc are listed separately under No. 17 below.

—, lute, guitar. Rombouts.

—, lute, violin. Paolini. Terbrugghen.

SINGLE FIGURES, BAGPIPES. A. Bloemaert. Bijlert. L. Portengen. Terbrugghen. Vignon.

—, CELLO. Bijlert.

—, CITTERN. Cesar van Everdingen.

—, CORNET. La Tour (engraving).

—, FLUTE, with still life and violin. Caravaggesque (? Spanish.)

—, played by shepherds. Bijlert. Kuyl. Van Oost. ?L. Portengen.

—, flutes to lips, players in feathered berets. Baburen (copy). Munnicks. Terbrugghen and imitator.

—, flute to lips. Caravaggesque (Roman-based).

—, flutes not to lips, players in feathered berets. A. Bloemaert. Bijlert. Master B. Master D. Stomer. Tournier.

—, with players crowned by laurel. Bijlert. Valentin.

—, player in beret decorated with foliage. Terbrugghen studio.

—, players in berets but without plumes or flowers. Baburen (after). Honthorst. Terbrugghen and imitator.

—, player trimming flute. Bijlert.

—, female player. Bijlert.

—, player half-nude boy. Sarburg.

—, GUITAR, girl players. Bronckhorst. Honthorst. Rombouts. Vouet.

—, with dice and cards. Manfredi imitator.

—, with mirror. ?Van Oost.

—, HURDY GURDY. La Tour.

—, LUTE, women and girls. Bijlert. O. Gentileschi. Honthorst. Terbrugghen and imitator.

—, player near full-length. Valentin.

—, with violin behind. ?Tournier.

—, drawing. Baburen.

—, with table in front. Caravaggio. Caravaggesque (?French). Heimbach (copy). Magnone. Rombouts.

—, players with feathered berets, head facing spectator. Baburen. Bijlert. Caravaggesque (South Netherlandish). L. Portengen. Terbrugghen. Tournier.

—, players with feathered berets, head to right. Master A. Terbrugghen.

—, player with head scarf. Caravaggesque (Roman-based).

—, tuning lute, and lute-making. Paolini.

—, MOUTH ORGAN. Baburen.

—, PENORCON. Terbrugghen.

—, ROMMELPOT. A. Bloemaert.

—, SINGERS, men, with music sheets. Baburen. Circle of Master A. Caroselli. ?De Coster. P. Portengen. Terbrugghen.

—, without music sheets. Master G.

—, boys. Bigot. De Coster. Terbrugghen. Vignon.

—, women and girls. Bronckhorst (fragment). Caroselli. Honthorst (after). Terbrugghen.

—, TAMBOURINE. Manfredi. L. Portengen.

—, THEORBO. Bronckhorst.

—, with tambourine and guitar. Gramatica (fragment).

—, BASS VIOL. Honthorst.

—, TREBLE VIOL. Terbrugghen (copy).

—, VIOLIN. Master B. Master D. O. Gentileschi. Honthorst. Paolini. Terbrugghen.

—, with prominent still life. Caravaggesque (Roman-based).

—, youth. Baburen (copy).

—, MUSICAL INSTRUMENT MAKERS. Cecco del Caravaggio. Paolini.

17. MUSICIANS COMBINED WITH OTHER GENRE ACTIVITY.

MORE THAN SEVEN FIGURES, with fortune-teller. Preti. Régnier. Valentin.

—, with eating and drinking. Bronckhorst. Finson. Tournier.

SEVEN FIGURES, with eating and drinking. Bijlert. Honthorst. Manfredi. Valentin.

SIX FIGURES, with eating and drinking. Bronckhorst. Caravaggesque (North Netherlandish). Honthorst. Manetti.

—, with gambling and drinking. Valentin (copy).

—, with gambling. Master H. Rombouts.

—, with fortune-teller. Valentin.

FIVE FIGURES, with drinking and love-making. Baeck.

—, with eating and drinking. Cossiers (copy). Honthorst (?pastiche). Tournier. Valentin.

—, with gambling. De Coster, and after.

—, with drinking and luteplaying. Valentin (?copy).

FOUR FIGURES, with eating and drinking. Baburen. Bronckhorst. Master J. ?Rombouts. Tournier. Valentin.

THREE FIGURES, with drinking. Caravaggesque (?French). Honthorst. Terbrugghen. Valentin and copy.

TWO FIGURES, singer and smoker. De Coster (?copy).

—, with drinking. Stomer (pastiche after). Terbrugghen.

—, singer and drinker. Master G.

—, girl fluteplayer seduced by Youth. Honthorst (copy).

—, girl luteplayer and boy with dead game behind parapet. Paolini.

SINGLE FIGURES, with musical instruments and tumblers or wine glasses. Master A. Honthorst. Stomer. Terbrugghen and after.

—, with musical instruments and tankards. Master B.

18. FEASTING SCENES
(see also under Nos. 17, 19, 23 & 25)

MORE THAN SEVEN FIGURES. Heimbach. Honthorst. Liss. Rombouts.

SEVEN FIGURES. Honthorst. Rombouts circle.

SIX FIGURES. Van Oost (after). Seghers.

FOUR FIGURES. Bijlert. Caravaggesque (?French). Master F.

THREE FIGURES. Bigot. Simon Cossiers. Heimbach. Vignon.

TWO FIGURES. Jan Cossiers. Honthorst. La Tour. Vignon.

SINGLE FIGURES, pouring wine from tankard into glass. Cossiers.

—, women with pestle and mortar. Master G.

—, smokers with tankards or wine glasses. Couwenbergh. ?Rombouts.

—, men with flasks or decanters. Master G. and circle. Stomer. Tournier.

—, ham-eater. Honthorst.

—, boy with glass and tankard. Couwenbergh.

—, man with tumbler and tall glass. Couwenbergh.

—, man with wine glass and still life. Master G.

—, men with wine glasses. Caravaggesque (North Netherlandish). ?De Coster. Lievens. Stomer (copy). Tournier.

19. GAMES PLAYERS
(see also under Nos. 17 & 20)

BACKGAMMON. Caravaggesque (South Netherlandish).

—, with woman pouring out glass of wine. Cossiers.

—, ten figures. Rombouts.

—, nine figures. Honthorst (copy).

—, five figures, with luteplayer. De Coster (after).

—, five figures, with drinker and smoker. Manfredi imitator.

—, four figures, with smoker. Couwenbergh. Lievens.

—, four figures, with drinker and smoker. Baburen.

—, four figures, one a negro boy. Bijlert.

—, four figures, one pointing to score board on wall. Terbrugghen.

—, three figures. Baburen (after).

CARDS, male and female. Rombouts.

—, nine figures. Tournier.

—, nine figures with cheating and fortune-teller. Régnier.

—, eight figures, no cheating. Rombouts.

—, six figures, with cheating. Ducamps.

—, six figures, no cheating. Manfredi and imitator. Van Oost (after).

—, six figures, with luteplayer. Master H. Rombouts.

—, five figures, with cheating. De Coster. Crabeth. Honthorst (copy). Van Oost (after).

—, five figures, no cheating. Caravaggesque (South Netherlandish). De Coster. Kuyl. Rombouts.

—, four figures, with cheating. Crabeth. La Tour.

—, four figures, no cheating. Manfredi imitator.

—, three figures, with cheating. Baburen (copy). Caravaggio. Caravaggesque (?Neapolitan). Heimbach. Manfredi. Régnier. Valentin.

—, three figures, no cheating. La Tour (copy). Rombouts.

—, three figures, with drinker. Bigot circle.

—, three figures, on military drum. Caravaggesque (South Netherlandish).

—, two figures. Baburen imitator. Caravaggesque (?South Spanish). ?Gramatica.

—, quarrelling over cards. Couwenbergh.

—, single figure. Manfredi imitator.

CHESS. Honthorst. Manfredi imitator.

DICE, eight figures, with fortune-teller. ?Régnier.

—, six figures. Valentin.

—, six figures, with gamblers and musicians. Valentin (copy).

—, five figures. La Tour. Tournier.

—, four figures. Manfredi imitator. Tournier.

—, three figures. ?Kuyl. Terbrugghen.

DRAUGHTS. Manetti. Preti.

MORRA. Caravaggesque (South Netherlandish).

GAMBLERS. ?Preti.

20. FORTUNE-TELLERS
(see also under Nos. 17 and 19; and under No. 6, CATS)

MORE THAN SIX FIGURES, in landscape. Caravaggesque (North Italian). Cossiers.

FIVE FIGURES. Bijlert. La Tour.

FOUR FIGURES. Caravaggesque (Central European). Paolini. Régnier. Tournier (?after Manfredi). Vouet.

THREE FIGURES. Manfredi. Tilmann.

TWO FIGURES. Caravaggio and copy. Caravaggesque (Roman-based).

THIRTEEN FIGURES, with musicians and brawl. Valentin.

NINE FIGURES, with card players. Régnier.

EIGHT FIGURES, with dice players. ?Régnier.

—, with drinkers. Valentin.

—, with musicians. Régnier.

SEVEN FIGURES, with draughts players. Manfredi.

SIX FIGURES, with card players. Honthorst.

—, with musicians. Valentin.

FIVE FIGURES, with drinker and luteplayer. Valentin (?copy).

FOUR FIGURES, with card players. Manfredi imitator.

21. LOVE AND LUST
(see also under No. 2, VANITY)

BROTHEL or PROSTITUTION SCENE. Bijlert. Honthorst. Manfredi imitator.

MAN MAKING OBSCENE GESTURE. Vouet (copy).

RAPE OF NEGRESS. Couwenbergh.

FOUR FIGURES, the dupe of love. Caroselli.

THREE FIGURES, boy and girl with procuress. Baburen. Bijlert. Honthorst. Paolini.

—, old man and girl with procuress. Paolini.

—, old man and girl with drinker. Terbrugghen.

TWO FIGURES, lovers. Vouet.

—, old man and girl. Bijlert. De Coster.

—, old woman tempting young one. Bijlert. Caroselli.

22. BRAWLS, GUARD ROOM FIGHTS
(see also under No. 20)

?Le Clerc. La Tour. Rombouts circle. Valentin.

23. GENRE, MISCELLANEOUS, GROUPS

SHIPWRECK SCENE. Saraceni.

HARVEST FESTIVAL, GATHERING FRUIT. Bor. Bronckhorst.

FOOD SALESMEN AND CONSUMERS (see also under No. 18) 'Pensionante del Saraceni'. La Tour. Rombouts. Vignon.

MAN EATING EGGS, being robbed by woman. H. Bloemaert.

KITCHEN SCENE. Heimbach.

FIGURES AT TABLE. Master F. Couwenbergh. Le Clerc.

PAYMENT OF DUES. La Tour.

ALMSGIVING. Preti.

TOOTH EXTRACTORS. ?Caravaggio. Honthorst. Rombouts.

INSTRUCTION CLASSES. J. Terborch. Volmarijn.

SOLDIERS. Tournier (?copy).

BLIND MAN, YOUTH and SERVANT. Preti.

MAN WITH STATUETTES. De Coster.

FIGURES READING. Heimbach.

SLEEPER AWAKENED BY LIT WICK. Régnier.

BOY FRIGHTENING GIRL WITH CRAB. Circle of Master K.

OLD WOMAN THROWING CANDLE BEAM ON GIRL. Honthorst.

FLEA CATCHER. Honthorst.

OLD WOMAN AND YOUTH BY ARTIFICIAL LIGHT. Stomer.

GIRL BLOWING ON COALS, with cavalier. Honthorst.

BUBBLE-BLOWING. Van Oost.

COAL HEAVER. Bigot.

TAVERN SCENE. Bigot.

THIEF. Van Galen.

BEGGARS. Preti.

CONTEST OF PUTTI. Reni (after).

24. GENRE, MISCELLANEOUS, SINGLE FIGURES

(a) *Men*

BEGGAR. Baburen circle (?Crabeth).

'BRAVO'. Vouet.

DOCTOR. Bigot.

FISHMONGER. 'Pensionante del Saraceni'.

GIPSY or MAGUS. ?Crabeth.

HALBERDIER. Vouet.

MONEY CHANGER. Rembrandt.

MUSICAL INSTRUMENT MAKER. Cecco del Caravaggio.

PAINTER IN STUDIO (see also under 'artists', No. 15). Caravaggesque (North Netherlandish).

PEASANT. La Tour.

?POET. Valentin imitator.

POMEGRANATE SELLER. Master J.

READING. Terbrugghen follower.

SECOND-HAND GOODS SELLER. Circle of Master G.

SHEPHERD. Bijlert.

SOLDIER. Bijlert. Master J. Manetti. Manfredi imitator. Preti. Stomer. Tournier.

SUTLER. Bijlert.

WITH TANKARD AND DRIED FISH. H. Bloemaert. Terbrugghen.

WITH FIREBRAND. Stomer.

WITH OIL LAMP. Heimbach. Stomer.

MASKING FLAME. Bigot. Heimbach.

GAZING AT HOURGLASS. Bijlert.

READING. Heimbach. Honthorst imitator.

WRITING. Baburen assistant. Terbrugghen, and follower.

LAUGHING. Master G. Terbrugghen.

FRIGHTENED. Caravaggesque (North Netherlandish).

WITH DOG. Terbrugghen.

WITH CHICKEN. A. Bloemaert (after). H. Bloemaert. Honthorst.

NUDE. Honthorst.

HEAD. Caravaggesque (French). ?Manfredi.

(b) *Women*

FLEA-CATCHERS. Bigot. Bor (Circle). Guerrieri. La Tour.

PEASANT'S WIFE. La Tour.

COMBING HAIR. Cesar van Everdingen.

WITH FLOWER AND HAND MIRROR. Cesar van Everdingen.

TAKING BATH. Heimbach.

SELLING EGGS. H. Bloemaert.

WITH COINS. Honthorst. Stomer, and copy.

PRAYING, WITH ROSARY. A. Bloemaert (after). Stomer.

WITH PESTLE AND MORTAR. Master G.

WITH CANDLE OR OIL LAMP. Heimbach. Honthorst.

WITH SPECTACLES. Terbrugghen imitator.

WITH BOOK. Van Campen (after).

SHEPHERDESS. Bijlert. Cesar van Everdingen. Honthorst.

WITH OBSCENE PICTURE. Honthorst.

WITH HAND ON CHALICE. Stomer.

HOLDING UP PAPER. Bijlert.

WITH STICKS. Stomer.

BY ARTIFICIAL LIGHT. Stomer.

HEAD. A. Bloemaert. Bor or O. Gentileschi. Honthorst. La Tour, and attributed.

(c) *Children*

SINGING (see also under No. 16). Bigot. De Coster.

WITH TANKARDS AND GLASSES. Cossiers. Terbrugghen, and imitator.

AS BACCHUS. Caravaggio. Honthorst.

WITH FRUIT. Caravaggio.

WITH FLOWERS. Caravaggio (copies).

WITH FISH, BIRDS etc., owl. H. Bloemaert (after).

—, bat. Bigot.

—, lizard. Caravaggio.

—, crayfish. Caravaggesque (Roman-based).

—, mouse. Caravaggesque (Roman-based). Guerrieri.

—, butterfly. Paolini.

—, fish. Terbrugghen imitator.

DRESSED AS MONK, with skull. ?Volmarijn.

DRAWING. Jan Terborch.

POURING OIL. Bigot.

WITH FIREBRAND or BRAZIER. De Coster. Honthorst. La Tour. Lievens. Stomer. Terbrugghen.

WITH CANDLES AND BOOKS. Caravaggesque (North Netherlandish). Caravaggesque (Central European). Heimbach. J. Moreelse. Stomer.

PAGE. Paolini.

HEADS. Master K. Paolini. Régnier. Vouet imitator.

25. SMOKERS
(see also under No. 17)

Note. Not all figures in concert parties, feasting scenes etc who are unobtrusively smoking are listed here.

MORE THAN SIX FIGURES, with concert. De Coster (copy).

FIVE FIGURES, with dice players. La Tour.

—, with backgammon and lute players. De Coster (after).

—, with card players. De Coster.

THREE FIGURES, with drinking. Simon Cossiers. Rombouts.

—, with card players. La Tour (copy).

TWO FIGURES, with drinking (fragments). Cossiers. Honthorst.

SINGLE FIGURES, with tankard. Baburen. Couwenbergh. ?Master B (after Baburen).

—, lighting pipe from oil lamp. ?Rombouts. Stomer.

—, lighting pipe from fire brand. La Tour (copies).

—, lighting pipe from brazier. Bijlert.

—, with candle. Bigot. Terbrugghen.

—, with empty glass. Baburen circle.

26. STILL LIFE

Caravaggio. Cecco del Caravaggio. ?Master J. 'Pensionante del Saraceni'.

27. UNIDENTIFIED SUBJECTS

Baburen (?*Offering to Ceres*). Caravaggesque (North Netherlandish). 'Giusto Fiammingo'. Honthorst. La Tour. ?Serodine.

Topographical Index

(For Masters A to L, see Lists under 'Caravaggesque')

References to the Literature

This is definitely not a bibliography but an index to the literary references in the lists. The latter are given by shortened titles in order to save space, here shown in brackets at the end of each entry. Almost all references are to illustrations, which explains why the early sources (Mancini, Baglione, Bellori etc.) and the documentary literature are not cited below. The result, as any student of the, period will recognize, is a somewhat eccentric list of publications. For full bibliographies, the reader is referred to Spear, 1971; Moir, 1967; and Marini, 1974.

Only the most important catalogues of collections and exhibitions are mentioned here, but many others are referred to in the lists.

1724

Susinno, see 1960.

1801–12

C. P. Landon, *Annales du Musée et de l'Ecole Moderne des Beaux Arts*, Paris, 1801–8. (Landon, followed by Vol. number. For volume with Giustiniani Collection, Landon, 1812).

1908

Maindron, *Revue de l'Art Ancien et Moderne*, 1908, p. 245. (Maindron, 1908).

Herman Voss, *Monatshefte für Kunstwissenschaft*, 1908, pp. 987–94. (Voss, 1908).

1909

Hermann Voss, *Monatshefte für Kunstwissenschaft*, 1909, pp. 108ff. (Voss, 1909).

1911–12

Granberg, *Trésors d'art en Suède*, Stockholm, 1911 (Vol. I) and 1912 (Vol. II). (Granberg, 1911, 1912).

1912

Erwin Rosenthal, 'Ein Bild des Utrechter Malers Luemen van Portengen', *Monatshefte für Kunstwissenschaft*, 1912, pp. 378–80. (Rosenthal, 1912).

L. Venturi, 'Opere inedite di Michelangelo da Caravaggio', *Bollettino d'Arte*, 1912, pp. 1ff. (Venturi, 1912).

1917

G. J. Hoogewerff, 'De Werken van Gerard Honthorst te Rome', *Onze Kunst*, 1917, I, pp. 37ff and II, pp. 81ff. (Hoogewerff, 1917).

1920

Th. Frimmel, *Studien und Skizzen zur Gemäldekunde*, v, Vienna, 1920. (Frimmel, 1920).

1923

Roberto Papini, 'Di Giovanni Serodine Pittore', *Dedalo*, 1923, pp. 121ff. (Papini, 1923).

1923–4

Dr A. von Schneider, 'Neue Zuschreibungen an Mattias Stoomer', *Oud-Holland*, 1923–4, pp. 225–30. (Von Schneider, 1923–4).

1924

G. J. Hoogewerff, *Gherardo delle Notti*, Rome, 1924. (Hoogewerff, 1924).

Hermann Voss, *Die Malerei des Barock in Rom*, Berlin, 1924. (Voss, 1924).

1925

Joachim von Sandrarts Academie der Bau-, Bild- und Mahlerey-Künste von 1675, ed. Dr A. R. Peltzer, Munich, 1925. (Sandrart, 1925 ed.).

1925–6

Anna Strümpell, *Marburger Jahrbuch für Kunstwissenschaft*, II, 1925–6. (Strümpell, 1925–6).

1926

Roberto Longhi, *Art in America*, June 1926. (Longhi, 1926).

1927

H. Siebern, *Die Kunstdenkmäler der Provinz Hannover*, XV, *Stadt Emden*, Hanover, 1927. (Siebern, 1927).

1928

Vitale Bloch, 'Zur Malerei des Paulus Bor', *Oud-Holland*, 1928, pp. 22–8. (Bloch, 1928).

Leopold Zahn, *Caravaggio*, Berlin, 1928. (Zahn, 1928).

1929

T. H. Fokker, 'Nederlandsche Schilders in Zuid-Italië', *Oud-Holland*, 1929, pp. 1–24. (Fokker, 1929).

1930

Mme Roblot Delondre, *Gazette des Beaux-Arts*, Sept. 1930. (Roblot Delondre, 1930).

1931

La Galleria Campori donata al comune di Modena. Inventario illustrato della Quadreria, n.d. (1931). (Cámpori catalogue, 1931).

1932

Cesare Brandi, *Rutilio Manetti, 1571–1639*, Florence, 1932. (Brandi, 1932).

T. H. Fokker, 'De Galleria Spada te Rome', *Mededeelingen van het Nederlandsch Historisch Instituut te Rome*, 1932, pp. 127ff. (Fokker, 1932).

A. Schneider, *Jan Lievens. Sein Leben und Seine Werke* (reprint, Amsterdam, 1973). (Schneider, 1932).

1933

Arthur von Schneider, *Caravaggio und die Niederländer*, Marburg/Lahn, 1933 (reprint, Amsterdam, 1967). (Von Schneider, 1933).

Fernanda Wittgens, 'Dipinti inediti del Seicento', *L'Arte*, 1933, pp. 444–57. (Wittgens, 1933).

1934

Les Peintres de la Réalité en France au XVIIᵉ Siècle. Musée de l'Orangerie, 1934. (Réalité, 1934).

1935

Gertrud Göttsche, *Wolfgang Heimbach*, Berlin, 1935. (Göttsche, 1935).

Roberto Longhi, 'I Pittori della Realtà in Francia ovvero I Caravaggeschi Francesi del Seicento', *L'Italia Letteraria*, 19 Jan. 1935. Republished in *Paragone* 269, July 1972, pp. 3–18. (Longhi, 1935).

1936

Vitale Bloch, 'Pro Caesar Boetius van Everdingen', *Oud-Holland*, 1936, pp. 2–8. (Bloch, 1936).

Thérèse Cornil, 'Théodore van Loon et la peinture Italienne', *Bulletin de l'Institut Historique Belge de Rome*, 1936, pp. 187ff. (Cornil, 1936).

1938

Jonkvrouwe Dr C. H. de Jonge, *Paulus Moreelse. Portret- en Genreschilder te Utrecht*, 1938. (De Jonge, 1938).

1939

Deoclecio Redig de Campos, 'Una "Giuditta", opera sconosciuta del Gentileschi nella Pinacoteca Vaticana', *Rivista d'Arte*, XXI, 1939, pp. 311–23. (Redig de Campos, 1939).

Antony de Witt, *Pantheon*, Feb. 1939, p. 51. (De Witt, 1939).

1940

N. S. Trivas, *Apollo*, Dec. 1940. (Trivas, 1940).

1942

E. P. Richardson, 'Renieri, Saraceni and the Meaning of Caravaggio's Influence', *Art Quarterly*, V, No. 3, Summer 1942, pp. 233–40. (Richardson, 1942).

1943

G. J. Hoogewerff, *Nederlandsche Kunstenaars te Rome*, The Hague, 1943, pp. 157ff. (Hoogewerff, 1943).

Roberto Longhi, 'Ultimi sul Caravaggio e la sua Cerchia', *Proporzioni* I, 1943. In same volume: 'Ultimissime sul Caravaggio', pp. 99–102. (Longhi, 1943).

D. Redig de Campos, 'Catalogo dei Dipinti olandesi e fiamminghi della Pinacoteca Vaticana', *Mededeelingen van het Nederlandsch Historisch Instituut te Rome*, 1943, pp. 157ff. (Redig de Campos, 1943).

1944

H. Bodmer, *Revue Internationale d'Art Ancien et Contemporain*, Dec. 1944, p. 528. (Bodmer, 1944).

1946

Anthony Blunt, 'Some Portraits of Simon Vouet', *Burl. Mag.*, Nov. 1946, pp. 268–75. (Blunt, 1946).

1947

J. Ainaud, 'Ribalta y Caravaggio', *Anales y Boletín de los Museos de Arte de Barcelona*, July–Dec. 1947, pp. 345–413. (Ainaud, 1947).

Dr T. H. Fokker, 'Een onbekend Werk van Matthijs Stomer', *Mededeelingen van het Nederlandsch Historisch Instituut te Rome*, IV, 1947, pp. 47–52. (Fokker, 1947).

George Isarlo, 'A la Sorbonne—Georges de la Tour', *Arts*, 4 July 1947. (Isarlo, 1947).

1948

S. J. Gudlaugsson, 'Nog eens Wolfgang Heimbach', *Kunsthistorische Mededeelingen*, 1948, pp. 11–12. (Gudlaugsson, 1948).

François Georges Pariset, *Georges de La Tour*, Paris, 1948. (Pariset, 1948).

A. Pigler, 'Une scène de Légende de W. Heimbach', *Kunsthistorische Mededeelingen*, 1948, pp. 8–11. (Pigler, 1948).

Lionello Venturi and others, *La Negazione di San Pietro di Michelangelo da Caravaggio*, Rome, 1948. (Venturi etc., 1948).

1948–9

J. G. van Gelder, 'De Schilders van de Oranjezaal', *Nederlandsch Kunsthistorisch Jaarboek*, 1948–9, pp. 119–64. (Van Gelder, 1948–9).

1949ff

F. W. H. Hollstein, *Dutch and Flemish Etchings Engravings and Woodcuts ca. 1450–1700*, 1949ff. (Hollstein, 1949ff.).

1949

Stefano Bottari, 'Opere inedite o poco note dei Musei di Catania e Siracusa', *Emporium*, cx, No. 659, Nov. 1949, pp. 202–20. (Bottari, 1949).

J. Bruyn, 'Een Onbekende Vroege Honthorst', *Kunsthistorische Mededeelingen*, 1949. (Bruyn, 1949).

Michele de Benedetti, 'Un Caravaggio già della "Borghese" ritrovato', *Emporium*, cx, 1949, pp. 3–14. (De Benedetti, 1949).

1950

Chefs d'oeuvre perdus et retrouvés, Société Poussin, troisième Cahier, May 1950. (Cahier Poussin, 1950).

Raffaello Causa, 'Aggiunte a Battistello', *Paragone* 9, Sept. 1950, pp. 42–5. (Causa, 1950).

Paul Mesplé, *Arts*, 24 Feb. 1950. (Mesplé, 1950).

D. Roggen, with assistance of H. Pauwels and A. De Schrijver, 'Het Caravaggisme te Gent', *Gentse Bijdragen tot de Kunstgeschiedenis*, 1950, pp. 255–85. (Roggen, 1950).

R. Siviero, . . . *Works of Art rediscovered in Germany*, 1950. (Siviero, 1950).

Georges Wildenstein, 'Le Goût pour la Peinture dans la Bourgeoisie Parisienne au début du Règne de Louis XIII', *Gazette des Beaux-Arts*, Oct.–Dec. 1950 pp. 153–273. (Wildenstein, 1950).

1951

Giuliano Briganti, 'Mattia Preti, i Seicentofili e gli snobs', *Paragone* 15, March 1951, pp. 45–9. (Briganti, 1951).

Roberto Carità, 'Un Battistello ritrovato', *Paragone* 19, July 1951, pp. 50–4. (Carità, 1951).

George Isarlo, 'L'Exposition Caravage', *Combat-Art*, 29 June 1951. (Isarlo, 1951).

Mostra del Caravaggio e dei Caravaggeschi. Catalogo, Milan, 1951. (Milan, 1951).

Charles Sterling, 'Observations sur Georges de La Tour à propos d'un Livre récent', *La Revue des Arts*, Sept. 1951, pp. 147ff. (Sterling, 1951).

Rudolf Wittkower, *Burl. Mag.*, 1951, p. 55. (Wittkower, 1951).

1952

S. J. Gudlaugsson, 'Crijn Hendricksz Volmarijn, een Rotterdamse Caravaggist', *Oud-Holland, Meded. v. h. Rijksbureau v. Kunsthistorische Documentatie*, 1952, pp. 241–7. (Gudlaugsson, 1952).

Jacob Hess, 'Die Gemälde des Orazio Gentileschi für das "Haus der Königin" in Greenwich', *English Miscellany*, 1952, pp. 159–87. (Hess, 1952).

G. J. Hoogewerff, *De Bentvueghels*, The Hague, 1952. (Hoogewerff, 1952).

R.-A. d'Hulst, 'Caravaggeske invloeden in het œuvre van Jacob Van Oost de Oude, schilder te Brugge', *Gentse Bijdragen tot de Kunstgeschiedenis* (1951), 1952, pp. 169–88. (d'Hulst, 1952).

R. L. [onghi], 'Caravaggio en de Nederlanden, Catalogus. . . .', *Paragone* 33, pp. 52–8. (R. L., 1952).

Benedict Nicolson, 'Caravaggio and the Netherlands', *Burl. Mag.*, Sept. 1952, pp. 247–52. (Nicolson, 1952).

D. Roggen, 'Werk van M. Stomer en Th. Rombouts', *Gentse Bijdragen tot de Kunstgeschiedenis* (1951), 1952, pp. 269–73. (Roggen, 1952).

L. Salerno, 'Di Tommaso Salini, un ignorato Caravaggesco', *Commentari*, 1952, pp. 28–31. (Salerno, 1952).

E. du Gué Trapier, *Ribera*, New York, 1952. (Trapier, 1952).

Exh. *Caravaggio en de Nederlanden. Catalogus*. Utrecht/ Antwerp, 1952. (Utrecht/Antwerp, 1952).

Dr H. van de Wael, *Drie Eeuwen vaderlandsche Geschied —Uitbeelding, 1500–1800*, The Hague, 1952, I, p. 273. (Van de Wael, 1952).

1953

Bernard Berenson, *Caravaggio—His Incongruity and his Fame*, London, 1953. (Berenson, 1953).

Ferdinando Bologna, 'Altre prove sul viaggio romano del Tanzio', *Paragone* 45, Sept. 1953, pp. 39–45. (Bologna, 1953).

Roger Hinks, *Michelangelo Merisi da Caravaggio*, London, 1953. (Hinks, 1953).

François-Georges Pariset, 'Le Repas d'Emmaüs par M. Stomer de la Collection Christian Cruse à Bordeaux', *Oud-Holland*, IV, 1953, pp. 233–6. (Pariset, 1953).

H. Pauwels, 'De Schilder Matthias Stomer', *Gentse Bijdragen tot de Kunstgeschiedenis*, XIV, 1953, pp. 139–92. (Pauwels, 1953).

Roger-Armand Weigert, 'Le Commerce de la Gravure au XVIIe Siècle—Les deux premiers Mariette et François Langlois, dit Ciartres', *Gazette des Beaux-Arts*, March 1953, pp. 167–88. (Weigert, 1953).

1954

Roberto Longhi, 'L' "Ecce Homo" del Caravaggio a Genova', *Paragone* 51, March 1954, pp. 3–13. (Longhi, 1954).

H. Pauwels, 'Nieuwe Toeschrijvingen aan M. Stomer', *Gentse Bijdragen tot de Kunstgeschiedenis*, 1954, pp. 233–40. (Pauwels, 1954).

W. Rave, *Kreis Borken, Bau und Kunstdenkmäler von Westfalen*, Münster, 1954. (Rave, 1954).

Federico Zeri, *La Galleria Spada in Roma*, Florence, 1954. (Spada Catalogue, 1954).

1955

Clotilde Brière-Misme, 'De Nouveau le Maître C. B. (Christiaen van Couwenbergh)', *La Revue des Arts*, 1955, pp. 231-7. (Brière-Misme, 1955).

Exh. *Les Tassel—Peintres Langrois du XVII^e Siècle*, Musée des Beaux-Arts, Dijon, 1955. (Dijon, 1955).

Walter Friedlaender, *Caravaggio Studies*, Princeton, 1955. (Friedlaender, 1955).

Exh. *Caravaggio e i Caravaggeschi*, Galleria Nazionale, Palazzo Barberini, Rome, April-May 1955. Catalogue under direction of Nolfo di Carpegna. (Gall. Naz., 1955).

Exh. *Caravage et les Peintres Français du XVII^e Siècle*, Galerie Heim, Paris, 1955. (Heim, 1955).

Julius S. Held, 'Notes on Flemish Seventeenth Century Painting: Jacob van Oost and Theodor van Loon', *The Art Quarterly*, Summer 1955, pp. 147-56. (Held, 1955).

J. Richard Judson, 'Possible Additions to Crijn Hendricksz Volmarijn', *Oud-Holland, Meded. v. h. Rijksbureau v. Kunsthistorische Documentatie*, 1955, pp. 181-8. (Judson, *Volmarijn*, 1955).

R. L. [onghi], 'Caravage et les Peintres Français du XVIII^e (*sic*) Siècle—Paris, Galerie Heim, 1955', *Paragone* 63, March 1955, pp. 62-3. (Longhi, 1955).

Roberto Longhi, *Giovanni Serodine*, Florence (n.d.), 1955. (Longhi, *Serodine*, 1955).

Paola della Pergola, *Galleria Borghese—I Dipinti*, I, Rome, 1955. (Della Pergola, 1955).

Federico Zeri, 'Tommaso Salini: la pala di Sant'Agnese in Piazza Navona', *Paragone* 61, Jan. 1955, pp. 50-3. (Zeri, 1955).

Federico Zeri, 'The Pallavicini Palace and Gallery in Rome', *The Connoisseur*, CXXXVI, 1955, pp. 185ff, 281ff. (Zeri, *Pallavicini*, 1955).

Federico Zeri, *Trenta Dipinti Antichi della Collezione Saibene*, Milan, 1955. (Zeri, *Saibene*, 1955).

1955-6

D. Roggen and H. Pauwels, 'Het Caravaggistisch Oeuvre van Gerard Zegers', *Gentse Bijdragen tot de Kunstgeschiedenis*, XVI, 1955-6, pp. 255-301. (Roggen/Pauwels, 1955/56).

1956

Kurt Bauch, 'Aus Caravaggios Umkreis', *Mitteilungen des Kunsthistorischen Institutes in Florenz*, July 1956, pp. 227-38. (Bauch, 1956).

Jean Boyer, 'Découverte d'un musée—Le Musée Raspail à Cachan', *Combat-Art*, 6 Feb. 1956. (Boyer, 1956).

Andrea Emiliani, *Giovan Francesco Guerrieri da Fossombrone*, Urbino, 1956. (Emiliani, 1956).

Denis Mahon, 'Un tardo Caravaggio ritrovato', *Paragone* 77, May 1956, pp. 25-32. (Mahon, 1956).

Paola della Pergola, 'Giovan Francesco Guerrieri a

Roma', *Bollettino d'Arte*, 1956, pp. 214-37. (Della Pergola, 1956).

Wolfgang Stechow, review of Friedlaender's *Caravaggio Studies*, *Art Bulletin*, March 1956, pp. 58-70. (Stechow, 1956).

1957

Ainaud de Lasarte, 'Francisco Ribalta: Notas y Commentarios', *Goya*, No. 20, Sept.-Oct. 1957, pp. 86-9. (Ainaud, 1957).

Antonio Corbara, ' "Un'Incredulità di San Tommaso" di Michele Manzoni', *Paragone* 89, May 1957, pp. 45-7. (Corbara, 1957).

Mina Gregori, 'Un nuovo Battistello', *Paragone* 85, Jan. 1957, pp. 105-8. (Gregori, 1957).

Roberto Longhi, 'Michele Manzoni—Caravaggesco di periferia', *Paragone* 89, May 1957, pp. 42-5. (Longhi, 1957).

Roberto Longhi, 'Due Dipinti del Battistello', *Paragone* 85, Jan. 1957, pp. 102-4. (Longhi, *Battistello*, 1957).

Robert Mesuret, 'L'oeuvre peint de Nicolas Tournier', *Gazette des Beaux-Arts*, Dec. 1957. (Mesuret, 1957).

1958

Andrea Emiliani, 'Orazio Gentileschi: Nuove proposte per il viaggio Marchigiano', *Paragone* 103, July 1958, pp. 38-57. (Emiliani, 1958).

F. Grossmann, 'A Painting by Georges de La Tour in the Collection of Archduke Leopold William', *Burl. Mag.*, March 1958, pp. 86-91. (Grossmann, 1958).

Roberto Longhi, 'A propos de Valentin', *La Revue des Arts*, March-April 1958, pp. 59-66. (Longhi, 1958).

Benedict Nicolson, *Hendrick Terbrugghen*, London, 1958. (Nicolson, 1958).

Benedict Nicolson, 'De Heilige Hieronymus van Hendrick Terbrugghen', *Bulletin Museum Boymans-Van Beuningen*, Rotterdam, 1958, pp. 86-91. (Nicolson, *Boymans*, 1958).

Benedict Nicolson, 'In the Margin of the Catalogue', *Burl. Mag.*, March 1958, pp. 97ff. (Nicolson, *Margin*, 1958).

François-Georges Pariset, 'Note sur Jean Le Clerc', *Revue des Arts*, 1958, pp. 67-71. (Pariset, 1958).

Paola della Pergola, 'Una Testimonianza per Caravaggio', *Paragone* 105, Sept. 1958, pp. 71-5. (Della Pergola, 1958).

Charles Sterling, 'Gentileschi in France', *Burl. Mag.*, April 1958, pp. 112-20. (Sterling, 1958).

1959

Exh. 'Kunstschatten van de Oud-Katholieke Kerk te Delft', Museum Prinsenhof, Delft, 1959. (Delft, 1959).

Giuliano Frabetti, 'Aggiunte a Luca Cambiaso', *Studies in the History of Art dedicated to William E.*

Suida on his 80th Birthday, London, 1959, pp. 267–75. (Frabetti, 1959).

H. Gerson, review of Nicolson *Terbrugghen*, *Kunst-chronik*, Nov. 1959, pp. 307ff. (Gerson, 1959).

Mina Gregori, 'Un nuovo Battistello', *Paragone* III, March 1959, pp. 46–7. (Gregori, 1959).

Nicolas Ivanof, 'Jean le Clerc et Venise', *Actes de XIXe Congrès International d'Histoire de l'Art* (1958), Paris, 1959. (Ivanof, 1959).

Berne Joffroy, *Le Dossier Caravage*, 1959. (Berne Joffroy, 1959).

J. Richard Judson, *Gerrit van Honthorst—A Discussion of his Position in Dutch Art*, The Hague, 1959 (Judson, 1959).

Roberto Longhi, 'Presenza alla Sala Regia', *Paragone* 117, Sept. 1959, pp. 29–38. (Longhi, 1959).

R. L. [onghi], 'Un San Giovanni Battista del Caracciolo', *Paragone* 109, Feb. 1959, pp. 58–60. (R.L., 1959).

Valentino Martinelli, 'L'Amor divino "tutto ignudo" di Giovanni Baglione . . .', *Arte Antica e Moderna*, 1959, pp. 82–96. (Martinelli, 1959).

Paola della Pergola, *Galleria Borghese. I Dipinti*, Vol. II, Rome, 1959. (Della Pergola, 1959).

Hermann Voss, 'Orazio Gentileschi: Four versions of his "Rest on the Flight into Egypt"', *Connoisseur*, Nov. 1959, pp. 163–5. (Voss, 1959).

Federico Zeri, *La Galleria Pallavicini in Roma. Catalogo dei Dipinti*, Florence, 1959. (Pallavicini Catalogue, 1959).

1960

Ferdinando Bologna, 'Altre aggiunte a Battistello Caracciolo', *Paragone* 129, Sept. 1960, pp. 45–51. (Bologna, 1960).

H. Gerson, E. H. ter Kuile, *Art and Architecture in Belgium, 1600 to 1800*, Pelican History of Art, London, 1960. (Gerson/Kuile, 1960).

Michel Hoog, 'Attributions anciennes à Valentin', *La Revue des Arts*, 1960, pp. 267–78. (Hoog, 1960).

Roberto Longhi, 'Terbrugghen e Valentin', *Paragone* 131, Nov. 1960, pp. 57–60. (Longhi, 1960).

Neil MacLaren, *National Gallery Catalogues—The Dutch School*, London, 1960. (MacLaren, 1960).

Benedict Nicolson, 'Second Thoughts about Terbrugghen', *Burl. Mag.*, Nov. 1960, pp. 465–73. (Nicolson, 1960).

Benedict Nicolson, 'The "Candlelight Master", A Follower of Honthorst in Rome', *Nederlands Kunsthistorisch Jaarboek*, 1960, pp. 121–64. (Nicolson, NKJ, 1960).

Benedict Nicolson, 'Some little known Pictures at the Royal Academy', *Burl. Mag.*, Feb. 1960, pp. 76–9. (Nicolson, RA, 1960).

Marek Rostworowski, 'Four Dutch Painters in the Czartoryski Gallery, in the National Museum at Cracow' (in Polish), *Nadbitka z Biulctynu Historii Sztuki*, 1960, pp. 299–308. (Rostworowski, 1960).

Luigi Salerno, 'The Picture Gallery of Vincenzo Giustiniani', *Burl. Mag.*, Jan., March and April 1960. (Salerno, 1960).

Luigi Salerno, 'Cavaliere d'Arpino, Tassi, Gentileschi and their Assistants', *Connoisseur*, Nov. 1960, pp. 157–62. (Salerno, *Bagnaia*, 1960).

Exh. 'Figures at a Table', Ringling Museum, Sarasota (Florida), 1960. (Sarasota, 1960).

Francesco Susinno, *Le Vite de' Pittori Messinesi*, ed. Valentino Martinelli, Florence, 1960. (Susinno, 1724, ed. 1960).

Ilaria Toesca, 'Due Tele del 1609 in S. Silvestro in Capite a Roma', *Bollettino d'Arte*, XLV, 1960, pp. 283–6. (Toesca, 1960).

Malcolm Waddingham, 'Another look at Gysbert van der Kuyl', *Paragone* 125, May 1960, pp. 45–51. (Waddingham, 1960).

1960–1

Hermann Voss, 'La Cappella del Crocifisso di Orazio Gentileschi', *Rivista d'Arte Acropoli*, 1960–61, pp. 99–107. (Voss, Orazio, 1960–1).

1961

Luc Benoist, 'Georges de La Tour et les Caravaggesques au Musée des Beaux-Arts de Nantes', *La Revue Française*, Aug. 1961. (Benoist, 1961).

Andreina Griseri, 'L'Autunno del Manierismo alla Corte di Carlo Emanuele I e un arrivo "Caravaggesco"', *Paragone* 141, Sept. 1961, pp. 19–36. (Griseri, *Paragone*, 1961).

Nicola Ivanoff, 'Mattia Stomer e il tema Caravaggesco dell'Incredulità di San Tommaso', *Emporium*, Oct. 1961. (Ivanoff, 1961).

René Jullian, *Caravage*, Lyon-Paris, 1961. (Jullian, 1961).

Roberto Longhi, *Scritti Giovanili 1912–1922*, Florence, two vols., 1961. (Longhi, S. G., 1961).

Janina Michałkowa, 'Une Musique Caravaggesque', *Bulletin du Musée National de Varsovie*, 1961, pp. 11–22. (Michalkowa, 1961).

Alfred Moir, ' "Boy with a Flute" by Bartolomeo Manfredi', *Los Angeles County Museum Bulletin*, 1961, pp. 3–15. (Moir, 1961).

B.N. 'Notes on Adam de Coster', *Burl. Mag.*, May 1961, pp. 185ff. (Nicolson, 1961).

Bruno Toscano, 'Andrea Polinori, o la provincia perplessa', *Arte Antica e Moderna*, 1961, pp. 300–12. (Toscano, 1961).

Malcolm Waddingham, 'Notes on a Caravaggesque Theme', *Arte Antica e Moderna*, 1961, pp. 313–18. (Waddingham, 1961).

1962

Giuliano Briganti, *Il Palazzo del Quirinale*, Rome, 1962. (Briganti, 1962).

William R. Crelly, *The Painting of Simon Vouet*, Yale UP, 1962. (Crelly, 1962).

Wolfgang Fischer, 'Claude Vignon (1593–1670)', *Nederlands Kunsthistorisch Jaarboek*, 1962, pp. 105–48. (Fischer, 1962).

Günther Heinz, 'Zwei wiedergefundene Bilder aus der Galerie Erzherzogs Leopold Wilhelm', *Jahrbuch der Kunsthistorischen Sammlungen in Wien*, LVIII, 1962, pp. 169–80. (Heinz, 1962).

Nicola Ivanoff, 'Giovanni Le Clerc', *Critica d'Arte*, Sept.–Dec. 1962, pp. 62–76. (Ivanoff, 1962).

Michael Levey, 'Notes on the Royal Collection—II: Artemisia Gentileschi's "Self-Portrait" at Hampton Court', *Burl. Mag.*, Feb. 1962, pp. 79–80. (Levey, 1962).

Alfred Moir, 'Alonzo Rodriguez', *Art Bulletin*, Sept. 1962, pp. 205–18. (Moir, 1962).

Benedict Nicolson, 'A Postscript to Baburen', *Burl. Mag.*, Dec. 1962, pp. 539–43. (Nicolson, 1962).

Erich Schleier, 'An unknown Altar-piece by Orazio Gentileschi', *Burl. Mag.*, Oct. 1962, pp. 432, 435–6. (Schleier, 1962).

Hermann Voss, 'Inediti di Orazio Borgianni', *Antichità Viva*, 1962, I No. 2 (Feb.), pp. 9–12. (Voss, 1962).

1963

Thérèse Bertin-Mourot, 'L'Evangéliste à la lampe de Tisseur', *Bulletin de la Société Poussin*, quatrième cahier, premier fascicule, Feb. 1962. (Bertin-Mourot, 1963).

Wolfgang Fischer, 'Claude Vignon (1593–1670)—III. Grossfigurig-dekorative Epoche', *Nederlands Kunsthistorisch Jaarboek*, 1963, pp. 137–83. (Fischer, 1963).

Roberto Longhi, 'Il vero "Maffeo Barberini" del Caravaggio', *Paragone* 165, Sept. 1963, pp. 3–11. (Longhi, 1963).

Roberto Longhi, 'Giovanni Baglione e il Quadro del Processo', *Paragone* 163, July 1963, pp. 23–31. (Longhi, *Baglione*, 1963).

Alessandro Marabottini Marabotti, 'Il "Naturalismo" di Pietro Paolini', *Scritti di Storia dell'Arte in onore di Mario Salmi*, Rome, 1963, pp. 307–24. (Marabotti, 1963).

Exh. 'Caravaggio e Caravaggeschi', Palazzo Reale, Naples, 10 Feb.–20 March 1963. (Naples, 1963).

Benedict Nicolson, 'Caravaggesques in Naples', *Burl. Mag.*, May 1963, pp. 209–10. (Nicolson, 1963).

Anna Ottani, 'Per un Caravaggesco Toscano: Pietro Paolini (1603–1681)', *Arte Antica e Moderna*, No. 21, 1963, pp. 19–35. (Ottani, 1963).

Rodolfo Pallucchini 'L'Ultima opera del Saraceni', *Arte Veneta*, 1963, pp. 178–82. (Pallucchini, 1963).

Seymour Slive, 'The Young Rembrandt', *Allen Memorial Art Museum Bulletin*, Spring 1963, pp. 120–149. (Slive, 1963).

1964

Jean Boyer, 'Un Caravaggesque Français oublié: Trophime Bigot', *Bulletin de la Société de l'Histoire de l'art français* (1963), 1964, pp. 35–51. (Boyer, 1964).

Simone Cammas and Michel Laclotte, 'Musée Départemental de Beauvais I, Peintures Anciennes', *La Revue du Louvre*, 1964, pp. 195–202. (Cammas-Laclotte, 1964).

Nicola Ivanoff, 'Intorno al tardo Saraceni', *Arte Veneta*, 1964, pp. 177–80. (Ivanoff, *Arte Veneta*, 1964).

Michael Levey, *The later Italian Pictures in the Collection of Her Majesty the Queen*, London, 1964. (Levey, 1964).

Benedict Nicolson, 'Un Caravaggiste Aixois—Le Maître à la Chandelle', *Art de France*, 1964, pp. 117–139. (Nicolson, 1964).

Alfonso E. Pérez Sánchez, *Borgianni, Cavarozzi y Nardi en España*, Madrid, 1964. (Pérez Sánchez, 1964).

Charles Sterling, 'Musée des Beaux-Arts de Nantes. Une Nouvelle Oeuvre de Gentileschi peinte en France', *La Revue du Louvre*, 1964, pp. 217–20. (Sterling, 1964).

Harold E. Wethey, 'Orazio Borgianni in Italy and in Spain', *Burl. Mag.*, April 1964, pp. 147–59. (Wethey, 1964).

1965

Pamela Askew, 'A Melancholy Astronomer by Giovanni Serodine', *Art Bulletin*, March 1965, pp. 121–8. (Askew, 1965).

Stefano Bottari, 'Aggiunte al Manfredi, al Renieri e allo Stomer', *Arte Antica e Moderna*, No. 29, Jan./March 1965, pp. 57–60. (Bottari, 1965).

Georgette Dargent and Jacques Thuillier, 'Simon Vouet en Italie—Essai de Catalogue Critique', *Saggi e Memorie di Storia dell'Arte* 4, pp. 27–63. (Dargent/Thuillier, 1965).

Exh. 'Art in Italy 1600–1700', Detroit Institute of Arts, 1965. (Detroit, 1965).

Howard Hibbard and Milton Lewine, 'Seicento at Detroit', *Burl. Mag.*, July 1965, pp. 370–2. (Hibbard/Lewine, 1965).

G. J. Hoogewerff, 'Jan van Bijlert. Schilder van Utrecht (1598–1671)', *Oud-Holland*, 1965, pp. 3–34. (Hoogewerff, 1965).

Nicola Ivanoff, 'Nicolas Régnier', *Arte Antica e Moderna*, Jan./March 1965, pp. 12–24. (Ivanoff, 1965).

Roberto Longhi, 'Le prime incidenze caravaggesche in Abraham Janssens', *Paragone* 183, May 1965, pp. 51–52. (Longhi, 1965).

Exh. 'Le Caravage et la peinture italienne du XVIIᵉ siècle', Musée du Louvre, Feb.–April 1965. (Louvre, 1965).

A. P. de Mirimonde, 'Les Sujets de musique chez les Caravagistes Flamands', *Koninklijk Museum voor Schone Kunsten*, Antwerp, 1965, pp. 113–70. (Mirimonde, 1965).

Justus Müller Hofstede, 'Zeichnungen des späten Rubens', *Pantheon* 3, 1965, pp. 163–80. (Müller Hofstede, 1965).

Benedict Nicolson, 'The Rehabilitation of Trophime Bigot', *Art and Literature*, No. 4, pp. 66–105. Reprinted in English from French text, 1964 (q.v.). (Nicolson, 1965).

Benedict Nicolson, 'Some Northern Caravaggesques in Russia', *Burl. Mag.*, Aug. 1965, p. 426. (Nicolson, *Russia*, 1965).

Anna Ottani, 'Su Angelo Caroselli, pittore romano', *Arte Antica e Moderna*, Nos. 31/32, July/Dec. 1965, pp. 289–97. (Ottani, 1965).

Anna Ottani , 'Integrazioni al Catalogo del Paolini', *Arte Antica e Moderna*, No. 30, April/June 1965, pp. 181–7. (Ottani, *Paolini*, 1965).

Alfonso E. Pérez Sánchez, *Pintura Italiana del Siglo XVII en España*, Madrid, 1965. (Pérez Sánchez, 1965).

Leonard J. Slatkes, *Dirck van Baburen (c. 1595–1624)— A Dutch Painter in Utrecht and Rome*, Utrecht, 1965. (Slatkes 1965).

Hermann Voss, 'Die Darstellungen des Hl. Franziskus im Werk von Georges de La Tour', *Pantheon*, 1965, pp. 402–4. (Voss, 1965).

1965–6

Exh. 'Hendrick Terbrugghen in America', Dayton Art Institute, 1965; Baltimore Museum of Art, 1965–6. (Dayton/Baltimore, 1965–6).

1966

Exh. 'Deutsche Maler und Zeichner des 17. Jahrhunderts', Orangerie des Schlosses Charlottenburg, Berlin, 1966. (Berlin, 1966).

Roberto Longhi, 'I "Cinque Sensi" del Ribera', *Paragone* 193, March 1966, pp. 74–8. (Longhi, 1966).

B.N., 'Candlelight Pictures from the South Netherlands', *Burl. Mag.*, May 1966, pp. 253ff. (Nicolson, 1966).

Leonard J. Slatkes, 'David de Haen and Dirck van Baburen in Rome', *Oud-Holland*, LXXI, Part III, 1966, pp. 173–86. (Slatkes, 1966).

1967

R. Ward Bissell, 'Orazio Gentileschi's "Young Woman with a Violin" ', *Bulletin of the Detroit Institute of Arts*, No. 4, 1967, pp. 71–7. (Bissell, 1967).

A. Blankert, 'Heraclitus en Democritus. . . .', *Nederlands Kunsthistorisch Jaarboek*, 1967, pp. 31–123. (Blankert, 1967).

Noemi Gabrielli, 'Tre Inediti', *Studi di Storia dell'Arte in Onore di Vittorio Viale*, Turin, 1967, pp. 45–6. (Gabrielli, 1967).

Enriqueta Harris, 'Orazio Gentileschi's "Finding of Moses" in Madrid', *Burl. Mag.*, Feb. 1967, pp. 86, 89. (Harris, 1967).

Roberto Longhi, *Saggi e Ricerche, 1925–1928*, Florence, 1967. (Longhi, S.R., 1967).

Alfred Moir, *The Italian Followers of Caravaggio*, Harvard U.P., 1967, two vols. (Moir, 1967).

Benedict Nicolson, 'Bartolommeo Manfredi', *Studies in Renaissance and Baroque Art presented to Anthony Blunt*, 1967, pp. 108–12. (Nicolson, 1967).

Mario Salmi, *Il Palazzo e la Collezione Chigi-Saracini*, Siena, 1967. (Salmi, 1967).

W. L. Van de Watering, 'Petrus, Roetert en Lumen Portengen', *Oud-Holland*, 1967, pp. 149–57. (De Watering, 1967).

1968

R. Ward Bissell, 'Artemisia Gentileschi. A New Documented Chronology', *Art Bulletin*, 1968, pp. 153–68. (Bissell, 1968).

Vitale Bloch, *Michael Sweerts*, The Hague, 1968. (Bloch, 1968).

Maria Vittoria Brugnoli, 'Un "San Francesco" da attribuire al Caravaggio e la sua copia', *Bollettino d'Arte*, 1968, pp. 11–15. (Brugnoli, 1968).

Gaspare Celio, *Memoria delli Nomi dell'Artefici delle Pitture . . . di Roma*, facsimile of 1638 Naples ed., introduction and commentary by Emma Zocca. (Celio/Zocca, 1968).

Mina Gregori, 'Su due Quadri Caravaggeschi a Burghley House', *Festschrift Ulrich Middeldorf*, Berlin, 1968, Band I, pp. 414–21. (Gregori, 1968).

Prof. Dr Wolfgang Krönig, 'Matthias Stomer's "Anbetung der Hirten" in Monreale', *Miscellanea Jozef Duverger*, I, Ghent, 1968, pp. 289–300. (Krönig, 1968).

Roberto Longhi, *'Me Pinxit' e Quesiti Caravaggeschi, 1928–1934*, Florence, 1968. (Longhi, Q.C., 1968).

Angela Marino, 'Un Caravaggesco fra Controriforma e Barocco, Antiveduto Gramatica', *L'Arte*, I, 1968, Nos. 3–4, pp. 47–82. (Marino, 1968).

F. Negri Arnoldi, 'I "Cinque Sensi" di Caccamo e l'attività siciliana di Giovanni van Houbracken', *Bollettino d'Arte*, 1968, pp. 138–44. (Negri Arnoldi, 1968).

Anna Ottani Cavina, *Carlo Saraceni*, Milan, 1968. (Ottani Cavina, 1968).

Mostra di antichi dipinti restaurati delle raccolte accademiche, Accademia Nazionale di San Luca, Palazzo Carpegna, Rome, 1968. (Rome, 1968).

Leonard J. Slatkes, 'Some Drawings around Dirck van Baburen', *Master Drawings*, 1968, pp. 27–30. (Slatkes, *Master Drawings*, 1968).

1969

R. Ward Bissell, 'Orazio Gentileschi and the Theme of "Lot and His Daughters" ', *Bulletin of The National Gallery of Canada*, No. 14, 1969, pp. 16–33. (Bissell, 1969).

A. Bredius, *Rembrandt, The Complete Edition of the*

Paintings, revised by H. Gerson, London, 1969. (Bredius, 1969).

Craig Felton, 'The Earliest Paintings of Jusepe de Ribera', *Wadsworth Atheneum Bulletin*, winter 1969, pp. 2–11. (Felton, 1969).

J. Richard Judson, 'Allegory on Drinking', *News Bulletin and Calendar*, Worcester Art Museum, Feb. 1969. (Judson, 1969).

Roberto Longhi, ' "Giovanni della Voltolina" a Palazzo Mattei', *Paragone* 233, July 1969, pp. 59–62. (Longhi, 1969).

Alfred Moir, 'Did Caravaggio Draw?', *The Art Quarterly*, XXXII, No. 4, 1969, pp. 354–72. (Moir, 1969).

Giovanni Previtali, 'Frammenti del Tanzio a Napoli', *Paragone* 229, March 1969, pp. 42–5. (Previtali, 1969).

Erich Schleier, 'Emilio Savonanzi: Inediti del periodo romano', *Antichità Viva*, No. 4, July/Aug. 1969. (Schleier, 1969).

Giuliana Zandri, 'Un probabile dipinto murale del Caravaggio per il Cardinale Del Monte', *Storia dell'Arte*, 1969, pp. 338–43. (Zandri, 1969).

1970

Didier Bodart, *Les Peintres del Pays-Bas Méridionaux et de la Principauté de Liège à Rome au XVIIème Siècle*, two vols, Brussels/Rome, 1970. (Bodart, 1970).

Didier Bodart, *Louis Finson*, Brussels, 1970. (Bodart, *Finson*, 1970).

Antonio Boschetto, 'Di Theodoor van Loon e dei suoi dipinti a Montaigu', *Paragone* 239, Jan. 1970, pp. 42–59. (Boschetto, 1970).

Raffaello Causa, *Opere d'Arte nel Pio Monte della Misericordia*, Naples, 1970. (Causa, 1970).

Italo Faldi, *Pittori Viterbesi di Cinque Secoli*, 1970, pp. 56–8. (Faldi, 1970).

Exh. 'Caravaggio e Caravaggeschi nelle Gallerie di Firenze', catalogue by Evelina Borea. (Florence, 1970).

Exh. 'The Age of Louis XIII', Cummer Gallery of Art, Jacksonville, Florida, 1969, and St Petersburg, Florida, 1970. (Florida, 1970).

J. Richard Judson, 'The Honthorst acquisition: A first for America', *Montreal Museum of Fine Arts, Bulletin*, June 1970, pp. 4–7. (Judson, 1970).

Exh. 'Museo del Prado—Pintura Italiana del Siglo XVII', Madrid, 1970. (Madrid, 1970).

Benedict Nicolson, 'The Art of Carlo Saraceni', *Burl. Mag.*, May 1970, pp. 312, 315. (Nicolson, 1970).

Exh. 'collections privées d'Auvergne', Musée Mandet, Riom, 1970. (Riom, 1970).

Erich Schleier, ' "Pintura Italiana del Siglo XVII . . .', *Kunstchronik*, Dec. 1970, pp. 341–9. (Schleier, *Kunstchronik*, 1970).

Leonard J. Slatkes, 'Dutch Mannerism', *The Art Quarterly*, 1970, pp. 420ff. (Slatkes, 1970).

P. Torriti, *Tesori di Strada Nuova*, Genoa, 1970, p. 200. (Torriti, 1970).

Carlo Volpe, 'Caravaggio e Caravaggeschi nelle Gallerie di Firenze', *Paragone* 249, Nov. 1970, pp. 106–18. (Volpe, 1970).

1970–1

Exh. 'Le Siècle de Rembrandt', Musée du Petit Palais, Paris, Nov. 1970–Feb. 1971. (Paris, 1970–1).

1971

R. Ward Bissell, 'Orazio Gentileschi: Baroque without Rhetoric', *The Art Quarterly*, No. 3, 1971, pp. 275–296. (Bissell, 1971).

Jean Boyer, 'La Peinture et la Gravure à Aix-en-Provence aux XVIe, XVIIe et XVIIIe Siècles', *Gazette des Beaux-Arts*, July–Sept. 1971. (Boyer, 1971).

Maurizio Calvesi, 'Caravaggio o la ricerca della Salvazione', *Storia dell'Arte*, 1971, pp. 93–142. (Calvesi, 1971).

Ph-G. Chabert, 'Le musée Hôtel Sandelin de Saint-Omer', *La Revue Française*, Feb. 1971. (Chabert, 1971).

Maurizio Marini, 'Tre proposte per il Caravaggio Meridionale', *Arte Illustrata*, Sept.–Oct. 1971, pp. 58–65. (Marini, 1971).

Justus Müller Hofstede, 'Abraham Janssens. . . .', *Jahrbuch der Berliner Museen*, 1971, pp. 208–303. (Müller Hofstede, 1971).

Benedict Nicolson, 'Gerard Seghers and the "Denial of St Peter" ', *Burl. Mag.*, June 1971, pp. 304–9. (Nicolson, 1971).

Stephen Pepper, 'Caravaggio and Guido Reni: Contrasts in Attitudes', *The Art Quarterly*, Autumn 1971, pp. 325–44. (Pepper, 1971).

Donald Posner, 'Caravaggio's Homo-Erotic Early Works', *The Art Quarterly*, 1971, pp. 301–24. (Posner, 1971).

Giovanni Romano, 'Nicolò Musso a Roma e a Casale', *Paragone* 255, May 1971, pp. 44–60. (Romano, 1971).

Luigi Salerno, 'Caravaggio e i Caravaggeschi', *Storia dell'Arte*, 1971, pp. 234–48. (Salerno, 1971).

Erich Schleier, 'Caravaggio e Caravaggeschi nelle Gallerie di Firenze', *Kunstchronik*, April 1971, pp. 85–102. (Schleier, *Kunstchronik*, 1971).

Erich Schleier, 'Un chef-d'oeuvre de la période italienne de Simon Vouet', *Revue de l'Art*, 1971, pp. 65–73. (Schleier, *Vouet*, 1971).

Richard Spear, *Caravaggio and His Followers*, Cleveland, 1971. Paperback ed., 1975. (Spear, 1971).

P. J. J. van Thiel, 'De aanbidding der koningen en ander vroeg Werk van Hendrick ter Brugghen', *Bulletin van het Rijksmuseum*, Dec. 1971, pp. 91–139. (Van Thiel, 1971).

1972

Evelina Borea, 'Considerazioni sulla Mostra "Caravaggio e i suoi Seguaci" a Cleveland', *Bollettino d'Arte*, 1972, pp. 154–64. (Borea, 1972).

Raffaello Causa, *La Pittura del Seicento a Napoli dal Naturalismo al Barocco*, Naples, 1972. (Causa, 1972).

Brian T. D'Argaville, 'Neapolitan Seicento Painting: Additions and Revisions', *Burl. Mag.*, Nov. 1972, pp. 808–10. (D'Argaville, 1972).

M. Díaz Padrón, 'Dos Grecos y un Jusepe Ribera inéditos', *Archivo Español de Arte*, XLV, 1972, pp. 318–320. (Díaz Padrón, 1972).

Mina Gregori, 'Note su Orazio Riminaldi e i suoi rapporti con l'ambiente romano', *Paragone* 269, July 1972, pp. 35–66. (Gregori, *Riminaldi*, 1972).

Julius S. Held, 'Caravaggio and His Followers', *Art in America*, May–June 1972, pp. 40–7. (Held, 1972).

Benedict Nicolson, 'Caravaggesques at Cleveland', *Burl. Mag.*, Feb. 1972, pp. 113–14, 117. (Nicolson, 1972).

Benedict Nicolson, *Burl. Mag.*, May 1972, p. 346. (Nicolson, May 1972).

Benedict Nicolson and Christopher Wright, 'Georges de La Tour et la Grande-Bretagne', *La Revue du Louvre*, No. 2, 1972, pp. 135–42. (Nicolson/Wright, 1972).

Anna Ottani Cavina, 'La Tour all'Orangerie e il suo primo tempo Caravaggesco', *Paragone* 273, Nov. 1972. (Ottani Cavina, 1972).

D. Stephen Pepper, 'Caravaggio riveduto e corretto: la Mostra di Cleveland', *Arte Illustrata*, March 1972, pp. 170–8. (Pepper, 1972).

E. K. J. Reznicek, 'Honthorstiana', *Nederlands Kunsthistorisch Jaarboek*, 1972, pp. 167–89. (Reznicek, 1972).

Pierre Rosenberg, *La Revue de l'Art*, 1972, p. 114. (Rosenberg, 1972).

Erich Schleier, 'A lost Baburen rediscovered', *Burl. Mag.*, Nov. 1972, p. 787. (Schleier, 1972).

Erich Schleier, 'Die Erwerbungen der Gemäldegalerie', *Jahrbuch Preussischer Kulturbesitz*, X, 1972. (Schleier, Berlin, 1972).

Richard E. Spear, *Renaissance and Baroque Paintings from the Sciarra and Fiano Collections*, Rome, 1972. (Spear, 1972).

Richard E. Spear, 'Unknown Pictures by the Caravaggisti (with notes on "Caravaggio and His Followers")', *Storia dell'Arte*, No. 14, 1972, pp. 149–161. (Spear, *Storia dell'Arte*, 1972).

Jacques Thuillier, 'Georges de La Tour—trois paradoxes', *L'Oeil*, April 1972. (Thuillier, 1972).

Carlo Volpe, 'Annotazioni sulla Mostra Caravaggesca di Cleveland', *Paragone* 263, Jan. 1972, pp. 50–76. (Volpe, 1972).

1973

Didier Bodart, 'Le Voyage en Italie de Gérard Seghers', *Studi offerti a Giovanni Incisa della Rocchetta, Miscellanea della Società Romana di Storia Patria*, XXIII, 1973, pp. 79–88. (Bodart, 1973).

Exh. 'Caravaggio and the Caravaggesques', Hermitage, Leningrad, 1973 (catalogue in Russian). (Leningrad, 1973).

Maurizio Marini, 'Due inediti di Battistello Caracciolo', *Paragone* 279, May 1973, pp. 77–9. (Marini, 1973).

Benedict Nicolson, 'Terbrugghen since 1960', *Album Amicorum J. G. van Gelder*, The Hague, 1973, pp. 237–41. (Nicolson, 1973).

Benedict Nicolson, 'A New Borgianni', *Burl. Mag.*, Jan. 1973, p. 42. (Nicolson, *Borgianni*, 1973).

Giovanni Previtali, 'Gentileschi's "The Samaritan Woman at the Well"', *Burl. Mag.*, June 1973, pp. 359–60. (Previtali, 1973).

Exh. 'Dipinti fiamminghi ed olandesi dal Quattrocento al Settecento', catalogue by Didier Bodart, 1–20 Dec. 1973, Galleria Gasparrini, Rome. (Rome, 1973).

Exh. 'Caravaggio y el Naturalismo Español', Seville, 1973. (Seville, 1973).

L. Slatkes, 'Additions to Dirck van Baburen', *Album Amicorum J. G. van Gelder*, The Hague, 1973, pp. 267–73. (Slatkes, 1973).

Jacques Thuillier, *Tout l'oeuvre peint de Georges de La Tour*, Paris, 1973. (Thuillier, 1973).

Enrique Valdivieso, *Pintura Holandesa del Siglo XVII en España*, Valladolid, 1973. (Valdivieso, 1973).

A. W. Vliegenthart, 'Das Bronckhorster Galeriebild auf Schloss Anholt', *Album Amicorum J. G. van Gelder*, The Hague, 1973, pp. 337–41. (Vliegenthart, 1973).

Carlo Volpe, 'Una proposta per Giovanni Battista Crescenzi', *Paragone* 275, Jan. 1973, pp. 25–36. (Volpe, 1973).

1973–4

Exh. 'I Caravaggeschi Francesi', Accademia di Francia, Villa Medici, Rome; 'Valentin et les Caravaggesques Français', Grand Palais, Paris, 1973–4. References to catalogue and page Nos. to French catalogue. (Rome/Paris, 1973–4).

1974

Evelina Borea, 'Caravaggio e la Spagna: Osservazioni su una Mostra a Siviglia', *Bollettino d'Arte*, Jan.–June 1974, pp. 43–52. (Borea, 1974).

Arnauld Brejon de Lavergnée, 'Pour Nicolas Tournier sur son séjour romain', *Paragone* 287, Jan. 1974. (Brejon, 1974).

Arnauld Brejon and Jean-Pierre Cuzin, 'A propos de Caravaggesques français', *La Revue du Louvre*, 1974, No. 1, pp. 25–38. (Brejon/Cuzin, 1974).

Andrea Busiri Vici, 'Inediti di Giacomo Galli, detto "Lo Spadarino"', *Antichità Viva*, No. 5, 1974. (Busiri Vici, 1974).

Colloquio sul Tema Caravaggio e i Caravaggeschi, organizzato d'intesa con le Accademie di Spagna e di Olanda, Accademia Nazionale dei Lincei, Rome,

Q. G. Marcus, 'Les Watteau de Lille', *Art et Curiosité*, May–July 1976, p. 25. (Marcus, 1976).

Maurizio Marini, 'Mattia Preti, "Magnum Picturae Decus"', *Ricerche di Storia dell'Arte*, 1–2, *Il Seicento*, 1976, pp. 103–27. (Marini, 1976).

Alfred Moir, *Caravaggio and His Copyists*, New York, 1976. (Moir, 1976).

Pierre Rosenberg, review of Nicolson/Wright *Georges de La Tour*, Art Bulletin, 1976, pp. 452–4. (Rosenberg, 1976).

Claudio Strinati, 'Un quadro di Orazio Gentileschi a Genova', *Ricerche di Storia dell'Arte*, 1–2, *Il Seicento*, 1976, pp. 189–96. (Strinati, 1976).

John Walsh, Jr., 'Stomer's Evangelists', *Burl. Mag.*, July 1976, pp. 504, 507–8. (Walsh, 1976).

Christopher Wright, *Vermeer*, London, 1976. (Wright, 1976).

1977

Liana Castelfranchi Vegas, 'Un Nuovo Quadro Caravaggesco a Brera', *Associazione Amici di Brera e dei Musei Milanesi*, Jan. 1977, pp. 14–20. (Castelfranchi Vegas, 1977).

Andrea Busiri Vici, 'Altri inediti dello Spadarino', *Antologia di Belle Arti*, December 1977, pp. 343–6. (Busiri Vici, 1977).

Jean-Pierre Cuzin, 'La diseuse de bonne aventure de Caravage', *Les Dossiers du Département des peintures* 13, exh. Louvre, 1977. (Cuzin, 1977).

Jean-Pierre Cuzin, 'Pittura francese nelle Collezioni pubbliche fiorentine', *Antologia di Belle Arti*, December 1977, pp. 370–92. (Cuzin, *Florence*, 1977).

Ann Tzeutschler Lurie in collaboration with Denis Mahon, 'Caravaggio's Crucifixion of Saint Andrew from Valladolid', *Bulletin of the Cleveland Museum of Art*, Jan. 1977, pp. 3–24. (Lurie/Mahon, 1977).

Benedict Nicolson, 'Stomer brought up-to-date', *Burl. Mag.*, April 1977, pp. 230–45. (Nicolson, 1977).

Mostra didattica di Carlo Sellitto—primo Caravaggesco Napoletano. Museo e Gallerie Nazionali di Capodimonte, Naples, 1977. (Exh. Sellitto, 1977).

Eric Jan Sluijter, 'Niet Gysbert van der Kuyl uit Gouda, maar Gerard van Kuijl uit Gorinchem (1604–73), *Oud-Holland*, Vol. 91, 1977, pp. 166–94. (Sluijter, 1977).

Michael Stoughton, 'Mostra Didattica di Carlo Sellitto: primo Caravaggesco napoletano', *Antologia di Belle Arti*, December 1977, pp. 366–9. (Stoughton, 1977).

Christopher Wright, *Georges de La Tour*, London, 1977. (Wright, 1977).

1978

Wolfgang Prohaska, 'Sellitto at Naples', *Burl. Mag.*, April 1978, pp. 263–4. (Prohaska, 1978).

Due to be published in 1979

Arnauld Brejon, 'New Paintings by Bartolommeo Manfredi', *Burl. Mag.*, 1979. (Brejon, 1979).

Benedict Nicolson, 'Orazio Gentileschi and Giovanni Antonio Sauli', *Burl. Mag.*, 1979. (Nicolson, 1979).

Feb. 1973, published Rome, 1974. (*Colloquio*, followed by name of author, 1974).

Frederick Cummings, Luigi Salerno and others, 'Detroit's "Conversion of the Magdalen" (the Alzaga Caravaggio)', *Burl. Mag.*, Oct., 1974, pp. 563–93. (Cummings, Salerno etc., 1974).

Luigi Dania, 'A "St John the Baptist" by Valentin', *Burl. Mag.*, Oct. 1974, pp. 616, 619. (Dania, 1974).

Giuseppe De Vito ,'Un inedito del Tournier', *Paragone* 297, Nov. 1974, pp. 55–6. (De Vito, 1974).

Pier Luigi Fantelli, 'Nicolò Renieri Pittor Fiamengo', *Saggi e Memorie di Storia dell'Arte*, No. 9, Florence, 1974, pp. 79–115. (Fantelli, 1974).

Mina Gregori, 'A new Painting and some Observations on Caravaggio's Journey to Malta', *Burl. Mag.*, Oct. 1974, pp. 594–603. (Gregori, 1974).

Exh. 'Cinquant'anni di Pittura Veronese 1580–1630', catalogue by Licisco Magagnato, Verona, 1974. (Magagnato, 1974).

Maurizio Marini, *Io Michelangelo da Caravaggio*, Rome, 1974. (Marini, 1974).

J. A. L. de Mayere, 'Mathias Stomer, Anamorphose', *Centraal Museum Mededelingen*, No. 5, Jan. 1974. (De Meyere, 1974).

Albert P. de Mirimonde, *Sainte-Cecile: Métamorphoses d'un thème musical*, Geneva, 1974. (Mirimonde, 1974).

Benedict Nicolson, 'Caravaggio and the Caravaggesques: Some Recent Research', *Burl. Mag.*, Oct. 1974, pp. 603–16. (Nicolson, 1974).

Benedict Nicolson, 'A Honthorst for Minneapolis', *The Minneapolis Institute of Arts Bulletin*, LX (1971–3), 1974. pp. 39–41. (Nicolson, *Minneapolis*, 1974).

Benedict Nicolson, 'Additions to Johan Moreelse', *Burl. Mag.*, Oct. 1974, pp. 620, 623. (Nicolson, *Moreelse*, 1974).

Benedict Nicolson and Christopher Wright, *Georges de La Tour*, London, 1974. (Nicolson/Wright, 1974).

Exh. 'Guy François (le Puy, 1578?–1650)', Le Puy and St Etienne, 1974. Catalogue by Marie-Félicie Pérez. (Pérez, 1974).

Marie-Félicie Pérez, 'Bilan de l'Exposition Guy François', *La Revue du Louvre*, 1974, pp. 468–72. (Pérez, *Musée du Louvre*, 1974).

A. Pigler, *Barockthemen*, Budapest, new ed. 1974. (Pigler, 1974).

Luigi Salerno, 'A Painting by Manfredi from the Giustiniani Collection', *Burl. Mag.*, Oct. 1974, p. 616. (Salerno, *Manfredi*, 1974). (See also under 'Cummings').

G. C. Sciolla, *I Disegni di Maestri Stranieri della Biblioteca di Torino*, Turin, 1974. (Sciolla, 1974).

Bozena Steinborn and Stanisław Filipiak, 'A Painting by Jan van Bronckhorst revealed from beneath the over-paintings' (in Polish), *Ochrona Zabytków*, 1974. (Steinborn, 1974).

John Walsh Jr., 'New Dutch Paintings at the Metropolitan Museum', *Apollo*, May 1974. (Walsh, 1974).

Youri Zolotov, 'Georges de La Tour et le Caravagisme néerlandais', *Revue de l'Art*, 1974, pp. 57–63. (Zolotov, 1974).

1975

Ferdinando Bologna, 'A New Work from the Youth of La Tour', *Burl. Mag.*, July 1975, pp. 434–41. (Bologna, 1975).

Andrea Busiri Vici, 'Ancora sullo "Spadarino"', *Antichità Viva*, No. 3, 1975. (Busiri Vici, 1975).

Jean-Pierre Cuzin, 'Pour Valentin', *Revue de l'Art*, No. 28, 1975, pp. 53–61. (Cuzin, 1975).

Fiorella Frisoni, 'Leonello Spada', *Paragone* 299, pp. 53–79. (Frisoni, 1975).

Caravaggio and his Followers. Introductory articles and notes by S. Vsevolozhskaya and I. Linnik. Aurora Art Publishers, Leningrad, 1975. (Linnik, 1975).

Benedict Nicolson, 'Caravaggesque Pictures in National Trust Houses', *The National Trust Year Book*, 1975–6, pp. 1–7. (Nicolson, 1975).

Novità sul Caravaggio, ed. Mia Cinotti Regione Lombardia, 1975. (*Novità*, 1975, followed by name of author).

Exh. 'Opere d'Arte restaurate', Soprintendenza alle Gallerie ed opere d'arte della Sicilia, Palermo, Dec. 1974–Jan. 1975. (Palermo, 1975).

Wolfgang Prohaska, 'Carlo Sellitto', *Burl. Mag.*, Jan. 1975, pp. 3–11. (Prohaska, 1975).

Richard Spear and others, 'Technical Examination of Four Baroque Paintings', *Dayton Art Institute Bulletin*, Vol. 34, No. 1, Oct. 1975. (Spear, etc. 1975).

1976

Didier Bodart, 'Unpublished Works by Matthias Stomer', *Burl. Mag.*, May 1976, pp. 307–8. (Bodart, 1976).

Arnauld Brejon and Jean-Pierre Cuzin, 'Une Oeuvre de Nicolas Régnier au Musée des Beaux-Arts de Lyon', *Bulletin des Musées et Monuments Lyonnais*, Vol. v (1972–6), No. 4, 1976, pp. 455–66. (Brejon/Cuzin, 1976).

Vittorio Casale and others, *Pittura del Seicento e del Settecento—Ricerche in Umbria—1*, Spoleto, 1976. (Casale etc., 1976).

Anna Ottani Cavina, 'On the Theme of Landscape—1: Additions to Saraceni', *Burl. Mag.*, Feb. 1976. (Cavina, 1976).

Sydney J. Freedberg, 'Gentileschi's "Madonna with the Sleeping Christ Child"', *Burl. Mag.*, Nov. 1976, pp. 732–4. (Freedberg, 1976).

A Catalogue of Pictures at Althorp, compiled by K. J. Garlick, Vol. XLV of *The Walpole Society* (1974–6), 1976. (Garlick, 1976).

Mina Gregori, 'Addendum to Caravaggio: the Cecconi "Crowning with Thorns" Reconsidered', *Burl. Mag.*, Oct. 1976, pp. 671–80. (Gregori, 1976).